Hanging a Rebel —

The Life of C.R.W. Nevinson

Hanging a Rebel –

The Life of C.R.W. Nevinson

Michael J.K. Walsh

The Lutterworth Press

The Lutterworth Press
P.O. Box 60
Cambridge
CB1 2NT

www.lutterworth.com
publishing@lutterworth.com

ISBN 978 0 7188 3090 8

British Library Cataloguing in Publication Data
A catalogue record is available from the British Library

Contents:

List of Illustrations

Cover image: C.R.W. Nevinson, *Column on the March*, 1915, Birmingham City Art Gallery. Artist's Estate.

Acknowledgements

This book has been a long time in the making, and has been indebted all along the way to particular individuals and institutions, which I would like to thank in this space. My thanks go to: the Paul Mellon Centre for Studies in British Art (Yale University) in London for repeated funding; the Visiting Research Collaborator status afforded me by the Department of Art and Archaeology at Princeton University and the Post-Doctoral Fellowship offered by the University of Texas at Austin. Other individuals and institutions which have been helpful along the way include: the Harry Ransom Humanities Research Center at the University of Texas at Austin (in particular Pat Cox); the staff at the Hyman Kreitman Research Centre at the Tate Gallery, London; the Imperial War Museum, London; the Bodleian Library, Oxford University; the Fitzwilliam Museum, Cambridge University; King's College Library, Cambridge University; the Warburg Institute, London; the British Library, London; the British Newspaper Library, Colindale, London; Bryn Mawr College Library, Pennsylvania; Temple University Library, Pennsylvania; the Karl A. Kroch Library, Cornell University, NY; Fales Library, New York; University of Delaware Library, Delaware; Friend's House Library, London; Houghton Libraries, Harvard University, Massachusetts; Museo di Arte Moderna e Contemporanea di Trento e Rovereto, Italy; the New English Art Club Archive, London; the New York City Public Library, NYC; the New York Historical Society, NYC; the Slade School of Art Archive, London; the Archive of American Art, Smithsonian Institute, Washington D.C.; Uppingham School Archive, Rutland; the National Art Library, Victoria and Albert Museum, London; Georgetown University Library, Washington D.C.; Churchill College, Cambridge University, Cambridge; the Estorick Collection, London; University of Victoria Library, Canada; and the Women's Library, London.

My thanks also go to Johann Pillai, Anber Onar, Paul Edwards, Christopher Martin, Angela V. John, Sue Malvern, David Boyd Haycock,

David Peters Corbett, Frances Spalding, Ben Jones, Geoffrey Haskins and Jonathan Black. I would like to thank Adrian Brink of Lutterworth Press, Polly Gant, the copy-editor, and Hawley Wright, the indexer.

On a much more personal note, my thanks go, as always, to Ann and John Walsh, and also to Cathy, Lee, Erin & Aleea Wortman. Last, but not least, I extend my thanks and my love to Gül, Erdal and Limon – to whom I dedicate this book.

Michael J K Walsh
Famagusta
2007

For Gül, Erdal and Limon

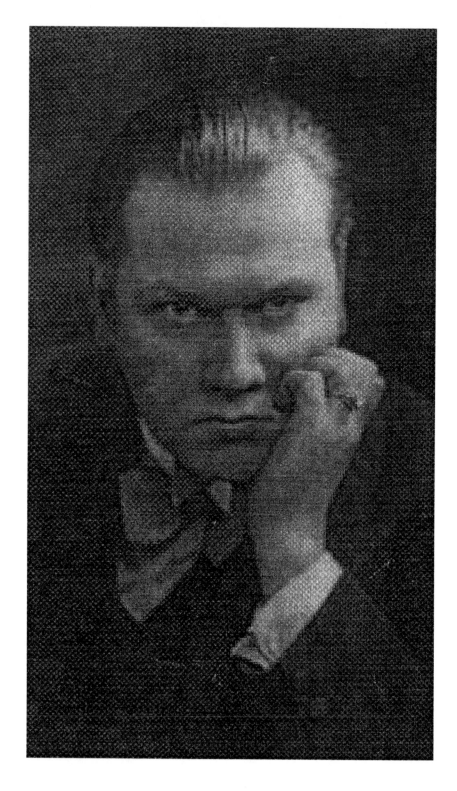

Introduction:

Writing about C.R.W. Nevinson in 1921, Hugh Stokes told the readers of *Queen* magazine 'When his biography is written, which I hope will not be for many years to come, what a wealth of material will await the author'.[1] Stokes was, after all, talking about one of the most prominent and distinguished artists of his time, and one of London's most celebrated icons of the pre-war avant-garde, of the Great War itself, and of the inter-war era in which he was writing. Nine years later, at the end of the Roaring Twenties and at the outset of the Great Depression, art critic T.W. Earp could write of Nevinson's continued achievement in *The Studio* claiming confidently 'he has triumphantly proved himself an interpreter of his epoch and a leader of its art'.[2] A further decade on, this time in late 1942, none other than British Prime Minister, Winston Churchill, wrote personally to the artist saying 'I am sure the young men who are fighting regard you as part of the England they defend.'[3] The compliment was indeed a serious one. And when it was all over in 1946, and writers, friends and critics got to work in eulogising this 20th-century English legend who had died at 57 years old in his studio, they remembered 'one of the most provocative artists of the century',[4] and a 'genius, playboy and war hero'.[5] C.R.W. Nevinson would have been pleased.

But Nevinson was also an extremely complex character and, whether they loved him or loathed him, those who knew him would have been familiar with the mutli-layered personality of the painter, social commentator, novelist, journalist and society host. Some might have respected him purely for his genius, which they believed unparalleled in his time, while others would have been unable to see past his ill-tempered outbursts which had characterised, or dogged, his career from the very beginning. Perhaps Dame Edith Sitwell came closest, when describing him as 'A good hater, and the best of friends, he is also a great fighter, and hits as hard as he is hit'.[6] But it would be an injustice to suggest that it was merely infamy which was the source of Nevinson's legend. Few would have forgotten the accolade that Walter Sickert had offered the young artist so many years before, in 1916, when he had insisted that the seminal canvas, *La Mitrailleuse*, was 'the most concentrated and authoritative utterance on war in the history of painting'.[7] In fact Sickert

was not alone as, by this time, critics and public alike had come to expect nothing less from this young rebel who, having graduated from the Slade, had come fresh from Paris and the bohemian life he had lived there, had taken up arms with the Italian Futurists in an assault on London, before heading to the Front to give incisive pictorial expression to what was being witnessed and experienced in The Great War. And then when the war was over it was Nevinson, and sometimes Nevinson alone, who had continued to fight - his life and work irrevocably intertwined - inseparable, yet misunderstood. He continued to 'go it alone' until his death in 1946.

To write the biography of the man who Wyndham Lewis called 'a lone wolf', and elsewhere 'a dark horse', has been an enormous undertaking for a number of reasons.[8] First of all there is Nevinson himself; he did everything possible to throw a potential biographer off the scent, leaving behind, amongst other things, a factually dubious (though highly entertaining) autobiography, *Paint and Prejudice*. Published in the same year that both Wyndham Lewis and Paul Nash released their autobiographies, this was Nevinson's own dramatised and selective account of the struggle which had been an artist's life. It was not, however, a triumphant or nostalgic retrospection on a life and a career almost over, but came across instead as a working manifesto for an individual still fighting his corner in inter-war England and carving out a niche for himself in the history of art. Some loved it and gushed 'Here is a high-spirited, swashbuckling, hearty adventurer, a high-Renaissance character of the stamp of Benvenuto Cellini,'[9] while, on the other hand, Thomas Caraven in the *New York Herald Tribune* undoubtedly spoke for many others when he said 'for sustained, defensive rudeness, and indiscriminate boasting, Nevinson's book takes the biscuit.'[10] The more astute observer could write 'Mr Nevinson's memoirs are like his fine paintings, bitter yet generous; sensitive and troubled, yet sane and affirmative; instinct with energy, movement and life.'[11] This record, he felt, would add the missing piece to the picture created of him in his parents' autobiographies which had preceded it – Margaret Nevinson, published her memoirs entitled *Life's Fitful Fever*; while his father, Henry Nevinson, left an autobiography which ran to three volumes; *Changes and Chances*; *More Changes More Chances* and *Last Changes Last Chances*. To trust the artist's autobiography implicitly would be foolish, but to trust the records left by his enemies would be worse – and Nevinson knew that. And so, to keep the paper trail fresh, the Tate Gallery (an avowed enemy of his) received, after his death through a bequest made by his wife, Kathleen, fourteen meticulously kept press cutting albums, which offered an account of the artist's life, or his edited perception of it, covering the years 1910-1947. This is indeed

an impressive record for any art historian of the era and one in which hardly any mention of his name, work and exploits (in London, Paris and New York), was missed, from as far away as Buenos Aires, Delhi and Melbourne. And finally, not satisfied with being the author of his own history and how, in the future, others might reconstruct and write it, he instructed his wife in his Last Will and Testament, to destroy any of his work that did not honour his name, but to avoid at all costs, the advice of any other artist who might yet bear a grudge. What Nevinson left behind, therefore, was a well signposted route for his biographer to take. To reconstruct the artist's life more objectively then, on terms other than his own, has required an international search for archives and sources which contain letters, personal communications, contracts and anything else that has not been included in his own memoirs or bequests, and which offers a more wide-angled perspective of a most controversial life. Though I identified, and used, hundreds of documents worldwide, none surpassed in importance his own father's journals housed in the Bodleian Library, Oxford University.[12] These quiet, hopeful, sometimes despairing jottings, unpublished and deeply personal, offer a behind-the-scenes glance from the perspective of a father who would not abandon his son to his fate, and who was his most avid supporter until his own death in 1941. In some ways then, this biography is actually the biography of two men whose lives were intertwined and in some way interdependent, socially and professionally.

The second problem with the reconstruction of Nevinson's life is that scholarship pertaining to it is so unbalanced. While few writers have doubted his position of centrality in the context of the Great War, or indeed just before it as 'England's only Futurist' (about which I wrote *C.R.W. Nevinson: This Cult of Violence*, Yale University Press, 2002), most then stop at that point – displaying an ignorance of the quarter of a century of painting, designing and writing that followed. This, to me, is ironic as the artist had only just found his confidence by the war's end, to the point that when Charles Lewis Hind introduced him to New York in 1920 at the outset of the Jazz Age, he could describe his protégé as 'among the most discussed, most successful, most promising, most admired, and most hated of British artists.'[13] He was not, as existing literature would have us believe, finished by 1918. This biography redresses this imbalance, and in so doing, does not simply re-create a forgotten life, but lets us see London through his eyes, and understand the debates that raged around him. He was, after all, involved in many of them through the press, public speeches and ill-advised personal vendettas, even if his crippling persecution complex meant that these spats often hurt him terribly, and on more than one occasion led him to the verge

of suicide. Who would have thought that the ultra sensitive, lonely and neurotic painter, so fearful of any attack on himself or his work, would be capable of outbursts like '. . . the Royal Academy is worse than a useless institution: it is a blight and a loathsome centre of decay and stagnation that does more to pollute living art than any other institution in the world'?[14] And who would then believe that only a few years later the outspoken provocateur would accept the status offered by that same institution and become an Associate of the Royal Academy? By the 1940s, as surprising as it might seem, he had accepted a host of other conservative accolades and awards too, including membership of the New English Art Club, The Royal Society of British Artists, the Royal Institute of Oil Painters, and even become a *Chevalier d'Honneur* – a magnificent gesture offered by a grateful French nation. Little wonder *The Scotsman* portrayed him as 'A rebel in art who lived to be acclaimed as a classic. . .';[15] an artist who had come, albeit circuitously, 'home'.

But the path had not been an easy one, and now he was not going to let down his guard, or pull any of 50 copies of his punches, when he sensed the slightest sense of danger coming from, amongst others: George 'Barnum' Shaw, Sir Kenneth 'Napoleon' Clark, Henry 'Henrietta' Tonks, Muirhead 'Bonehead' Muir and the rest of the shepherds of 'Gloomsbury' (Roger Fry, Clive Bell and the rest of the Bloomsbury Group whom he abhorred). He did not always come out on top either, chalking up pyrrhic victory after pyrrhic victory, and grinding production in his studios to a halt through depression, disillusionment and shattered confidence. Before long he felt that, as a living artist, victimized and ostracized at the hands of the veritable dictatorships of the Tate and the National Gallery, he 'would rather be a Jew in Germany than an artist in England'.[16] Nevinson was seen by others as 'a legendary figure of violence',[17] and by himself as a victimised, ostracised visionary, driven to the verge of despair by his own genius, which inflicted upon him 'the strangest manifestations, and [the recipient of] prophetic visions that deal with the affairs of man'.[18] These forebodings led to an apocalyptic series of paintings in the 1930s, and a doom-laden novel, *Exodus AD: A Warning to Civilians*, which he co-wrote with Princess Troubetzkoy, as Europe descended into another war. And yet this was the same artist who was famed as a boulevardier, a bon viveur and the 'playboy of the West-End World', who normally cut such a dash, with his glamorous wife Kathleen, in their numerous public appearances or at their infamous studio parties which were the talk of London. It was on the back of the latter image, and escorted by his hallmark bellowing laugh, that Nevinson rode his way into many novels of the era by writers such as Ronald Firbank, Sisley Huddleston, Ethel Mannin, Henry Williamson,

and even into the original draft of T.S. Eliot's monumental *The Waste Land*. Whether using the brush or the pen, Nevinson's contribution to English cultural history, as this book demonstrates, was certainly not dead by the Armistice – far from it.

It seems inexplicable to many that Nevinson's name drifted into obscurity after his death. He would have argued, of course, that this exclusion was no accident or oversight, rather the result of an intentional plot at the hands of his enemies to erase him completely from the map of English cultural history, as the 'cabal' had tried to do throughout his own lifetime. Neither would he have been surprised to find today's bookshelves filled with volumes on The Bloomsbury Group, Wyndham Lewis, Mark Gertler, and even a full movie about his ex-paramour Dora Carrington (in which he did not get a mention), while references to himself and his work, remain sparse. Even with my exhaustive study of his life and work, I am quite sure, C.R.W. Nevinson might have taken issue, while acknowledging fully the absolute need for it. Were he alive today I am quite sure that I would receive one of his outraged letters about my presentation of his life and work, though in this, I would be in good company with a great many others who undertook a similar appreciation and analysis, albeit on a much smaller scale.

From all I've done and I've said
Let them not seek to find who I've been

'Hidden', by Constantine P. Cavafy, 1908

1
Internationalism and Intellectualism, The Nevinsons (1889-1908)

It was, it seems, all out of C.R.W. Nevinson's hands from the very beginning. According to the *Sunday Times* art critic, Frank Rutter, his destiny had been decided from before he was born, as he was the 'child of parents who had singularly noble ideas, [and] who were markedly progressive and humane in their habit of thought'. As a consequence of this, he continued, Christopher Richard Wynne himself 'started life with a pre-natal tendency to revolt against injustice, cruelty and oppression'.[1] *The Listener* agreed completely and declared 'Eugenists, psychologists and socialists combined could scarcely have created conditions more favourable to the production of an artist.'[2] Richard, of course, did nothing to dispel this image, not least in his autobiography, when he too reminisced:

> I was born into the most exquisite and intellectual ambience, and in the early years at home I was surrounded by scholarship and all the brilliance and wit of the nineties.

He went on:

> Although both my Father and my Mother came from old English families, I was brought up in a spirit of internationalism. My father had only lately given up a post he had held as professor at Jena.

This was stretching the truth a bit (his father studied at Jena), but added nicely to the rich mix of internationalism and intellectualism that the artist felt had moulded him in his formative years. When he went on to say in his autobiography that 'Both my parents were as much at home in Europe as they were in London',[3] leaving him tri-lingual in French, German and English, he completed the image of the cosmopolitan home which awaited now only the heir to such a legacy. It was not, however, a 'happy' family as can be seen when Henry, his father, privately recorded in his journal how his wife was 'a nagging ceaseless blast of ill temper', and how the wider family produced 'horrible wrangling and ill

temper at home all day from Richard's illness & Phil's opposition & an
unhappy woman's unhappiness'.[4] But these were private observations,
away from the very public image of a role-model family, embodying
impeccable moral standards, as England traversed awkwardly from the
Victorian to the Edwardian era. In fact, it was with considerable pride
that Richard recalled a 'father [who] had been chucked out of more
meetings than any other man in London and had even achieved the
distinction of being publicly rebuked by Lloyd George at the Albert
Hall'.[5] The artist's lifetime of high-brow, and often reckless, rebellion,
was therefore, to some extent, modelled on, and often supported by, his
parents, especially his celebrated father, who had won high distinction
as a war correspondent, social and political reformer, writer, critic,
speaker, traveller and adventurer. Observers were not slow to make the
connection either, even early in Richard's career, commenting with some
excitement, 'He is the son of H.W. Nevinson, the war correspondent,
who also has a rebellious temperament. The father, however, confines
his violent revolutionism to politics and journalism, while the son finds
more colour for his views in the paint-box.'[6] The connection, or possibly
rivalry, was evident even in the 1930s when W.R. Titterton wrote of an
encounter with an editor suggesting an interview with 'Nevinson':

> 'What, the artist?' said the editor.
> 'No' said I, fuming slightly, 'H.W. Nevinson, the greatest war
> correspondent of modern times.'
> The editor frowned thoughtfully. 'Oh yes,' he said at length.
> 'The father of the artist, isn't he?'
> I told him he was misinformed; the artist was H.W. Nevinson's
> son.[7]

By amalgamating the private and the public personae, Richard could
conclude 'I was trained in war long before my doomed generation,' while
simultaneously 'By upbringing I could never accept the established.'[8]
Behind the scenes, it was clear that Richard often found this familial
legacy bewildering, perhaps even intimidating, as seen when he wrote to
Dora Carrington:

> I have seldom met such egoists as either my father or mother.
> On Sunday instead of you we had two Indian revolutionists, a
> fellow of some college at Cambridge & the other a Black, an
> authority on economics. They had dinner & went up to William
> Rothenstein's to hear Yeats read his poems.[9]

Henry Woodd Nevinson had been a schoolboy at Shrewsbury and had
then taken a degree in Classics from Christ Church, Oxford, in 1879.

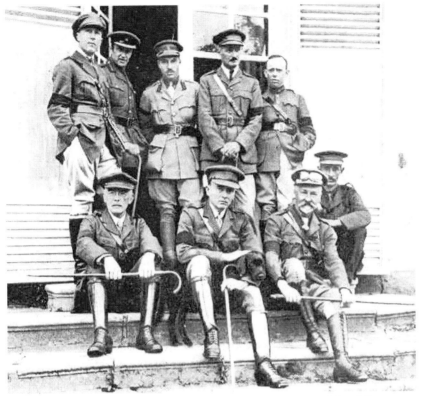

War correspondents: H.W. Nevinson is seated front right. Bodleian Library

Loathing his brief period as a school teacher, and following a visit to Germany (after which he published his first book *A Sketch of Herder and His Times*, 1884), he married Margaret Wynne Jones, and returned with her to Germany where they had their first child, Philippa. The period in Jena, followed by another unhappy period of teaching in London, resulted in another book (*Life of Frederick Schiller*, 1889), which was published in the same year that their second child, Christopher Richard Wynne, was born (13 August 1889). Utterly unfulfilled, Henry took the decision, in 1897, to abandon his domestic misery and turn to a life of adventure, reporting first from the Graeco-Turkish War, then later from the Spanish-American War, the Siege of Ladysmith, revolutionary Russia, the Portuguese slave colonies of Angola, and as far afield as India, Ireland, Macedonia, the Baltic Provinces, Morocco, Bulgaria, Egypt, the United States of America and the Ottoman Empire. In London he was, in the fullness of time, president of both the National Council for Civil Liberties and the Poets, Essayists and Novelists (P.E.N.) Club; was vice-president of the Anti-Slavery Society; a founder member of the Men's Political Union for Women's Enfranchisement; editor of the literary page of the *Daily*

Chronicle and, by the time of his death, author of more than thirty books. Though Richard suffered from the physical (though not intellectual) estrangement that such a lifestyle demanded, and was as a result distant from Henry, he did respect him and what he stood for, conceding that 'I of course have freedom bred all over me thanks to my father.'[10]

Richard's mother, Margaret Wynne Nevinson (née Jones), was also quite a daunting act to follow, being as she was a well-educated and active liberal, a suffragette campaigner and one of London's first female Justices of the Peace. She had lived briefly in France and Germany, before taking a part-time LLA (Lady Literate in Arts) degree from the University of St Andrews in Scotland. So immersed was she in the events of the day (such as the Women's Freedom League, The National Union of Women's Suffrage Societies, The Woman's Social and Political Union, The Women Writers Suffrage League, The Church League for Woman's Suffrage, and The London – Welsh Cymric Suffrage Union), that her son lamented understandably, 'if my mother does happen to be in for a meal she is so engrossed in other things that she hardly hears and certainly never takes in a word I say'.[11] Henry and Margaret, as husband and wife, though far from physically or emotionally intimate, were nominally united by their vocational work in the poorer communities of the East End; Henry as Secretary to the London Playing Fields Association, teacher and commanding officer of the St George in the East End cadet corps; and Margaret teaching French and dance in the slums at Toynbee Hall. But, even if both parents were strong activists and socially engaged commentators and agitators of the society in which they lived, they both regretted their hasty decision to marry in 1884. As Angela V. John has recently highlighted, however, they may have had very little choice in their decision as Margaret was already pregnant at the time of their marriage, necessitating their imminent departure for Germany. But it had all gone very wrong and Henry wrote miserably in his journal, just after the turn of the century, about the 'usual abuse & contempt at home from the woman who lives here & spends all her time speaking evil of me to her friends & children'.[12] This was not a place of warmth and it is telling that in all of the family autobiographies emphasis falls more on the issues of the day, rather than on their unhappy domestic lives, to the point that there is scant mention of their daughter, Philippa, at all, even if she was a talented pianist, trained at the Royal College of Music and at the Milan Conservatoire. Music ran in the family as Philippa and Richard's uncle, Basil Nevinson, played Cello with Edward Elgar, but the archival records which exist relating to Philippa and her career, point only to Henry's disappointment in her underachievement, and to her own lifetime of discord with her brother. Even in 1942, when

Margaret Nevinson

Philippa and Richard were both in their fifties, Evelyn Sharp (Henry's second wife after the death of Margaret) observed 'her horrible desire to hurt Richard whenever she can', a condition which lay, in her opinion, 'buried in her childhood'.[13] Less surprisingly, Margaret and Henry's respective autobiographies hardly mention each other either, though both talk warmly of their son. Margaret's *Fragments of Life* was dedicated to Richard, and told of how a fictional woman had endured her husband's affairs as 'I had my son, you see I could not leave him,' while the story 'Port After Stormy Seas' stressed how the wives of literary men 'must get used to being forgotten'.[14] Margaret had almost died in childbirth, then admitted quite openly that she did not adapt easily to the constant demands of small children, concluding that 'it is a terrible thing to be a mother'.[15] Her son, however, thought the world of her and on one occasion when

Portrait of Nevinson in 1892
at age 3

his nanny had explained to him what was happening in a passing funeral he had raced home 'in a state of dreadful agitation, feverish and terrified, clinging to me and crying 'Oh! Mother, don't you die, I'll never let them put you in a hole, let us go on here forever.'[16] They remained devoted to each other until her dying day in 1932, and indeed it was his name on her lips as she passed away.

The first family home was Scarr Cottage, John Street (from 1887), an 'old, white, Hampsteadean monument of stucco, dampness, bad plumbing, and immense kitchens, and set in a garden of lilac and may'.[17] It was, however, appropriately situated opposite John Keats' house, and between those of Herbert Asquith and Ramsay MacDonald. In 1896, with the help of a legacy left to Margaret, the family moved to a new house at 44 Savernake Road, off Parliament Hill, and again, in 1901, to 4 Downside Crescent, Hampstead, which remained their permanent home until they were bombed out during the Second World War. The door of 4 Downside Crescent, Richard reminisced, was always open to 'French, Germans, Finns, Russians, Indians, 'Colonials', Professional Irishmen and Suffragettes. . . . It was, indeed, clear to them that England had nothing to be proud of.'[18] Melodramatically, and rather opaquely, Richard later mused on the consequences of this, saying 'What would they think, those Nevinson's who lie in peace in our old cathedrals, or those others on the soldier side of the family, what would they think if they knew we were now called Jews?'[19]

But Richard was not an easy child, being temperamental, outspoken, argumentative and also deeply (possibly irrationally) sensitive. Margaret worried about the nature of a boy who would 'throw himself on the floor and roll over and over, not crying, but roaring softly and holding his breath till he was black in the face', then watched in amazement as stories, pictures and music could all lead her child, inexplicably, to tears.[20] Formal education was about to exacerbate these emotions further, especially as he

*Photo of Nevinson in 1898
at age 9*

had to be removed from his first school, following a public flogging in 1897. There was a momentary respite at the Junior Department of University College School, under Charles Simmons, where he seemed very happy and even won some prizes for paintings with lofty titles such as *Arrival of the Viking Ships in England, Joan of Arc's Vision of St Michael, The Knight's Vision Before the Battle* and *St Simeon Stylites*. Despite this, Henry was clearly not impressed, writing in his journal 'tried to imagine how ignorant and stupid my brain must have been at nine',[21] and later, 'Rich growing up all wrong.'[22] Though he sat with him night after night at home helping him with Greek, Latin, arithmetic and drawing, and despite taking him sculling himself, Henry learned from the headmaster that Richard had 'no exceptional talent'.[23] Nor did he excel at sport of any kind – a serious problem when he went to public school in 1903. So grim was the whole business of being removed from his childhood 'Manboya Gang' (also called the Red Brotherhood), and being sent to Uppingham, that Richard prefaced the section in his autobiography with the stark statement 'Then came the *debacle*.' He went on to explain how, in his mind at least, the process had come about:

> Before that, when Ladysmith was relieved, my father had returned on short leave before going to Pretoria, and there is no doubt he was impressed by the charm and brilliance of the Army staff, and the nobility and altruism that seemed to be founded on the public-school spirit. In those days he was a polished Englishman of culture, and said he wanted me to go to Shrewsbury, his old school, and on to Balliol, if not into the Army itself.

Regardless, Margaret chose Uppingham (having also considered Clifton and Haileybury), and this decision ensured that he was transferred into what would be a living nightmare. He mused over thirty years later 'No qualms of mine gave me an inkling of the horrors I was to

undergo.'[24] Henry had travelled to meet the Headmaster, Selwyn ('not an impressive or splendid character'),[25] and to look the place over before his son's arrival, and had felt the school 'rather dreary and useless. One felt the immense waste of time in all the school and its courses – the dreariness & isolation of it all'. But it would do as it was no better or no worse than any other public school at the time, and certainly no worse than Shrewsbury. Henry and Margaret, tolerating each other for the sake of their son, accompanied him and helped him to settle in at the beginning of his first term, despite Richard's memoirs to the contrary, which suggested they were miles away and uncaring. Though Henry was getting ready to go to Macedonia, he wrote emotionally of 'a day of choking sadness to me & us all', then went on:

> I never felt such sorrow as when the train whistled & the boy had to turn back alone to go to his lonely place, unknowing what to do & alone for the first time. He tried to be brave and that made it the harder. It was worse than going to school again myself. Came home in extreme misery.[26]

Henry stuck by the decision, nonetheless, and only secretly, far from the prying eye of his wife or his son, revealed the pain he was experiencing when he wrote 'Full of grief & yearning about poor Rich'.[27] A week later he added 'Missed poor Rich very much'[28] and wrote of how his own misery was linked inextricably to that of his son, scribbling 'Unhappy all day at Rich's unhappiness.'[29] When the letters from Richard started to arrive at Downside Crescent, they talked only of a life hardly worth living in Uppingham. Henry was distraught about 'my poor Rich [who] is suffering horrible misery – bullying, filth, thieving, underfeeding and every torment. I can hardly live for sorrow.'[30] Eventually he could tolerate it no longer and intervened, sending a copy of his son's letter, which had been 'full of terror and rage', to Selwyn, whilst sending his son a note 'to hold out in hope'.[31] He followed this up with a personal visit where he found Richard sitting on a bench in the garden of the school where 'He cried terribly at first', then 'poured out all his griefs (sic) & miseries quite frankly and pathetically'. But soon he regained his composure and became 'manly & capable & resolute' and admitted by the end of the meeting, that he 'like[d] his masters & all the work well & seems to be doing well'. Clearly putting a brave face on the whole gloomy spectacle, and searching for solace in art, he tried to take his father to see his paintings, though the particular building in which they were housed was locked much to his disappointment.[32] Henry, if anything, felt that the visit had been cathartic and had demonstrated only that his son was homesick and not adjusting quickly to being away from the family household,

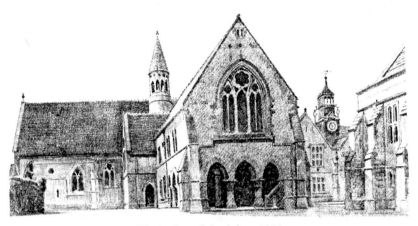

Uppingham School circa 1903

however imperfect. He wrote to Selwyn saying 'the boy will pull through & be a good sort of man',[33] though he also expressed some irritation with Richard's 'slack' and 'loafing' ways.[34] Selwyn replied pointing out that Richard often displayed a 'want of manners & brusqueness' – traits that would characterise the rest of his professional and public life.[35] By the Christmas holidays in 1903, Henry reported with great relief, 'Rich came home with great joy and success.'[36] On future termly visits home, he and Richard visited art galleries, in particular admiring the works of Stanhope Forbes, John Lavery, Muirhead Bone and Charles Shannon,[37] while in term time, Henry would keep his distance, communicating only by letter (in one case warning him on the dangers of women).[38] But behind the veneer Richard remained miserable and suffered not only from an intolerable patriotic indoctrination (anathema considering his family upbringing prior to his schooling), and mental and physical bullying, but also, very possibly, sexual abuse. He wrote 'I learned nothing: I did nothing. I was kicked, hounded, caned, flogged, hairbrushed, morning, noon and night. The more I suffered the less I cared.'[39]

By 1905, back from his adventures in Portuguese Angola where he had been reporting on the illegal slave trade, Henry felt that the whole experiment might at last be working, as his son, to his delight, had become 'much advanced in freedom and manner'.[40] On the downside he seemed to be continually suffering from one illness or another, to the point that the Headmaster had had to let Margaret come and share his house as she nursed her son back to health over a three-week period. In the end Richard had to be removed for the remainder of the term, which Henry believed to be a great show to elicit sympathy and to catalyse his withdrawal from the school altogether.[41] In April 1906 it was proved that the illnesses had

been genuine when he was operated upon for appendicitis. His failure
to return led Henry, finally, to admit that it all seemed to have been a
grave, and expensive, mistake which filled him with a 'sense of failure &
loss at the wasted years in the boy's life there, just through the bad choice
of school'.[42] And yet he still did not formally remove him, departing
instead to report from Russia and the Caucasus. It was only on his return
that Selwyn finally incensed him sufficiently to act, by suggesting that
his son was quite simply not made of the right stuff to benefit from the
institution. This, combined with another serious illness, induced by a
particularly harsh beating at the hands of the cricket eleven, and coupled
with the next suggestion of Selwyn – that Richard should go into fruit
farming in California – persuaded Henry that it was time to cut his losses,
withdrawing his son in 1907. In a later memoir Henry glossed over all of
these details, simplifying the situation and saying: 'The expenses for my
daughter's excellent musical education, and for my son's continuance in
ignorance at a great public school, were heavy, and the future of both was
dubious.'[43] In another volume he went into more detail:

> For myself, by far the most vital external event in those years was
> the discovery of my son Richard's love of drawing and capacity
> for imagining scenes in uncommon forms. He was then about
> thirteen and I recognised with apprehension that he would
> become an artist or nothing. Soon afterwards, most unhappily, I
> was induced to send him to a public school for three years, and I
> might just as well have sent him for three years to hell. Once or
> twice I went down to play the unpleasing part of the indignant
> parent, but it is useless to try changing the tone of a school from
> the outside. I offered to remove him to Shrewsbury, where my
> old friends among the masters would have helped him, but he
> preferred to 'stick it', and very likely the school was not in itself
> much worse than the average public school for a boy whose
> main interest lay in art. Indeed, one can imagine no more fatal
> characteristic for ensuring the contempt or detestation of boys
> and our ordinary masters alike. And it seems to me a terrible
> thing that any boy, however unusual and incomprehensible his
> inclination, should look back upon his school days with horror,
> and only wish to blot them out of his memory, after having in
> three years, at great expense, learnt nothing.[44]

The reality was that Uppingham had fostered no love of learning in
Richard, and had, if anything, pushed him towards the lonely pursuit
associated with art. More than anything, it had created in him a loathing
of institutions that he was to carry with him throughout his life. He

reminisced in 1926: 'It has made me aggressive on one hand and too shy on the other hand, and both states are opposites of the same thing. The only things that I ever learned as a youth are those I have spent years trying to forget.'[45] Years later, in 1931, Richard wrote a letter on public schools to the editor of the *Daily Express* which read:

> In theory the public school code embodies honest dealing, self-sacrifice, a capacity to lose without ill-nature, a love of justice towards all men, and a certain culture of the mind, body and spirit. In actuality it expects privilege without talent or capacity, shows a hatred of enterprise and a contempt for all the finer fruits of civilization, culture and intellect, worships defeat, displays self-satisfaction, and indifference to honesty or truth when it comes to maintaining 'appearances' or on the defence of hypocrisy, with a genial despising of all whose parents are poorer than ones own.[46]

Henry wrote in a similar manner in 1937, perhaps after reading a few pages from *Paint and Prejudice* and realising the resentment still harboured in his son, concluding that 'unless a boy shows aptitude for sport' it was 'a crime to send him to a Public School'.[47]

Richard claimed that it was his mother, who, regretting the terrible drawn out suffering at Uppingham, rallied round and took him on a 'Grand Tour' of Spain, Northern Africa and Venice. Even if it was not on this particular occasion, Richard also talked nostalgically of trips with her:

> In the art colonies at Pont-Aven, Concarneau, Quimper, St. Pol, Cauelebec, and St. Michel we always associated with the painters. The name of Monet had been familiar to me for some time. As my mother had been in Paris from about 1870 she was particularly versed in the Impressionist school; and I had already devoured, by the age of fifteen, the books of Camille Mauclair on Renoir, Monet, Degas, Sisley and Pissarro, and had heard of Gauguin and Cezanne. I had even heard of the 'mad' painting of Van Gogh some five years before their 'discovery' by Roger Fry and the dealers.[48]

On his return from India, Henry was also eager to nurture his son's love for art, and throughout 1907 and 1908, attended the most forward looking exhibitions to come to the capital, including a Max Beerbohm show at the Carfax Galleries, which they attended with Robert 'Bobbie' Ross.[49] When Richard finally got back on track educationally it was both a timely and pleasant move, and accordingly he gushed 'From

Uppingham I went straight to heaven.'[50]

St John's Wood School of Art was the 'heaven' to which Richard alluded, located at Elm Tree Road, and founded in 1878 as a form of nursery for the Royal Academy Schools.[51] The difference from his former institution led him to comment that 'within half an hour, I was almost unrecognisable as the same character that had been at Uppingham'.[52] It was at St John's too that Richard first started to enjoy the company of female students, in particular one called Philippa Preston,[53] whom Henry would colourfully describe as 'wildly impossible & irrepressible in charm, with a touch of Ibsenite daring'.[54] Here youth began to really flourish for the first time, in an environment which encouraged, not despised, his naïve excitement for an art world on which he had now set his sights. Enthused at first by Messina, Holbein and Dürer, he was soon lured to the 'music hall habit',[55] the bohemian Café Royal, the Tivoli, the Pavilion, the Alhambra, the Empire, and a whole new world of 'London bohemia' into which he was making his first nervous steps. This 'habit' then presumably directed him towards Walter Sickert and his colleagues at Fitzroy Street, where his father may have pushed a little to obtain an entré. Next came an admiration for de Wint, Monet, Turner and, of course, local hero, Augustus John – who really 'upset my apple cart'.[56] Working daily in life classes and sketching classical casts, Richard studied to develop the skill of creating tonal effects and tightness of technique, which he believed were essential prerequisites, before dabbling in the more avant-garde ideas coming from France. Whether or not he was reading the debates unfolding in *Burlington Magazine* between Roger Fry and C.J. Holmes is unknown, but before long he would be facing the reality of the French influence, imported into England at the hands of the former. Even if, as Henry reported, 'that queer kind of work that seems so unlike work' had not as yet matured into a 'true style'; even if he displayed a 'want of concentration';[57] and even if Sir William Orchardson had been forced to conclude that 'he has no true line yet',[58] it was not a source of concern to this teenage artist who was, at least, happy. Further encouragement came in the form of a prize, presented by Sir David Murray, and then with more encouraging words from Charles Sims, Sir James Lynton and Sir John Clausen. And if *Paint and Prejudice* is to be believed, his first commission came at this time too, at the tender age of seventeen, from none other than Ramsey MacDonald, who, having visited the Nevinson household to discuss certain contemporary issues, had ended up being impressed with the teenager's painting. Lunch at the House of Commons, followed by an introduction to Keir Hardie, the Independent Labour Party pioneer, was indeed a grand start to a career in painting, even if the finished piece was, in the end, rejected.

But, it was on seeing a copy of *The Studio* that he was struck that he should abandon the path to the RA, in preference for the more liberal, and European, Slade School of Art. The previous year he had sensed that this might hve been a possibility when John Fothergill, a mature student at the school, had published an illustrated magazine, *The Slade: A Collection of Drawings and Some Pictures done by Past and Present Students* which revealed to Richard that the 'method of draughtsmanship had a liveliness and intention unknown in the misapplied energy of the old-fashioned dogmas that came to England through the salons of 1870'.[59] The final push he needed in that direction came when he took the drawings of Augustus John to one of his teachers who,

> to my horror, . . . dismissed them as no good. John was simply a posing charlatan who wore gold earrings, 'long hair like Christ' and a Salvation Army jersey.[60]

The result was clean cut. 'I left for the Slade and abandoned any attempt to get into the Royal Academy Schools, a grave step which I took lightly.'[61] His father shared no such flippancy, however, and wrote to his friend Gilbert Murray, 'No, my son absolutely refuses to go to Oxford. He cares for nothing in the world but "art". It is a dreary prospect.'[62]

But art in London was far from dreary. Though still, to a large extent, conservative and bound by the standards of taste and etiquette set by the Royal Academy at Burlington House, there was, and had been, a surge of discontent that had been felt, for example in the words of Roger Fry when he had said:

> The Academy becomes every year a more and more colossal joke played with inimitable gravity on a public which is too much the creature of habit to show that it is no longer taken in.[63]

The publication of D.S. MacColl's *Nineteenth Century Art* had then been followed with Paul Durand-Ruel's exhibition of Impressionist painting in London and, in the same year, the return to England of German born Walter Sickert, friend of Whistler and Degas, who had set up his atelier on Fitzroy Street. Hope had appeared too with the creation of the Allied Artists Association (A.A.A.) in 1908 by Frank Rutter, which was modelled on the French Salon des Indépendents, and, in short, offered a subscription funded, jury free, exhibition at the Albert Hall. The foundation of the Modern Art Association in 1909 had offered similar liberties. Outside the walls of St John's Wood School the first perceptible changes were taking place that would so soon culminate in a heyday of modern painting just before the outbreak of the Great War in summer 1914. Besides, even if London was a slow starter, Richard was

now visiting Paris frequently, where, he recorded in his autobiography, he had become familiar with the Gallery Durand-Ruel and the Monets and Pissarros which adorned the walls there, and had even met Toulouse-Lautrec, whom he described as 'a dwarf in a frock-coat'.[64] He might, as he strolled around the boulevards, have looked longingly at the venues that had already been central to modern Art History, such as the Moulin de la Galette and the Moulin Rouge, and also at those that would soon be his haunts, like the Pierrot, the Royal, the Monico or the Rat Mort. Those days were not far off, and Uppingham already an eternity ago.

2
Made at the Slade (1909-1912)

The wall of the Café de Paris on the Tottenham Court Road was once adorned with a painting by John Currie called *Some Later Primitives and Mme Tisceron*,[1] in which a youthful and optimistic group of young artists, called the Neo-Primitives, stared keenly into a future which they believed was theirs. There is also a photograph in the Tate Gallery archive of the Slade 'gang' taken at the 1912 summer picnic in which the same artists sit and stand side by side, smiling for the camera, blissfully unaware of the momentous events which awaited both them and their country in the not-so-distant future. Indeed, Richard was hardly overstating the case when he reminisced that the Slade 'was full with a crowd of men such as I have never seen before or since',[2] at the very epicentre of the 'art quake' that rocked London in the halcyon days before the war. Margaret wrote of this 'crowd of men', her son's new friends, which, today, reads like a Who's Who in British art history, and remembered the callers at Downside Crescent which included: 'Curry ... the Spencers, Wyndham Lewis, Gertler, Allinson, Ethelbert White ... the Nashes, the Carlines, McKnight-Kauffer, Gaudier-Brzeska, Nina Hamnett, John, Sickert, Epstein, Ginner, ... Robert Bevan and Harold Gilman'.[3] Literary figures, such as Siegfried Sassoon, Robert Nicols, Osbert and Sacheverell Sitwell, according to the same account, might also drop in from time to time. Henry, though away in Spain, Morocco, Finland, Albania, Bulgaria and Ireland during his son's Slade days, must surely have been equally delighted with the circles in which Richard was now moving. And yet with this brilliance and optimism there was tragedy, as Randolph Schwabe observed:

> Suicide, madness, disease and war exacted a heavy toll on them. Much talent and some genius were born into their generation, and their loss, even for those who were not bound to them by ties of friendship, is deplorable in its tale of waste and un-fulfilment.[4]

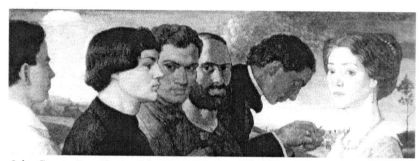

John Currie, Some Later Primitives (*Nevinson 3rd from left*) and Mme Tisceron.

The Slade School of Fine Art had been founded in 1871, modelling itself on the French method of teaching and style of painting. It could thus offer an intriguing alternative to the Royal Academy. Drawing from life and *en plein air* sketching (yet rooted in a thorough knowledge of draughtsmanship and design), was encouraged. Importantly too, it was closely linked, through Wilson Steer and Fred Brown, to the New English Art Club, which, from 1886, was responding to Impressionist influences coming from France through *émigré* artists like Jules Bastien-Lepage and Alphonse Legros. At the height of its influence, in 1910, Sickert wrote:

> I doubt if any unprejudiced student of modern painting will deny that the New English Art Club at the present day sets the standard of painting in England.[5]

It set the standards in art perhaps, but on a more personal level the Slade was far from welcoming, and Paul Nash, while admitting that it 'was in one of its periodical triumphal flows', also conceded that the atmosphere was 'more like a typical English Public School seen in a nightmare', comparing it to his own school, 'St Paul's at its chilliest'.[6] Richard felt this too and remembered: 'Immediately I was aware again of that terrible disapproving atmosphere of the public school. Once more shyness and uncertainty came back to me.'[7] At the helm, and to some extent responsible for this atmosphere, was Henry Tonks, a man for whom Richard would bear a lifelong hatred – a feeling reciprocated in full. The latter recorded an early brush with the former who

> asked me to define drawing, a thing I was fortunately able to do to his satisfaction, as I neither mentioned tone nor colour in my stammering definition but kept on using the word outline. But he nevertheless managed to shatter my self-confidence, and I was wringing wet by the time he left me to go on to Stanley Spencer.[8]

Paul Nash told his friend Gordon Bottomley of the same tutor:

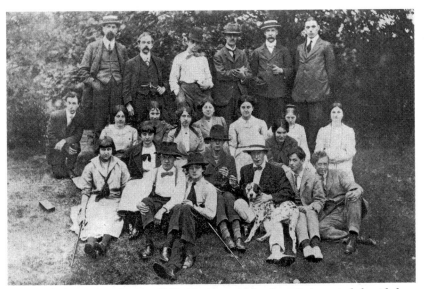

*The Slade Summer Picnic, 1912. Nevinson with a bow-tie is seated front left,
between Dora Carrington and Mark Gertler..*

> one learns a great deal from [Tonks] but until one gets used to it,
> his manner & sarcastic comments rather damp hope. He never
> praises and can find more faults in five minutes than another
> man could think of in a fortnight.[9]

Gilbert Spencer, who followed his brother Stanley to the Slade in 1912,
wrote how Tonks

> talked of dedication, the privilege of being an artist, that to
> do a bad drawing was like living with a lie, and he proceeded
> to implant these ideals by ruthless and withering criticism. I
> remember once coming home and feeling like flinging myself
> under a train, and Stan telling me not to mind as he did it to
> everyone.[10]

Even the young ladies such as Dora Carrington, Dorothy Brett and
Barbara Hiles were not exempt, and some 'were known to weep at
Tonks's acid comments on their works'. That said, their respect for him
was still such that they

> flocked to the Slade to throw themselves before Tonks's Jaganath
> progress through the life rooms. There was a time when poor Tonks
> had to walk the streets not daring to go home, lest ladies be found
> at his door awaiting his arrival with drawings in their hands, whose
> easels had been passed by, and in whose hearts was despair.[11]

Perhaps it was typical of Richard's frustrations that Tonks should be an

admirer of his father, not him, while Henry, despite his son's protestations to the contrary, hailed the Professor as a 'remarkable man with wide sympathies & knowledge'.[12] Richard shared none of that compassion or admiration, writing to Sir Hugh Walpole, even in 1940, of 'that vile virgin Henrietta Tonks, that "great teacher" who caused the suicide of 70% of his students all more talented than he & whose death was a joy to most'.[13] For the time being, however, there was no getting away from the fact that 'Tonks was the Slade and the Slade was Tonks.'[14]

Perhaps Richard's unhappiness and loneliness throughout his first year was due to the fact that he did not enroll immediately after leaving St. John's Wood in summer 1908, and so arrived at a time when everybody else had settled in. Additionally he seemed to divide much of his time between Gower Street (the Slade), sculpture lessons with Harvard Thomas and drawing lessons at Heatherly's in Chelsea. Later, however, the friendships of Edward Wadsworth, Mark Gertler and Adrian Allinson, led him to Rudolph Ihlee, Maxwell Gordon Lightfoot, David Sassoon, Darsie Japp, William Lionel Claus, John S. Curry and Stanley Spencer, who, in turn, became the Coster Gang. And here, collectively, youthful exuberance and rebellious tendencies could be played out with daily growing self-confidence, to the point that Richard admitted 'we must have been a sore trial for poor virgin Tonks',[15] and leaving the old teacher to ponder 'What a brood I have raised.'[16] In fact, within his peer group, Richard's confidence grew to the point that Nash remembered him at the Slade as the school bully, saying that 'He invented the tortures for the self-conscious new boys. I came in for sarcasm because of my rather neat appearance.'[17] Stanley Spencer was victim too of his taunts, though was not so passive in accepting them:

> His dedicated nature had little patience with the public-school-type humour prevalent among some of the well-heeled young bloods there. Goaded on one occasion beyond endurance, he silenced one tormentor by pouring white paint over his new suit.[18]

Richard (the 'tormentor'), in return, organised for Stanley Spencer to be hung upside down in a sack in the boiler room and scared him by pointing to marks on the floor, saying it was all that was left of previous students who had been exposed to the wrath of Tonks. Also recorded, in Nash's memoirs, was the rather cosmopolitan appearance of the student Nevinson 'with his Quartier Latin tie and naïve hat',[19] which was further described by Richard himself when he reminisced about how fellow students gathered around to see the work of 'this old hand with the large bow-tie, bewaisted coat, socks and han[d]kerchiefs of a delicate peacock blue, and a slight growth of whiskers à la Rapin about his ears'.[20] And

just in case there might be any misunderstanding concerning the nature of his bohemianism (as opposed to that of the Bloomsbury Group) he stressed 'In those days it was possible to be a dandy without being thought a pansy as well.'[21] Rather less kindly, Allinson recorded that 'Because of his bulbous forehead, high cheek-bones, flat nose and crinkly hair, Richard received the nickname 'Bucknigger',[22] while to fellow student, Dora Carrington, he was affectionately known as 'Chips'.

Paint and Prejudice nostalgically talked of days in which the Coster Gang had been 'the terror of Soho and violent participants, for the mere love of a row, at such places as the anti-vivisectionists',[23] and how this had led, inevitably, to the police stations and court-rooms of Bow Street and Vine Street. But the real hub of London bohemia was the Petit Savoyard on Greek Street and more so, the Café Royal on Regents Street, which Max Beerbohm described captivatingly:

> There . . . in that exuberant vista of gilding and crimson velvet set amongst all those opposing mirrors and upholding caryatids, with fumes of tobacco ever rising to the painted and pagan ceiling, and with the hum of presumably cynical conversation broken into sharply now and again by the clatter of dominoes shuffled on marble tables, I drew a deep breath and 'This indeed', I said to myself, 'is life?'[24]

This was the real stage on which the three year studentship would be played out, by a group of five which Adrian Allinson described as follows:

> We formed a quintet that became inseparable in work and play. Nevinson and Wadsworth as first and second violins, led, Gertler and I followed as viola and 'cello, with Sassoon occasionally audible in the background in the part of the double bass.[25]

An alternative view of these characters, and the lives they led at the Slade, can be obtained through the novels *Crome Yellow* by Aldous Huxley and *Mendel* by Gilbert Cannan.[26] Though the latter was written as a portrait of Mark Gertler, (Mendel), it relates the story of the Slade (Detmold), and the friends therein, like Carrington (Morrison), Currie (Logan), John (Calthrop) and Richard (Mitchell). The novel also offers an intriguing insight, in particular, into Richard's relationship with Gertler (Mendel Kuhler), who he introduced to the rest of the gang as 'a genius'.[27] Richard knew that it was to him that so much of his own artistic and personal development was indebted as they studied together at the British Museum, met at the Café Royal, dined at Downside Crescent, went on short holidays and discussed art daily, and at length. Together they recognised each other's talents, and Richard took a protective role of his

friend '. . . and defended him from the detestation which he aroused in the majority of his fellow students'.[28] Gertler, for Richard, was the key to the *terra incognita* of Whitechapel, home of the Russian, Polish and Central European Jews, which Richard was to find so refreshing in contrast to his own middle-class and intellectual upbringing in Hampstead. In return Richard too was of use to the student Gertler, so much so that in a letter to William Rothenstein, the latter remarked:

> My chief friend and pal is young Nevinson, a very, very nice chap. I am awfully fond of him. I am so happy when I am out with him. He invites me down to dinners and then we go on Hampstead Heath talking of the future. Oh! So enthusiastically![29]

A little later Mitchell (Richard) exclaimed 'We'll I'm jolly glad to know you. I'm not much of a fellow, but I'd like you to know my people. My father's a great man. He'll stir you up.' In fact, a surviving letter shows Henry helping 'the Whitechapel jew Goertler' (sic) by introducing him, on personal recommendation, to Professor Sadler.[30] Richard recorded in his autobiography in 1937, two years before Gertler's suicide, 'I am proud and glad to say that both my parents were extremely fond of him.'[31]

So, whether in fact or fiction, the Coster Gang roamed at night, while the Neo-Primitives worked seriously by day, until a seventeen-year-old student arrived who would divert Richard from these priorities – and indeed lead to the destruction of his most precious friendship at the Slade. Carrington, as she insisted on being called, together with Ruth Humphreys, Dorothy Brett and Barbara Hiles, formed a friendship which was seen as being as rebellious as any group formed by their male counterparts. Like Richard, she was single-minded, determined, and obtuse, so, quite naturally he rather took to her. In *Mendel* even Mitchell's (Richard) father approved of his son's platonic relationship with Morrison (Carrington) saying that it was 'The first sensible thing you've done my boy. A pure relationship between a boy and a girl has a most ennobling influence – most ennobling.' Mitchell's mother commented 'She is truly spiritual, the type who justifies the independence of the modern girl, whatever the Prime Minister might say.'[32] For Richard, away from the romance of fiction, she could be everything from 'an ill-bred shop-girl' (a description she didn't care for), to a 'gorgeously egotistical, impulsive, unsettled youth. . .'.[33]

Artistically, Richard, though grimly serious in intent, had not as yet identified a hallmark style with which anything like a career could be built. Neither did he seem prepared for the artistic shock waves that hit London, in only his second year at the Slade, with exhibitions such as 'Modern French Artists' and Roger Fry's groundbreaking 'Manet and the Post Impressionists' at the Grafton Galleries. Richard went to the

latter exhibition, despite Tonks' warnings to stay away, with his father, Mark Gertler and Charles Lewis Hind – a critic of future importance to his career. Fry himself (who had started lecturing at the Slade in 1910) had known there would be trouble, writing 'I am preparing for a huge campaign of outraged British Philistinism',[34] and, as anticipated, the show met widespread derision from a curious, then incensed, crowd that soon topped 25,000. The critic for the high-class *Pall Mall Gazette* described the paintings on display there as 'the output of a lunatic asylum',[35] whilst Robert Ross (a family friend of the Nevinsons) declared the exhibition 'a widespread plot to destroy the whole fabric of European painting'.[36] Sir Claude Phillips acted for many when, on leaving the galleries, he threw down his catalogue and stamped upon it. Tonks could do little to contain this 'brood' and 'could only warn us and say how very much better pleased he would be if we did not risk contamination but stayed away'.[37] In private Tonks despaired 'I cannot teach what I don't believe in. I shall resign if this talk about Cubism doesn't cease; it is killing me.'[38] And yet this was the course his young students were on, and the gulf between tutors and students was ever widening. Chaplin acknowledged this veritable chasm, observing 'Indeed with the student generation of 1908-1912, it was unbridgeable. Nevinson and Wadsworth were within, Roger Fry within and without; and both Cézanne and Picasso announced.'[39] A handful of intellectuals felt that the time was right for change, and so Frank Rutter wrote and distributed *Revolution in Art* in which he declared with pride 'To the rebels of either sex all the world over who in any way are fighting for freedom of any kind, I dedicate this study of their painter comrades.'[40]

But it did not finish there. There was one further arrival in London in 1910, and it would be infinitely more important to Richard's career than any of the French influences that had just been unleashed. Though he was as yet unaware of F.T. Marinetti, and didn't attend the lecture at the Lyceum Club entitled *Un Discours Futuriste aux Anglais*,[41] his mother, Margaret, did, and wrote of the Futurist Movement:

> The members of the society are young men in revolt at the worship of the past. They are determined to destroy it, and erect upon its ashes the Temple of the future. War seems to be the chief tenet in the gospel of Futurism: war upon the classical in art, literature, music.[42]

Though she found Futurism, on the whole, a 'shallow and insubstantial piece of Latin bombast and exuberance', she admired Marinetti for being a 'very stimulating companion' and a 'brilliant conversationalist'.[43] Little did she know that her son would soon be his right-hand-man in London and would soon expound outrageous ideas of daring and energy:

We rebel against the spineless worshipping of old canvases, old statues and old bric-a-brac, against everything which is filthy and worm-ridden and corroded by time. We consider the habitual contempt for everything which is young, new and burning with life to be unjust and even criminal.[44]

The youth would certainly have loved too the outrageous remarks made by Marinetti about Tonks' (and his father's) idol, and the stalwart of Victorian conservatism, who was:

> your deplorable Ruskin, whom I intend to make utterly ridiculous in your eyes.... With his sick dream of a primitive pastoral life, with his hatred of the machine, of steam and electricity, this maniac for antique simplicity resembles a man who, in full maturity, wants to sleep in his cot again and drink at the breasts of a nurse now grown old....[45]

This was, to a very large extent, what Richard was looking for, even if he didn't as yet know it. After all, he was the restless art student, studying at London's most progressive school, and coming from a home in Hampstead which was famed for its intellectual inhabitants and controversial politics. Though his parents were deeply involved in the Suffragette demonstrations, the crisis of Ulster, the decline of the Liberal Party and the continuing turbulence caused by Britain's trade unions, Richard was allowing himself to be seduced by, the arrival of the French and Italians. In his mind there was little doubt that in the art world, every bit as much as in other walks of life, a substantial and irreversible change was taking place, and cautiously he was prepared to be a part of it, perhaps even to lead it, if only he could ascertain how. For the moment, however, he had missed his cue and, instead of marching off after the Futurists, he and his Neo-Primitive peers, seemed to move in the opposite direction, drawing artistic influence directly from the early Italian Renaissance – an artistic source of which Tonks would undoubtedly have approved. As late as August 1913 Gertler would tell Dorothy Brett:

> *do* study Giotto! & at once – He is tremendous!!! Study also Dürer – *the* draughtsman. These men are a constant cause of inspiration to me. It will never do, unless we too, express ourselves with such knowledge & emotion.[46]

Following the example of his family which had stood firm in a dignified manner, though had suffered financial consequences from a changing environment where 'money was rapidly taking the place of breeding, birth

C.R.W. Nevinson, The Port, *1909*

and culture',[47] Richard was at least quick to reject the material vulgarity of *nouveau riche* English patrons. These, mostly merchants from the north, in his opinion, had dragged art down to 'Darbies and Joans, deeds of daring-do or of sacrifice, or perhaps young girls praying while dogs looked on with human eyes expressing reverence mixed with envy'.[48] With his upbringing, his internationalism and his love of innovation, he was never going to be able to accept this mode of working and this understanding of what painting might be. Though the Neo-Primitives rejected the kitsch of Victorian/Edwardian genre painting, they were nevertheless a long way from the route prescribed by either Fry's show, or by Marinetti's aggressive pronouncements. For the moment, instead, they would gravitate towards the home-grown hero, indeed fellow Slade graduate, Augustus John. Gilbert Cannan described this worship of John, who appeared as Calthrop in *Mendel*:

> Calthrop dressed extravagantly: so did the four. Calthrop smashed furniture: so did the four. And as Calthrop drank, embraced women, and sometimes painted outrageously, the four did all these things.[49]

A hastily scribbled note of Richard's to Carrington from the Café Royal also helps us to capture some of the excitement caused by the arrival of the great bohemian when it said 'John has just arrived wild excitement at our table keen competition whether he will sit at our table

or the Camden Town lads.' Later he added, flattered, 'John did after all come & sit with us and was most pleasant & affable, he actually knew my name and all about me.'[50] Their great mentor advocated that young artists paint from real life, however unsavoury the subject, and accordingly some of Richard's earliest compositions had subjects such as *Liverpool St* and *Gasometers*, executed in a manner that found itself somewhere 'between the colour and technique of Boudin and Claude Monet'.[51] Encouraged, he went on to exhibit *Carting Manure* and *Cement Works* at Frank Rutter's Allied Artist's Association in the Albert Hall, and so could claim, quite justifiably 'I, who was born for Oxford and the army in a hotbed of intellectualism, religion and the classics, found refreshment in ugliness and the uncouth.'[52] The *Railway Bridge, Charenton* also came in for particular praise, as *The Port* had done, in subject matter, technique, colour and finish, in a composition which bore many similarities to the *en plein air* compositions of Monet. Henry rejoiced in this finding of form and was jubilant too to see that the show produced Richard's first ever sale, as *Bridge on the Seine* (*The Railway Bridge, Charenton*), was destined for the prestigious Manchester City Galleries. His delight was extinguished, however, when he realised that his wife 'has caused Rich's picture to be bought & is placing him in a Fools' Paradise'.[53] But it was a start, and now Richard, it seemed, was staring across the channel for inspiration, as opposed to digesting what was really new and had been imported into the galleries in London. On the contrary he felt that much of it had gone a bit too far, being now both 'anarchic & egotistical', and so he warned Carrington 'above all don't get into this post-impressionist cleverness of pretending to be a great[er] fool than you are'.[54]

Encouragingly, father and son were now growing closer, and records exist of the two high-minded and extremely serious men roller skating, playing soccer, and camping. One journal entry of Henry's even recorded a walk with Richard before his departure for Albania, which signed off triumphantly 'Parted in great friendship.'[55] And on his arrival home from the Balkans, when he went to inspect his son's work, he could report 'a great advance',[56] then helped out by throwing a critical eye over Richard's final essay on the Mona Lisa.[57] They also went together to observe striking dockers in Trafalgar Square in late summer 1911, which led to a composition called *Strike*; this is now, unfortunately, lost. Henry had some extremely useful contacts too and so continued to introduce Richard to artists, critics, and other influential patrons in London, such as Charles Lewis-Hind, Frank Rutter and the Rothensteins. Together they went to effect an introduction to Roger Fry at Christmas 1911 and this was followed with a visit to Clive Bell in Gordon Square.[58] It

seems to have gone virtually unnoticed that Philippa had got married to architect Sydney Caulfield at the Savoy in the same year.

As he entered into his final year at the Slade, and perhaps horrified by the suicide of his friend, Maxwell Lightfoot, Richard swore off the Coster Gang in a letter to Carrington which said 'I am not going to waste your time next term with riotous living'.[59] Instead he turned to focus on her applications for scholarships which were necessary for her continued studies at the school. Rather dramatically he told her 'I will really turn my face to the wall & die if you miss it,' though eased the tension with 'I am not after your money, my honey, but I simply want you, for don't yer see if yer dinna get this scholarship, you are going home & I am lonely, way down here & the rain coming down.'[60] He worried that his own poor reputation at the school might, by association, damage her chances of success, and warned her of this saying 'I do not think my friendship with you is exactly popular especially as I am supposed to be leading you to the dogs.'[61] Nonetheless, Richard and Carrington were spending more and more time together, attending dances, going to the music halls, and generally living the student life. Not so long before he had moaned 'I am leading the most profoundly dull life',[62] while now, a mere month later, courtesy of Carrington, he could say 'I do not recall ever having been in such an exotic condition.'[63] Though he had had a relationship of sorts some years before, it was Carrington whom he believed to be his first, perfect, love. One way or another he told her 'I am flattered, I believe you really love me. If I should happen to be in a fools' paradise don't tell me. I infinitely prefer it to a wise man's purgatory.'[64] Cautiously from the Café Royal he wrote suggestively that 'we need not strain ourselves by exerting self control' though this was not a view she shared.[65] In fact, Richard was not aware of the fact that Carrington was also conversing, writing and meeting with Gertler (who had left the school in 1911) in a similar fashion, and the latter was beginning to want to rid himself of competition for her affections, even if Carrington had no particular desire to become romantically involved with either man. It was not through a want of trying though, on both men's part, and Richard had even begun calling her 'My Cherubim' and declaring 'I do so love you Carrington & I am absolutely yours.'[66] Richard, the 'old hand', reassured her 'I am not ashamed of really liking you (I have even carried that basket of yours) but I am rather secretive not by nature but experience. You must remember I am now middle aged.'[67] In his self appointed role of mentor he would now steer her away from those who would spike her drinks, and guide her through both life and art, discussed over secret breakfasts (when his parents were away) with ambitions which seemed to be both realistic and modest:

You cannot think how frightfully keen I am to get on & be appreciated sometimes, yet my brain always is telling me how silly and futile it is of me as I know only to [sic] well I have not a single touch of genius, yet I still have this mania to do at least one really good picture in [the] course of my lifetime & as a secondary ambition I would love someday to get hung in the new English. . . . I will never get in to the New English & Allinson always will.[68]

He was determined to work hard to conquer his self-diagnosed lack of ability, and this can be seen in an early communication which read 'I have been working like Satan drawing my own and my mother's head. . . . I am really improving in my drawing. If only I could feel some hope that I might someday do a fairly good drawing I think my life would be more tolerable. Even if I lost everything and gained some hope. . . .' Later, in the same letter he claimed 'I can warn you it is quite the lowest ebb of misery to become always a passive onlooker of your own incompetence or to be fatuous, hopeless.'[69] To avoid a similar experience he warned her 'Get your work as solid & as simple & as strong as you can, avoid superfluous ornimentation (sic) & remember all useless things are ugly, all useful things beautiful.'[70] He suggested 'the greatest difficulties in all arts is to keep spontaneity & completeness together, it is really a matter of concentration, but so is the greatest art from Michael Angelo downwards & particularly in the primitives & Early Greeks'.[71] And by offering advice to Carrington his own direction was becoming a little clearer too, to the point that he could condense it into three major categories: 'First I wish to paint this present age above all, secondly to combine it with the pattern of form besides colour as the primitives did, third to keep realism predominant in spite of it[s] decorative qualities or shortly to combine Atmospheric effects & design.' There was also a clear emphasis on technical virtuosity as an underlying prerequisite, having been achieved, in his opinion, for the last time in this country by Whistler. His analogy, though crude, was straight forward when he wrote 'A man with an impediment in his speech can't talk well, I don't care what he's got to say, nor will I read a badly printed book.'[72] There was no need, either, to be scared by the inclusion of sentiment in a painting, and he wrote of this too, saying that to ignore it would be the act of a 'Futurist Shavian'.[73] Surviving paintings such as *The Towing Path, Camden Town*,[74] confirm this impressionist, almost romantic, leaning, not least as he described it to Carrington as a 'love drama'.[75] As an artist who was beginning to feel at home with a cocktail of early Renaissance Italian painting, French Impressionism and more locally, the Camden Town Group, he would have been unaware (or indeed, uninterested) that, for

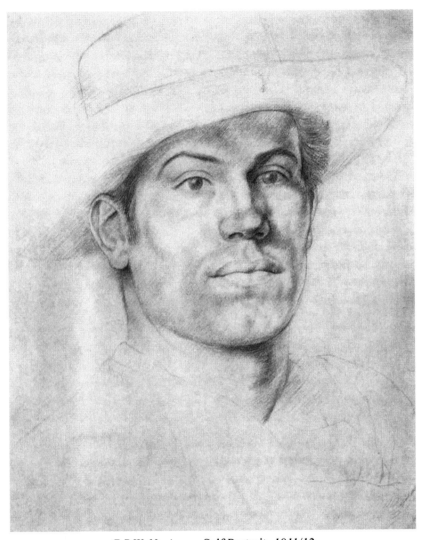

C.R.W. Nevinson, Self Portrait, *1911/12.*

the second time, destiny was bringing Marinetti back in his direction.[76]

In this second visit, which began in March 1912, Marinetti spoke openly of his admiration for, and excitement in, London, and in so doing rapidly became a society novelty. He was entertained by Viscountess Warwick and Lady Cunard – the latter whom he described as having the 'wit of an aviary'.[77] But this was a working trip, and so, accompanied by 'the Futurists', the lectures and activities, both official and unofficial, began. There was time, Marinetti felt, to be spent in London before turning his attention to the world's ultimate Futurist city, New York and the triumphant arrival there on board the *Titanic* – but that would

have to wait until the ship was ready to sail in April. In the meantime there was the Sackville Gallery show, 'Exhibition of Works by the Italian Futurist Painters', which opened on 1 March 1912, and which introduced the theories, and over forty paintings of Umberto Boccioni, Carlo Carra, Luigi Russolo, Giacomo Balla and Gino Severini, to a public who, unprepared for the impact of the ideology, were soon as outraged as Marinetti could have hoped for. So too, the catalogue carried the 'Initial Manifesto of Futurism', and the 'Technical Manifesto of Futurist Painters', provoking the perfect, if predictable, critical response.

To recap briefly, the Italian Futurists – a loosely knit group of rebels, anarchists and misfits under the command of the bombastic F.T. Marinetti – were demanding an art more closely associated with the principal characteristics of the age, which might include danger, energy, fearlessness, courage, audacity, speed and politics. Art, they felt, in a pseudo-Nietzschean way, had to destroy the past in order to make the construction of the future possible. Sentiments like this came across most ferociously in passages such as:

> So let them come, the gay incendiaries with charred fingers! Here they are! Come on! Set fire to the library shelves! Turn aside the canals to flood the museums! Oh the joy of seeing the glorious old canvases bobbing adrift on those waters, discoloured and shredded! . . . Take up your pickaxes, your axes and hammers and wreck, wreck the venerable cities, pitilessly.[78]

This was, after all, the era of Morse, Bell, Edison, the Wright brothers, the great Cunarders, the Woolworth Building, mass production, the car and a host of other technical triumphs which art inexplicably seemed to ignore. In response, Futurism aimed to be dynamic and vital, abhorring the retrospective obedience that European nations seemed to have to their heritage and cultures. Marinetti, described as 'The Caffeine of Europe',[79] was setting out to rid European art of its lethargy and its worship of the past. But this was not always a welcome view, and Charles Lewis Hind felt confident that 'England as a whole will laugh at or loathe these works',[80] while *The Times* could categorically state that 'The anarchical extravagance of the Futurists must deprive the movement of the sympathy of all reasonable men. . . .'[81] But would that include the Nevinsons? Margaret had already met Marinetti in 1910, and now in 1912 Henry met the maestro, albeit far from home, on the Bulgarian frontier on

> a never-to-be-forgotten occasion in the Balkan Wars, when the Italian had found himself cooped up in a train full of journalists

for a whole day, a golden opportunity for him. He made the most of it by reciting for hours on end various Italian poems and expounding the theory of Italian Futurism to an audience which could not get away.[82]

It remained only for Richard to meet the Italian and fall under his spell, though for the moment that seemed as remote a possibility as ever before. Instead, his progress was steady, if perhaps a little directionless, and this was leading to a frustration which could be felt in a letter to Carrington which said 'today I am cursing the New English & . . . am praying that Tonks may soon be called upon to make his ascent to Heaven . . .'. In the same letter he displayed the shattered confidence that the rejection of one of his pieces from the NEAC had left him with and the sense that as long as Tonks was at the helm of anything, his career would go nowhere. He wrote 'I shall not probably try to exhibit there for another 2 years by then I hope to have improved somewhat . . . & possibly some [of the jury] will have died off.'[83] Such was the impact of the blow he wrote 'I am chucked from the New English, I am ashamed to say . . . please don't despise me . . .',[84] even if his father had reassured him that 'I am in good company & Millet & most good men have their failures early in life.'[85] He went on, saying 'everything I touch turns to failure' before dramatically pondering 'I don't know whether God is trying to speak to me & telling me to give up Art if so I wish He would convey his meaning more clearly. . . .'.[86]

Passion now merged confusingly with melancholy and this was exacerbated by self-doubt. In fact, feeling increasingly isolated, he began too to doubt his own ability to succeed, a problem which he felt might even stem from his nationality when he ventured 'Intellect or Art & cold bloodedness can never go together – perhaps that is why Englishmen are never real artists only the Celts or Jews.'[87] He confided that his lack of success in art, and his staunch individualism which had led only to isolation, had had devastating results, saying 'I wish to preserve my sanity & throw off this melancholia. I think by meeting people & talking & having to put on a cheerful face I may get myself out of the vile introspection which my absolutely lonely life leads me to.'[88] In groups, with friends, at the Café Royal and with Carrington he was happy, but alone he was miserable, and so he planned to attend as many 'Red Revels', 'Artist's Revels', 'Gorgonzolas' and 'Circuses' as he possibly could, preferably in the company of Carrington, if she would agree to go with him. But Carrington was not simply a good-time friend, he felt, rather his closest friend and confidant, especially when he discovered that he had got himself into some difficulties with a model at the school who

had subsequently given birth to a child which could very well have been his. This was fictionalised in *Mendel* when Mitchell (Richard) received a letter whilst in Brighton with Mendel (Gertler) instructing him to come back to the Pot-au-Feu Café in London to meet Mendel's model friend, Hetty Finch, who was pregnant. In the novel Mitchell offered her both money and marriage, both of which she rejected. In reality, his nervous state was more accurately recorded in a letter to Carrington when he wrote retrospectively 'I was always alert for a telegram announcing a death & birth with a child left for me to look after or every letter I was terrified might be from that busybody Tonks or some blackmailer. . . .'[89] Despite claiming that 'Women have always proved the triumph of matter over mind',[90] it was clear that he had become almost dependent on this woman for support and he was not shy in telling her that 'I owe you everything. I have no doubt but for the sudden appearance of you, I would now be a dissipated criminal of the most carnal description. I would [have] lost money, reputation & my very soul.'[91]

Traumatic as this was there was more turbulence ahead in his final days of the Slade, which would cost him his two most precious friendships. The problem came out of nowhere when a letter arrived from Carrington, and though this letter itself has not survived, his response to it has. It begins 'Your note came as a horrible surprise to me. I cannot guess what has happened to make you wish to do without me as a friend next term.' Obviously Gertler's name had not come up in the original letter, but nonetheless Richard was panicking. Perplexed at what might have caused the rift he guessed that perhaps the fault had been partly his own through the increasingly intimate tone he had been adopting with her and so he promised 'I swear I will never speak a word to you as your lover.' He went on, 'I promise you I will be a great friend of yours nothing more & nothing less & if you want to get simple again I am only too willing to do the same.' He appealed to her sense of pity saying 'you & Gertler & Wadsworth & mother are the only friends I have ever known' before satisfying himself with the explanation that the problem must be her great desire to study and to remove all other distractions. He finished his reply by writing:

> if you still find it absolutely necessary to chuck me, remember should you ever need any help or companion[ship] do please come back to me as I know I shall always like and respect you for the rest [of] my life. I most admire your self-control & grit to throw away a great deal of your happiness for your work even though I consider you are horribly wrong in doing so.[92]

Meanwhile, a letter from Gertler to Carrington threw a different light on the situation, opening 'You somewhat shocked me by telling me that

you kissed Nevinson. . . . What can it matter whether it shocked me or not. I don't blame you or Nevinson a <u>bit!</u> . . . The only thing is it hurts a lover <u>terribly</u>.' He went on 'Of course it is absurd to ask me to be friends with Nevinson. Do you think that I am made of stone? That I should be friends with the man who kisses my girl.'[93]

It transpires Gertler had written to Carrington two days earlier, on 19 June 1912. This letter had been a final admission of his love in which he had clearly outlined why Carrington should marry him. Although he admitted in the letter that he expected she would reject his proposal, he also requested that, this being the case, the friendship should end there.[94] Sensing a lack of enthusiasm he wrote a further letter soon afterwards in which he identified the real fly in the ointment, concluding 'Your affections are completely given to Nevinson. I must have been a fool to stand it as long as I have, without seeing through you. I have written to Nevinson telling him that we, he and I, are no longer friends.'[95] This letter in fact survives as Richard, on receiving it, sent it directly on to Carrington with his own distraught observations. It began:

> Dear Nevinson,
> I am writing here to tell you that our friendship must end from now, my sole reason being that I am in love with Carrington and I have reason to believe that you are so too. Therefore, much as I have tried to overlook it, I have come to the conclusion that rivals, and rivals in love, cannot be friends.
>
> You must know that ever since you brought Carrington to my studio my love for her has been steadily increasing. You might also remember that many times, when you asked me down to dinner, I refused to come. *Jealousy* was the cause of it.
>
> Whenever you told me that you had been kissing her, you could have knocked me down with a feather, so faint was I. Whenever you saw me depressed of late, when we were all out together, it wasn't boredom as I pretended but *love*.

The letter finished saying 'We must be rivals openly, really rivals dramatically & theatrical & not friends,' though allowed that if they happened to bump into each other in company that there need be no fuss.[96] Quite simply Gertler had put to an end the friendship and in doing so had brought Carrington away from Richard too. The blow, as sudden and severe as it was, placed an enormous burden on the already pensive and melancholic Richard, and his response to Carrington expressed desperation (as opposed to anger) and exasperation at the thought of becoming friendless again through no fault of his own. He wrote to Gertler too who then reported to Carrington 'Nevinson also

wrote me, in return to my letter to him, how miserable my letter has made him. His letter has made me wretchedly miserable. I shall have to do my best to be friends with him too.'[97] Had Richard known the contents of a further letter from Gertler to Carrington he would have been even more hurt when it stated 'As regards Nevinson, I am afraid I cannot go back to being his friend. It is not jealousy at all. You see I have lost interest in him . . . why should I be with a person for whose company I do not care'.[98] The competitive edge was still present when Gertler wrote 'Nevinson was once my friend, but now my greatest friend is Currie, and Currie would consider it rather funny if I said tomorrow night I shall go out with Nevinson.'[99] This too was recorded in *Mendel* when Mitchell (Richard) had taken Mendel (Gertler) to meet Logan (Currie) and almost instantly they had conspired against him. Logan said the following, 'He [Mitchell/Richard] is a liar and a coward, and he will never be an artist because he is too weak. He is not true. He is not good. I have trusted him with my secrets and he tells. I wanted him to be my friend, but it is impossible.'[100] In despair Richard wrote to Carrington 'I am now without a friend in the whole world except you,' and claimed 'I cannot give you up, you have put a reason into my life & I am through you slowly winning back my self-respect. I did feel so useless so futile before I devoted my life to you.' He assured her that he was calm 'as fortunately I have been able to weep hard', then went on to say that he would not stand in their way if she and Gertler wished to love each other openly. He claimed that he would be fine taking second or even third place in a group friendship and assured her that 'I am not so exotically in love with you as Gertler.'[101] The letter does not come across as a plea to get her back as a lover (which they probably never were in reality anyway), but as a friend, and also to win back Gertler's friendship, the loss of which he had felt profoundly. He wrote of how he was 'aching for the companionship of Gertler, our talks on Art, on my work, his work & our life in general, God how fond of him I am, I never realised it so thoroughly till now'.[102]

But Richard's self-pity soon turned to anger to the point that he could write to Carrington 'I am distinctly amused at you two. I congratulate Gertler on his delightful ease and facility he is able to change from the role of a passionate and over-jealous lover to that of a philanthropic platonic friend.' The trouble he said had left him, as a result of his 'abnormally affectionate temperament', with an enlarged liver, which accompanied his sense of betrayal, disappointment, disillusionment and everything else that had been thrust upon him. In finishing, he [mis]quoted Oscar Wilde saying 'All men kill the thing they love, a brave man with a sword, the coward with a kiss.'[103] His parting shot to

Carrington was to grow up and to see what Gertler really wanted from her, and to remember that, even when all of this had blown over, she had both an advisor in art and a reliable friend, in him. In the meantime, he signed off 'I do earnestly beg you: may I, in the future be kept absolutely outside all your future lapses and quarrels & depressions'.[104] Shortly before departing for Paris with Adrian Allinson, Richard went to Gertler's house and some sort of reconciliation was effected, the latter writing without optimism to Carrington 'You will be interested to hear that since I wrote my letter Nevinson has come to see me and asked me to dinner & I have accepted. But I still feel the same about him.'[105]

And so in the summer of 1912 Richard could sum up his final year at the Slade as a 'horrible wild nine months of births, scandals, police courts, Slade dances, Friday Clubs & Chenils, of hopes . . . my complete disillusionment of some of my "friends", then getting more and more mad on you & now complete boredom'.[106] In fact, despite the dynamism of art in London, combined with the excitement of his release from formal schooling, he brooded huffily 'I am now unfitted for everything else + so I must stick to painting as my only possible means of livelihood.'[107] Perhaps this was exacerbated by Tonks' advice to give up art altogether (very much as Selwyn had advised fruit farming in California), or by Edward Wadsworth who was knocking the spirit out of him, as remembered by Stanley Spencer:

> I have had experience; you have not. I have passed through all the stages an artist can go through; Rembrandt & all the rest. He went on like this & Nevinson looked very glum. It is extraordinary, but on this occasion I was silent. I thought perhaps he was ragging, until one day I asked Nevinson & he said Wadsworth was doing the same thing to him.[108]

Richard mused retrospectively in 1937 'Had Gertler, for instance, told me seriously that I was wasting my time I should have been heart-broken, but as things were I managed to bear up.'[109] Instead he went skiing in Switzerland and dismissed Tonks' advice as typically destructive of a master for whom he had nothing but contempt.

3
Paris, London and the *Bon Viveur*
(1912-1913)

Following his training at the Slade, Richard knew he 'was ripe for Paris and all it could teach me'.[1] Even if he had been moving in progressive circles in London it was still not enough (by his own account) to contain the young, ambitious and international artist seeking inspiration outside England and the English tradition. It was time for re-invention, both of himself personally, and within the work that he was producing, and where better than on this foreign stage. Anyway, if Malcolm Bradbury's description of London at that time is to be believed, Richard was missing nothing, in

> one of the dullest and most deadening of capital cities, one with no real artistic community, no true centres, no coteries, no cafes, a metropolis given to commerce and an insular middle-class life-style either indifferent or implacably hostile to the new arts.[2]

Paris, on the other hand, was in Wyndham Lewis' words 'expansive and civilised, temperate in climate, beautiful and free',[3] and was perhaps the only city in which the legendary *vie de bohème* still survived. It was in Paris then, swept along by new-found friends and associates such as Amadeo Modigliani and Gino Severini, fired by the Saturday Salons of Gertrude Stein, and fuelled at venues such as the Closerie des Lilas on Boulevard Montparnasse, or at the Rotonde, where Boulevard Raspail and Boulevard Montparnasse crossed, that a more focused orientation began. This was the full avant-garde in European painting *in situ*, as opposed to the filtered and edited versions which Rutter and Fry had been bringing to London, and was to be learned from, both quickly and thoroughly, at the Salon des Independents, in Julian's Schools, both in rue du Dragon and in Montmartre, and in Matisse's 'Circle Russe'. Inspired by Rousseau, Goya, Daumier and Toulouse-Lautrec, Richard immersed himself in the seedy quarters of Paris, under the acquired name of 'Nevinski', where 'The bleak poverty of Paris and the desperados were mere colourful grist for my mill'.[4] Delight could be found in the brothel/

café areas around rue de la Gaité, and at the Moulin Rouge, where, he said, the list of his acquaintances were too numerous to recall, though he did emphasise a prevalence of Austrian and Russian aristocrats. Dinner was taken at the 'Eléphant' on rue Blanche among the artists, actors, actresses and musicians who frequented the place, while late evenings continued with drinks at Medrano's Circus with the clowns and the performers, then finished off with Italian Futurist painter Gino Severini, at the Monaco or the Tabarin. The days were spent rubbing shoulders (if not actually working with) Picasso and Matisse at the Louvre or visiting haunts made famous by Degas. The evenings, always alive and vibrant, were spent, lost in conversation with Lenin, Apollinaire, Fry, Bell, Derain, Modigliani, Soficci, Boccioni, *et al.* where 'we used to hammer out the solution of things in those days!'[5] Away from the hubbub of the bars, other nights at the theatre were equally magical when he would watch Sarah Bernhardt with admiration from afar. Together with Severini, Derain and especially Modigliani (with whom he was now sharing a studio in abject poverty), he could dismiss the superficial avant-garde in England with hardly so much as a glance over his shoulder. His summary of current trends at home contained little nostalgia when he observed:

> The New English falls back on the 18th C, the Academy on the Medieval times, Howard Thomas tries to be Greek, Epstein Egyptian, & I now see a danger amongst Currie & Gertler to be early Italian & costumy. We must guard against raking up the past.[6]

He seemed to have out-grown his old mentor, Augustus John, too writing 'I am not very fond of John's work. It strikes me as being by a symbolic Slade man who is a marvellous exponent of Slade teaching, conventions and eccentricities, but somehow not quite art.'[7] Instead, he surmised, he was better off sitting in the café with Soffici, Boccioni and Kisling, listening to words of wisdom from Apollinaire, than ever he might be amongst the effetes in London. Not even the Café Royal could match what Paris had to offer in 1912.

It is perhaps then a little disappointing to realise that much of this account is fundamentally the fiction of autobiography. Even if Jacob Epstein was socialising on a daily basis with Modigliani and Brancusi, and even if Roger Fry, Vanessa Bell, Spencer Gore, Frederick Etchells, Wyndham Lewis and Duncan Grant were exhibiting to reasonable acclaim in Paris, Richard's period in the great capital, it transpires, was unhappy, uninspiring and was, in reality, a series of short visits that began in July 1912. Henry recorded in that month 'Rich went away to Havre and Paris',[8] following an argument with Carrington, then met up

with his mother in Rouen, from where several letters originate, stating his prejudices and disappointments from the outset. For example, at the Louvre he had found himself surrounded by Americans, and so 'I heard nothing but nasal banjo-strings wanging out puritanical Anglo-Saxon sentences of crass vulgarity & tedious appreciations of well-known hackneyed but bad work of which the Louvre is crammed'. He then went rather further exclaiming 'Curse America! Christopher Columbus convinces me of the power of the devil.'[9] That said, and peripheral distractions and irritations aside, he did at least love some of the work on display, and admired a handful of the other student artists frequenting the halls, exclaiming 'My God, there are some pearls among the swine.'[10]

Quite naturally his painting now began to change, and so in rue Lepic, he experienced 'the strangest epoch of my life', beginning with the important revelation that 'I was dissatisfied with representational painting'.[11] He went on 'Like many others I was attracted by abstract art, and the colour harmonies of Kandinsky',[12] but this paled into insignificance with the inevitable impact of an even more modern form of representation. Thus, 'I felt the power of this first phase of Cubism and there was a desire in me to reach that dignity which can be conveyed pictorially by the abstract rather than by the particular.'[13] He went on to describe this Parisian revelation, saying 'I was like a man in any other walk of life who is struck suddenly by a truth which he has always known to be at the back of his mind. . .'.[14] But the transition was not immediate and instead the problem was that he simply did not know how to incorporate this new interest into his existing mode of work, writing 'I am displeased in every way with the work I have done up to now and I don't want to merely improve on the sort of stuff I have done . . . but what am I to do if I <u>can't</u> find out how to do it. I am quite in the dark and completely lost.'[15] If anything, he felt frustrated that his métier was gravitating towards that of Marque, Signac and Monet, a path that was now well worn, and so he lamented 'What a pity I was not born fifty years earlier. . . . I would have been considered quite good & even revolutionary.'[16] At least he could be sure that the way forward lay in the depiction of modern times and civilisations, in 'the triumph of man over nature',[17] and in a hatred for the 'loathsome rich' and the decaying population of 'Chinamen', 'niggers' and 'Germans', all of whom suffered from 'poverty of the imagination'.[18] In the midst of this confusion, he felt sure there must emerge a subject and a technique which could become 'his'.

The letters from France also seemed to suggest that a lot of personal business had been left unfinished in London, and so he told Carrington 'Oh, I am so fond of you today. I already long for the sight of you after

Dora Carrington at the Slade

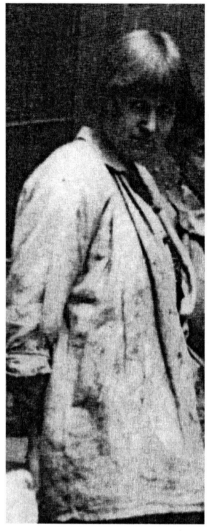

these wibble-wobbling French women', declaring himself her Sir Lancelot – a sentiment that Gertler was hardly likely to appreciate.[19] At the Hotel de la Place de L'Odéon, where he, Sassoon and Allinson had stayed the previous year on their student visit, he also saw an image that emerged as a painting some years later. He wrote to Carrington of a

> room which looks onto a typical Paris courtyard very narrow heavily curtain windows opposite behind which I occassionly [sic] see a woman flit by, like some Ghostly heroine of Balzac, a woman was there when the revolution howled . . . but still this woman flits about dressing slowly, patting her hair as generations of her sex have done before her.

He hurriedly went on to allay any fears Carrington may have been developing about this voyeurism by assuring her 'Little is more repulsive than a modern French woman with her feather bed sensuality & commercial face.'[20] Simultaneously, the details of the 'scandal' in which he had got himself involved in his dying days at the Slade, became clearer through these letters. Though Richard joked in the autobiography that the father of the model's child could have been any one of seventeen men, including Tonks himself, he said that when the child was born all doubt had been removed as it had looked just like him. In reality, there was no such flippancy and letters to Carrington talked of the panic and shame, and summed up saying 'This affair has blighted the whole of my life.' Tonks had collected money for the girl but Richard could not afford to make his contribution, and he explained this to Carrington as follows:

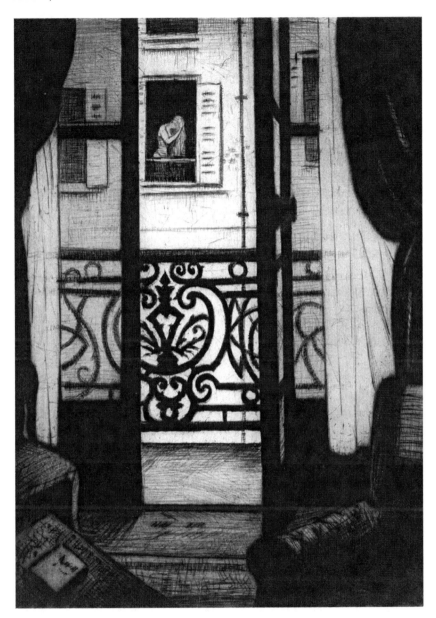

C.R.W. Nevinson, A Paris Window, 1922

Tonks has been saying about me that he has never in all his life heard of any man behaving worste [sic] than I have done, he little knows how I loathe not being able to pay for my own misfortune (if it is mine) but as it is by the girl's particular wish not to tell my people I do not see how I can pay Tonks the beastly £10 or whatever it is he gave the girl.[21]

He pleaded to Carrington to keep the whole shameful affair quiet for the sake of his own good name, but more importantly to protect his sister and mother, and confided his trust in her saying 'I feel absolutely convinced you will never play me a dirty trick & you are the first person I have ever at the bottom felt sure of saying that of.' He went on to explain:

> Ever since I went to public school I have been fighting with my back to [the] wall suspicious of everyone, trusting no-one just one long struggle of harsh dealings and retaliations. There was one truce while I was at St Johns Wood but that was with fools or gentlemen so hardly counts.[22]

It seems possible then, if not probable, that Richard had a son or daughter sometime in 1912, though in *Mendel* the illegitimate baby of Mitchell and Hetty Finch died shortly after its birth.

On 16 August 1912, Henry recorded that Richard came to dinner in Hampstead, and so we must assume that this first period overseas was, in total, about three weeks. At this dinner the mood had changed though and Richard told his father of 'his woes & quarrel with Goertler [sic] over the girl Carrington, whom both prefer now to hate'.[23] But having just had his twenty-third birthday, and received 'fags' from her as a present, he decided to write to Gertler to clear things up once and for all explaining that he would be 'perfectly willing to play second fiddle to him' so long as he did not object to the continuance of the friendship.[24] Things didn't get better though and within a week he was observing new problems, notably that Gertler 'has simply used me as a stepping stone & now that in his estimation I am no more use he is no longer interested in me'.[25] Worse still, he seemed to have convinced the rest of the old Slade boys that Richard had been the perpetrator of cruel and un-sporting actions, resulting in the fact that 'now I am cut dead in the street by Currie'. Gertler, who had been 'almost a gentleman' in the midst of 'cads', was finally showing his true colours.[26] It was clear there was very little to stay for in London, and so Richard started to plan a return to Paris on a more permanent basis. Writing of 'the revolting horrors & disappointments of a painter' he concluded 'I have been misunderstood a bit in my life & too well understood in my work.'[27] Retreating into his painting again he told Carrington 'I am now working all day really trying to do some justice to myself & trying to get back some hopes and beliefs in myself.' This was the escape he needed, the focus which might relocate to the sidelines his personal unhappiness, his lack of belief in his own talent, and suggest a route to freedom. He concluded 'I then do really think I might feel not so hopelessly empty & at war with myself

& as far as [I] know my only salvation will come not through Christ but draughtsmanship.' The alternative was unthinkable: 'Oh I would love to prove I could draw; I think I would shoot myself to prevent any deterioration.'[28] In the meantime he would continue behind closed doors, as 'I think it is better to make a fool of myself in private than public, though I suppose the "moderns" would laugh at me for this.'[29] But frustration was becoming evident in his behaviour too and a glimpse of this might be caught in a letter he wrote which described a fit of fury which had overcome him for two days and which had led to 'a dreary street at midnight' where he found himself 'in order to administer a thrashing on the offender's doorstep with my stick'. Without remorse he wrote 'How superb is physical violence if you happen to be the stronger' – though who his victim was that night remains unclear.[30] He even joked about it saying 'in future if I ever get violent, insane or melancholic I will go & knock about a bit. Tonks for preference.'[31]

Though he went to Bradford (Manningham Lane) for a short time, and despite the fact that 'Allinson blights the place',[32] he got the vital breathing space, socially and artistically, that he had been looking for, having 'cut entirely away from all artists and the Slade clique'.[33] As a pleasant surprise, Ruth Humphreys, an old Slade colleague and friend of Carrington's, seemed to be in residence there at the same time too. On his return to London, and doing what he could to forget the painful loss of his friendship with Gertler, Richard began to nurture his friendship with Edward Wadsworth who had paid him a studio visit and been extremely enthusiastic about his recent work. This had been reciprocated when Richard went round to Wadsworth's studio and exclaimed that what he had seen there had been 'bloody good', demonstrating as his work did a 'healthy strength & vigour & modern feeling & independence'[34] – qualities that he, himself so anxiously sought. And when he learned that he had sold a painting, via the dealer Cupid, he turned his attention with real enthusiasm to Paris one more time, to work along the lines of what Wadsworth might do were he to be taken out of England. In fact, not only would he do what he could to forget his Slade training, he would consciously set out to un-learn the lessons that he had so painfully learned there. He warned Carrington against the 'Albertian Slade' and told her that he would have 'to go right back & begin fresh & think only of the fees I have wasted'. In pre-fixing the Slade with the word 'Albertian', Richard had made reference to Albert Rothenstein of whom he had the following to say: 'If this day I commit murder I am sure Albert R. will be the victim. He is to me all that is symbolic of all that is useless, futile, civilised, beautiful, soft . . . [which] leads to exactly what Art should not do or be.'[35]

On a more personal note, the return to France, he felt, would help
him to 'get out of London & forget all this trouble',[36] though privately
he confided 'I am rather dreading it'. Besides, what had he to lose as, in
London, 'I am now getting quite used to seeing no-one all day or night.
I hope by decrees to be able to get rid of all desire for people's company
& get quite self-contained & happy without them.'[37] And when he did
meet or communicate with people it lead only to trouble with the result
that 'I have practically quarrelled with everyone.'[38] Gertler was gone, but
Carrington could still be saved, and so he implored her to wait for him, or
better still, to visit him in France. He wrote 'I was practically compelled to
make a choice between lo[o]sing [sic] one of you & naturally I preferred a
man', then bungled on unconvincingly, 'there was one person I liked better
than you & that was Gertler, but now that's over you have the privilege
of being the "favourite".'[39] To distance himself from the problems and the
pressures she was experiencing from that quarter he reminded her, one last
time, that she had nothing to worry about from him as, despite the fact he
still loved her, he had become proficient at suppressing it, and 'nipping it
in the bud'. He even suggested delaying his departure to Paris until after
the next Slade term started as seeing him before his grand exit, he hoped,
might encourage her to look no further in his absence. He promised her
in return 'to be as pious as possible' saying that he would refrain from
'bringing women in at night'.[40] Just before his departure he must also have
taken encouragement from learning of Carrington's rejection of Gertler's
advances. Indeed there are the undertones of conspiracy when, jubilant,
he wrote to Carrington 'for heaven's sake & mine don't go & write to him
at all or see him alone, do please promise me this if you are my friend &
don't breath (sic) [a] word to anyone that I helped you to come to the
conclusion that you ought to give him up'. Indeed, far from harbouring
hostility, he concluded 'Gertler must become my friend again, I can't do
without him even if he can do without me.'[41]

It was in a rather more optimistic frame of mind then that, in the
days immediately before his departure, Richard worked on a painting
of a span of Southwark Bridge. His spirits would have been buoyed
further with two more sales through Cupid and a new submission at the
NEAC. But this, he knew, was a fragile confidence and he was glad that
'I shall be in a far country when the judging [for the NEAC] goes on. If
I get rejected again it will not be quite so terrible.'[42] In so many ways his
sincerity could be felt when he wrote 'I do hope Paris puts me right.'[43]
But his first letter from 120 Boulevard Raspail some days later suggested
otherwise, and he grumbled 'I am very wretched indeed I simply cannot
find any work & the fellow I am living with is a frightful slacker with
no energy whatever.' While conceding that 'Paris is artistically perfect'

he could see no role for himself there as, 'After all I am not Parisian but a Londoner.' The French capital had at least helped him to identify what he did not want and, unashamed of the discovery, concluded that he could not change his skin and that every artist should paint his own era and country. To clarify his point he ridiculed, rather grandly, the idea of Rembrandt painting in Florence. As to the artistic, intellectual and enlightened friends which he was reported to have made there, he reported 'The artists here are swine. . . . Bohemians who slack about all day sitting in the Luxembourg Gardens talking to sluts. . . . The rest are Americans who are worse . . . or doodaas from the Slade.' And as to the cutting edge of modernism the bewildered Englishman commented that they were all 'endeavouring to be more incompetent than [their] neighbour in treatment & more eccentric in outlook'. Cautiously, his own work, as seen in the *Charenton* series, witnessed a gradual shedding of the previous affiliation with Impressionism in preference for a more simplified, geometric and brittle representation of the city. Emergent now were canvases drenched in ideas of *naïveté*, stripped of warmth and emotion, where structural rather than tonal emphasis, predominated. But they lacked conviction and his dissatisfaction, disorientation and frustration could be felt ingrained in these hard images. It may not be an accurate reminiscence then to read in his autobiography 'Abroad I had been fired with an enthusiasm which precluded any other consideration. I was a modernist.'[44]

The legendary nightlife he found to be second rate too when he wrote 'I went to a Cours de Croquis to-night at Colorossi's, it wasn't bad but London is better.'[45] That said, we must never lose sight of the fact that he was writing to Carrington and trying to sell the idea to her that he was incapable of happiness, let alone creativity, without her. This was the groundwork for his next suggestion in which he proposed she might come to Paris to share it with him, enabling him to see and experience the whole city in a different light. The added bonus would be that she would be out of Gertler's reach (who had similar Parisian plans for her) for at least a short time. Richard knew his audience well and played into her non-committal hands saying 'Yet marriage must be loathsome & no wonder men do anything & everything to avoid it & only do it when their senses have quite lost them & every other reason has failed. . . .' In short, she could feel safe with him – but she never came, and instead it was his mother who crossed the Channel.

A second letter, from the same address, and dated 13 October 1912, suggested that the fuse was getting short and opened with the sentence 'My clearing away to this godforsaken hole has been quite useless.' Unhappy, and miles away from the problem in London which was making his life

unbearable, and happiness unobtainable, patience, even with Carrington was now beginning to wear thin. He told her 'To be quite frank I do this time feel very annoyed with you', then continued 'if you intend to be "just friends" with Gertler you may as well know you are his worst enemy'. If anything, it seemed, Richard was beginning to take his former friend's side in this argument and Carrington must have been aware of it when she read 'I do hope you will let Gertler either win or lose you & finish this dangling about as he can't stand it.'[46] This outspoken letter led to the worst purgatory of all – a prolonged silence from Carrington, which in turn led Richard to write to her again pleading to open up the lines of communication one more time, if only to tell him that Tottenham Court Road runs into Oxford Street. He apologised for his outburst, claiming that it was the fault of his environment as 'I am morbidly bored & uninspired in this "gay city".'[47] After that there was no further communication from Paris and so 1912 finished on a solitary note, back in London. He seemed to have missed his cue artistically, while personally, he attended Christmas services at Westminster Cathedral and at Brompton Oratory alone, and in desperation pleaded 'Come back to me, Carrington, as soon as Gertler lets you.'[48] He would most certainly have sympathised with the sentiments outlined in a letter from Gertler to Dorothy Brett which said of Carrington 'She is a very peculiar person & terribly difficult to manage. I wish I had never met her!'[49] Richard might even have enjoyed Gertler's agony, even if it strongly resembled his own, but could still muster up no amnesty, when he told Carrington 'Gertler and I have definitely separated & it is entirely & absolutely his fault. . .'.[50]

Richard might just have caught 'The Second Post-Impressionist Exhibition of English, French and Russian Artists', at the Grafton Galleries, which opened its doors three days before his departure for France and continued for some weeks after his return, well into January, 1913. In this the 'Old Masters of the Modern Movement' were exhibited, with pride of place going to Matisse, Kandinsky, Picasso, Vlaminck and others of the Cubist and Fauve ilk. Roger Fry's introduction to the exhibition catalogue perplexed the public when he claimed that the artists on display 'do not seek to imitate form, but to create form; not to imitate life, but to find an equivalent for life. In fact they aim not at illusion, but at reality.'[51] What was being asked of the public was not only to observe what was happening in the art world in mainland Europe, but to question completely what the aims and objectives of art in the modern period were. In doing so they were being made to reassess and re-evaluate the means by which they viewed art and by which it justified its existence at all. The links with the Bloomsbury Group were obvious, not least as Clive Bell selected the English contingent for the

show, then wrote the preamble, introducing the concepts of 'plastic form' and reiterating the idea of 'significant form' as the basis of all aesthetic experience. His introduction in the catalogue optimistically assumed that the basic tenets in art criticism were now accepted:

> The Battle is won. We all agree, now, that any form in which an artist can express himself is legitimate, and the more sensitive perceive that there are things worth expressing that could never have been expressed in traditional forms. We have ceased to ask, 'What does this picture represent?' and ask instead, 'What does it make us feel?' We expect a work of plastic art to have more in common with a piece of music than with a coloured photograph.[52]

To all but a few the exhibition was an anathema, more so even than the first one. Critics and students, however, came to learn, and so, despite the uproar and the furore in the press and in the academies, Paul Nash could still observe that

> The Slade was then seething under the influence of Post-Impressionism. Roger Fry had brought about the second exhibition of Modern continental art in London and now all the cats were out of the bag. . . . It seemed literally to bring about a national upheaval. . . . All this had a disturbing effect at the Slade. The professors did not like it at all. The students were by no means a docile crowd and the virus of the new art was working in them uncomfortably. [53]

Nonetheless, it was a sensation, with over 50,000 visitors paying to come and see the works of modern British, Russian and French artists; and this time, barring Cézanne, they were all living. Richard attended the Grafton Galleries with his father, where the latter recorded his difficulty in appreciating the work of Wadsworth, and indeed with his son's new direction, but also with what was being exhibited by another young artist:

> about 10 were comprehensible: or fine: the rest were insanity to me, espec. a man W. Lewis who paints everything including women as though made of plate armour. But Roger Fry who was there admires him. . . .[54]

The innovative work of American, English and Scottish Fauves, exhibited in the same month at the Stafford Galleries, under the moniker 'The Rhythm Group' also seemed to have excited little in Richard, whose sympathy would, even now, still have rested in the type of work shown at 'The Third Exhibition of the Camden Town Group' at the Carfax

Galleries. Fairly sure that his artistic apprenticeship was now complete,
he turned, accordingly, to the Café Royal, not the Clôserie des Lilas
or Les Deux Magots, for inspiration. In fact Sickert's claim that the
art schools were only the day nurseries for artists who would continue
to work towards graduation up to the Café Royal seemed eminently
suitable for Richard's particular case. In *Paint and Prejudice* he succinctly
described the transition from Slade student, via Parisian artiste, to
leading avant-garde artist in London, as being accomplished with the
greatest of ease. 'Now', Richard reminisced, 'began my life as a rebel
artist, discussed everywhere, laughed at and reviled by all contemporary
critics, with the exception of P.G. Konody, Robert Ross, and Frank
Rutter.'[55] As well as showing at the Salon des Independents in Paris,
his career it appeared was picking up momentum in London too at the
Allied Artists Association (where his work was shown alongside that of
Sir John Lavery, Walter Sickert, Charles Ginner, Harold Gilman and
Lucien Pissarro), and this, in turn, led to the Doré Gallery where he
proudly exhibited next to foreign heavyweights such as Paul Signac, Paul
Cézanne, Pablo Picasso, Andre Derain, Giacomo Balla, Gino Severini
and Henri Matisse. Importantly, he also recorded that he had accepted
Lewis' invitation to join the Rebel Arts Centre (registered as 'The
Cubist Art Centre Ltd', at 38 Great Ormond Street, and funded by
Kate Lechmere), in its opposition to the Fry-run Omega Workshop in
Fitzroy Square, and had found in his new companion 'the most brilliant
theorist I had ever met'.[56] And then, if we follow his memoirs closely, he
declared quite suddenly, 'Marinetti, the Italian Futurist, [who] thought
of coming to England and told Severini, who wrote to me about him. I
asked Severini to persuade him to come.'[57]

In reality, 1913 started much more modestly, when he and his father
went to Muirhead Bone's studio to see the drawings he had made on
a recent trip to Italy, and when they entertained Edward Wadsworth
and Percy Wyndham Lewis at Downside Crescent. Gertler's friendship
and mentorship was being replaced at last, and this in turn helped
Richard manoeuvre himself into a more central 'flow' of modern English
painting. Now, he was working again and aiming to exhibit some of his
Paris subjects at the Friday Club, while ascertaining just where his stance
actually was on this whole debate of modern painting. In describing one
of his Parisian scenes he suggested where the emphasis would not lie:

> The whole is very full of colour but low in tone as I believe the
> best of modern work will not be violent or vivid in colour.[58]

Instead, he declared, the nature of its success lay in the fact that it
'smells strongly of Cézanne', with a new emphasis on structure, line and

simplicity. Better still, all of his paintings were accepted a fortnight later, for the Friday Club show, even if his offerings at the New York City Armory Show proved to be, as yet, a little premature.

But if things were improving artistically, they were rapidly going downhill in the on-going saga of the Gertler, Carrington triangle, and Richard, hardly surprisingly, was now out of patience. He wrote furiously to Carrington saying:

> Does Gertler own you? If so it is final. If not I am damned why I should not see you. I don't care if Gertler can't stand it, I can't stand this frightful lonely life that he has compelled me to live. Why should I not have friends? He is not God Almighty.[59]

Once again his temper led him to the melodramatic in which he expressed the desire to murder Gertler, or if not, to kill himself as life was growing, every day, more vile. Later letters adopted a superior tone and talked about Gertler being 'the produce of Petticoat Lane', criticising his over jealous state, his abusive comments about Carrington, and his lack of manners.[60] And yet with Carrington he did not give up, reminding her yet again that he had ruled out a formal relationship a long time ago and implored 'I like you for other reasons besides your sex.' Of course, he admitted, 'naturally being a man I should have liked more' but reiterated that he was perfectly content with friendship, and nothing else.[61] Had he not proved that already by clearing away to Paris in an attempt to make life easier for her? And now as loneliness was becoming his greatest enemy he played on her conscience by telling her 'you are my only friend. I see no-one week in week out except once or twice my mother at breakfast & weekends & my father on Sunday.'[62] He was not, however, going to consider Gertler's feelings now as he had not respected his, and, like it or not, he would continue writing to her. He declared 'it will do no harm to you & a lot of good and happiness to me'. Taking the blame for the entire mess away from her, he wrote 'I have lost all control of myself & my nervous state makes me think all sorts [of] delusions against people & imagine everyone my bitter enemy . . . no wonder every one else has dropped me'. Going on to call himself 'a little spiteful beast', he left the decision with her as to the future of their friendship, and signed off by saying that he felt burning shame and remorse over the entire situation.[63] No response came and so Richard packed up and headed for Falmouth where a further letter also went unanswered. Feeling distinctly hard-done-by on his return, he wrote once again, enclosing a stamped, addressed envelope, to assist her return letter, and began formally and coldly with 'Dear Miss Carrington.' Then, having one final purge of emotions, and closing the chapter once and for all, he asked for the return of his belongings, before getting to work calling

her friends 'scum' and claiming that 'they make a whore of you'. Ironically he signed off telling her that, young and naïve as she was, he was still her best friend.[64] Carrington, upon reading the letter (or at least using that as her pretext), washed her hands of him entirely despite his pleas that he was 'insane with misery' and his protestations that 'everybody has kicked me down'.[65] She remained unmoved and remained silent for over a month. At first he tried in vain to clear his name and to elicit pity by describing his solitary life, going to dances alone, and showing his disappointment that his new motorbike was not the solution to his problems he had hoped it might have been. He then tried to stimulate nostalgia by recalling the excitement and euphoria of summer 1912, reminding her that 'the only happy times of my life were spent with you, but how you have blighted my life since'. Next he threatened his complete withdrawal as he saw only a bleak future for himself in London saying 'you have an interesting present & future, I have nothing', and wondered should he not turn for Paris again to 'try & raise some interest in something'.[66] And finally he may even have tried to scare her by saying 'I have spent hours trying to pluck up the necessary half second to kill myself but I only sweat and tremble.'[67] But all this got him nowhere and, ironically, it was Carrington who turned a gun on herself some years later. A matter of months later Richard met his wife-to-be, Kathleen Knowlman, while receiving treatment for pericarditis and rheumatic fever in Buxton.

Thankfully his painting was going a lot better than his private life and so, following the closure of the Friday Club show in January, came the opening of the First Grafton Group Exhibition at the Alpine Gallery where his work was shown in the company of Clive Bell, Frederick Etchells, Roger Fry, Duncan Grant, Wyndham Lewis, Cuthbert Hamilton, and even Wassily Kandinsky. Proudly Henry could write in his journal that 'Richard's two of a Paris suburb . . . much the most beautiful there', while simultaneously condemning the painting of Duncan Grant, Max Wilber, Wyndham Lewis and Frederick Etchells, as 'just insane', before signing off with 'What a lot!'[68] Though he was still dabbling with 'every conceivable medium'[69] in search of a clear artistic identity, Richard's wait was almost over, catalysed by the exhibition 'The Futurist Painter Severini Exhibits His Latest Works', at the Marlborough Galleries. Futurism was back in London, and this time Richard would notice it. In Henry's journal there is an entry, dated 21 April 1913, which reads 'Severini came to dinner and talked Futurism in French,'[70] though strangely there is no mention of a reunion between the Italian and his son who had allegedly known each other in Paris. Perhaps their introduction had not been in Paris at all, rather at the hands of family friend Charles Lewis Hind who, having got to terms

C.R.W. Nevinson, Portrait of a Pretty Girl, *1924*

with the movement from the previous year, now supported the young Italian in London and, in addition to introducing him to Epstein, might also have provided the introduction to Richard. Or perhaps they had met the previous year at the Futurist Exhibition, or on another occasion through the invitation of Clive Bell and Roger Fry.[71] Whatever the

origins of the friendship, Severini was impressed with what he saw and wrote to Marinetti enthusiastically:

> I have to tell you about a young painter whose name is Nevinson. I met him during my exhibition, and he introduced me to other young artists, who, with him, all became convinced futurists. . . . Nevinson will thus introduce himself to you on my behalf; he writes to me enthusiastically about Futurism and will put himself at your service for any purpose that you might deem useful.[72]

After several false starts, it was *this* friendship and this movement, which was to prove the definitive turning point in Richard's career, as he was immediately seduced by the incorrigible theories, performances and paintings of the Italian movement. How attractive it must all have seemed, and how logical considering his parents' professions, to gravitate at last towards an ideology, the basis of which lay in revolt, rejection of the past, and the acceptance and celebration of the time in which they lived. It is probably fair to say, however, that Richard was not ready for this, indeed hardly educated in the basic principles which leaned so heavily on the theories and philosophies of Georges Sorel and Henri Bergson. He was, however, certainly keen to learn, and to be a part of such an enticing movement that seemed, on the surface at least, to be offering many of the answers to the questions he had been asking for some years now.

Severini, like Marinetti, was fascinated by London, and praised the city and its inhabitants for their spirit, strength and energy. As a Futurist he also declared the National Gallery full of 'dead things', and so recommended that it should be turned into a crematorium.[73] He trotted out the same sort of rhetoric that Londoners had heard on previous Futurist visits in 1910 and 1912, saying that 'Motor-omnibuses passing and re-passing rapidly in the crowded streets, covered with letters, red, green, white, are far more beautiful than the canvases of Leonardo or Titian. . . .'[74] Even if the public was sceptical, Richard was attracted to this seemingly straightforward, yet dynamic, set of theories which served a new boundless subject matter, and converted into a scintillating mode of painting seen even in some of Severini's titles such as: *The Motor Bus, The Nord-Sud Railway* and *A Spanish Dancer at the Tabarin*. Was this not the up-beat, urban, contemporary motif for which he had been searching in vain with the vocabularies of Impressionism and Post-Impressionism and which had led him only into a cul-de-sac? The talk now was of intuition, dynamism, and the synthesis of abstraction and force lines inherent in all objects, in a contemporary environment, and this, most conveniently of all, meant he could turn his back on the uncomfortable reverence for the past which he had, as a student, been forced to adopt.

As if to confirm this significant departure and send him on his way, all his submissions to the NEAC were rejected leading his father to write in his journal 'so another artist's life goes miserably on'.[75] But this time Richard would hardly have minded.

Far from confident, and in a constant state of poor health, Richard did not assume that he would automatically head the English 'wing' of Futurism. If anything, he rather encouraged Lewis to take the helm, behind whom all other young artists would rally in their collective *crie de guerre*. Richard wrote to Lewis 'it will need the combined effort of Etchells, Hamilton & Wadsworth & myself under your command',[76] then wired Lewis, excited, saying 'I have at last run Marinetti to earth. He is in Brussels! & has just wired me from there & fixed an appointment with me at the Savoy tomorrow (Sat) at 6 o'clock.'[77] And so a band of rebel artists linked themselves closely, for the time being at least, to Futurism via a new exhibition at the Doré Galleries, called 'The Post-Impressionist and Futurist Exhibition'. For this Frank Rutter wrote a forward, in an attempt to introduce 'schools of painting which have made some noise in the world during the last quarter of a century',[78] and omitted any contributions by the Bloomsbury artists, and surprisingly by the Italian Futurists themselves. Among those exhibited, and in addition to Richard's six pieces, were Sickert, Lewis, Wadsworth and Etchells, representing the ill-defined English Cubo-Futurist 'school'. These were in the prestigious continental company of Cézanne, Van Gogh, Matisse, Delauney, Picasso and Marc, making up a total of two hundred and thirteen works. Frank Rutter observed with some satisfaction: 'That "Cubism" and "Futurism" have already stirred English artists is shown by the contributions of Mr. Wyndham Lewis, Mr. Nevinson and others.'[79] In fact it was Richard's *The Departure of the Train De Luxe* which attracted attention for being the most modern interpretation of an industrial urban scene yet undertaken and perhaps even, in Rutter's view, 'the first English Futurist picture'.[80] Here, only a matter of months after the love drama of *The Towing Path, Camden Town*, the pastoral serenity of *The Railway Bridge, Charenton* and of the Neo-Primitive influences of 14th century Italian art, was evidence of an artist who had found a new direction and was turning to embrace concepts far more modern. *The Departure of the Train de Luxe* demonstrated a definite move towards modernising the presentation of the modern theme very much in the mode of Severini and his depiction of the Paris Metro in *Nord-Sud* of 1912. Richard had also been particularly taken by Severini's *Pan Pan at the Monico*, and so used it as the foundation for his own *At the Dance Hall*, both of which revelled in the noise and movement of modern music, fashion and dance as seen in two of Europe's most dynamic cities. Critically, this met with

C.R.W. Nevinson,
Departure of the Train
de Luxe, *1913*

a mixed, and sometimes hostile, response but at least, Richard felt, it was something. It was certainly better to attract attention and create a discussion of some sort than constantly to paint hoping that a selection jury might accept a work for exhibition at a conservative gallery. What possible harm could it do when the *Daily Sketch* printed a copy of Richard's *Waiting for the Robert E. Lee* upside down, along with Delauney's *The Football Team* and Wadsworth's *The Omnibus,* under the scathing banner 'You wouldn't think that these were paintings, would you?'[81] That said, Richard emerged fairly well from the exposure and Clive Bell (who was to become a life-long enemy), while scathing in his attack on Futurism in general, allowed a little leeway for him, saying:

> Yet Nevinson bears the Briton's burden more lightly than his fellows; probably because he is cleverer than most of them. He is clever enough to pick up someone else's style with fatal ease; is he not clever enough to diagnose the malady and discover a cure.[82]

In short, Bell believed that after this brief flirtation with a plagiarised style, he would see the error of his ways and probably be a fine painter, unlike the others. Bell finished with some sobering advice:

> I would advise Nevinson and the more intelligent of his company to shut themselves up for six months, and paint pictures that no-one is ever going to see. They might catch themselves doing something more personal if less astonishing than what they are showing at the Doré Galleries.[83]

Another reviewer commented that Richard had 'taken his father's "Essays in Freedom" a little too seriously'. Henry himself wrestled with the exhibition and concluded:

> Went to the Futurist show at the Doré Gallery: some strange
> things there, but I feel the whole fashion for Post-Impressionism
> is becoming stiff: It is already imitative and doesn't grow. Rich's
> 3 pictures & 3 drawings were well liked. To me both Wadsworth
> and Wyndham Lewis were horrible: really hideous and I was
> sorry, for I like the two men.[84]

Of course accusations flew that they were just impetuous youths doing
whatever it took to get into the spotlight and perhaps Richard himself
would not, at heart, have disagreed too violently with that. He had had
enough of the doldrums and was delighted to have met this dynamic
Italian with whom he now travelled, studied, painted and even, briefly,
lived. Severini too remembered Richard affectionately in his autobiography
saying 'the person with whom I became closest was the painter Nevinson.
He was a reserved man like many of the English, but very sensitive and
intelligent.'[85] It is also recorded in Severini's autobiography that Richard,
Fry and the rest of the English rebels were the only artists to send him
money (£10), when he was desperate and when his Futurist colleagues
refused to help.[86] On another occasion Richard petitioned Lady Ottoline
Morrell to contribute to a fund to keep Severini in a sanatorium when his
health finally collapsed. Perhaps this is why a later writer could observe
'The Futurists were fascinated by London, a modern metropolis which
took them to its heart with a warmth that Paris never displayed.'[87]

Inevitably Severini would lead to Marinetti and the return of the
bombastic Italian would, as always, create a stir. Whether or not Richard
was the direct source of Marinetti's invitation, as he claimed in *Paint
and Prejudice*, is unknown, but either way a renewed lecture tour began
in November 1913, which involved presentations at The Cave of the
Golden Calf's Cabaret, the Poet's Club, the Poetry Bookshop, Clifford
Inn Hall and the Doré Gallery on New Bond Street.

In fact, Madame Strindberg's 'Cave' was to prove the perfect location
(within walking distance of the Café Royal) for avant-garde thinkers and
rebel artists with whom Marinetti would have been made quite welcome
and where Richard was by now becoming a well-known habitué. A den
devoted to pleasure, modelled perhaps on the Kabarett Fledermaus in
Vienna, decorated in a 'primitive' manner by Gore, Gilmann, Lewis,
Epstein, Gill and others, Osbert Sitwell's succinctly described it as:

> This low-ceilinged nightclub, appropriately sunk below the
> pavement . . . and hideously but relevantly frescoed . . . appeared
> in the small hours to be a super-heated Vorticist garden of
> gesticulating figures, dancing and talking, while the rhythm of the
> primitive forms of ragtime throbbed through the wide room.[88]

A Night in the Cave of the Golden Calf, *Daily Mirror*, 4 July 1912

And it was from there that Henry reported enthusiastically on one of Marinetti's performances declaring that 'no-one could escape the spell of listening'.[89] Imagist poet Richard Aldington also recorded in *The New Freewoman:*

> Mr. Marinetti has been reading his new poems in London. . . .
> London is vaguely alarmed and wondering whether it ought to laugh or not. . . . It is amazing and amusing to a glum Anglo-Saxon to watch Mr. Marinetti's prodigious gestures . . . a better man than the bourgeois men and women who grin at him when he reads. . . .[90]

Lewis too wrote enthusiastically of these performances telling Mrs Percy Harris 'Marinetti declaimed some peculiarly blood-thirsty concoctions with great dramatic force. . . . He will be lecturing again soon . . . and will no doubt be well worth hearing'.[91] If anything, the reputation of Futurist evenings exceeded the events themselves, not least as, on mainland Europe, they had often lead to outbreaks of violence; and so Fishburn, the

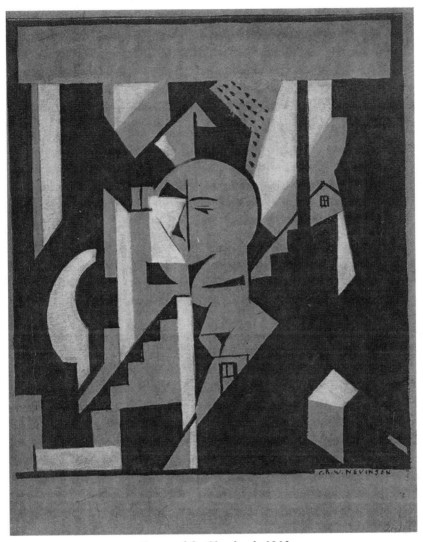

Cover of the Chapbook *1913*

proprietor of the Doré Gallery, wrote to Richard expressing his concern and saying that he was 'most nervous of any of the pictures getting injured, especially Delauney's but I don't suppose they will chuck anything even if the fools come'.[92] So far as Marinetti (whose futurist portrait by Richard had just appeared on the cover of the *Chapbook*) was concerned, things could not have been progressing better and a letter to Severini, in the same month, showed that he had already committed himself to a return to the Doré Galleries in early 1914.[93] In another key lecture, entitled 'Futurism in Literature and Art', Marinetti found his stride and turned on the English whom he admired for their 'brutality and arrogance', yet described as 'a

nation of sycophants and snobs, enslaved by old worm-eaten traditions, social conventions and romanticism . . .'.[94] In a letter to a Milanese friend he went further, describing the English as 'beautiful, monstrous, elegant, well-fed, well-dressed, but with brains as heavy as steaks. Inside the houses are magnificent: cleanliness, honesty, calm, order, but fundamentally these people are idiots, or semi-idiots.'[95] Umberto Boccioni wrote of their exploits too:

> In London I went with Marinetti to insult a journalist at his home. What a wonderful car trip, sixty kilometres out of London! I witnessed all the riots of the suffragettes, encouraging and cheering them on when I saw them being arrested. . . . I fought with fists and elbows.[96]

Marinetti and Boccioni, later tracked down journalist Frank McCullagh to his Surrey home and challenged him to a duel for an unfavourable report he had written concerning the Italian army in the 1911 Tripoli campaign. To their frustration he refused the duel but instead invited them in for afternoon tea.

In response to this new wave of notoriety, a committee of rebel artists, led by Richard and including Etchells, Roberts and Lewis, organised a dinner in Marinetti's honour at the Florence Restaurant on Rupert Street on 18 November 1913. The fact that Richard took a leading role in this, if not the leading role, is suggested in a letter from Fanny Wadsworth to Lewis which says 'Nevinson wants to get up a dinner for Marinetti who is coming to London [on] November 14th for six days.'[97] The idea was a popular one and was well supported. Futurism, its audience and associated artists, was strengthening not only in interest but also in numbers. Henry's journal provides us with a further insight into the evening, though contradicts the figure of sixty people given by Richard in *Paint and Prejudice:*

> About 25 men came + one woman appeared for a short time. Rich and Wyndham Lewis gave the toast in French. Marinetti spoke + recited in French with extreme vigour + eloquence + apparently could have continued all night. He gave his Adrianople + the train of wounded.[98]

But some astute observers were beginning to note a scarcely perceptible division appearing between what was loosely called English Cubism (Lewis and Wadsworth) and English Futurism (Nevinson and Delauney). Though Lewis would call Marinetti 'the intellectual Cromwell of our time' and acknowledge that 'England has need of these foreign auxiliaries to put her energies to rights and restore order',[99] there

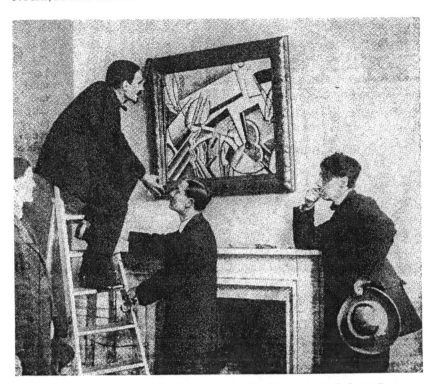

Wadsworth, Nevinson and Lewis hanging Caprice *at the Rebel Art Centre,*
Daily Mirror, *30 March 1914*

was something else beginning to bother him. In short, he did not wish to
see the Italian dominate the emergent English avant-garde. Richard too,
at this stage, saw the dangers, or at least wanted to appear aware of this,
and wrote to Lewis the day after the dinner saying 'I had quite a great
deal of difficulty in preventing Marinetti from again expounding and
proposing his philanthropic desire to present us to Europe and be our
continental guide.'[100] It was a problem that would remain dormant only
for a short time. In the meantime, however, the publicity was doing no-
one any harm and soon commissions came in as a result. Through the
Doré Galleries, Richard met Lady Muriel Paget who was 'astonished to
find me not absolutely insane nor some form of clown',[101] and the same
week he received, and forwarded to Lewis, a letter from Lady Drogheda,
who was developing an idea concerning a 'Futurist Frieze'.[102] Lady
Cunard also asked them to design small gifts for the 'rich & influential' at
a dinner to honour George Moore, requesting specifically handkerchiefs,
scarves, fans, and candle shades, each of which would command the
handsome fee of ten shillings. Futurism, Cubism, or simply the avant-
garde, was indeed becoming fashionable amongst the 'society set' but
was, in the eyes of others, becoming a frivolity that would have to be

anchored to something more solid if it desired serious consideration as 'art' in London.

In the last significant exhibition of 1913, the 'Camden Town Group and Others', Richard, Etchells, Lewis, Wadsworth and Hamilton, chose to separate themselves from within, distinguishing their exhibit as the 'Cubist Room'. Here, despite yet another illness, Richard exhibited two paintings of the *Gare St Lazare*, then packed his bags and left for Paris with his mother, writing to Lewis 'I am so unwell & I am going away to try & get right.'[103] From Boulogne-Sur-Mer, he wrote to Severini, retrospectively, giving himself much of the credit for the successes of the last few months, and also evidently beginning to assume that Futurism and the avant-garde in England were synonymous. But, far from content to sit back, Richard was already planning on how to get Severini back to London for the exhibition which was almost certain to run the following March. Aware of the Italian's financial difficulties he invited him to stay at Downside Crescent for the duration of the show but warned that due to serious strikes, London was not, as yet, spending money on art.[104] He wrote again to Severini, shortly after Christmas, confirming his debt to the Italian's work and saying 'I am delighted that you will write soon about your latest ideas, because they interest me enormously.'[105] Richard would have been delighted with the events of the year, not least in his painting where the primacy of instinct and imagination were beginning to triumph over reason; where the cold logic of energy was beginning to triumph over tradition; where a modern primitivism was shaking off the fetters of civilisation; and where anarchy seemed to be making some headway over peace (and in turn, stagnation). The artist too changed, being fiercely independent, critical, analytical, outspoken, decisive and strong. Events had certainly taken a turn for the better since the last time he had wandered the banks of the Seine only a year before.

4

'The Distinction of Abdiel', London's Only Futurist (1914)

Few would have failed to notice that London was rapidly acquiring a new interest in, or perhaps just a morbid fascination with, modern art sweeping in from overseas. This, if proof was needed, was clearly seen through the exhibition of 'Modern German Art' at the Twenty-One Gallery, which was eclipsed in public interest only by the work of young native artists at the 'Twentieth Century Art' exhibition at the Whitechapel Gallery or at the debut show of the London Group at the Goupil Gallery. And if there was a feeling of loss at the closure and liquidation of the Cabaret Theatre Club on Heddon Street, this was more than compensated for by the opening of the Rebel Art Centre and the Crabtree Club. Additionally, while Roger Fry and Vanessa Bell were nurturing friendships with both Picasso and Matisse in Paris, David Bomberg was thrilling audiences at home with his Chenil show, and Michael Sadler was bringing the translated words of Kandinsky to an eager audience. But it was Marinetti and the Futurists who had London most firmly in their sights again; and it was the 'English Cubists', as they were crudely called, who were marching into the headlines in tandem with the opening of the enormous seventh Allied Artists Association Salon, which, in Richard's reminiscences, 'was a fiasco, though a splendid one'.[1] And he too, through his fledgling celebrity, was becoming quite at home in the company of Lady Cunard, Sir Edward Marsh, Lady Diana Manners, Lady Lavery, Lady Constance Hatch and various members of the Guinness family, and was coming to the fore in any serious debate concerning art in London.

Both father and son together tackled Futurism head on, with first blood, in fact, going to Henry on 17 January 1914, when the *Evening News* published a long article entitled 'Some of the Manifestoes of "Futurism"; Amazing, Absurd, Amusing – As You Like.' Though he admitted that the movement 'deliberately defied every known canon, not merely of art but of eyesight' he went on, enthusiastically, to express his admiration, specifically for Marinetti:

Into our ancient life of precedents and perpetual repetition he burst like a shell. Antiquity exploded. Tradition ceased to breathe. Those who heard him in the last few days know what vitality means. He over-runs with it. There is no stinting or sparing. He pours out life like ungrudging nature. Like all true hearted fanatics he lives only for his cause and never counts the cost. I have heard many recitations, and have tried to describe many battles. But listen to Marinetti's recitations of one of his battle scenes – a train of wounded stopped by the enemy, or the destruction of a bridge under fire. I may very well have witnessed both the events he describes for he was with us in the Bulgarian Second Army a year ago. But I have never conceived such descriptions as these not heard such recitations. The noise, the confusion, the surprise of death, the terror and courage, the grandeur and the appalling littleness, the doom and chance, the shouting, curses, blood and agony – all were recalled by that amazing succession of words, performed or enacted by the poet with such passion of abandonment that no-one could escape the spell of listening.

Richard would have agreed with his father completely when the article finished 'At any rate, Signor Marinetti has performed a service in stirring people up.'[2] It was then Richard's turn to take the Futurist experiment into the galleries with his rebel peers, but this time under a different moniker. Extracted from a group that would spend evenings at Mrs Kipplewhite's on Frith Street (and which included T.E. Hulme, Jacob Epstein, Henri Gaudier-Brzeska, Rupert Ainslie, Rupert Brooke, Robert Bevan, Harold Munro, and a host of other Germans, Spaniards, Irishmen, Americans and Italians), had sprung The London Group. This group had attempted to bring together the disparate factions of the avant-garde in London, under the presidency of Harold Gilman (after Sickert's refusal), and was based at the Goupil Gallery. Richard, as a co-founder, was elected secretary (against Roger Fry's wishes), whilst Spencer Gore became treasurer. Richard claimed that the group represented the best of what London had to offer at the time (even if the membership applications of Nash, Gertler and Currie were rejected), but acknowledged that commercially it was a failure and critically, merely a source for constant derision. Described as 'The Camden Town Group, the Seceders from Mr Roger Fry's Omega Workshops, and other English Post-Impressionists, Cubists and Futurists',[3] their exhibition inspired many articles and instigated many lively discussions. The press, once again, reproduced some of Richard's paintings (most frequently *The Strand*) somewhat cynically under titles such as 'The London streets are

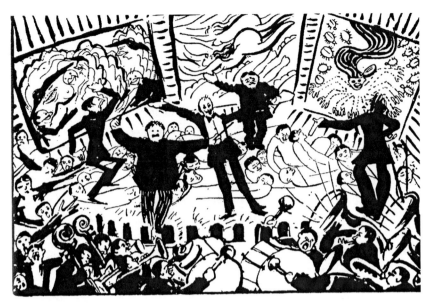

Umberto Boccioni, Caricature of a Futurist Evening, *1911*

indeed perilous.'[4] But this only spurred him on to paint ever more daring works such as the *Non-Stop*, which was a depiction derived from the sensations experienced whilst travelling on the London underground. Some perceptive reviewers rather liked what they were seeing:

> That mixture of streaks of light, and fragments of advertisements, and curves, and colour, with lines that suggest straphangers here and there, is quite obviously an impression of a compartment on the Underground. This exhibition is certainly a success of curiosity; and it proves, at any rate, that the young London artists are not deficient in daring.[5]

Astutely, *The Observer* review also noted that, had this sort of work been exhibited three years ago, it would have 'provoked unmeasured hilarity or furious indignation',[6] suggesting that, by 1914, the efforts of the Slade generation of artists were having a significant impact on critical opinion in pre-war London. Other reviewers remained bewildered, however, claiming that there was still 'truth in Whistler's contention that only the artist is capable of understanding his art'.[7] Some attacks came from unlikely quarters too as was seen in a letter to the press from Walter Sickert which singled out Richard in particular for 'Resting on your oars.' He then went on to criticise young artists in general, saying 'If these meaningless patterns are all they have to show for the time that has passed since their scholarships, they will have considerable leeway to make up to convince neutrals that they take their own talents seriously.'[8] This came as

a particularly harsh criticism from an established artist who was not only
a family friend but who had been one of the few noted figures to speak
positively about the March 1912 Futurist exhibition. This he had called
'Austere, bracing, patriotic, nationalistic, positive, anti-archaistic, anti-
sentimental, anti-feminist . . .', and had concluded that the movement 'is
one from which we in England have a good deal to learn'.[9] But it wasn't in
Richard's nature to take this, or any other form of attack, lying down, and
so began a long and turbulent letter writing relationship with the press.
His first communication, in comparison to some of the more explosive
efforts that were to come, was mild and reminded his critics 'I can well
afford to do without notoriety. I prefer something not quite so useless.'[10]
Sir Claude Phillips was having none of it, however, and wrote that Richard
was 'a partial convert, or pervert, to Italian Futurism'.[11] Other, more open-
minded, critics were beginning to place Richard within a hierarchy of their
own that, by default, was bound to upset his peers:

> Mr. Nevinson and, perhaps, Mr. Bomberg, show that they can be
> the medium of both beauty and thought. But the pictures of Mr.
> Wyndham Lewis, Mr. Etchells, and Mr. Wadsworth can, surely,
> only be the work of men who know that there is a buying public
> that cannot distinguish the real thing from third-rate imitation.[12]

With Wadsworth and Phelan Gibb completing the line up of 'out-
and-out Futurists',[13] all others were relegated to a peripheral, and less
legitimate, role.

The inevitability then was that Richard and Marinetti should finally
come together, and this happened publicly at the Doré Galleries for their
first joint performances on the last three days of April 1914.[14] This was
part of an overall Futurist show which had opened its doors the week
before, exhibiting about eighty works by Umberto Boccioni, Giacomo
Balla, Carlo Carra, Gino Severini, Ardengo Soffici and Luigi Russolo,
and which had already led to articles with titles like 'Would You Allow
A Futurist To Marry Your Daughter?'[15] The evenings were planned as
typical *conferenze*, giving Marinetti, and in turn, Richard the opportunity
to deliver their theories on the nature of painting, sculpture, poetry and
music in a wild and unrestrained environment which had, in other cities,
led to riots and arrests. Marinetti's poems, *The Siege of Adrianople* and
Dynamic & Synoptic Declamation, stole the show, capturing as they did,
the rage of the Balkan War with the striking of wood by a hammer,
and echoed by the beating of 'two big drums in a distant room from
which the painter Nevinson, my colleague, produced a boom of cannon
fire when I told him to do so over the telephone'. Marinetti further
described the performance:

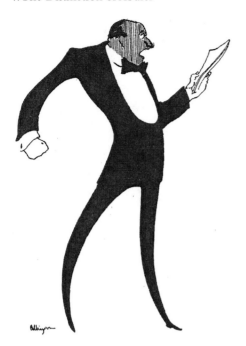

Adrian Allinson, Marinetti
Reading One of his Restful
Futurist Poems, *1913*

Blackboards had been set up in three parts of the hall, to which in succession I either ran or walked, to sketch rapidly an analogy with chalk. My listeners as they turned to follow me in all my evolutions, participated, their entire bodies inflamed with emotion, in the violent effects of the battle described by my words-in-freedom. [16]

The audience reaction to the work was extremely enthusiastic and this infuriated Marinetti who bellowed at the end of the reading 'This was a very imperfect rendering. There should be no passive listeners. Everyone should take part and act the poem.'[17] Even Lewis, recalling the evening in his autobiography, could not help but profess some admiration for the combined efforts of Marinetti and Richard, when he recorded 'A day of attack on the Western Front, with all the "heavies" hammering . . . was nothing to it'.[18] Henry, who had been reading pamphlets sent from Milan and visiting the 'Futurist School' on Great Ormond Street,[19] recorded his admiration for the Italian, once again saying 'He was superb on new & old poetry. Recited his Automobile and the Bombardment of Adrianople with effects of hammering for machine guns.' He believed also that 'No Englishman could have touched it. It overwhelmed me. It was so terrific.'[20] Richard, taking it all in his stride, recorded in his autobiography 'I made a good deal of noise and enjoyed myself'.[21] Lewis then extended an invitation to Marinetti to perform at the Rebel Art Centre, where the latter made 'loud puffing noises pretending he was a train',[22] before moving on to the home of W.B. Yeats, where Aldington remembered that a 'bewildered Yeats begged him to stop as his neighbours were banging in protest at the row on the floor, ceiling and on the front door'.[23] Marinetti and Richard were then introduced together by Ford Madox Ford to the exquisite set at South Lodge in Campden Hill,[24] before, finally, Marinetti dined at the Nevinson household where

Henry recorded, perhaps a little disappointedly, he was 'quite tame and sensible'.[25] He also observed his son's 'Englishness' by writing:

> We entertained Marinetti, and listened to his fervid speech and recitation of his poems – the Italian Futurist declaiming in sharp contrast to the English manner of my son, Richard, in those days the Futurist of London.[26]

Perhaps it was on this occasion that Marinetti saw, and approved of, Richard's most daring Futurist composition to date, *Tum-tiddly-um-tum-pom-pom*, which was destined for the Doré Gallery. Severini would also have seen it as he stayed at the Nevinson household for the duration of the exhibition, and it is possible that another young Englishman, Ethelbert White, might even have added a few touches to it before completion. This was a composition which had been on Richard's mind for over two years as a letter to Carrington testified. In this he had written:

> Last Friday nineteen hundred and twelve years ago Christ was crucified therefore Christian London went up to Hampstead Heath in its thousands to celebrate the occasion amid blaring . . . bands & booths of bright and brilliant colour. Really you must next whitsun bank-holiday come up with me to see sweating democracy heeding not the rumble of the distant drum it is a glorious sight, the gipsies, the cocoanut shies, all men, bright purple factory girls, old women, fat & thin, all yelling, song-sellers singing, barrel organs grinding . . . jew boys auctioneering, women washing & cooking & feeding infants, some eating, most drinking, . . . & all happy. Oh Baby dear why aren't you here to revel in it, it's wonderful, & why is a crowd always happy & individuals always unhappy.[27]

The name had inherent similarities to Marinetti's publication *Zang-Tumb-Tumb*, while the artist had clearly attempted to capture, using both paint and confetti in the manner of Severini and Boccioni, the dynamism of the atmosphere, rather than the static appearance, of Hampstead Heath on a Bank Holiday. T.E. Hulme declared it Richard's 'best picture', praising it particularly for its 'interesting contrasts of round and angular forms',[28] while Gaudier-Brezska dismissed it as 'union jacks, lace stockings and other tommy rot'.[29] The same work, with the addition of *Aerroplane*, Futurist at least for its onomatopoeic title and its mixed media of wood carving and painting, appeared at the London Salon held by the Allied Artists Association at the Holland Park skating rink. *The Times*, in its article 'Rebels in Art', feeling that this had all gone far enough, singled Richard out for a fairly stern warning:

C.R W. Nevinson, Tum-tiddly-um-tum-pom-pom, *1914*

But Mr. Nevinson . . . is a rebel in execution. He used to be a painter with a modest talent; but now he is like a singer with a small voice who has taken to shouting. Futurism, we are sure, is merely poison to him; and, if he has not lost his talent altogether, it will take him some time to recover it.[30]

But the most significant alliance of Richard and Marinetti came in the joint declaration of 'A Futurist Manifesto: Vital English Art', in early June 1914. In time-tested Futurist manner, Richard reported that he had had the manifesto published in the press, and then gone to theatres to shower the leaflets down on the unsuspecting and shocked audiences in the stalls and dress circles below. The document, if not the manner of its delivery, created a fracture among the English 'rebel' artists however, and led to consequences that Richard could never have anticipated. John Rothenstein suggested that had it been presented by Marinetti, and Marinetti alone, it would merely have been seen as 'a spirited display of fireworks',[31] but the fact that Richard co-signed it, and thus thrust himself to the forefront of the avant-garde, and using the Rebel Art Centre address at that, created an irreparable rift. Though the document had been designed to unite the avant-garde artists of the day behind a common rallying cry, it was to have precisely the opposite effect, not least as other artists' names had been used without their permission. This implied that they were somehow the 'London branch' of Futurism, and perhaps even under Richard's command. Though Henry himself had read an early draft of the manifesto

in question, and had seen no real cause for alarm, it was to prove quite an error of judgement.[32] Modelled, as it was, on 'The Technical Manifesto of Futurist Painting', the proclamation had divided into two lists (originally 'We Declare' and 'We Fight'), in which, the past, good taste, art critics, the nude, and many other traditional elements of painting, had been violently rejected once and for all. In this new English version of the manifesto the divisions were called 'Against' and 'We Want' (while Lewis' later 'Blast' manifesto was later divided into 'Blasted' and 'Blessed'). The contents, though self-confident, were almost certainly ill-advised in the number and variety of people and institutions caught up in their scythe-like sweep.

A Futurist Manifesto
Vital English Art
F.T. Marinetti
C.R.W. Nevinson.

I am an Italian Futurist poet, and a passionate admirer of England. I wish however, to cure English Art of that most grave of all maladies – passe-ism. I have the right to speak plainly and without compromise, and together with my friend Nevinson, an English Futurist painter, to give the signal for battle.

AGAINST:
1. The worship of tradition and the conservatism of Academies, the commercial acquiescence of English artists, the effeminacy of their art and their complete absorption towards a purely decorative sense.
2. The pessimistic, sceptical and narrow views of the English public, who stupidly adore the pretty-pretty, the commonplace, the soft, sweet, and mediocre, the sickly revivals of mediaevalism, the Garden Cities and their curfews and artificial battlements, the Maypole Morris dances, Aestheticism, Oscar Wilde, the Pre-Raphaelites, Neo-Primitives and Paris.
3. The perverted snob who ignores or despises all English daring, originality and invention, but welcomes eagerly all foreign originality and daring. After all, England can boast of Pioneers of Poetry, such as Shakespeare and Swinburne; in Art, Turner and Constable (the original founders of the Impressionist and Barbizon School); in Science, Watts, Stephenson, Darwin, etc etc.
4. The sham revolutionaries of the New English Art Club, who, having destroyed the prestige of the Royal Academy, now show themselves grossly hostile to the latter movements of the advance guard.

5. The indifference of the King, the State, and the politicians towards all arts.

6. The English notion that art is a useless pass time, only fit for women and schoolgirls, that artists are poor deluded fools to be pitied and protected, and Art a ridiculous complaint, a mere topic for table talk.

7. The universal right of the ignorant to discuss and decide upon all questions of Art.

8. The old grotesque idea of genius – drunken, filthy, ragged, outcast; drunkenness the synonym of Art, Chelsea the Montmarte of London; the post Rossettis with long hair under the sombrero, and other passeist filth.

9. The sentimentality with which you load your pictures – to compensate, perhaps, for your praiseworthy utter lack of sentimentality in life.

10. Pioneers suffering from arrested development, from success or from despair, pioneers sitting snug on their tight little islands, or vegetating in their oases refusing to resume the march, the pioneers who say: 'We love progress, but not yours'; the wearied pioneers who say: 'Post-Impressionism is all right, but it must not go further than deliberate naivete.' (Gauguin). These pioneers show that not only has their development stopped, but that they have never really understood the evolution of Art. If it has been necessary in painting and sculpture to have naivete, deformation and archaism, it was only because it was essential to break away violently from the academic and the graceful before going further towards the plastic dynamism of painting.

11. The mania for immortality. A masterpiece must disappear with its author. Immortality in Art is a disgrace. The ancestors of our Italian Art, by their constructive power and their ideal of immortality, have built for us a prison of timidity, of imitation and of plagiarism. They sit on their grandfather chairs and for ever dominate our creative agonies with their marble frowns; 'Take care, children. Mind the motors. Don't go too quick. Wrap yourselves up well. Mind the draughts. Be careful of the lightening'. 'Forward! HURRAH for motors! HURRAH for speed! HURRAH for draughts! HURRAH for lightening!

WE WANT:

1.To have an English Art that is strong, virile and anti-sentimental.

2. That English artists strengthen their Art by a recuperative optimism, a fearless desire of adventure, a heroic instinct of discovery, a worship of strength and a physical and moral courage, all sturdy virtues of the English race.

3. Sport to be considered an essential element in Art.

4. To create a powerful advance guard, which alone can save English Art, now threatened by the traditional conservatism of Academics and the habitual indifference of the public. This will be an exciting stimulant, a violent incentive for creative genius, a constant inducement to keep alive the fires of invention and of Art, so as to obviate the monotonous labour and expense of perpetual raking out a re-lighting of the furnace.

5. A rich and powerful country like England ought without question to support, defend and glorify its advance guard of artists, no matter how advanced or how extreme, if it intends to deliver its Art from inevitable death.

F.T. MARINETTI
C.R.W. NEVINSON.

This is the reproduction of the manifesto from *Paint and Prejudice*, which leaves out the entire sixth clause:

6. So we call upon the English public to support, defend, and glorify the genius of the great Futurist painters or pioneers and advance forces of Vital English Art – ATKINSON, BOMBERG, EPSTEIN, ETCHELLS, HAMILTON, NEVINSON, ROBERTS, WADSWORTH, WYNDHAM LEWIS.

Also, the original document was signed:

F.T. Marinetti – Italian Futurist Movement (Milan)
C.R.W. Nevinson – Art Rebel Centre (London)

This was too much for Lewis who was not keen on following anyone as had been seen following his secession from Roger Fry's Omega Workshop. Better to go it alone, he believed, than to play second fiddle to some European movement which seemed to be championed in London by an Englishman six years his junior. Who were they, after all, to diagnose English art as being a sick patient, and who were they to provide the antidote of revolution, hygiene and purity? Even if these named, but un-consulted, artists, had sympathy for the list of complaints (which they had), they could not stomach the fact that the new renaissance was to be led by the self-appointed authors of the manifesto. Naturally,

they stood against the worship of tradition, effeminacy, decorativeness, sentimentality, snobs, the New English Art Club, the King, sham revolutionaries, indifference, the 'right of the ignorant to discuss ... Art', passéist filth and the 'mania for immortality'. And of course they stood for an 'English Art which would be strong, virile and anti-sentimental', in the current atmosphere of optimism, heroism, creativity, excitement, genius, courage, and pioneering spirit. But the audacity of the proclamation itself had backfired as it had not offended or alienated the passéists for whom it had been intended, rather the other progressive artists with whom there should have been an alliance. It was not long, of course, until the named artists counter-parried with a letter to *News Weekly* which stated:

Dear Sir,

To read or hear the praises of oneself or one's friends is always pleasant. There are forms of praise, however, which are so compounded with innuendo as to be most embarrassing. One may find oneself, for instance, so praised as to make it appear that one's opinions coincide with those of the person who praises, in which case one finds oneself in the difficult position of disclaiming the laudation or of even slightly resenting it.

There are certain artists in England who do not belong to the Royal Academy nor to any of the passeist groups, and who do not on that account agree with the Futurism of Signor Marinetti. An assumption of such agreement either by Signor or by his followers is an impertinence. We, the undersigned, whose ideals were mentioned or implied, or who might, by the opinions of others, be implicated, beg to dissociate ourselves from the 'Futurist' manifesto which appeared in the pages of the *Observer* of Sunday, June 1.

Signed

Richard Aldington, Lawrence Aldington, David Bomberg, Gaudier-Brzeska, Frederick Etchells, Cuthbert Hamilton, Ezra Pound, William Roberts, Edward Wadsworth, Wyndham Lewis.[33]

By mentioning Richard, not by name, but as a 'follower', an intentional insult had been cast in his direction making the split progressively more inevitable. G.K. Chesterton advised against a nonchalant dismissal or an early proclamation of victory on the part of those who objected when he wrote 'But there is no light touch about the English Futurists, and one must deal with Mr C.R.W. Nevinson as with a professor.'[34] Later, the same writer obviously felt that the threat had passed when he wrote

'But Mr Nevinson and the Futurists . . . rush after the car of progress like poor baby-laden charwomen after a motor bus'.[35] Trying to pour oil on troubled water Richard wrote to *New Weekly* to clarify the situation and to fix the damage that he had unwittingly caused, outlining both his mistake and the innocent nature of it. Indeed, he claimed, it had been a simple misunderstanding as he had used the R.A.C. address in the same way that any gentleman would use the address of the club to which he belonged. The letter was neither angry nor offensive, rather an attempt to put the record straight, but it went unanswered. Instead, Lewis and his colleagues took the opportunity to distance themselves from Futurism definitively by establishing the Vorticist group, and re-claiming the origins of the ideology saying 'Futurism is largely the product of Anglo-Saxon civilization,'[36] reminding everyone that modern life was the invention of the English and that Marinetti was merely an outdated plagiarist, as were, by extension, the Futurists. He went on:

> you wops insist too much on the machine. You are always on about these driving belts, you are always exploding about internal combustion. We've had machines here in England for donkey's years. They're no novelty to us.[37]

Instead, Lewis wanted to move away from romanticising the modern era (a form of immaturity in his opinion) to concentrate more on the solidity, rigidity and geometric interpretation, made possible using a classical control over the phenomenon of modernity. In so doing, art, he felt, should imply a reverence to, but not a novel fascination with, the modern industrial era. Later he proclaimed Marinetti 'Man of the Week', and in so doing suggested that he would be gone and forgotten again soon. Anyway, it made sense to put some distance between the claims of high art and the label 'Futurist', which was rapidly becoming synonymous with anything new or shocking, principally among the rich and the aristocratic. Nothing could undermine more the basic point of the Futurist revolution than to have won widespread acceptance by the establishment that it had set out to destroy. Rapidly becoming a 'fad' it was now being used to describe men's clothing, pyjamas, and even novel culinary dishes, which might include 'tomatoes with brandy, Cod liver oil soup, Herrings mashed with raspberry jam & fricasse of lamb with marzipan balls. . . .'.[38]

And so the rebel generation split and with it went the security and comfort that Richard had briefly enjoyed in a group of like-minded individuals. Gone too was the collective identity, the excitement of the Rebel Art Centre and any further involvement with the publication

project to which he had just given the name 'Blast'. Interestingly, Douglas Goldring had sensed friction earlier in relation to this and wider projects, which he feared would lead to an imminent break when he wrote of a meeting at Lewis's studio where he and Ezra Pound presided. 'We solemnly compiled lists of persons who should be blasted and others who should be blessed. . . . The proceedings terminated with a quarrel between Lewis and C.R.W. Nevinson, I fancy on the subject of Futurism.'[39] But this had been mere jousting. Now the departure of Lewis from Richard's life and career was permanent, and he, like Gertler before him, was a friend that Richard could ill afford to lose. Worse was yet to come though with the mutiny which followed at the Doré Galleries, and this, if any proof was needed, demonstrated that the rift was not simply an ideological one, but deeply personal too. Charles Lewis Hind remembered that it had all started well enough:

> One evening I strolled into the Doré Galleries, in Bond Street, because a meeting of art extremists had been announced, and because I like wild words. . . . Richard was on his legs, talking to beat the band, slashing out, but sanely . . . and there was papa in the chair, smiling.[40]

Unperturbed, Richard, stepping out from Marinetti's shadow, delivered a lecture on the disgrace of immortality in art; of how the United States viewed England as 'a little old woman with a past' and identified a list of enemies of progressive art.[41] This was common enough and Henry even reiterated the basic idea, writing elsewhere:

> No one could live with a singer incessantly and constantly singing in a room. So it is impossible to live with a picture. This applies to all pictures past, present and future. Why is it that no-one would take the *Mona Lisa* as a gift? . . . Nothing can be done twice. That is why my son is right in saying that only bad work goes on forever.[42]

But Richard's attack did not end there and soon he was on the rampage against the 'backwoods of Chelsea', the 'barbarians of the West End' and those who paint in the style of Blake, Constable and Turner. Having read the Futurist Manifesto in its entirety he sat down and Marinetti stepped up to attack the rich for not buying Futurist pictures and to give another of his typically high-energy performances. Henry then suggested a further element of discord here when he wrote 'Then all to the Doré Gallery where Rich read good papers on Futurist painting: very strong style & thought: too quickly given. Marinetti then spoke: superb: partly in answer to Wyndham Lewis and others who denounced

Poster for the Art of Noises
at the London Coliseum, *1914*

LONDON COLISEUM

MONDAY, JUNE 15th, 1914
And During the Week

IMPORTANT ENGAGEMENT OF

MARINETTI

THE FUTURIST LEADER
who will speak on the Art of Noises

Performance of the Two Noise Spirals
Composed and Conducted by

LUIGI RUSSOLO

Inventor of the Art of Noises

1. The Awakening of a Great City
2. A Meeting of Motor Cars & Aeroplanes

Orchestra of 23 Noise Tuners

Buzzers	Whistlers	Rattlers
Exploders	Murmurers	Cracklers
Thunderers	Gurglers	Roarers

These new Electric Instruments have been Invented & Constructed by

LUIGI RUSSOLO & UGO PIATTI

the new manifesto.'[43] A group led by Lewis, supported by the artists whose names had been used in the manifesto, and with Hulme and Gaudier-Brzeska in tow, began to heckle the speakers and let off fireworks. Lewis recorded in his own autobiography 'I assembled in Greek Street a determined band of miscellaneous anti-Futurists. There were about ten of us.'[44] From there they moved to the galleries and got to work bringing down their new enemy. Richard particularly recalled the interruptions of Gaudier-Brzeska, not least when Richard got the new group name wrong and referred to them as 'Vorti-kists'. Jacob Epstein also added to the tirade of abuse before finally violence erupted, chairs got overturned, the fire brigade and the constabulary were called as the violence spilled out onto New Bond Street. There Marinetti went for Gaudier-Brzeska while Richard attacked Ezra Pound in retaliation for having been called a 'negroid jew'.[45] Art had certainly become newsworthy – Marinetti's most cherished success – even if it seemed to have turned to attack itself. As the young artists dusted themselves off they must now have realised that the avant-garde in Britain was openly and fatally split. To the press, Richard was now 'the eminent English Futurist'[46] – the artist who could provoke public and critical responses from the bland and dismissive, to the furious. At any rate the national (and even the international) press loved it, calling the weekly sparring 'volcanic and at any rate, temporarily exciting'.[47] None of this deterred Richard who, as an out-and-out Futurist, and now England's only one, went to, though did not participate in, Marinetti's first performance of Futurist music at the Coliseum. Here the *Grand Futurist Concert of Noises*, including *Awakening a Great City* and *A Meeting of Motor Cars and Aeroplanes*, came from twenty three of the newly invented *intonarumori* that emitted an awful din. The audience should have had some idea that they were going to get something unusual when they had read the poster advertising an event promising

> The Performance of Two Noise Spirals . . . composed and con-
> ducted by Luigi Russolo [with]: Buzzers; Exploders; Thunderers;
> Whistlers; Murmerers; Gurglers; Rattlers; Cracklers and Roarers
> . . . Electrical Instruments invented and constructed by Luigi
> Russolo and Ugo Piatti.[48]

Richard referred to the evening as 'one of the funniest shows ever put on in London',[49] especially when the audience turned nasty. He described the evening in *Paint and Prejudice:*

> Marinetti swaggered onto the vast stage looking about the size of
> a housefly and bowed. As he spoke no English there was no time
> wasted with explanations or in the preparation of his audience.
> Had they understood Italian, I do believe Marinetti could have
> magnetised them as he did everybody else. There was nothing for
> it, however, but to call upon his ten noise-tuners to play, so they
> turned handles like those of a hurdy-gurdy. It must have sounded
> magnificent to him for he beamed, but a little way back in the
> audience, all one could hear was the faintest of buzzes. At first
> the audience did not understand that this was the performance
> offered them in return for their hard-earned cash, but when they
> did there was one vast, deep and long sustained 'Boo!'[50]

Marinetti, on the other hand, was ecstatic and in a letter to Severini pronounced the entire project 'trionfali',[51] going on to perform the work eleven more times to London audiences. Later, an Elgar gramophone record was played over the top of the Futurist racket, promoting the audience response to stony silence, and leading *The Times* to report that 'the audience seem to be of the opinion that Futurist music had better be kept for the Future. At all events, they show an earnest desire not to have it at present.'[52] Henry was there too and wrote that the whole event was 'queer and full of interest'.[53] Five months later we wrote 'At the Coliseum in London we have lately seen and heard what the Futurist can do with sound. The first and most beautiful composition or combination aroused the emotion we feel at the "Awakening of a great city".'[54] The experiment, he argued, was both as legitimate and as adventurous as anything Wagner, or more recently, Stravinsky, had attempted in his lifetime. Fuelled by this, Marinetti carried on from London to Cambridge University, without Richard this time, and this led to an 'incident' on Magdalene Bridge, after which he headed for Milan. Futurism, he felt, had rooted itself sufficiently deeply in England under the command of a competent and loyal Englishman, and so his attention turned elsewhere. That was Marinetti.

But the zenith of Richard's peace-time Futurist experiment was yet to come with his painting *The Arrival*. Certainly in subject matter – the arrival in port of a transatlantic steamer – would have met the criteria set forward by the Futurists; while his technique of fragmenting the picture plain into a simultaneity of time and movement would also have been deemed sufficiently modern in technique, creating a kaleidoscopic abstraction of a recognisable central theme. He had clearly tried to capture the entirety of events surrounding the arrival of the ship into port and had attempted to hurl the spectator to the centre of his composition. *The Star* jokingly observed that 'It resembles a Channel steamer after a violent collision with the pier',[55] while others didn't pull their punches and called the work 'hideous suggestions of all that is most objectionable in modern life. It reminds us of everything in modern life that most of us are anxious to forget.'[56]

Now the row between Richard and Lewis continued to intensify and before long the former, tired of explaining himself, and convinced of his inability to rectify the situation, put pen to paper again saying 'I regret having been the cause of so much trouble & expense to the "Rebel" Art Centre on account of my "irresponsibility" regarding the Manifesto that Marinetti & myself drew up.' He emphasised one more time how he had not meant to imply that the named artists were Futurists, or even endorsed the movement, but had named them only as 'advanced forces of English Art' – a compliment! He then asked, as a matter of interest, what Pound, Aldington and Brzeska had to do with it as their names had not even appeared on his list, and as they were as unrepresentative of English art as 'the Pope, the King the Tsar, the Kaiser, [and] Rosevelt' [sic], being foreigners. The attack became more personal as the letter progressed, to the point that Richard diagnosed the problems as 'entirely and absolutely the Delusions of your highly suspicious NEURESTHENIC mind', and warned Lewis that Marinetti 'does not seem to care in the slightest of your attitude'.[57] Besides, why was it so offensive, he asked, to praise his colleagues, even if it had been an error to use the address of the Rebel Art Centre, which he reiterated was 'through thoughtlessness, not evil intent as <u>you</u> naturally suppose'. Richard got to the bottom of the problem, the real problem in his opinion, towards the end of the same letter, where he concluded that jealousy had to be the problem:

> Also, neither you nor the others have in the past objected to your names being used by Marinetti, but when my name appears also then you adopt your narrow minded and pompous tone. <u>There lies the cause of the trouble.</u>[58]

Lewis recalled in his memoirs that Richard had 'declared war on us, and specifically on me',[59] but the net result was that, in so doing, he

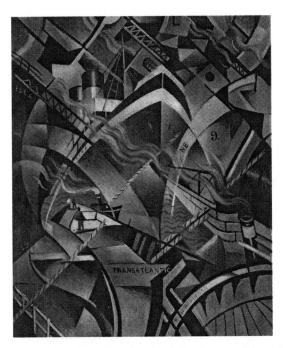

C.R.W. Nevinson, The Arrival, *1914*

had signed himself out of the company that had been his greatest hope and stimulation, especially since Gertler and Carrington had walked out of his life the previous year. Once again Richard had become 'the outsider' and the victim, as could be seen when he wrote to Lewis 'in your desire to abuse me you have accused me of being a very clever knave & a very great fool'. He finished the letter, and probably his friendship with the parting shot 'I am utterly indifferent whether they (R.A.C.) endorse my opinions or not' then scrawled in the margin 'Beyond pointing out two or three inaccuracies I shall ignore your letter.'[60] But he didn't let it drop and instead shipped the argument out into the public arena again, via *The Observer*, and then again privately in a letter written on board the P. & O.S.N. Co. ship *S.S. Maria* in the Bay of Biscay, in which he pointed out to Lewis:

> As a Futurist and not a Vorticist I have no doubt I shall change and evolve what ideas I possess. I know this to be a great source of trouble to you as I notice a continuous complaint in your articles on 'automobilism' that the Futurists are not doing exactly what they were doing two years ago.[61]

Whether he had desired it or not Richard had unwittingly become the national defender of Futurism, and now it had isolated him from his peers. He had been happy in his association with the movement, even to promote it, but now there were those who could see that he was 'the only orthodox Futurists left in England'; and they speculated accordingly 'When Signor Marinetti leaves us, Mr Nevinson will have the distinction of Abdiel – "Faithful among the faithless, only he".'[62] This could not happen a moment too soon as far as the *English Review* was concerned, saying 'the hideous Futurist craze for sensationalism is

happily passing'.[63] Another saw the curtain coming down quite naturally, and logically, as Futurism was 'now a thing of the past, exploded by its own silly gun powder train of progressive theory'.[64] The *Illustrated London News*, hardly able to contain its indifference, shrugged 'Let them paint whatever they do not dislike, and welcome; but one still wonders against whom they desire defence; for as far as one can see, they have no enemies.'[65] Richard must have worried that, while he had achieved heights of notoriety and celebrity unimagined in years gone by, and had unquestionably loved the ride, he was now on a sinking ship.

As it happened, war came, and when it did, according to *Paint and Prejudice*, he was painting in Marseilles and at Aix, home of Cézanne and Zola, with his mother. When the news of the outbreak came, they calmly turned for home in the midst of panic and confusion, and before embarking for England, dropped in at Sagot's to purchase a Gauguin, which was never delivered. As Russia and France mobilised, Richard and Margaret headed for London to await the news as to which stance Britain would take and so, what their destinies might be. Richard knew that he was the only Englishman who had subscribed, by association, to the Futurist ethos that proclaimed 'We wish to glorify War – the only health giver of the world', which had soon developed into a passion for 'militarism, patriotism, the destructive arm of the Anarchist, the beautiful Ideas that kill'.[66] In private, therefore, he was having deep concerns and this could be felt in his father's journal which read 'Rich much disturbed about the war + the Futurist support of its horror. Declares he will abandon Futurism + and will call his new movement Mintalitist.'[67] Additionally, he would have been painfully aware of a wider debate that, in its hostility, even suggested that war might have a positive impact on art and culture in England, by getting rid of the likes of him – permanently. Samuel Hynes, in identifying the 'condition of England' as industrialization, unionism, feminism, modernism, and so on, observed the common perception that war on Germany was a war on these unwelcome domestic conditions too. John Ruskin had felt something similar half a century before when he had written: 'There is no great art possible to a nation but that which is based on battle',[68] and this had been updated by the Slade Professor of Art at Oxford University in August 1914 to read 'War and Art are not always enemies, and Peace is not always Art's best friend'.[69] The decadence of peace would be swept away and national/cultural benefits would be apparent in the form of a positive re-emergence of decency and logic, with the extinction of 'degenerates' *en route*. The trouble was, Richard appreciated, he was one of those 'degenerates' earmarked for extinction. J.D. Symon warned that without this purge, 'Future historians will say that the age went

dancing to its doom.'[70] In other reviews Richard would have seen his efforts described as 'fools and their folly' whose theories and practices had been 'as destructive as they were ridiculous'.[71] The champion of such 'fools' and 'folly' knew his fledgling career could be ruined (or secured) depending on what he did next. St John Ervine spoke for many, and directly to Richard, when he declared:

> The Vorticists and the Imagists and the Futurists and the rest of the rabble of literary and artistic lunatics provided slender entertainment for empty days; but our minds are empty no longer. . . .[72]

Other writers rejoiced in the inevitable extinction of the pre-war avant-garde:

> All those pretty little fancies, only to be explained by algebraic symbols, Cubism, Futurism, Vorticism, will receive their death blow.[73]

Albert Rutherston, writing to Dora Carrington concluded that, though the dose was a bit too generous, the medicine was, on the whole 'good for us & Europe later. At least it will do away with "Blast" & such like idiocies. In the face of such mighty happenings there will be no room for the artificial, the unreal & the trivial.'[74] Futurism, and therefore Richard, found only a glimmer of support in publications like the *Athenaeum* which optimistically acknowledged, 'In an age of brutal strife, the art, if any, will be brutal also, the extremes of Futurism being alone suitable to express its spirit.'[75] The feeling was that in a soulless conflict, only the most a-cultural, de-humanised and resilient medium would suffice. *Colour* agreed that there was a niche, albeit a narrow one, for Richard:

> It is a splendid opportunity. The explosive style of the Futurists is eminently suited to the character of modern warfare, and battle subjects are the very things that would appeal to their anarchic views of life. The Futurists should give us the true expression of War in Art.[76]

Writing his autobiography over twenty years later Richard mused on the consequences of his Futurist association and wrote 'It is a black thought for me to look back and see that I was associated with Italian Futurism, which ended in Fascism.' Fallen into the wrong hands, he bemoaned 'What a fate for an intellectual idea!' But Hamilton summed up boldly concentrating on the positive bequest Marinetti (and Richard) had made:

Arriving in London in 1912, found the most industrially and scientifically advanced nation in the world, the country of H.G. Wells, overrun with some of its most backward and house trained poets and painters. Two years later they were breaking up his lectures on a British Futurist programme they claimed more futuristic than the Futurists.[77]

Richard also saw the value of his apprenticeship and stated that 'some of us were already preparing our technique to express the horror, the cruelty, and the violence which were to be our destiny'.[78] But when Britain went to war would *he* go and take with him an art which he believed ready, and appropriate, for the challenge, having undergone an apprenticeship in a mechanised chaos which had catalysed art, and sensitised artists, to the modern age? Could he share Marinetti's enthusiasm as he ranted about 'the dreadful symphonies of the shrapnels and the mad sculptures that our inspired artillery moulds among the masses of the enemy'?[79] Could an artist, traditionally outspoken, unruly and ill disciplined, don a uniform and throw aside his independence, individualism and internationalism in the name of King and Country? He simply could not predict what would happen if he didn't.

5

The Western Front I,
Nevinson's War (1914-1915)

While Margaret and Richard were struggling to get back from mainland Europe to England, Henry was heading in the opposite direction, managing to get to Germany and also the Front before the war was two weeks old. When he got back to Downside Crescent a few weeks later he saw Richard reject what must have been a tempting offer from an agent to lecture about Futurism in the United States of America, while still showing no sign of 'going out' to Belgium. The war was still a voluntary one in the United Kingdom with the choice resting entirely with the individual as to whether or not they ought to go to the rescue of the underdog and to fight the barbarous 'Hun'. The social pressures were, however, mounting in London (and probably in the home too), and so later the same month a decision was reached, with Henry and Richard both making their association with the Friends' Ambulance Unit and leaving for Flanders in mid-November. In later reminiscences Richard emphasised his own calm and level-headedness when he said 'I was pursued by the urge to do something, to be "in" the war; and although I succeeded in the end and was "in" it, I was never "of" it.'[1] Even in 1937 he would make no particular nationalistic claim saying that 'I regarded myself as having no patriotism' though 'I preferred the English'.[2] Instead he reiterated his own strength of character and independence writing 'Brass bands, union jacks, and even "Kitchener wants YOU" had no power to move me',[3] then added how he had been 'Eager to do my bit for Old England, Home and Beauty.'[4] Physical weakness in the form of rheumatic fever, however, had ensured that he could not join the ranks and so he had turned, logically enough, to the Friends Ambulance Unit. Some might have felt that, for a Futurist, going to war in the service of a Quaker's unit of an ambulance corps (the same organisation which, between 4 August and New Years Eve, 1914, organised over 300 peace meetings), was hardly an act of a committed rebel. Others would have appreciated that at least he was doing something while those around him appeared to be doing nothing. Also, acutely aware of the charged climate, not least in the arts, Richard made time

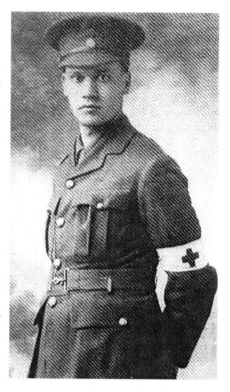

Photographic Portrait of
C.R.W. Nevinson, 1914

to write to *The Observer* before
he left, outlining the opportunity
that the war presented, with a jibe
at the artists who had so recently
become his enemies, and the critics
who were dragging their feet:

> Sir
> The love of art and architec-
> ture displayed by the English
> journalists and the nation
> in general during this war is
> most encouraging to British
> artists. In time of peace
> this same public has shown
> a contempt and neglect of
> art (especially architecture)
> as cynical as the monstrous
> vandalism of the Germans.[5]

The vandalism of the Germans was a reference to the shelling of
Rheims Cathedral in the early stages of the war (22 September 1914),
which led to outrage in intellectual and artistic circles throughout Europe.
In the same well-timed letter therefore Richard went on to proclaim that
London should be made the new Mecca of art, eclipsing the previously
fashionable centres of Munich and Berlin. Through a short letter like this
he could also side-step accusationsthat modern painters are 'simply idlers,
hiding from one reality in the pretence of another. . . . Once more I express
the hope that they may all perish in the war.'[6] Richard was not going
to leave un-noticed, as the 'artist-turned-warrior' shipped out to defend
not only his country, but also his culture; protecting it from the 'lowest
and most inhuman conception of civilisation'.[7] The *dilattanti*, the anti-
establishment agitator and debauched icon of the pre-war era, was *en route*
to the conflict and was quick to remind the public 'that the modern artist
is not the effeminate long-haired creature of the eighties', but was now a
national symbol of the intact and progressive condition of contemporary
English culture – unthreatened by the *Kultur* of the Central Powers. Even
the boat crossing was eventful as the vessel on which Henry and he were
travelling was called to the rescue of the rapidly sinking *Hermes* which
had just been torpedoed in the Channel. And when they arrived on the

European mainland the drama intensified in the aftermath of the Battles of Mons, Marne and Aisne, and in the midst of the commencement of activities at Ypres, where they set up camp. Richard recorded the difference that a mere 50 or 60 miles made:

> It was a sudden transition from peaceful England, and I thought then that the people at home could never be expected to realize what war was. A few hours from London . . . just an hour or two away, and here we were working in a shed that was nicknamed 'The Shambles'.[8]

The collapse of the medical system near the front line had left wounded men in railway sidings for weeks while the hospital trains had been re-commissioned to bring reinforcements to the Front. 'The Shambles', therefore, was the nickname given to these ghastly railway sheds beside the quay. Henry, much to the annoyance of the French surgeons, spoke to the German wounded in their own language, while Richard placated the French in theirs. Richard's autobiography described very clearly the conditions and atmosphere in which subsequent paintings like *La Patrie* and *The Doctor* were rooted:

> By the time I had been at 'The Shambles' a week my former life seemed to be years away. When a month had passed I felt I had been born into a nightmare. I had seen sights so revolting that man seldom conceives them in his mind, and there was no shrinking even among the more sensitive of us. We could only help, and ignore shrieks, pus, gangrene and the disembowelled.[9]

The Official History of the Friends' Ambulance Unit backs up this nightmare scenario and talks of how, at Dunkirk at the time of their arrival, 'there were not less than 3,000 wounded men in the goods sheds at the station with only half a dozen men to attend them'.[10] It went on:

> In the half-darkness of these bare sheds lay hundreds upon hundreds of wounded men stretched on the straw covered floor – Frenchmen, Belgians, here and there a few British and Germans. They had been there, many of them, for three full days and nights, practically untended, mostly even un-fed, the living, the dying, and the dead, side by side. . . . It required a great effort of will to face the sight and stench of the countless gangrenous limbs that lay there helpless among the foul straw. None who were there can ever forget the horror and the hopelessness of that sight.[11]

In an atmosphere of semi-organised chaos, one learned as one went, to the point that Henry wrote 'Found Rich had been dressing the wounded

in the sheds with some success. But his driving of the motor ambulance was very poor.'[12] Later Richard wrote to his father telling him about how he knocked someone over in the unwieldy vehicle.[13] The cafés of Paris and the classrooms of the Slade could have done nothing to prepare him, or his art, for this, and yet Richard prided himself in his ability to adapt and to contribute to the war effort, going so far as to have his photographic portrait taken in front of the ambulance, which was then sent to Marinetti. In fact, Richard seemed to settle in fairly well and when his father returned towards the end of December he could observe that 'I joined Rich doing orderly in a ward of 10 or 12 wounded, some very terrible. He seems to be a great success as orderly, interpreter . . . but has been put off driving thro' rheumatism.'[14] In charge of the nursing staff at the Malo-les-Bains hospital now, his father left, optimistically scribbling 'Said goodbye to Rich who is quite content with his work there and is much liked by the wounded for his sympathies.'[15] Later in life Richard would get a lot of mileage out of his war service in Belgium and accordingly *Paint and Prejudice* is full of his adventures on the road from Dunkirk to Woesten to Furness to Ypres. Even at the time, however, he wrote to Kathleen, the soon-to-be Mrs Nevinson, telling her of a shell that had passed directly through the canvas rear of his ambulance as he had been driving and implied that had the sides of the ambulance been solid it would have exploded. He wrote again saying 'A damned shrapnel shells [sic] exploded under the back wheel of my "bus" & smashed it',[16] and then to his father who received 'a long letter from Rich describing a drive to Boulogne and a night at Woesten when a shell smashed his ambulance'.[17] Other tales which emerged centred around the cinema-like drama when, during a zeppelin raid, and in the midst of burning buildings, he got the wheels of the ambulance stuck in the railway points as a train rumbled out of the night towards him, the ambulance and his injured men – only to be stopped a hair's breadth from disaster. On one other occasion he described how it looked as though there might be an attack on the hospital itself, and how staff were all turned out to fight, the chef even armed with a long knife, though he protested 'Could we not have claimed immunity because we were Red Cross men?'[18] Richard recalled that he would also joke with the motley group of French colonial soldiers, who had probably lived a more dangerous life before the war than they were doing now, and said that they talked knowledgably about Bonnard, and contemptuously about English food. Many, he claimed, would stay in touch long after the war, and their letters were his treasures. But this, quite understandably, was as far as Richard wanted to go towards the firing line and Henry wrote that he was 'very apprehensive about going to the front'.[19] When it was

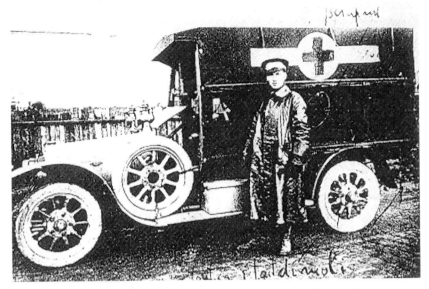

Photographic Portrait of C.R.W. Nevinson in front of his ambulance on the Western Front, 1914

time to go home, Richard said that he was haunted by the voices of those in agony and those dying; and especially with an image of a dead child lying in the street after an air-raid, but concluded 'A man is all the sadder for seeing war; but I grew better and painted.'[20]

By the middle of January 1915 Richard was officially discharged for 'Business Reasons',[21] though his autobiography recorded 'I crocked up and was sent home'.[22] His father's journals make no mention of excessive illness, neither does a letter from his mother to a friend when she commented that he came home looking and feeling very well.[23] Nonetheless, the question now was how to convert his experiences into paint, and how to pitch his work at an audience that knew little or nothing of where he had been and what he had just seen. As a Futurist, and as an artist with a reputation for dynamic and self-confident pronouncements, he began with a strong press statement, which declared:

> All artists should go to the front to strengthen their art by a worship of physical and moral courage and a fearless desire of adventure, risk and daring and free themselves from the canker of professors, archaeologists, cicerones, antiquaries and beauty worshippers.[24]

Even after his harrowing experiences he wished to re-assure the press and public alike that he had come home stronger and better than ever, invigorated by the environment and in no way doubting his pre-war

allegiances. In a lengthy article entitled 'Painter of Smells at the Front: A Futurist's View of the War' in the *Daily Express*, he carefully created some distance for himself, away from the mainstream of Futurism saying 'Unlike my Italian friends, I do not glory in war for its own sake, nor can I accept their doctrine that war is the only health-giver.' He was determined, however, not to be seen to be performing a u-turn and so returned to the more familiar rhetoric, describing the war as a 'violent incentive to Futurism' and saying that 'there is no beauty except in strife, no masterpiece without aggressiveness'. Continuity was crucial, in fact, and he used the press to publicly declare 'Our Futurist technique is the only possible medium to express the crudeness, violence and brutality of the emotions seen and felt on the present battlefields of Europe.'[25] Likewise, a suggestion that he had returned home due to shell shock was quickly rebutted by the artist in a return letter in which he declared 'Beyond a severe attack of rheumatism, my health is better than before the war, and I am absolutely in no way suffering from any form of nerve trouble.'[26] The last thing he wanted was to come home, and be seen as the impetuous youth who had been taught a man's lesson. To rule out any ambiguity concerning this, and his war service in general, he also got a letter off to the *Manchester Guardian* confirming the dangers that Red Cross members were faced with,[27] and in the same letter attacked their stay-at-home critic who seemed so forthright with his judgements. When Arthur Clutton-Brock wrote an article in *The Times* entitled 'Sowing of Wild oats in Art' (which implied that young artists were still carrying on with their pre-war antics despite the seriousness of the situation unfolding in Europe) Richard raged:

> I have spent the last three months at the front in France & Belgium amongst wounds, Blood, Stench, Typhoid, agony and death & as a member of the Friday Club I resent your critic writing 'about the sowing of wild oats and managing to amuse myself with Art in spite of the war'. He ought to discover that I take Art as seriously as he take [sic] criticism flippantly.[28]

When the *Daily Graphic* mistakenly reported that Richard had 'paid a visit' to the Front, they too were soon put right on the subject, and by way of recompense printed a photograph of him, in full uniform, explaining a Futurist bust to a wounded patient.[29] Now, it was clear, the artist, soldier, Futurist, patriot and carer, had all been neatly rolled into one charismatic figure, whom the press would have trouble resisting. Others, who knew him better (though cared for him less), were not so keen on bumping into the uniformed artist, as was seen when Mark Gertler wrote to Dora Carrington complaining 'He had come back from the Front! Told me in five minutes *all* about it, and you can imagine how ghastly it sounded in "Nevinsonian"

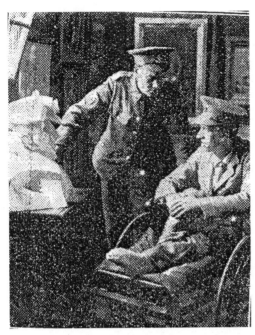

C.R.W. Nevinson explaining the sculpted bust to a wounded patient

language....'[30] Lewis was quick to get in a jibe too, writing in *Blast 2*:

Marinetti's one and only (but very fervent and literal) disciple in this country, has seemingly not thought out, or carried to their logical conclusion, all his master's precepts. For I hear that, de retour du Front, this disciple's first action has been to write to the compact Milanese volcano that he no longer shares, that he REPUDIATES, all his (Marinetti's) utterances on the subject of war, to which he formerly subscribed. Marinetti's solitary English disciple has discovered that War is not Magnifique, or that Marinetti's Guerre is not La Guerre.[31]

But the critic of the *New Witness* was not going to allow that and stuck up for Richard against such attacks saying:

He is a disciple of Marinetti and Marinetti's Futurist painter friends, but he is the only one to have the courage to proclaim it. Most of Marinetti's other disciples in England, whilst helping themselves liberally to his ideas, have not only forsworn their master but publicly abused him.[32]

On a practical level, the artist now faced other difficulties. How would he balance his artistic output between what he had experienced and what, he knew, the public wanted to see? What technique would he use to paint this ghastly subject – the modernist vocabulary of the pre-war days (now despised) or the traditional Royal Academy style of painting that he had openly loathed? How would he, as an international and intellectual artist, cater for the new needs of ultra-patriotism and xenophobia in London? How would he represent an environment denuded of the picturesque elements of all previous conflicts, where colourful uniforms had been replaced with khaki; the heroic charges and defences with the Armageddon caused

C.R.W. Nevinson,
My Arrival at Dunkirk, *c*
1915

by long range shelling; and sweeping military manoeuvres with trench warfare? The resultant vacuous picture space demanded an appropriate visual vocabulary to replace the now irrelevant high diction of the *style historique*, leading *The Times*, in an article entitled, 'The Passing of the Battle Painter', to declare that 'The trench is the enemy of military art. . .'.[33] Art, like war, would have to modernise, yet in a controlled and relevant manner, in what Fussell described as 'leaving, finally, the 19th century behind.'[34]

At the Exhibition of the Friday Club in February 1915, Richard cautiously revealed the first of his experiments on a war theme in the form of *Searchlights (First Searchlights at Charing Cross)*, which did not draw on his experiences at the Front at all, being a quasi-Futurist depiction of the London sky during a threatened air raid before his departure. Wyndham Lewis, perhaps surprisingly, complimented the originality and success of the work declaring 'Mr Nevinson's *Searchlights,* the best picture there, is perhaps too, the best he has painted.'[35] This seemed to suggest that Futurism might yet have a future and be able to traverse the bridge from peace to war, if guided by the right artist. And if this was the case, might the war then act as a vindication for this element of modernism as opposed to being any form of threat to it? Modernist art could, it seemed, co-exist comfortably with the modernity of modern warfare. Almost immediately after this, the Second London Group exhibition opened at the Goupil Gallery which included four more strong images by Richard: *My Arrival at Dunkirk* (a re-hash of *The Arrival*), *A Taube pursued by Commander Samson, Ypres after the Second Bombardment* and *Returning to the Trenches*. Though he was unable to attend the opening due to illness, plenty of others came prompting one paper to report 'One never saw so many folk assembled for

a private view before, except at the annual academies. Futurism, Cubism etc are evidently still popular.'[36] The spotlight for most reviews was firmly fixed on Richard's *Returning to the Trenches* and on Epstein's *The Rock Drill*, in an exhibition that had set out to prove that modernism was as well and defiant as ever it had been in the past. Of course there were detractors who moaned 'the Cubists and Futurists still live and do their worst', even if they had been to the front 'it does not seem to have done them any good'.[37] Others remarked in frustration that 'Nevinson and Wadsworth and Co. are weirder and wilder than ever, for war, it seems, hasn't toned down *all* the cranks'.[38] The *Daily Express* had much graver concerns and asked 'Will these pictures help the Germans?'[39]

But it was generally recognised that in *Returning to the Trenches* a very new image of modern war had been presented to an art public who, on the whole, endeavoured to like it. In Richard's scene individual soldiers were moulded together into one semi-abstract unit as humanity itself had been reduced to a mere facet of the military machine – stripped of sentiment as its own inertia carried it towards the murderous task ahead and indeed to its own destruction. So distant from the recruitment posters, where sanitized images of lines of immaculately dressed youth marched towards a better dawn for civilization, Richard's Frenchmen trudged heavily towards an enslavement within a new world order which appeared to advocate systematic murder as both patriotic and Christian. The critics loved it and said 'Mr Nevinson, the English disciple of this movement [Futurism], is a very oasis of intellectual clearness among a

C.R.W. Nevinson, Returning to the Trenches, *1915*

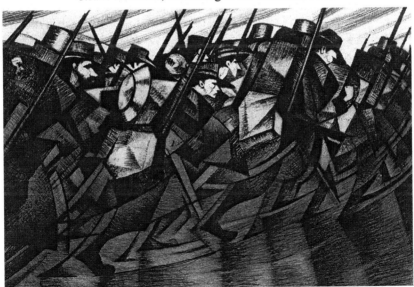

babel of artistic gibberish'.[40] Others were not so charitable of his vision and Richard recorded in his autobiography:

> Of course the Clive Bell group dismissed them as being 'merely melodramatic'. The *Times* was horrified, and said the pictures were not a bit like cricket, an interesting comment on England in 1915, when war was still considered a sport which received the support of the clerics because it brought out the finest forms of self sacrifice, Christian virtues, and all the other nonsense. . . . To me the soldier was going to be dominated by the machine. Nobody thinks otherwise today, but because I was the first man to express this feeling on canvas I was treated as though I had committed a crime.[41]

It was not just a case of how to paint, but also what to paint – and in this Richard scored another early victory by choosing aviation as a new theme for art, and in so doing created a new genre, the 'airscape'. The sky – previously the domain of the mythical Icarus (who demonstrated convincingly, if nothing else, that men were not meant to fly) – had only ever been observed from below, and never truly experienced, let alone depicted. As well as that, war in the air might actually be one of the last bastions of decency, Richard believed, where heroism, sportsmanship and chivalry could still be revered in preference to the cold blooded (and pictorially vacuous) mass murder on the ground. In short, Richard knew he had to get airborne and when he did the results were memorable. *A Taube Pursued by Commander Samson* was hailed by the critics as an absolute triumph, relating as it did, the adventures of Charles R. Samson, hero of Ypres, Egypt, Gallipoli, and the Red Sea. Richard's composition itself was as eye-catching as its subject matter, balanced precariously between a visually precise depiction, and an abstract representation of speed, force and motion, in an overall composition which stunned critics could describe only as 'cinematographic'. The critic P.G. Konody wrote 'It is not too much to say, that never before has flight been expressed in paint so convincingly, so clearly,'[42] while the *Sunday Times* conceded that some sort of *rapprochement* with the artist might yet be attainable:

> If all Futurists gave us such beauty of colour and conveyed movement with such imaginative power as Mr. Nevinson shows us in these aeroplanes rushing through space, we should have no quarrel with them.[43]

The *Evening Standard* went so far as to call it 'the best flying picture that has yet been done'.[44] But Richard knew that he needed to build on these early successes and so wrote a public letter from his studios entitled 'Dry

C.R.W. Nevinson, Taube Pursued by Commander Samson, *1915*

Rot in Art', which clarified what he believed, or perhaps more importantly, what he wanted to be seen to believe:

I insist it is impossible to get any inspiration from the antique, or to let us dominate it, because evolution and change in vital art are essential, and has no eternal truths. The beauties ... of yesterday are the ugliness and sentimentality of today. Above all, it is impossible for an artist at the present time to have the same emotions, sensibilities, or modes of expression as an Egyptian, and early Italian, or a Michel Angelo, surrounded as he is by steel construction, speed, machinery, and high explosives, for art must represent, and always has represented, the spirit of its age. . . .[45]

As the message was clear, his niche established, and sufficient distance placed between himself and those associations that could yet potentially harm him, it was therefore a little unusual that he agreed to take part in the Vorticist Exhibition of June, 1915, at the Doré Galleries. One way or another the exhibition made almost no direct reference to the war and the reviews were most conspicuous by their absence, suggesting that pre-war and non-war subjects, handled in the Vorticist manner, had run their course, exhausted the patience of the critics and exiled themselves to the realms of the peripheral, if not the irrelevant. The *Westminster Gazette* talked of 'artistic bankruptcy'[46] while the *Daily Graphic* captured

the mood of many declaring 'nobody cares twopence about the lot of them'.[47] Richard would have noted all of this with interest, especially as he observed, simultaneously, the equally unenthusiastic reception the theatrical and sentimental works of those much more conservative than himself were also receiving. Their traditional and romanticised form of battle painting was seen to serve neither art nor war, and so any form of utopian descriptive realism on the part of the un-uniformed, was deemed as un-authentic as the abstractions of the un-reformed and un-repentant. It might, he would have concluded, be better to go it alone.

In May 1915 Richard attempted to return to active service in the Friends' Ambulance Unit though this was far from a smooth procedure as they were reluctant to take back someone who had overstayed their leave as badly as he had done. [48] Henry recorded 'Difficulties about Rich's return to the Quakers',[49] and later talked of a different course of action through the Royal Army Medical Corps (RAMC). A few days after that, father accompanied son to Wandsworth and watched him being sworn in as an orderly, while simultaneously extracting an important assurance from the commanding officer that this son would not be sent to Gallipoli. Richard's alternative description of events in his autobiography ran like this:

> Soon I heard that the 3rd London General Hospital had made an appeal to the Chelsea Arts Club (of which I was not a member) for men of intelligence. With an impulsiveness, that afterwards made me ponder, I threw up everything and joined the army.[50]

In fact, in his autobiography he depicted himself as the enthusiastic volunteer who had had to trick his way into the army by enlarging on his experiences in Flanders and by keeping his rheumatism quiet. Of course life at the Wandsworth 3rd General Hospital was far from perfect and had its stressful and unpleasant moments, but at least it was safe. Henry's journals contain multiple entries at this time, reminiscent of those from the Uppingham period, that typically read 'Very bad account of his life at Wandsworth hospital from Rich who seems unutterably miserable among the men, nurses and officers.'[51] The work was grim too and before long he found himself undertaking a variety of ghastly tasks which included emptying bed pans, building roads, cooking, unloading hospital trains, helping in operating theatres and dealing with shell shock victims. With little time to paint or sketch, and with the demand for blind adherence to orders, Richard saw a whole new element to the war, away from the dynamism, excitement, noise and action that had characterised his last experience. In fact, he had landed himself in the worst of both worlds where he had to suffer the regimentation of the military, as a private,

'Kathleen Nevinson', Evening News, *26 April 1927*

whilst experiencing none of the benefits, artistically, of being near to the Front. Later he wrote that this had been 'the worst job I have ever tackled in my life',[52] and hypothesised that had he not been removed from it he could have ended up 'catching' the nervous and mental disorders of the men he was looking after. Among his fellow workers things didn't run smoothly either, and he remembered how he got his 'first real taste of the jealousy of artists and the nastiness of intellectuals'.[53] Perhaps the twenty five Chelsea artists serving at the hospital were not so much jealous as angry, having read of themselves, in the Futurist Manifesto, only months before, that they represented 'The old, grotesque idea of genius – drunken, filthy, ragged, outcast; drunkenness the synonym of Art, Chelsea the Montmartre of London.'[54] In 1928 Richard recollected again that 'a certain state of war existed at Wandsworth', and as this was too trying for his constitution, already sapped by his experiences in the field, he applied for leave.[55]

In late October 1915 leave was granted and so Richard and Kathleen decided, rather suddenly, to get married, catching family members

and friends off guard. Richard recalled in his autobiography that his father didn't come and that, even months later, he suspected that he knew nothing about the wedding.[56] The reality was rather different as, immediately on arrival back from his first trip to Gallipoli, and before the wedding, Henry invited 'Rich and Miss Knowlman to dinner',[57] then dined twice more with the couple before his return to the Dardanelles (where he received an almost fatal wound).[58] On one final occasion he wrote 'Dined at home to say goodbye to Richard before his sudden marriage next week to the sweet draper's daughter of Islington.'[59] It is hardly surprising that there was a hint of sarcasm in his tone as his exclusion had been virtually assured by the haste of his son and his fiancée. Nonetheless, Henry opened the doors of Downside Crescent for the newly married couple to live in, and even wrote from Messina suggesting that Richard re-locate to the hospital in Palermo – but nothing came of that.[60] For Richard himself marriage came at a time when he was, once again, involved with a model at the Slade called Leila, who had got pregnant during the summer months of 1915, when he had been on leave from the RAMC. As Albert Rothenstein, Alvaro Guevara and Richard had all been involved with her it was now quite unsure who the father might be. Leila disappeared from their lives shortly after the birth, which Richard himself booked at the Royal Free Hospital.[61] His sister Philippa had even more serious concerns as her son, Toby, had just been born with meningitis. Far away from such worries, and in the two days that remained after the honeymoon in Ramsgate, two of the strongest war pieces that Richard was to paint, *La Mitrailleuse* and *Flooded Trench on the Yser*, were executed. Perhaps this 'finding of form', his recent marriage, the hostility of those around him and his declining health, led him to seek a formal discharge from the army on a permanent basis. He had found his rhythm, his subject and his metier and now he needed to paint – not fritter further valuable time away with meaningless jobs. It was granted and the hospital *Gazette* saw him off with:

> It was with very real regret that we recently bade farewell to Pte. C.R.W. Nevinson, who, after a severe illness, was invalided out of the service. We hope that Mr. Nevinson will find the time to send us some other examples of his remarkable art, and thus keep in touch with our community through the *Gazette*.

On a light-hearted note, and signing off the whole story, Richard related the conversation he had with a colleague who had commented to him, on hearing his complaints, that the only thing the army couldn't do with you was 'to put you in the family way'.[62]

In November 1915, the third exhibition of the London Group at the

Goupil Galleries opened and, conspicuous by their absence were Lewis, Bomberg, Etchells and Epstein, leaving Richard as the last 'modern artist' still standing. He must have delighted in the fact that those who had caused such a fuss over their signatures in 1914 had now been sidelined completely (and so soon), while he had prevailed. The press was not slow to observe the absence of the pre-war rebels either and to suggest that their absence was no loss. The London Group could now be taken seriously as 'The white heat of this great world crisis through which we are passing will sooner or later separate the pure orr from the dross, and under penalty of utter extinction compel a return to artistic sanity.'[63] At the centre of this separation was Richard, 'our one and only Futurist, [who] is becoming ever more rational and intelligible'[64] – the artist who could offer a 'powerful, dramatic and emotional presentation of the thing seen and felt'.[65] His was a vision of emotional intensity, enhanced with a biting realism and catalysed by the formalising influence of Futurism to take his images beyond anything which anyone else was doing. Charles Marriot explained Richard's *métier* succinctly:

> The object, we take it, of all such expedients is to intensify reality; and they always come off most successfully when the suggestion of optical illusion is frankly avoided. The eye is accepted as the channel to the mind, but not as a critic of reality in itself; and any person of ordinary intelligence soon learns his way about the new convention.[66]

Catching on, critics could soon write 'Mr. Nevinson's formula has vision behind it; he is an interesting artist, and his Futurism, or Cubism, needs no defence.'[67] This, it transpires, was the acceptable face of modernism, the moderation that would secure artist relevance in a society with very much graver concerns. *The Observer* proceeded with care, concluding 'To say that the change would be regrettable does not exactly imply an unconditional approval of Futurist principles, but the conviction that Mr Nevinson alone among the artists of his group seemed able to exploit these principles in intelligent and intelligible fashion.'[68] Futurism it seemed, or at least his version of it, was not only creditable, but valued. But Richard still had doubts and suspicions concerning his own future, as could be seen in a letter to Professor Sadler. Here he remained firm in his conviction that modern painting must be upheld during wartime, while expressing very real fears about an 'art-dealers war' where they 'will push nothing but the "pretty-pretty" or "antique" & run no risks with the public that seems getting more sentimental & reactionary as the war goes on'.[69] Richard had conquered his audience, but now he had to keep them. Stephen Watney, in *English Post-Impressionism*, stated quite logically that 'No art can exist

without an audience, be it real or imaginary,'[70] and the fact that Richard's brand of Futurism survived, and indeed went from strength to strength, is testimony in itself to this fact. A sensitive appreciation of what war really was also helped him to curry public favour, unlike his old friend Henri Gaudier-Brzeska who had rashly declared:

> This war is a great remedy. In the individual it kills arrogance, self-esteem and pride. It takes away from the masses numbers upon numbers of unimportant units. . . .[71]

But he was dead now, 'purged' in the actions around Neuville St Vaast in 1915. Richard would have been acutely aware of the fact that Edward Wadsworth was now in the Navy, David Jones and David Bomberg had enlisted, and Stanley Spencer was with the RAMC. Though he had had a head start, some others would soon be competing with him again at his own, new, game. The Bloomsburys, on the other hand, had alienated themselves from public sympathy with their stance as conscientious objectors. This sentiment could also be felt in the power of a letter from Gertler to Dorothy Brett when he demanded:

> Don't ask me to enlist! Can a fish do much out of water? Do you want my spirits to be broken forever? This *Wretched Sordid Butchery!!* They call it war! Oh the sordidness of it! Leave me alone, I'm unhappy enough. Only when I work do I forget. . . . All my plans over. All that I wanted to paint – over.[72]

The Vorticists had proved beyond all doubt that, in failing to observe the war at all, and with the continuation of their pre-war ways, they were finished, while the conservatives of the Royal Academy had proved only that their vision of modern war would be valuable and germane only when the British Empire annexed Utopia itself. But the war was far from over, and as Europe spiralled, uncontrollably, towards the carnage of Verdun, the Somme and Passchendaele, there was a realisation that it would continue to be fought by the youth and therefore should be depicted by the youth too. It was a people's war and if art was to have any real function within it, it too would have to abandon its pre-war, self-satisfying, aloof and class conscious posturing. By the end of 1915 Richard was safely at home, out of the army, having seen the war, having painted it and, as a result, having cornered the London galleries and press reviews on his own terms. As it seemed most unlikely that he would have to go back either, he could concentrate on his new found status as the sole modern British artist of war.

6
The Western Front II,
Le Beau dans l'Horrible (1916)

In his autobiography Richard remarked that 1916 was the year in which 'I became the talk of London',[1] courtesy of a one-man show at the Leicester Galleries that displayed his most modern utterances on art and war to a public that could hardly deny either the potency of the images or the charisma of the young artist and his wife. This was work unlike anything London had seen before, and so when tantalising tastes of the labours of the last 15 months leaked out at the Allied Artists Association a few months before, the critics responded immediately, talking of 'the best and most ruthless illustration of the menace of the deadly machine-war that has been produced'.[2] This was the modern artist (indeed, ex-Futurist), with military credentials too, who had earned the authority, and the right, to paint the war as he had perceived it. He was even invited to exhibit three war subjects at the NEAC, hinting that the pre-war antagonisms had now been forgotten about and that he, even as a non-member, was winning respect from factions previously hostile to his art. Some critics, feeling that they were about to witness something very special indeed, could wait no longer and appealed 'Come out of it, Nevinson, and let us see you as you are!' saying 'Leave the tomfoolery to idle or ungifted youths, who use it either to convince people they are clever, or to avoid the hard work that is necessary for all sound art'.[3] Simultaneously, there was an unidentified 'leak' in the press which hinted that he was to be sent to the Front as an official war artist (though the scheme did not officially exist as yet), and so the press championed Richard's name, depicting him as the uncompromising and somewhat difficult-to-harness truth teller.[4] Though a false alarm, it was indeed food for thought. Meanwhile, with Wyndham Lewis and David Roberts now in the artillery, and Stanley Spencer on his way to Macedonia and Greece, Richard knew that he would not be the sole artist in uniform for very much longer. Other galleries were also mourning the artist-as-martyr, through special displays of the work of Henri Gaudier-Brzeska and Henry Doucet, recently killed on the Western Front, while simultaneously congratulating those who were doing their bit

through a 'Roll of Honour', which listed which artists were serving where and with whom. The suggestion seemed strongly to imply that this was not a time to abandon the war theme – on the contrary, it was precisely the time to make the most of any military credentials available.

Richard's one-man show which opened at the Leicester Galleries in September 1916, entitled 'Paintings and Drawings of War by C.R.W. Nevinson (Late Private RAMC)', was a masterstroke, down to the very last detail. The title of the exhibition itself, it could be argued, was intentionally ambiguous as it insinuated that Richard was dead, presumably killed while in the service of his country with the ambulance corps. Though far from dead, when Richard did appear at the opening it was with a limp and a walking stick, fuelling speculation that perhaps he had been wounded, or was 'just home' from the Front. In all, he prepared, or borrowed, thirty five paintings, eighteen drawings and etchings, and one sculpture. He then promoted it using two photographs taken by Malcolm Arbuthnot of himself in military uniform, goggles and cap complete. His father had played a vital role in instigating the exhibition too by making sure his close friend, Charles Lewis Hind, saw *La Mitrailleuse* in his son's studio and consequently 'was conquered, [and] went in hot haste to the Leicester Galleries, and told the proprietors that they must, and quickly, hold a Nevinson exhibition'.[5] Henry also convinced his Boer War and Gallipoli friend Sir Ian Hamilton, commander of the fated Dardanelles expedition, to write the introduction to the catalogue – a powerful military and society endorsement for a Private. Sir Ian gave the show a soldier's blessing albeit in a form of 'high diction' which hardly seemed relevant to the war, the works on display, or, for that matter, the priorities of the artist himself. Undeterred, Hamilton waxed lyrical about the quality of truth, the symbolic relevance of the artist's compositions 'crossing the bloodiest pages of history', and concluding that 'we come away feeling that the Cup of War is filled not only with blood and tears, but also with the elixir of life'.[6] In this military context, and in the midst of such optimism, Henry invited C.F.G. Masterman to assist with the hanging of the show, a figure who would later be of vital importance in selecting Richard as an Official War Artist in 1917. Richard then defended his independence as an artist in the catalogue notes, which Henry had helped him to write, saying:

> But it will be seen from the later examples of my painting that (though working within a geometrical convention) I free myself from all pedantic and academic theories of 'Post' or 'Neo', as well as from the deadening influence of the idolatry to 'Primitives' and 'Old Masters' which has lately caused so many enfeebled and emasculated revivals.'[7]

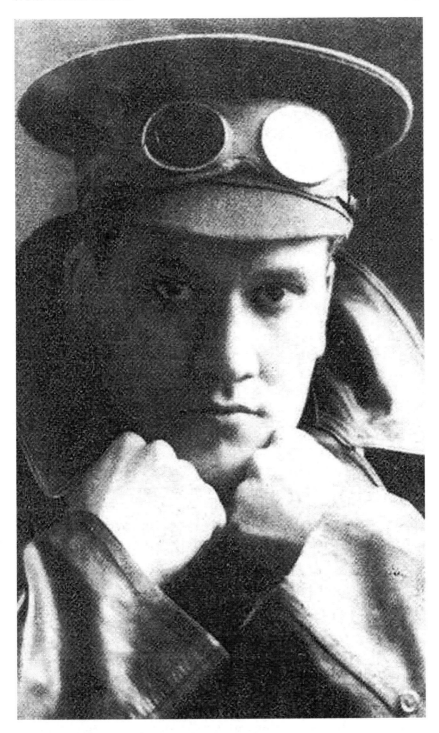

Photographic Portrait of C.R.W. Nevinson by Malcolm Arbuthnot, 1917

What was the point, Richard thought, in utilising a vocabulary that no-one understood and which was now associated negatively with pre-war antics? Or why stray into the realms of the conventional Royal Academy style work which all but a few knew to be fraudulent and which were obviously 'accounts of some war . . . written in comfortable cafes far from the scenes they describe'.[8] John Salis, himself a serving war artist, reiterated this point when he wrote 'Why, when these men are risking everything for us, should the plums of their profession be handed to our unfits and conscientious objectors, who have had the leisure to haunt the boudoirs and such places through which these appointments filter.'[9] Instead, Richard insisted that no single style, nor set of theories, was sufficient to grasp effectively the range and potency of the scenes at the Front, and argued convincingly that the artist had to go there to see and experience them for himself. Richard had done this, and as a consequence had evolved his own style, free from all plagiarism, which was significant, socially engaged, modernist and expressive – all in one. The *Daily Chronicle* traced the valuable pedigree and concluded:

> He is an artist, a fighting artist, who has rampaged like a 'Tank', through all the modern movements; he has bustled through Impressionism, Post impressionism, Cubism, Vorticism; and out of Cubism he has brought to birth a curious geometrical formula, sharp and glittering as a sword, which is admirably suited to his vision of this scientific, mechanical war.[10]

He also concluded (some years later) 'I was the first artist to paint war pictures without pageantry, without glory and without the over-coloured heroic that had made up the tradition of all war paintings up to this time.'[11] The romanticism of the Ancient Greeks, Rome, the Medicis and Napoleon, would find few pictorial parallels at the Marne or on the Somme, a point emphasised by J.D. Symon:

> Old wars, so late even as the Russo-Turkish War of 1878, were still full of glitter and colour; the very rags of long campaigning held some picturesque traces of ceremonial parade; the plume, the hussar's floating sleeves, the flying sabretache kept the rhythm of war alive; the soldier made a gallant figure to the eye amid the grime and smoke the hot engagement, and the brush of Delaroche could dwell with loving fidelity on the dust stained uniform of Napoleon. The man was still paramount; he had not been lost behind a utilitarian disguise: it is this disguise that now confronts the battle painter with a task that will try his skill to the uttermost.[12]

Even if the previously glamorous pursuit of war was now reduced to 'a game of moles',[13] it seemed that one artist at least had found a way to depict it. Why else would traditionally conservative, and therefore hostile, critics publish sentiments like 'Never have the conditions of modern warfare been interpreted with such vital force and convincing realism',[14] and why would they laud him as 'the first British artist to give really profound and pictorial expression to the emotions aroused by the war'? Who else but a soldier/artist, a hero and patriot, and yet not so very long ago, a rebel, could express so perfectly, in their summation, '*le beau dans l'horrible*',[15] in what was surely his coming-of-age? With confidence Richard later declared:

> The war did not take the modern artist by surprise. I think it can be said that modern artists have been at war since 1912. . . . They were in love with the glory of violence. Some say that artists have lagged behind the war, I should say not! They were miles ahead of it [16]

Charles Lewis Hind saw it the same way saying 'Then came the war, and this vivid revolutionary, eager and intelligent, had the luck of his life, got his subject, in horrible completeness, straight and deep, as you will see if you visit the Leicester Galleries.'[17] His Futurist apprenticeship ensured, it seemed, that he could depict not only the modern appearance of war but also the dehumanised sense of modern war, in a mechanised environment where, to quote Clutton-Brock, 'He has emptied man of his content.'[18] Far from glorifying war, Richard was in awe of the industrial force of it, and the impact on the individual who fought in its midst. Through scenes of destruction, the impersonality of the conflict was being approached in a way that subverted the human role to that of the machine in a de-humanizing, mundane, routine, and above all merciless environment. Perhaps tactfully, his key images at the show were not of British soldiers anyway, depicting rather the French *poilus*. This, it could be argued, kept him clear of the censor, of overtly sentimental and patriotic emotions and expectations on the part of the public and critic, whilst boosting the legend of the artist's own internationalism. But war was above all a human activity, a human tragedy, and that could not go unrecorded in paintings such as *Belgium 1914* and *A Taube*. Perhaps depicting dead Belgian children was an obvious thing to do, appealing as it did to the popular beliefs that portrayed dead civilians or allied soldiers as victims of the fabricated and fictionalized atrocities of the Central Powers, fitting in nicely with the anti-German sentiment of the day that guaranteed the legitimacy of Britain's efforts in the conflict. It kept at least one element of his work accessible to those who would be

unable to comprehend the less intelligible mechanical imagery elsewhere. Ezra Pound noticed this and concluded that there was no mystery in his success, and almost as little credibility, as the masses had come to see the war, not the art. He concluded dismissively 'It is manifestly an exhibition for the wide public, and not for the connoisseur in new movements. There are troops on the march, rather than new discoveries in form and form composition.'[19] There was no merit or future, Pound argued, in basing art on the level of comprehension of the majority. To do this was to relegate literature to the level of tabloid journalism. But for others this was the very fact to be celebrated, and the words of H.W. Massingham, in *The Nation*, made its reception clear:

> For the first time in recent years, the pioneer seems to be seeking a manner which will not be merely the amusement of a coterie, but might by its directness, its force, and its simplicity, appeal even to the unsophisticated perception. I can imagine that even Tolstoy might have welcomed this rude, strong style, a reaction against the art of leisure and riches.[20]

Richard also promoted the idea that Belgium and France, especially the latter, were the homes of his artistic education, and so, having been there, in peace and in war, he knew his subject like no other. The critics agreed and now backed down from their harsh pre-war stance, suggesting that, all along, they had felt that Richard had been 'the only one of the English Futurists who had a future'.[21] The uncompromising truth teller was poised to expose to the public, in a perfectly intelligible vocabulary, the reality of war, as he himself had known it, using the most up-to-date technique acceptable to popular taste, and, as usual, in contempt of any tradition and pedigree previously associated with the genre. Those who pleaded 'Are we not better served by pictures which illuminate for us the fine spirit of endurance and the nobility of action . . .'[22] were simply to be brushed aside. And the final, and crucial, seal of approval arrived when the common soldier visited the exhibition, and approved of what he saw, thus assuring the public of the truth of the depictions. How else would a civilian know whether it was 'the real thing' or not? A review in the *Star* picked up on this and relayed the story of a young officer who, on seeing the exhibition declared, 'Well, I'm strafed.'[23] Another officer in the *Daily Mail* described the build up before going 'over the top' in which he said that the soldier, both as an individual and as a collective group, was 'as full of angles as he is in a Nevinson war picture'.[24] Sir Ian Hamilton himself wrote 'The appeal made to the soldier by these works lies in their quality of truth. They bring him closer to the heart of his experiences than his own eyes could have carried him. '[25] A fine accolade indeed

C.R.W. Nevinson,
Bursting Shell, *1915*

and an indication that Richard's painting was both known and accepted by those well outside the normal parameters of art appreciation. He concluded 'My Futurist training ... had convinced me that a man who lives by the public should make his appeal to that public. ...',[26] and so the press had their new champion: the 'Warrior and Artist'.[27]

But his paintings were not just crowd pleasers. Enthused by the early press reaction to his 1915 work and confident in his ability to push the limits as far as he could, he chose as one of his principal subjects, the Futurist theme of an exploding shell. Of the four such scenes he exhibited, one really caught the eye and the imagination of the critics and became a symbol of precisely how modernism might survive at war. In *Bursting Shell* Richard had chosen the flash of the destructive moment, in a shattered composition dominated by radiant swirling lights and colours. Some realistic references, such as bricks, rafters and other identifiable objects were included, to remind the viewer – now at the heart of the explosion – of the destruction of towns like Ypres and Liege. It was an image that only a soldier could have conjured and one which could only be appreciated in full by those who had experienced it. And yet, it was 'Futurism, pure and simple ... an extraordinary sense of irresistible, destructive force is conveyed by that revolving rainbow-coloured spiral from which radiate black, orange bordered shafts'.[28] Richard had presented both a novel and innovative depiction of a relevant subject, comprehensible to most, yet not regressive in terms of art theory. It was, in retrospect, perhaps the most abstract, and Futuristic, of all his war time depictions, and a point past which he decided not to risk a further advance.

But it is *La Mitrailleuse* for which Richard is best remembered; a

painting which propelled him to (and has kept him at) the forefront of any meaningful discussion on art and war. Stepping back from the extremities of Futurism, Richard employed a more moderate geometric vocabulary, firmly rooted in an identifiable narrative, to depict what might be interpreted as the triumph of the machine over man. He embraced the complexities of creating a philosophical reality, not just copying a visual reality, in which the message was modern; morally, socially and officially acceptable, and artistically intact. His French gunners, in metallic colours and geometric form, were barely distinguishable from the weapon they depended upon for their survival – a machinomorphic image, stripped of individual conscience, which, in happier days, would have precluded them from this abhorrent pursuit, but which the paralysis of stalemate now demanded. Now man and machine were inextricably aligned, co-dependent, and remorseless in their goal of destruction, in what Paul Leautaud described as 'the legal return to a state of savagery'.[29] The idea was elaborated upon by a London critic at the time who, on examining the painting, reeled:

> And the gunners? Are they men? No! They have become machines. They are as rigid and as implacable as their terrible gun. The machine has retaliated by making man in its own image. . . . The crew and the gun are one, equipped for one end, only one – destruction. Horrible![30]

He went on:

> He has seen, and has been deeply moved by the sight of this grim pit in the French lines covered with barbed wire through which the reluctant daylight peers; he has seen the crew of the mitrailleuse crouched in their pit (one dead), angular, implacable, machine-brains of destruction, the men like the gun, the gun like the men.[31]

The only reference to the greater war being fought lay in the orientation of the gunners, who faced left to right on the canvas, defending the free world behind them in the west (though Ireland was far from peaceful at the time) from the tyranny emanating from the east. They faced the enemy squarely, with a determination that betrayed no sense of indecision or any possibility of retreat, in keeping with Petain's ethos of *Ils ne passeront pas*. A fallen comrade, lying slumped in the gun-pit, which in itself existed beneath a modern-day crown of thorns (barbed wire), reminded the viewer of the dictum *Et in Arcadia Ego*,[32] while its proximity to a wooden cross enhanced the romantic and theological symbolism associated with the martyrdom of the individual who, like

C.R.W. Nevinson, La Mitrailleuse, *1915*

Christ himself, had given everything for the triumph of good over evil. And yet if it was to be read as an anti-war statement it was at least balanced ambiguously enough not to be relegated to the unacceptable ranks of pacifist politics and rhetoric, and in turn unacceptability. More commonly it was felt to embrace the honourable, though ghastly, pursuit of the allied soldiers against the misapplied technical innovation of Prussian militarism that was the fundamental cause of the war. Konody, who had previously claimed it to be 'the most interesting picture so far shown in London'[33] was soon eclipsed in his comments by none other then Walter Sickert who went so far as to call it 'the most concentrated and authoritative utterance on war in the history of painting'.[34] In

addition, both *La Mitrailleuse* and *La Patrie* were recommended for purchase by the nation; the former by Sickert, the latter by C. Lewis Hind, not only as landmark works of art but also as valuable national records of war.

Richard did not want to forget the soldier either, nor the very personal and human idea that the war was being fought by a large number of individuals, many of whom were suffering horribly. *La Patrie*, therefore, was an image based on his experiences at 'The Shambles' in Dunkirk where he had seen such suffering. The title itself may well have been drawn from 'La Marseillaise', though cynically, when it encouraged '*allons enfants de la patrie*', to that great love '*amour sacré de la patrie*'. Far from such sentimental jingoism Richard's subjects were very ordinary:

> These soldiers had been wounded during the retreat onto the frontiers at Furnes just before the Battle of Ypres. They had been roughly bandaged and packed into the cattle trucks which were to carry them to hospital. Here they lay, men with every form of horrible wound, swelling and festering, watching their comrades die. For three weeks they lay there until only a tortured half of them were alive; and then, a staff officer happening to pass that way, there were protests because the train should have been used for other and more important things, and the men were dumped out of the way in a shed outside Dunkirk.[35]

The soldier's duty was now done but the worst had not yet passed. If anything it had only just begun. With their wounds and their expressions of suffering, there was little attempt here to depict the 'happy hero', the patriot, who willingly had given all for King and Country. On the contrary, the dressing station was depicted more as a morgue than as a warm and comforting place, filled with the youth of many nations. And yet, even in the midst of such despair, some reviewers could still find hope:

> There is not the faintest attempt to emphasise the pity of it all, no suggestion of sentiment, and yet through the grim reality, the stricken men, the impoverished beds, the rough surroundings, the dim light, one may detect the loftier note that radiates the conception, the glow of patriotism, the sacrifice of life and limb for home and country.[36]

Frank Rutter saw no such ambiguity saying that the artist had 'chosen the method of the epic poet rather than that of the sensational journalist' to depict, as never before 'the pitiable horror of war'.[37] Hind went further, to say that it had 'an almost unbearable intensity';[38] then

advocated the permanent value of the depiction saying '*La Patrie* will stand, to the astonishment and shame of our descendants, as an example of what civilized man did to civilized man in the first quarter of the Twentieth Century.'[39] Whether using the medium of the 'epic poet' or the 'sensational journalist', the impact of his experiences in Flanders whilst with the RAMC, had to be conveyed to those who as yet had not been to, or seen, war. The subject, the message of *La Patrie* was simply too important to risk losing through an unintelligible medium, and this explained the apparent retreat, on this occasion, from a more staunch modernist stance. Some critics believed that, at last, Richard was being 'reeled in' and sobered up, having 'felt the moral influence of the trenches . . . [which] is curing him of eccentricity'.[40] Fittingly, Richard also observed that 'the public . . . showed more intelligence than the intelligentsia' and understood right away that the more *élite* coteries and writers had not enjoyed the populist feel of the exhibition which had in Ezra Pound's summation, not cared 'a fig for aesthetics and theories'.[41] On the contrary, it was an exhibition for the 'average man',[42] and this had made Richard *the* British painter of modern war by 'general consent'.[43] It would soon transpire to be an unstable platform on which to build an artistic career in anything other than the short-term, especially when the unity and passion of a nation in crisis had once again passed. For the moment however it was perfect. He had sought success with the public, and he had attained it by speaking a language they understood to convey a message with which they had sympathy. So too, he did not force an opinion on them, simply offering the 'truth', as he perceived it, in an objective way, and leaving the interpretation up to the individual.

In the end, the Leicester Galleries exhibition was extended by a week due to popular demand, and had, by its close, been attended by a glittering array of guests, including: Winston Churchill, Ramsay MacDonald, Joseph Conrad, John Galsworthy, Arthur Balfour, Mrs Asquith, Jacob Epstein and George Bernard Shaw.[44] Indeed, such was its success, a full study of Richard's war pieces was published in a book by P.G. Konody, and published by Grant Richards, entitled *Modern War Paintings by C.R.W. Nevinson* which placed him firmly in the tradition of the great battle painters, from the ancient Greeks, through Uccello, Leonardo, Michelangelo and Goya, to this artist of the Great War. It is also interesting to note that Konody, like Richard, saw this as the finishing point for the study of war, concluding his essay 'He has done with the interpretation of the war and may be confidently expected soon to start in search of new artistic adventure.'[45] Richard reiterated the point saying 'I have painted everything I saw in France and there will be no more.'[46] Writing to William Rothenstein, he concluded 'In fact,

I intend to paint no more war pictures for some time. I hope to change my method of painting. . . . I wish always to work within the limits of some self-imposed convention and a different one in relation to each new subject'.[47] There was, therefore, a sense of finality in the way in which Henry recorded 'Went for a last look at Richard's exhibition & grieved at necessity of breaking it up. The whole show is of extraordinary beauty as it stands.'[48] To round off the experience Richard helped out with the production of some illustrations for Mrs H. Haden Guest's, *Princess Marie-Jose's Children's Book*, raising money for milk and clothes for children who had lost everything behind the firing lines of this war. The 'charitable' artist could now be added to all those others qualities he had so carefully crafted.

But, as Jonathan Black observed, 'Nevinson may have thought he was finished with the War, but the War was by no means finished with him.'[49] In fact there was a very serious problem on its way, and this first appeared in his father's journals at the beginning of May 1916 in an entry which read 'Anxious too about Rich and the new Bill'.[50] This was the Compulsion Bill, which followed in the wake of conscription at the hands of the Military Service Bill, and called for the re-examination of every discharged soldier. Having turned his attentions to his painting, outside of the armed forces and yet with military credentials and honour intact, Richard had assumed that his role in the war was over. Perhaps too, this time, his father would not be able to secure him work behind allied lines, or at home. A few days later Henry's journal expressed relief saying 'Rich is clear as a discharged soldier',[51] before, a matter of days later, pessimism returned with 'Threatened inclusion of discharged soldiers in army again [which] makes Richard's position again uncertain.'[52] And that is the way the summer continued, well into autumn, when in October 1916 Henry recorded 'I grew most wretched again at possibility of discharged soldiers being called up, & Rich being forced into either munitions or active service.'[53] And who would not be fearful as the appalling tragedy of the Somme on 1 July had just been played out and continued, in its renewed stagnant state, to cost thousands of British lives every day? Henry wrote powerfully 'Much trouble about Richard's anxiety as to recall into the army'[54] and a little later 'Extreme misery at night owing to Richard's terror of being called up again.'[55] As Christmas approached, Henry, returning from a visit to Sir John Lavery's studio, found his son taking the situation into his own hands and making plans to depart for Spain; one of the few remaining neutral nations in the war. Together they discussed the idea at length, and within a few days Richard was at the passport office making sure that everything was in order for an imminent move. In fact everything was not in order and Henry recorded

'Rich + Kath were refused passports for Spain because of my political opinions.'[56] When the trouble had passed, and perhaps with a modicum of pride, Henry published the incident in 1944 as follows:

> The Official asked him: 'Are you related to that man, Henry Nevinson?'
>
> 'He is my father' Richard replied.
>
> 'He is a man of very violent opinions, isn't he?' asked the official.
>
> 'Oh dear, no!' said Richard, who had known me from his childhood; 'he's the mildest of men.'
>
> 'When I say violent opinions,' the official replied, 'I mean he doesn't see eye to eye with the man in the street. Now does he?'
>
> It was an official definition of violence unsurpassed in precision, and I understood then the grounds of my evil repute.[57]

But at the time it was a serious matter and the following day an official note came forbidding their move to Spain, with the explanation that 'discharged men sh. not go to any neutral country but Switzerland lest they should be interned as belligerents'.[58] This made Henry furious, arguing that it was he, not his son, who should be treated with suspicion. At the Foreign Office he found an officer who told him that Richard's re-location could be effected in another way, quite simply by altering the destination to the south of France, and by providing an address and a doctor's certificate. That plan went wrong too when Richard was accepted but Kathleen was rejected for unknown reasons.[59] Henry's diary entry for 19 December 1916, therefore suggested the start of a new plan whereby Konody's book on Richard's art, which he felt was 'quite excellent',[60] was distributed widely with a view to drawing official attention to the paintings therein. Henry 'Went to the Galleries and got Rich's book wh. I left at the War Office for Adj. Gen.! MacReady with a note',[61] and then immediately wrote in his journal 'Horizon looking rather clearer about Richard.'[62] In the following days, General Haig himself got a copy, while father and son went to Sir George Newman together to see what the future might be for an artist in uniform. In a final communication, dated 'Decembre 18 1916', Severini wrote from Paris to relay the news of his child's death to his friend in London and, importantly, echoed Richard's own sentiments 'J'espère que vous n'êtes pas rappellé dans l'armée.'[63] While others pontificated 'Will Mr Nevinson have the power to paint for us, some day, the daylight after the nightmare?'[64] Richard knew only too well that his nightmare was far from over.

7

The Western Front III, 'From the Barren Wilderness of Abstraction' (1917-1918)

In January and February 1917 Richard continued to enjoy the momentum of the recently closed exhibition at the Leicester Galleries, and showed some new work with Jacob Epstein, at the same venue. A long shadow still hung over the Nevinson household, however, concerning the possibility of a return to active service. With the Russians out of the war, the British government had tabled the Discharge Bill, which left Richard utterly convinced that he was going to be clapped into uniform and sent off to the harsh conditions of the Front which would surely finish him off, as it had just done T.E. Hulme. Accordingly, he went to see a specialist to get an opinion on his condition, both mental and physical, the verdict being, according to his father's journal, conclusive: 'his nerve all gone: almost insane: says he will never go back to the army alive.'[1] As if to remove any lingering doubt Richard went back to his old RAMC workplace, the Wandsworth hospital, 'and saw Bruce Porter who told him he was utterly unfit for active service and would let it be known if need be'.[2] But the tension continued to mount when the Military Service (Review of Exceptions) Act became fully operational leaving Henry to jot 'The Bill recalling discharged soldiers was passed second reading – & so fate moves nearer'.[3] If ever there was a time for father and son to step up their efforts to avert the disaster that awaited it was now, and so Richard tactfully made a gift of *Swooping Down on a Hostile Plane* to the National War Museum (later the Imperial War Museum), and, no longer waiting, wrote privately to C.F.G. Masterman advancing his suggestion to become an official war artist. Next, Henry wrote to Lieutenant General Sir David Henderson, with whom he had served during the Siege of Ladysmith, to see if his son might not be accepted into the Camouflage Corps, while Richard wrote in a similar vein to Edward Marsh asking what was 'the best means of getting attached to the camoflage (sic) section ... that paints and disguises guns etc for invinsibility (sic) from aeroplanes'. It was clear in the letter that he did not want to 'be put in the ranks of some infantry regiment', and argued

convincingly that his 'knowledge . . . of colours, tones etc would be of more use to the country', if used appropriately.[4] Just over two weeks later he was writing to Marsh again, however, to express concern at how his plan seemed to have been misinterpreted as he had just received a letter from the War Office advising him that he was to be sent out to France as a 'private-sapper in the camouflage'. This did not appeal to him at all and the mere thought of going to France again, and as a private, he knew would lead only to 'the loneliness which breaks my spirit'.[5] Perhaps, he suggested, if there was something closer to home, and especially with a rank, the situation might be more palatable. As it turned out, only five days after parliament passed the Military Service (Review of Exceptions) Act, some work in the cartography department of the Machine Gun Corps in Grantham did come up, though Richard seemed far from relieved to be offered it. His father commented 'Rich heard of possible work at Grantham, but was much distressed at the thought of the army and its sergeants.'[6] The next day his father wrote 'I induced him to go to Grantham for appearance';[7] a different picture from that presented in *Paint and Prejudice* which suggested that it had been an eager artist who had gone north to try out for the Machine Gun Corps, but who had frustratingly been rejected on health grounds one more time.

Either way, it was precisely at this stage that fate dealt a kinder hand when Richard found out that his *Taube* had been bought by the War Museum 'and Mond thought he sh. go out as an artist'.[8] The idea of the war artist, whether any direct result of his, and his father's, efforts had finally become associated with his name, and so he wasted no time in inviting Masterman to have a closer look at his work, and in writing a letter to Alfred Mond, M.P., and Chairman of the National War Museum, asking him to 'put in a good word for me at the proper quarter'.[9] Earlier he had written to Edward Marsh asking him to 'put in a word for me if an opportunity occurs', and also hinting that the idea of becoming a war artist, though 'strictly confidential', was something he had a 'vague & sporting chance' of getting.[10] Two days later, Marsh received another letter from Richard asking him, through General Lowther, to write a letter to assist his application to the Special School of Works to get him distanced from the recruitment board,[11] while his father was writing again to Masterman, saying that his son was 'very anxious to go to France as one of the authorised War Artists', emphasising that it was on Muirhead Bone's recommendation that he had known where to direct the letter.[12] As a result, Masterman wrote to Richard, 'I have received a letter from my friend your father', saying that on the strength of this he would be happy to see him.[13] Masterman pushed his case with

General Charteris, stating that through illness he would be unfit for any other form of service, reiterating 'there is no doubt he has genius' and claiming that his success (and therefore his influence) was felt as far away as the U.S.A. and Russia.[14] Rather dramatically he described Richard as a 'desperate fellow and without fear' being 'only anxious to crawl into the front line and draw things full of violence and terror'.[15] Clearly Masterman was keen, and though the timing of the efforts of father and son could hardly have been more perfect, it was obvious that Wellington House was also realising the potential of his painting as a propaganda tool.

Paint and Prejudice, written two decades after the crisis had passed, presented an entirely different picture about the inevitability and inescapability of a return to the war. In it the author recalled calmly:

> I thought I would apply for a commission before the rush came. My outlook was that the war was a loathsome job from which there was no escape; but if I must go back, I was this time going as an officer. After all I was a public school man. . . .[16]

Ushered along by events absolutely beyond his control, he wrote 'Imagine the nervous state I was thrown into when I was suddenly rung up by the War Office . . .';[17] a call which had been followed by an interview with a bewildered Masterman who had said 'I have never seen a man with so many generals' recommendations,'[18] and which had led to his being swept through the corridors of power to a conversation that went something like this:

> 'But I understand that you want an artist's commission', he said.
> 'All right,' I agreed in my innocence. 'I should be happy to join the Artist's Rifles.'
> He referred again to the letter, then glanced at me.
> 'But Douglas Ainslie says you ought to be made an Official War Painter,'
> I had just enough presence of mind to give him the right answer.
> 'Of course,' I said. 'If it could be arranged it would be ideal.'[19]

One way or another, within a day or two he was sketching factories and scenes of aircraft production for the Efforts and Ideals of War series – a scheme sponsored by the Department of Information to which Richard contributed six lithographs collectively entitled 'Building Aircraft'.[20] Simultaneously he had taken to the London skies in a balloon and was taking flying lessons with Air Vice Marshall Sir Sefton Branker at Hendon as he was keen to work on some more aerial pieces when he

got back to the war. Then, armed with a 'Guest of the King' permit, he awaited his mobilisation order for France to arrive, albeit with no salary, no uniform, and no commission. To send him on his way Masterman wrote saying:

> I am delighted that you are going out now, and I hope very much that you will have a thoroughly interesting time, and come back with some war drawings equal – if not excelling – in merit the wonderful series which you showed at your last exhibition here.[21]

On 1 July the telegram came and so he penned a quick note to Masterman outlining his aims saying:

> I hope I shall be able to make a fine record + that my pictures will give the civilian public some insight as to the marvellous endurance of our soldiers + the real meaning of hardships they are called upon to face.[22]

Across the Channel, Severini was also delighted with the developments in the life and career of his old friend in London and wrote to express his satisfaction at the news that Richard was now a 'peintre d'armee'. Perhaps, he felt, this might even bring them geographically closer together and might even afford the opportunity of a visit to Paris and to a collaboration on a scheme he was working on there.[23] Severini noted sadly that Boccioni and Sant'Elia were now both dead, but revelled in the continued success of the young Englishman who seemed as radical as ever. In fact, far from being terrified his father noted, following a lunch with Richard and Kathleen, 'He is asking to go by aeroplane wh. shows a fine recovery of nerve.'[24]

After a short delay Richard departed for the Chateau d'Harcourt, where he was to be billeted during the major preparations for the Third Battle of Ypres, or Passchendaele, and in the immediate wake of the Battle of the Messines Ridge. This sixteenth century chateau, eighteen miles south of Caen, and a long way from the front line when considering the 1917 offensive, soon proved dull for him, however, and so he had himself transferred to the 4th Division of the 3rd Army at Scarpe, between Arras and the front line.[25] In the chateau he had seen *The Times* war, of officers and gentlemen in white gloves, and had been pressed into immediate service, he recorded, as the cocktail maker. He had had a personally driven car, and his father's correspondent's uniform, which he considered 'a bastard affair' (though it did reduce his chances of being shot as a spy)[26] and in it had visited areas of the Somme, Etaples, Montreux, Calais, Abbeville and even Paris. Undoubtedly he

felt a certain pressure to produce something dramatic having had all this service lavished upon him, and in a letter to Masterman he shared these concerns saying 'I am very worried that my pictures will not justify the wonderful opportunity that you have given me not to mention the petrol I have used up.' The same letter, however, went on to demonstrate that he was doing his best, as he had been 'all about the line North + South in trenches, balloons, aeroplanes, batteries dug-outs + most of the roads behind the lines'.[27] Grant Richards also received a letter dated 28 July 1917 from 'Head Quarters, 3rd Army Corps, BEF' in which Richard explained how he had 'had a hell of a time & I should say have ruined this job as a "nice one" by making the most positive precedents for "the Dear Artists" who are planning to work in France & are yet to come'. Certainly he had embraced the war, according to his driver, much more so than ever Muirhead Bone had done in his nine month residency, and had made the most of his time there, even if 'I have seen almost too much'.[28] Later the tales stemming from this month were elaborated upon, not least in *Paint and Prejudice*. Here, he told of a trip up in a balloon at St Nicholas (near Arras), with Siegfried Sassoon's friend Richmond Temple, to monitor the changing positions of the German guns, best done in the dark due to the flashes. And there, while listening to the terrestrial sounds rising to the basket, playing as 'an orchestra of the wildest modernism',[29] and perhaps thinking back to his own Futurist experiments in the pre-war years, his nostalgic reminiscences were shattered when the balloon was attacked by a German aeroplane. In the end, the attack passed off without serious incident but he (never one to play down a good story) told the *New York Times* that, although terrified and sitting on the edge of the basket awaiting the order to jump, he had never stopped sketching.[30] Another possibly enhanced version of this story found him crash landing in a tree, presumably after a parachute descent, where he hung 'like a fly in a spiders web until dark [when] I was able to cut myself free'.[31] Richard clearly liked the self-image of aviator as the natural successor to that of the rebel and Futurist, and the resultant 'airscapes,'[32] he believed, were amongst the best paintings of his career. On the ground too it seemed that Richard came very close to the Front, especially when he wrote 'I nearly got done in a few days ago at an Observation Post with some "Lovat Scouts". We were spotted and got shelled, had to stick glued against a bank for an hour, wondering when Fritz would leave off. . . . '[33] This, he went on to say, had occurred on all but one occasion when he had gone down the line. A similar story, or perhaps the same one enhanced, appeared a year after the war finished. The death of the man next to him was described, as were his efforts to get the body back to British lines under heavy machine gun fire.[34] Henry

wrote less dramatically that his son had been 'rather overwhelmed with the confusion'[35] and that, on the whole, everything seemed so much more grand and complicated than it had been on his first visit, especially in the build up to the Passchendaele campaign which began on 31 July 1917. Later, taking the car one more time, he was driven to a location where it was believed some major engagement was about to occur. Sketching, for what would later be painted up into *Shell Holes* and *Harvest of Battle*, was done in and around Passchendaele and this earned him the reprimand from H. S. Goodhart-Rendell that would get him sent home in the first week of August 1917. Years later Richard presented a charming vignette in *Paint and Prejudice* of the meeting and of the absurdity of the conditions in which he had been expected to work at the hands of military censors:

> 'Are you not aware that you are forbidden to go into the Ypres sector?' he said sternly.
> 'No. No-one told me' I replied.
> 'Of course not' rejoined the censor thoughtfully.
> 'Now I come to think of it, we were forbidden to tell you'[36]

This was only the beginning of his problems with military authorities as the following few months would demonstrate.

Shortly after his arrival home there followed a serious downturn in his mental condition and before long his father was writing, 'Richard still nervous and miserable'[37] though not specifying about what. By September the situation had not improved and his father observed, perhaps with a little frustration, 'Richard again distressed with anxiety about some scare which was nothing.'[38] Henry felt that perhaps his son was suffering from anxiety brought on by the zeppelin raids which had started again on 1 October in the area of London where they were living, and which had necessitated their taking to the tube for safety.[39] A stray bomb on one such raid even damaged Richard's lithographer's studio and three of his stones, one of which was *The Road Form Arras to Bapaume*. Additionally, he also felt sure that he could not live up to the opportunities afforded him artistically and this became only too clear when the Mastermans came to his studio to inspect the fruits of his labours, and concluded that 'they missed imagination and originality'.[40] Department of Information documents from October 1917 tell a similar story of disappointment with officially commissioned works such as *Survivors at Arras* which had clearly been painted 'with the intention of gaining official approval', but 'to the point of dullness'. Internal memos sent back and forth throughout the department expressed a hope that Richard's 'own unrestraining savage self, can appear in subsequent work ... and that his restrained,

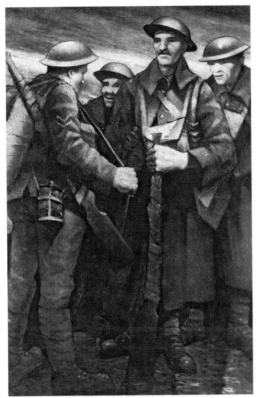

C.R.W. Nevinson,
A Group of Soldiers, *1917*

decorous, official self, is valued rather less highly'.[41] It was strongly suspected that he 'has abandoned his own <u>metier</u> in order to produce <u>official</u> (perhaps dull) pictures',[42] and this frustrated Masterman who felt a great opportunity had been lost. Edward Hudson, who was preparing the *British Artists at the Front* book, which focussed entirely on Richard, was also dissatisfied with the work he was seeing and wrote 'I do not wish to be rude to Nevinson, but there is an approach to the pavement artist's touch in it.'[43] This was definitely not the case with two other pictures which were to become martyrs to the censor and which, instead of boring the authorities, outraged them – specifically the War Office Censors M17 (A). Major Lee, the department's censor under DORA (Defence of the Realm Act), and an old Uppingham peer, was initially concerned over *Old Contemptibles*, later called *A Group of Soldiers*, and had censored the work on the grounds that it depicted 'the type of man . . . not worthy of the British army'.[44] Richard was suitably irritated as he had simply set out to depict 'the British working man in khaki' and had therefore asked some men to pose outside a London tube station.[45] But now in the eyes of the government, he was depicting the Tommy away from the parade ground and away from 'the field of honour' in an uncomfortably real depiction of the un-idealized Briton. In fact, Richard's Britons were hardly identifiable as the same immaculate patriots who were brave at heart and had such lofty ideals, and who willingly were prepared to, in Sir Henry Newbolt's words, 'play the game'.[46] The physiological code for the depiction of the British was obviously not the same as it was for the Germans, who could (and should) be depicted as uneducated and uncultured brutes. But Richard's Tommies, reminiscent of working class

labourers, dressed in military paraphernalia, were precisely as he knew the conscript army to be like, and he was not prepared to bend to the pressures of the establishment to idealise and lie. His depiction of the British army was seen, therefore, as an unacceptable, warts-and-all, self-portrait of the national 'self'. His father noted his son's reaction to the censorship decision and wrote in his journal: 'Richard in great trouble and rage'.[47] These emotions erupted in a letter to Lee:

> Dear Major Lee,
> I am writing to you to ask if you would be good enough to let me have an idea of your ideal type of manly beauty as I have just heard that you have censored one of my best pictures as 'too ugly.' When I took on this job I of course understood that my work would be submitted to a military censor but I had no idea that it would also be submitted to an aesthetic censorship. So if you would just let me know what you consider a pretty man, I will in future paint all my soldiers up to your ideal, only I must know what it is. . . . On the other hand I will not paint 'Castrated Lancelots' though I know this is how Tommies are usually represented in illustrated papers etc. . . . high-souled eunuchs looking mild-eyed, unable to melt butter on their tongues and mentally and physically incapable of killing a German. I refuse to insult the British army with such sentimental bilge.[48]

Richard fumed that even the Royal Academy had an appeal procedure, and, that working on these ludicrous criteria, Lee would also have censored the great military dramas of Forain, Rubens and Goya. To his surprise the protest worked and lead to the reversal of the censorship order by Masterman, causing Lee, who had a personal dislike for the artist, to grumble 'he deserves all he gets'. For him these soldiers resembled only a collection of ventriloquist's dummies and so he suggested cynically that the painting should be re-named *A Group of Brutes*.[49] More seriously, Lee genuinely believed that such images would help the Germans and fuel their propaganda machine were they to fall into their hands.[50] Richard wrote to Masterman in disbelief, 'My only instructions from you were to paint exactly what I wanted, as you knew my work would be valueless as an artist and propagandist otherwise,'[51] and in response Masterman brushed Lee aside and wrote to Richard saying 'I entirely agree with you that Lee should only censor things from a military point of view and that there is of course nothing of any military significance in the picture to which exception could be taken.'[52] Masterman also wrote to Lee, for future reference, saying 'If we judge of its ugliness or beauty as censors we are "in the soup" at once!!'[53] In fact, when the painting was exhibited,

the critics rather agreed with Lee and the work attracted comments suggesting that, far from the honourable Englishman in uniform, it was merely a depiction of 'a crew of dummy hooligans . . . semi-idiotic puppets . . . a gang of loutish cretins'.[54]

But the censorship question, through its timing, was causing much deeper, more fundamental, concerns as it was happening at precisely the time that Richard learned he was going to have to register yet again, like any other discharged soldier, for a possible return to the army. Henry despairingly recorded 'The torture of life is hardly bearable',[55] going on to write about a Christmas which was 'Sad and distraught.'[56] On 21 January 1918 momentary relief came when Henry met John Buchan who 'said Richard need have no fear at all of going back into the army. If Head's letter didn't work, Buchan's department would take him for the whole war. An unspeakable relief.'[57]

Richard now set to work, with the assistance of Wellington House, preparing for the second Leicester Gallery show, and painting up his countless sketches in his studio (which had previously belonged to both Whistler and Sickert), in Robert Street, off the Hampstead Road. Early indicators, however, suggested that, polemics aside, his paintings were not creating the stir to which he had become accustomed. His contributions to the NEAC, The Senefelder Club, the Allied Artists, and a host of other fundraising events in Hampstead and Chelsea, had drawn only lukewarm, or downright poor, reviews, while Frank Rutter, previously a staunch supporter, started to make comments that he had '*tout Paris* in his portfolio'.[58] Richard felt that what was lacking was just a little zest, a bit of the old Futurist panache, and so he wrote to Masterman saying 'If I could fly over London on the opening morning of my show chucking out handbills on the heads of "men in the street" this would start great publicity in the press.'[59] Offering to pay for the leaflets, and counting on help to fly the plane from General Brancker once again, he felt that this would be a means of getting the publicity that he believed the propaganda machine wanted, and from which he, and the War Office, could so directly benefit. Masterman, however, said 'no'. Henry did his bit too, writing to see whether Jan Smuts, an acquaintance of his from the days in South Africa, would open his son's exhibition, and followed this up with a letter requesting the same thing from Lord Derby only three days later.[60] Richard wrote to Winston Churchill at the Ministry of Munitions but was turned down, while Lord Derby requested that if he was to accept he would only do it without publicity, which rather defeated the point of the invitation. Perhaps Derby had had a point, not least when Henry proof-read the preface of the catalogue and felt it to be 'a terribly provocative document'.[61] But Richard could not be talked out of publishing it, saying

that it only clarified who he was, what he stood for, and perhaps more importantly, what he was not, and did not. He merely wanted to point out that the exhibition of works conducted over the previous seven months was a synopsis of his officially commissioned work and was therefore an 'exhibition [which] differs entirely from my last in which I dealt largely with the horrors of War as a motive'.[62] The *raison d'être* of his work was now to be found in the human activity and the prodigious organisation of 'our' army, seen and recorded intelligibly. He distanced this exhibition from the last and from the taunts of Ezra Pound who mocked him for having the deplorable 'habit to choose a "different style" on what seems an average of once a fortnight', and had gone on to advise him 'leave off trying to suit everyone all at once'.[63] But that was not the way Richard worked and he was not going to start taking orders from others – not now! Admitting that he had experimented with various new styles he remained unapologetic saying 'I do not believe the same technique can be used to express a quiet static moonlight, the dynamic force of a bomber, and the restless rhythm of mechanical transport.'[64] Individuality, and the personality of the artist, should triumph over intellectual mannerism, in reaching the largest possible public and remain faithful to a need for 'truth to subject'. He also stated clearly that he had no hidden agenda which could be linked to politics, theory, aesthetics or anything else; only a devotion to truth and honesty in fulfilling his role as a War Artist. Confident and intolerant, the introduction even wandered back to the Futurist outpourings of summer 1914 in his attacks on former enemies, detractors and would-be critics:

> I have no illusions about the public for, owing chiefly to our Press, our loathsome tradition-loving Public Schools and our antiquity-stinking Universities, the average Englishman is not merely suspicious of the new in all intellectual and artistic experiment, but he is mentally trained to be so unsportsman-like as to try to kill every new endeavour in embryo, especially if it shows signs of developing a future health and strength.[65]

Elsewhere the pre-war rhetoric appeared again in confident statements like:

> I also feel convinced that it is the duty of every sincere artist to have the courage of this bellicose ideal, giving his finest, singing his song from the roof-tops, even using a mega-phone if necessary to overcome protesting howls. . . .'[66]

In the days leading up to the exhibition, Richard and Henry were both awarded the *Mons Star* by the Friends' Ambulance Unit (though Henry felt 'mine was cheaply won'[67]), and a book of Richard's work was

published by the Department of Information, entitled *British Artists at the Front*, with an introduction by Campbell Dodgson, all of which suggested that this was an artist who 'knew'.

The exhibition, entitled *Exhibition of Pictures of War by C.R.W. Nevinson*, was eventually opened by Lord Beaverbrook, Minister of Information, thus conferring upon it an official 'seal' of approval as an important propaganda event. In fact Beaverbrook, on his first official engagement, seemed to focus in his comments almost as much on Henry saying 'that Rich was an instance of inherited genius in a different art'.[68] The *Westminster Gazette* listed the dazzling array of society guests too, which included: the Princess Royal, Princess Beatrice of Connaught, the Duchess of Marlborough, Herbert Asquith, Arthur Balfour, Lord Ribblesdale, the Marquis and Marchioness of Sligo, the Countess of Scarborough, Lady Tredegar, Baroness d'Erlanger, the Countess of Lytton, Lady Cunard, Countess Drogheda, Lord Desborough, General Sir Ian Hamilton, Sir John Lavery and a great many others.[69] Richard was clearly the talk of the town – no longer the soldier, rebel and patriot, but now the 'artist', out of uniform and attired instead in a 'black velours hat and a red crepe scarf round his neck'.[70] The crowds were record breaking to the point that it became difficult to see the pictures at all. This had shocked Richard who wrote 'I am the more surprised at this popularity, as the general quality of the work is so much higher aesthetically than the last, and has very little appeal to the sensational which is so dear to the literary-minded Englishman.'[71] Many of the paintings exhibited were bought by official institutions too, four going to the Canadian War Memorial Fund and a further eight going to the Imperial War Museum. But the critics were not to be put off so easily and the *Saturday Review* published an article entitled 'Duds for the Imperial War Museum' in which they stated 'Not to beat about the bush, the Trustees of the Imperial War Museum have put their money on the wrong horse. . . .' Richard responded with a letter to the editor, damning his 'hack-journalists', and the editor himself saying 'thank God I have never known nor met you', as he presumably had the same artistic sensibilities as 'some Italian woman'.[72]

There were other problems brewing too. Behind the scenes, and away from the glittering society set, Major Lee was once again incensed by Richard and his outspoken and disrespectful tone, writing 'I am going to see Nevinson's effort and shall find him out too and tell him what I think of his rotten little booklet. Bad from start to finish.'[73] In fact Lee was not finished with the artist at all. Even if his censorship of *A Group of Soldiers* had been overturned by Masterman, he had subsequently succeeded in getting an absolute ban put on the exhibition of another piece, *Paths*

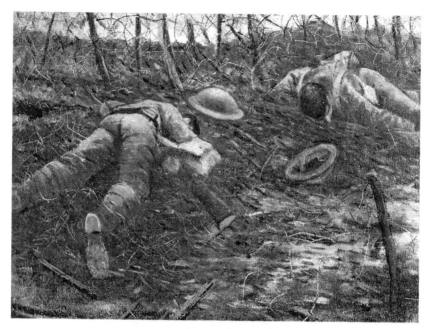

C.R.W. Nevinson, Paths of Glory, *1917*

of Glory – and yet there it was in the gallery. Richard, it became clear, had taken no notice of the restriction and, worse, had openly flaunted the censorship order to make Lee and the department in general look ridiculous. At a time in the war like this, such a gamble was indeed risky. The title of the painting in question was taken from the popular *Elegy Written in a Country Churchyard* by the 18th-century poet Thomas Grey:

> The boast of heraldry, the pomp of power,
> And all that beauty, all that wealth e'er gave,
> Awaits alike the inevitable hour,
> The paths of glory lead but to the grave.

Some might have felt that in this painting Richard was sincerely lamenting the dead of Passchendaele and other campaigns at the end, both realistically and metaphorically, of the 'parting day'. His work, therefore, was merely a fitting and melancholy tribute to the thousands of British soldiers who had lost their lives in yet another fruitless campaign in Flanders. On the other hand, the painting could be interpreted as employing a satirical 'bitter truth' to draw the public's attention to the old 'lie', *dulce et decorum est pro patria mori*. If this was the case, then Horace's poetic ideology was being applied to the inglorious bloated corpses of nameless, slaughtered youth for whom this was anything but a path of glory. The government, understandably, was not

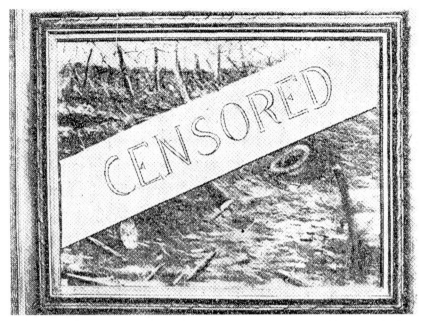

C.R.W. Nevinson, Paths of Glory 'Censored', *1917.* Daily Mail, *2 March 1918*

prepared to let such an ambiguous and therefore potentially morale-damaging image into the public domain, preferring the sentiments of journalists such as W. Beach Thomas who seemed to treat the dead Tommy as the 'fallen' of a modern Thermopylae. Herbert Asquith had even written

> His lance is broken
> But he lies content
> With that high hour
> In which he lived and died.[74]

But Richard knew, as did any soldier on the Western Front, that the dignity that was deservedly theirs would have to wait, and be awarded in death, not in life, when a uniform collective memory of patriotism and heroism would eclipse the random, meaningless, slaughter of the present. And so, undaunted by the outright ban placed on the painting, he exhibited *Paths of Glory* with the word 'Censored' scrawled across it in blue chalk on brown paper and stuck to the canvas. Whether through naïvete on the artist's part, or through carefully crafted media manipulation, the restricted painting very predictably cornered the press reviews, which asked 'Things we want to know . . . what is hidden by the patch?'[75] None of this could have endeared him to the military authorities, however, and so he wrote privately to appease Masterman

explaining, in a bewildered tone, that he had been summoned to the War Office to be interviewed by a Captain Foster. The letter read:

> It appears there is some regulation which forbids the mention of censorship; as usual I did not know about it, and I hope I made it clear to Captain Foster that I have better things to do than offending the censor.[76]

At a later date we would see him recall the controversy much more simply and with less naïvete:

> A Don't had been issued to the censors on pictures of dead bodies. Cause – some poor mother had recognised the mangled body of her own son in an official photograph. A painting which I made of corpses, of course, had no portraits in it, but nevertheless the rule applied.[77]

In another article entitled 'When the Censor Censored "Censored" ', he referred to the whole incident as 'censorship reduced to an absurdity'.[78] But his defence, as always, was rested with the common sense of the common man, the subjects, and consumers, of his work. A letter from a Lieutenant in the Royal Warwickshire Regiment to the editor of the *Saturday Review*, for example, claimed that Richard was speaking for those who knew war and who needed no protection from images of it:

> Show them to any fellow who has inhabited a dug-out. Pass them round any mess in France or Flanders. Ask the man next to you in hospital in town what he thinks of them. . . . I think you will find he has a pretty whole-hearted admiration for the Art of the man who has realised it so wonderfully.[79]

But all of this was taking a toll and though he appeared calm and supremely confident publicly, his father was dismayed to note that, privately, 'Rich was in trouble as I expected about the exhibition of the censored picture'.[80] His journal entry concluded with 'If one is defiant, one must expect disturbance and face it'.[81] A timely departure to St Ives for a month seemed advisable, based on the advice of neurologist Sir Henry Head, as a cure for 'nerves and acute insomnia', and to pursue some other non-war commissions (such as the covers of the books *Limehouse Nights* and *Twinkle Toes*).[82] Exhausted mentally and physically, Kathleen and he set off for Cornwall 'to paint anything but the war'[83] – not least as he had recently collapsed twice during one dinner, first on Winston Churchill and then later on Lord Beaverbrook. But even when they returned from their break Henry saw no improvement writing 'he is almost insane with anxiety as I feared'.[84] And not without reason. Not only had Richard

upset the authorities over the censorship question, and thus called into question his hard-fought-for status as an official artist, but he had done it at exactly the time that the Germans were launching their 'spring offensive' at St Quentin. The catastrophe for the British army that had been Passchendaele had left enormous gaps in the ranks and now, more than ever, even with the arrival of American forces, every eligible British man in the field was required. As a consequence, the Military Service Act (no.2) of 1918 was within days of being passed, further invalidating all previous exemption clauses and extending the eligible age of service to fifty one. In short, it was a national emergency, and when Henry took his son and Kathleen for lunch at Maxims 'to distract R's haunted mind',[85] he could not be sure that he would avoid the draft this time. Eventually, Masterman wrote to Henry and 'assured me that Richard is absolutely safe',[86] and then P.G. Konody, now head of the Canadian War Memorials, went one step further, transferring his friend's son into another commission, effectively shifting his employment from the British to the Canadian authorities. Richard would soon to be followed to the Canadian project by old sparring partners Bomberg, Etchells, Lewis, Roberts and Wadsworth. Under these auspices Richard went back to France one last time during the war for a week in September 1918, but this was both disappointing and unproductive as the subject Konody had set him, an air battle of the Canadian ace W.A. Bishop, simply proved too difficult. It was clear to all who saw the resultant *War in the Air* that his youthful enthusiasm and artistic inspiration for aviation had gone. In fact in France, it seems, he suffered a nervous breakdown of sorts, possibly Flying Sickness D (acute anxiety and depression), and this necessitated an immediate return home. He recalled that although perfectly calm during flights, he had experienced a trembling which led to convulsive vomiting as soon as he got back to earth. Asleep too, he experienced the sensation of falling through the air, only to wake up violently at the imagined moment of impact, a condition which was diagnosed, rather crudely, as 'Air Nerves'. While wrestling with all of this, Richard also entered into negotiations with his father's friend Robert Ross, who was an advisor to the British War Memorials Committee, concerning a future contribution to the planned permanent exhibition commemorating the war dead in the Hall of Remembrance.[87] This would manifest itself after the war in *Harvest of Battle*, though in the meantime Richard continued to write to Ross, trying to forge his own path away from the Front, with local commissions, saying 'I wish someday I might have permission to paint a huge work up north. I paint that type of thing with far greater enthusiasm than these eternal aeroplanes. Oh! I'd love to paint a camouflaged liner at the docks.'[88] Perhaps inspiration had come from the Dazzle Painting project Edward Wadsworth was currently

engaged in following his discharge from the navy, and which manifested itself both on canvas and on the ships themselves. Alternatively, later in the month, he suggested a return to an old, successful theme; that of the field casualty stations, saying 'I feel most competent to do this side of the war as I became familiar with it in the ranks, and it is the side that interests and moves me the most.'[89] When another book was published on his work called *The Great War Fourth Year by C.R.W. Nevinson*, with an introduction by J.E. Crawford-Flitch, Richard was toasted as the celebrated ex-Futurist who had 'dethroned Venus only to enthrone Mars'.[90] But Arnold Bennett, a fellow habitué of Richard's at the fashionable home of the Sitwell's at Swan Walk, began to note a more general deterioration now:

> My opinion is that this artist is running short of inspiration for war subjects at the front. I suggest that he should either have a rest or be put on to a different sort of subject in England. If he continues on present lines the result is likely to be unsatisfactory.[91]

And perhaps this was no bad thing, other critics felt, leaving the route open for an artist who was 'predestined for the Academy at an early date' and perhaps even to 'the Presidential Chair itself'.[92] Konody, with more than a little cynicism, concluded 'Who knows? Mr Nevinson may yet become a pre-Raphaelite.'[93] Triumphantly some critics reminisced that, before the war, he had been 'a young oak amidst a tangle of creepers', painting meaningful canvases while 'his contemporaries were preaching anarchy and painting piffle'.[94] But that had been four long years ago, and a lot had happened since then.

On hearing of the cessation of hostilities on 11 November 1918 Henry returned immediately to mainland Europe, not even returning for Christmas, and wrote on New Years Eve 'So another year ends: a year which at last brought peace and woman suffrage: and to me personally Richard's safety. . . .' For Richard the news came while he was in his studio, and led to the predictable relief of a man who had been living in fear for years. Dropping everything he and Kathleen jumped on a lorry from the Hampstead Road to Whitehall, danced in Trafalgar Square, then celebrated at the Leicester Galleries and the Studio Club. From there they went to the favourite pre-war haunt, the Café Royal, where 'I climbed the pillars of the old café . . .'.[95] Though he was delighted the war was over, and though he was more than ready to leave the war subject behind, he returned one more time to France during the last week of November and during the first few weeks of December to trudge the ghostly battlefields of Picardy in preparation for his last great painted statement of the war.

8
The Post-War Dream (1919)

There was no point in pretending, Richard realised, that London would now return to the way it had been four years before. Physically, the city looked the same, having avoided the immediate ravages of war (barring some zeppelin raids), but its inhabitants had not emerged unscathed. Instead, a dazed population wondered how long it would take to mourn those who had been killed (or died subsequently of the Spanish flu epidemic) and when, if ever, it would be appropriate to enjoy oneself again? The intellectuals wondered how long it would take for the patriotic fervour to die down and allow the return of 'foreign' cultural influences to the capital again, while millions of returning soldiers asked, on a more practical level, when they would get the 'homes fit for heroes' that had been promised in the wake of the 'khaki election'. Indeed many had not even got home yet and served in new conflicts in White Russia, 'Mespot' (Mesopotamia), Ireland, India and the dying Ottoman Empire. And artists who had fought in this 'War For Civilization', were now aware of their new duty: to re-cast (or at least reinvigorate) the very civilization for which such a heavy price had been paid. But how? The nation had scored a hard fought victory over the Central Powers, in which artists had played no small part, but this had also been a rite of passage, suffocating the radicalism of pre-war modernism and the extreme ideas, which had accompanied it. Artists like Richard who had once been expected to be loners, revolutionaries, eccentrics, and yet who had still been valued as analysts and observers of the society in which they lived and worked, now found themselves faced with a continued cultural resistance to pre-war polemics, combined with a revulsion for all that had happened between 1914-18. There was no return to the status quo ante, and in short, the standard bearers who had come this far, were not necessarily the same artists who were now going to thrive in times of peace. But if anyone was likely to succeed it was Richard. He had proved time and again that he was a survivor, even when he had had to build his career on depictions of a war which everyone knew had appalled him. Now, in its place there could be

construction, based on all the positive values of modernity, as opposed to those that had systematically destroyed his generation since 1914. In fact it was widely held that Richard might fit rather well into the dizzying frivolity of the Jazz Age, within a society now relieved of the onerous baggage of war. And so, as Bonar Law was observing 'The crying need of the nation at this moment is that we should have tranquillity and stability. . . .',[1] Richard would have known that he and his art would have to be prepared to respond accordingly, and so matched Law's sentiment with his own 'enormous longing for order'.[2]

There was an additional problem however. Richard had made some fairly substantial enemies over the past decade, and these now began to resurface leading him to comment 'The relief that the war was over was tremendous, yet this turned out to be for me the most repulsive time of my life.'[3] Even old allies like Frank Rutter, within weeks of the Armistice, seemed to be abandoning him when writing 'There is a danger that Mr Nevinson may have survived the war only for his art to be killed by his popularity',[4] then publishing an even less subtle article entitled 'Exit Nevinson'. In his review of the first major peace-time show, 'The Canadian War Memorial Exhibition' at Burlington House in January 1919, he even suggested that the government thin out their collection of Nevinsons and 'lose the later ones in the Atlantic'.[5] Richard, never slow to defend himself publicly, responded with a letter to the Sunday Times:

> However, when your critic announced, with thinly disguised pleasure, my deterioration, he ought to prove his case – to be able to distinguish between my early and later work. This he has failed to do; therefore I feel I am entitled to some explanation, not to mention my 'ignorant and contemporary public' whom I presume your critic is employed to enlighten.[6]

There were others who felt the same disappointment, and in an article entitled 'The Backslider', the Daily Mail noted not only how far away from his pre-war, and early war, ways he had drifted, but took the opportunity to leak a rumour of the ultimate u-turn: that his name had been put forward for membership of the Royal Academy.[7] The extremists on the left, where he had once belonged, had disowned him a long time ago for capitulating his rebel stance when the going had got tough in the war years. This had won him favour amongst his old enemies of the conservative 'right', such as Claude Phillips, who celebrated the fact that such a promising young talent was 'no longer [to] be counted among cubists, hardly indeed among the ultra-moderns'.[8] Disorientated, Richard didn't seem to defend his pre-war stance and actually added fuel to the fire in an article entitled 'Are Futurists Mad?' in which he openly declared 'I have now given up Futurism

and am devoting my time to legitimate art'.[9] Anyway, as a 'liberty-loving artist' he had decided a long time ago to leave the paths that led only to the dreary and oppressive cul-de-sac of the so-called art rebel'.[10] But the conservative 'right', having used him, and having enjoyed their triumph in his abandonment of modernism, now ousted him too as they felt that he would not join the national sentiment that, however ghastly and costly the war, had been, it had, on the whole, been worthwhile. This became even clearer when Alvaro Guevara suggested joining the Chelsea Arts Club, the membership of which Richard revoked after only one night following a series of insults by Derwent Wood. It was becoming very clear to him instead that he would have to steer away from group identities, away from isms and institutions, away from the company of other artists, and to go it alone, distanced from previous associations and drawing inspiration now from much more positive and constructive times. Turning to stability, construction and order he concluded 'My joy in chaos is gone' then suggested a route modelled on that other historic loner, saying 'The immediate need of the art of today is a Cézanne, a reactionary, to lead art back to the academic traditions of the Old Masters, and save contemporary art from abstractions, as Cézanne saved Impressionism from "effects".'[11] Not everyone, he knew, would share such a retrospective vision and so he got his retaliatory strike in first, renouncing vociferously in particular the Francophile Bloomsburys with all their associations of pedantry in the name of cultural liberation, which he considered nothing grander than a faddish despotism. But they were re-emerging in influence and now taking the helm of the London Group (Roger Fry had become a member in 1917 and Vanessa Bell and Duncan Grant joined in 1919), taking the twice-yearly exhibitions very much in their own direction, and away from anything he might have sympathy with artistically. On a personal level too, Walter Sickert also introduced the 'young Nevinson with the Prince Albert Whiskers' to Virginia Woolf, who had at that time just completed *Night and Day*,[12] but they cared little for each other and no friendship resulted. In fact Richard's feelings, both personal and professional, were aired very publicly in an article entitled 'Bolshevism in Art: Catering For The Intellectual Snob', in which he attacked élitist coteries who worked for a minority intelligentsia, and who prided themselves in the comprehension of the obscure as a form of 'one-up-man-ship'. These rebels, he claimed, were a 'parasitic growth', and should not be the voice of all labelled 'rebels' in the capital, concluding rather opaquely 'When a movement becomes a movement it ceases to be a movement; which means that organisation kills the idea.'[13] Others of Richard's generation agreed and, rather than fight this Bloomsbury dominance, walked out of the London Group, and in some cases began to group around Lewis

once again and the ray of hope that was Group X. But too much water had passed under the bridge for Richard to go anywhere near Lewis again, and besides, he knew, even if Lewis' optimism seemed undented, that the cultural context in which they had once flourished before the war, had not survived. Group X was soon to disappear. And unlike Paul Nash and David Bomberg, Richard possessed no real wish to hide away or to retreat into a convalescent post-war period, where a return to nature and all things natural seemed to dominate. Instead, he was raring to go, determined to retain the momentum of his celebrity while converting his artistic currency into something palatable for the public and critics. The balancing act would be in retaining his individualism, his kudos as a rebel and his unassailable reputation for valued critique, without sinking alone, submitting to the hated Bloomsburies, or taking his place in Burlington House. It was understandable then that Richard should write of the post war period:

> In the artistic muddle I now found myself to be in, I decided that the only thing possible for me to do was to break from all studiotic theory and find my way as best I could.[14]

As if this disorientation was not enough, the war as a subject refused to die too, despite the claim in *Paint and Prejudice* that 'after the Armistice I did not do a stroke of painting which dealt with the war'.[15] Instead he had been called upon to paint one final, grandiose statement (to match the historic dimensions of Paolo Uccello's *Rout at San Romano*), for the nation's permanent exhibition in the Hall of Remembrance.[16] Within this wider scheme, as pioneered by the Canadian War Memorial Fund, the British commissioned seventeen 'history paintings', to go alongside two large sculptural reliefs and twelve smaller canvases, all of which would eventually find their way into the Imperial War Museum. Richard's swansong image, to be called *Harvest of Battle* (commissioned for £300) was to be one of memory, of a collective national sentiment which recoiled at the reality of the last four years and yet allowed for the fact that there may be a future again for those who came home, enhanced by the merits of the cause for which they had fought. Unsurprisingly, in the epic canvas he set out to portray no glory, no victory and refused to pander to cheap jingoistic sentiment. In earlier canvases his men had been regimented, on their way to battle, blissfully naïve as to what lay ahead; firm in their nationalist convictions and uninitiated in the business of modern war. Now they were 'experienced', broken and represented both the lost generation and the lost innocence that the war had brought about. Richard, acknowledging this, combined it with the sentiment of another family friend, Thomas Hardy, who had lamented:

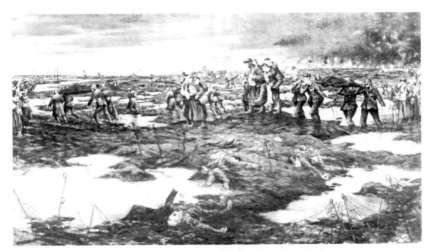

C.R.W. Nevinson, Harvest of Battle, *1919*

Calm fell. From Heaven distilled a clemency;
There was peace on earth, and silence in the sky;
Some could, some could not, shake off misery:
The Sinister Spirit sneered: 'It had to be!'
And again the Spirit of Pity whispered, 'Why?'[17]

They had, at least, survived, despite each other, and could leave this field of destruction together (as rugby players do at the end of a muddy and painful, though ultimately honourable, match) to embark on a life of reconstruction in the post-war world. Richard strongly suspected, in the light of the calamitous Versailles Treaty (in his view a 'patched-up peace'), that they were merely staggering towards another war. But a panoramic scene of the Great War, he also knew, was not going to be particularly eye-catching unless it could be unveiled in a context that was interesting in its own right. Not quite exhausted with polemics, therefore, he expressed publicly his intention to exhibit *Harvest of Battle* at the May 'Peace Show' at the Royal Academy. The idea was immediately rejected on the grounds that it would seriously dilute the impact of 'The Nation's War Pictures and Other Records' exhibition later in the year for which it was originally intended.[18] The *Daily Express* was even denied its request to publish a photograph of the artist at work on his large canvas for the same reason, and the resultant publication showing only Richard in his studio.[19] (Here Richard saw his chance (not least as the same restrictions had not been placed on John Singer Sargent and his painting *Gassed*), sending invitations to a private studio viewing of the work, complete with bus and tube routes, at which the press would surely enjoy the opportunity to get a controversial 'scoop'.[20] The subsequent

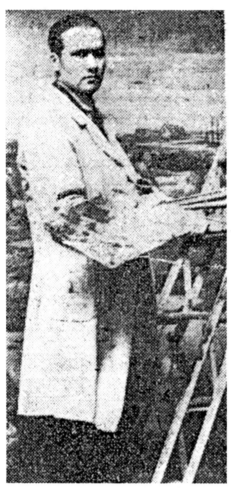

C.R.W. Nevinson in his studio,
Leeds Mercury, *1 April 1919*

stories concerning the 'cloak and dagger' *exposé* ran rampant with one headline telling readers of the 'Mystery of a War Picture.... Academy Closed to Grim Flanders Scene',[21] and others conjecturing that 'it is considered to be not only his finest painting, but the most wonderful of all war pictures'.[22] Of course it had not been the academy which had closed its doors to the painting, nor had there been any issue with its 'grim' contents, but nevertheless, that is the way the press reported it, and in so doing manoeuvred Richard into the spotlight on the censorship ticket one more time. Neither did it harm his now inescapable reputation as the truth telling, uncompromising, modern, military and often misunderstood, artist, who was constantly thwarted by the establishment. In the end his painting did not appear in the Royal Academy 'Peace Show' of May, 1919, and Sargent's did, but he had made sure that even its absence had created attention. This would, he would later discover, turn out to be a pyrrhic victory.

Richard knew only too well that these mini pyrotechnic displays would not pass for progress for very much longer. Accordingly, and in an attempt to make a clear break with all that had gone before, he returned to Paris and to his old friend Severini who still had a studio, albeit a freezing cold one, at Denfert-Rochereau. Though he and Kathleen went and renewed their acquaintances with Kisling, Metzinger, Laurencin, Zadkine and Asselin (and bought a Modigliani for £5, which immediately re-sold for £120), poor health and his impending 'Peace Show' necessitated a return to London before much serious work got done. More depressingly still, they observed the lack of post-war spirit in the once great art capital and

perhaps this drummed home the fact that both London and Paris would take quite some time to recover from the ordeal they had just passed through.

New York, on the other hand, seemed to boast a youthful exuberance and confidence in which modern art must surely thrive, and with which Europe could not, at this time, compete. *Les transatlantiques* were also becoming the set to know and *americanisme* appeared, in the post-war world, to be emerging as a viable alternative to Paris for bohemian chic. Richard, and his fashionable wife were nothing if not chic, and no evening in London seemed complete without them taking their seats at the Café Royal,[23] singing bawdy songs at the Poet's Club,[24] dressed in 'Futurist' costume at the Chelsea Art Club Ball at the Albert Hall, or dancing (and sketching) at London's other re-emerging nightclubs such as Desti's.[25] Would not the world of the cocktail, the bobbed hair style, the short dress, the 'Shimmy', 'Twinkle', 'Jog Trot', 'Vampire', 'Missouri Walk', 'Elfreda', and 'Camel Walk', be ideal for them? And might not New York then be the answer to the dilemma that post-war London had created for him socially and artistically? This being the case, he was determined not to skulk off like an artist caught in a retreating tide of popularity, or worse, one scuttling away from re-emergent competitors. As he had embraced Futurism and then the war unreservedly, now he would turn to the New World for inspiration while the old world gradually recovered from the latest bloody page in its history. A going away dinner was held in his honour at the Café Royal, organised by Grant Richards, The Right Hon. Lord Henry Cavendish-Bentick, M.P., H. Chadwick Moore and Mr Charles Sims, RA (absent), and was chaired by Walter Sickert, at which about sixty people in all were present. His father's diary entry reads:

> Then Richard spoke and read a long defensive offensive as to his position in art against narrow cliques + little sets who try to scorn and reject him as successful. Many of the words & illustrations were daring and violent: but the general effect fine and powerful.[26]

Indeed, the old Marinettian protégé seemed to be back on form when, in his speech, he dramatically announced:

> An artist cannot be too aggressive. As I have often said, an artist should be a bellicose Jesus Christ: a man convinced of his mission and unashamed, with a song to sing impossible to repress, and determined to be heard.[27]

The press reported fully on his 'fiery and warlike response' which proclaimed absolute freedom from all groups and ideologies, against which he was

happy to declare war if they would not respect his autonomy. Other papers published extracts which attacked 'little Revolutionary groups in art which call themselves free, yet tyrannise their members into one formulated expression and turn themselves into narrow little academic societies'.[28] Years later Gerald Cumberland had not forgotten the words, nor indeed the attitude of the artist who had delivered them, when he wrote:

> Self-confident? One might use a harsher term for that flamboyant and not too intelligible speech he delivered at the dinner some of his admirers gave in his honour on the eve of his departure for America. It was a clever, muddled, conceited harangue, which must have been regretted by all who had his interests at heart. But it was delivered without a single doubt, or a moment's hesitancy, or even the first faint fluttering of a qualm.[29]

Not without significance one report in London stated:

> I see that a farewell dinner is to be given to Mr Nevinson before his departure to New York. I wonder whether he is going to be feasted by his erstwhile colleagues of the advance guard in art, or by his future fellow-members of the Royal Academy.[30]

Though tongue in cheek, Richard would have observed how notoriety had brought with it implications of conservatism, and this must have haunted him as he sailed up the Hudson on board the *Mauretania* (then a troop ship). This fresh start in the new world, and this re-invention of himself and his work, was going to have to be dramatic.

Richard adored New York from the moment he saw it, and New York seemed to love him in return – at least initially. Of it, he wrote:

> Then came New York. It was a wonderful morning, with some of the skyline in the mist and the higher towers jutting out of it in clear silhouette. Much as I love Venice, I was overjoyed by that glimpse of beauty New York gave me as we made our way up from Staten Island to the docks.[31]

In return the press welcomed their grateful guest about whom they wished to know so much more. The *New York Evening Post* led by presenting a generous two-page spread which let him speak, introduce himself to the new world, and create the image of the modern master. Here, the readers learned, was the veteran artist who had been a patriot, a youthful rebel, a lone intellectual, a victimized genius, and a rankless soldier, who had turned down a captaincy in the British army for the benefits of access that only a freelance could have.[32] Who could doubt the sincerity of an artist who, in his two years of almost unbroken service,

had had his car blown up on the front line as he drove it, had survived an attack on a balloon in which he was sketching high above the Western Front and who had heroically dragged back the body of a comrade in arms from no-mans-land. From Ypres at the beginning; Cambrai at the dawn of the great offensive in 1917; and the German collapse at St Quentin in 1918 – Richard had seen it all. His American audience must have felt that there could be no greater miracle than the survival of this reckless youth who had 'hunted at night' and who had received numerous 'invitations to commit suicide'.[33] With such a pedigree, the press declared confidently 'There is no other living artist who is so equipped as he is to show the inhabitants of this city what an interesting place they are living in.'[34] In the *New York Times Magazine* the good work continued when he reiterated the distance between himself and the macabre, and from the war in which 100,000 American 'doughboys' had died. He declared:

> Having lived among scrap heaps, having seen miles of destruction day after day, month after month, year after year, they are longing for a complete change. We artists are sick of destruction in art. We want construction.[35]

Besides, he did not want to be seen as cashing in on, or benefiting inappropriately from, what in the end was the tragedy of others less fortunate than himself, and on a war that many Americans had yet to be convinced had been their war at all. When Hamilton Easter Field concluded his article with the statement 'Nevinson is a master' there could have been little doubt that the red carpet had been rolled out and that Richard had only to turn up to ensure that the next stage of his career was off to a dynamic start like those to which he had now become accustomed.[36]

Away from the popular press and the attentions of journalists and gossip columnists however, the real New York avant garde clearly did not require the paternal guidance of this young and eye-catching Englishman, who seemed only to mimic the earlier pronouncements of other European émigrés. Francis Picabia had, after all, 'discovered' their city in 1913 and declared 'Your New York is the cubist, the futurist, city. It expresses in its architecture its life, its spirit, the modern thought. . . .'[37] Richard's 'discovery,' therefore, was really no discovery at all in their opinion, rather a second rate repetition of the ideas of the real pioneers, including Marcel Duchamp, Albert Gleizes and Elie Nadelman. Though their aloof attitude had been tolerated and even welcomed as an education, Richard's did not follow suit as he didn't seem to wish to learn anything from the city and its inhabitants - coming across instead as the altruistic missionary in the midst of an uncultured mob. Such arrogance became intolerable following a series of high profile speeches at the American Federation of Artists, and

at the Society of Independent Artists at the Waldorf-Astoria where over two hundred artists were present. Perhaps remembering the manner in which his old mentor Marinetti had come to London in 1910, or perhaps riding on the back of his own polemical outbursts during the war years, Richard surprisingly, and unnecessarily, went on the attack. He repeated, and intensified the barrage, in a further lecture delivered at the Kevorkian Gallery (40 West 57th Street), entitled 'Art as a National Asset' where he not only read the old Futurist Manifesto, but described Americans as 'splendid painters, but no artists'. He then distanced his audience further by saying that 'It was with horror that I found artists in America a thing apart and of little importance' and then finally, burned the last of his bridges with 'The impression I have thus far gained of the American public is one of mental sterility.'[38] Little wonder that James Montgomery Flagg (the designer of the Uncle Sam recruitment poster) could write in the *Pittsburgh Gazette* 'Don't you think your remarks were at least tactless and at most gratuitously insulting?'[39] After a mere week in the United States Richard was snatching defeat from the jaws of victory and the positive impact of his earlier work was now being undone before his highly publicised Keppels show had even opened. Almost two decades later, and by then an outspoken anti-American, he griped in his autobiography 'Americans have no sense of humour, and as I was later to find out they took this Shavian joke in dead earnest.' In their defence, and perhaps as a very late olive branch, he conceded 'Never had I come across so few intellectual people, yet that tiny minority was more first-rate than any circle I have discovered in Europe.'[40] Horace Brodsky, Joseph Pennell, Miss Bliss and Charles Lewis Hind were all amongst the 'first-rate minority', as was John Quinn who had been one of Richard's earliest patrons. Quinn in particular, in Richard's opinion, was a man of learning and taste, especially as his private collection ran to Picasso, Derain, Matisse, Kandinsky, Yeats, Gertler and John. Quinn, on the other hand, was not so convinced by his new acquaintance and wrote to Wyndham Lewis back in London, saying that Richard had visited, stayed for a few hours and talked a good deal about himself, but not seen much of his collection. Quinn observed 'I do not really think that he does have a feeling for the best art,' then went on to say that, when shown a couple of late Matisse paintings and a few by Walt Kuhn, he had not shown any particular interest or appreciation of them. The letter then got down to the crux of the matter saying:

> He seems to realize that the war and the post-bellum art exhibitions have given him a real chance. I have the feeling that he knows that he has not the real stuff but that he wants to cash-in and make big sales now while there is a market for war stuff.

He also could not help but comment upon the onslaught in the press and the legend Richard was building around his own name:

> he told about making sketches while sitting on the side of a flying machine, with the shells bursting all around. The damned thing was nauseating and the conceit of it was most amusing. . . . Nevinson's vanity was really bad taste.

Finally Quinn concluded 'America did not "swell" Nevinson as an advanced artist' and noted that the real artists 'sized him up very quickly as a journalist and a self-exploiter'.[41] There would have been those back in London who would have readily agreed with this assessment, not least the recipient of the letter itself. Eugene Gallatin was another such exception to the scythe-like sweep Richard had made of art personalities, and was described as 'the most amazing art connoisseur I met in New York. . .'.[42] In fact it was Gallatin who wrote the 'Introduction' for the long awaited exhibition at Keppel's,[43] entitled 'Etchings and Lithographs by C.R.W. Nevinson', in which he presented Richard as one of Britain's 'most vigorous and original painters', whilst stating, rather hypothetically, that no American, not even John Marin, could have painted the way he had done on the Western Front. Indeed the show did demonstrate a marvellous diversity of images, from the first year of the conflict through to the last, utilising both 'freelance' and 'official' styles, and displaying the autonomy and diversity that he had fought so hard for. As it turned out, the actual images were well received, even if his comments were not.

At the end of his visit, Horace Brodsky, a mutual friend through the late Gaudier-Brzeska, advised him 'You've made good here, and they seem to like you. Beat it and get away with it, and don't come back. I know these New Yorkers.'[44] Richard obliged and sailed, first class and still using his King's Guest pass, on the *Aquatania* following 'probably the most extraordinary month ever lived by an artist'.[45] A journalist for an English paper however reported that he had just sailed away from a storm of his own making, and warned him, as Brodzky had done, 'if he could hear the things they say about him now he would not be so keen to come back in the autumn as he was when he left America the day after that speech was made'.[46] As it turned out, Richard had much greater problems waiting for him in England as he would surely have realized when he saw his mother waiting for him at the dock.

During his absence Kathleen had given birth to their first and only child, who had attracted media attention, as 'The Cubist Baby'. The joy and the jokes were short lived however as Henry's journal entry for 3 June 1919 explained 'Rich and Kath's child must die.' The following day Henry wrote 'Richard's and Kathleen's child lay dying + died. I was strangely

unhappy at the thought.'[47]
A few days later, with
Richard mid-Atlantic, he
recorded unreservedly that
he was 'Overwhelmed
by the death of that poor
child, now lying still in the
studio,' and wrote of his
concern for his daughter
in law when he 'looked in
on Kathleen, sitting in the
garden of the nursing home.
She cried a great deal when

The Cubist Baby.—Congratulations to Mrs. C. W. R. Nevinson on the birth of a small son at her house at Hampstead the other day. She is the wife of the famous Futurist painter, who, by the way, has just gone to America. Mr. Nevinson's exhibition at the Leicester Galleries some time ago caused quite a sensation, and most of the pictures dealt with war subjects. He was at the front himself for some time as a motor mechanic, ambulance driver, and hospital orderly, and gained by his experience a wealth of material. He doesn't always go in for Cubism, Impressionism, Post-Impressionism, Vorticism, and other "-isms," and can paint real pictures if he wants to.

—(Bertram Park

I was 'kind'. Spoke much of the child, its intelligence and strength of will. All very sad.'[48] On 7 June 1919, the day before Richard's return from New York,

> We buried Richard's and Kathleen's little son in a white coffin.
> Happily the service was short. The poor little thing was dropped
> into a hole on the top of my father in the old Hampstead
> Churchyard. His name which we never knew was Anthony
> Christopher Wynne.[49]

Richard's sole reference to the family tragedy, written almost twenty
years later in *Paint and Prejudice*, was to recall 'On my arrival in
London I was met by my mother, who told me my son was dead.'
He then added 'I am glad I have not been responsible for bringing
any human life into this world', especially with 'my blood, my morbid
temperament and cursed as I am with apprehension of torments and
degradations yet to come'.[50] But from this point to the end of the year
Henry's journals charted no such relief: instead the slow decsent of
his son towards a nervous breakdown, accelerated by this tragedy, the
residual anxiety of war, the failure of his New York experiment and
the uncertainty in the post-war world of success as an artist. More
personal problems arrived too when Richard found out that Wyndham
Lewis had taken the flat above the one that they had just moved to
on the Euston Road, leading Kathleen to worry about 'the madman's
violence'.[51] Henry was taking no chances and was clearly still prepared
to fight his son's battles, physically if necessary, when he recorded 'put
off going to see Wyndham Lewis against whom I meant to brawl if he

insulted Richard in his speech'. Lewis was not the only problem and so Richard remembered unhappily:

> Still the intelligentsia were showing me every form of hostility and contempt, and when I returned to London I found social life impossible. Everywhere I went I was wounded or driven to fury through some cheap insult from some superior Bloomsbury or an aesthetic bohemian.[52]

But this was all kept private. Instead, the public image showed no sign of weakness or doubt, and the public image projected was one of an eager artist preparing confidently for the next solo Leicester Galleries show. Richard's 'Peace Show' would open along side the work of Matisse in the same gallery, to a public which eagerly awaited an exhibition of these modern masters, who had known each other in Paris and who were to spend studio time together now in London. Secretly, Richard feared being eclipsed by the French legend (he did however enjoy his company and took the opportunity to buy one of his works),[53] and also by his English peers who were showing in galleries elsewhere. Edward Wadsworth and David Bomberg, for example, were creating a stir at the Adelphi Gallery, Wyndham Lewis was at the Goupil and the 7&5 Society was up and running. Almost certainly this accounted for Richard's need to become aggressive again, this time in his catalogue introduction, an early draft of which Henry read. He was immediately concerned and wrote 'Rich showed me his preface & I made a few changes, but it is still bellicose (sic) and too defensive',[54] in its characteristic struggle for artistic autonomy. Richard warned his reader again that 'I wish to be thoroughly dissociated from every 'new' or 'advanced' movement; every form of 'ist,' 'ism,' 'post,' 'neo,' 'academic,' or 'unacademic'.' This was nothing new and one critic retorted 'Good! This saves me a heap of trouble. One need only describe these curious but forceful works as sheer Nevinson.'[55] So too he was sticking to his ideology concerning eclecticism in art, or 'art rules the artist', by saying 'I refuse to use the same technical method to express such contradictory forms as a rock or a woman.'[56] This was also picked up on positively by the press which reported 'The versatility of the man is amazing. He can paint in half-a-dozen styles – according to subject – and you feel that, as often as not, he does it with his tongue in his cheek.'[57] The subject matter of the paintings on display were certainly consistent with this ethos as they ranged widely: from *When Father Mows the Lawn* to *The Inexperienced Witch*; from cityscapes of New York to traditional nudes; from portraits of celebrities to landscapes of England; and from comic pieces to jazz subjects. Perhaps most importantly of all, there was nothing at all to

do with the war. The *Daily News* reported gleefully that 'the lost sheep had returned to the fold' whilst observing that amongst other extremists there would surely be 'wailing and gnashing of teeth as over one who has deliberately chosen to return to the realms of darkness'.[58] Michael Sadler agreed and summed up by saying that he 'must be a great trial to those serious young painters who would have English secessionism move relentlessly from one abstraction to another'.[59] P.G. Konody, not wholly approving of the technical eclecticism, nor indeed the cocktail of subject matters, concluded 'The sky-scrapers and cabarets of New York are a happier hunting ground for him than Olympus or Parnassus.'[60] Others shrugged 'But in spite of his disclaimer, I'm afraid that Mr Nevinson will always be a stuntist.'[61] Despite everything, the show according to the *Pall Mall Gazette*, was an unmitigated success, in terms of attendance and profits, and so Richard could be content that he had bridged the gulf back from war to peace successfully, using a clever combination of versatility, variety and adaptability, in what was reported as 'the most popular one-man show ever known'.[62]

A new crisis was looming however, with the 'Nation's War Paintings and Drawings' exhibition at the Royal Academy at which *Harvest of Battle* was finally to be unveiled. Though not a Royal Academy exhibition, the collection of the Imperial War Museum was to be exhibited in the rooms of Burlington House and would represent artists of 'every sort of school' who had depicted the 'Titanic struggle'[63] – a fact that would have former academicians like 'Millais and Leighton turning in their graves'.[64] Masterman publicly outlined the goal of the exhibition, then identified the hanging committee (who had to select one thousand out of the three thousand paintings in the collection), as, amongst others, Yockney, Bone, Dodd and Tonks.[65] Richard would have known right away that this was going to lead to trouble and all doubt would have been removed when Henry Tonks wrote to tell him that his dislike of his work was surpassed only by his dislike of him as a person. It was no coincidence then that none of his paintings made the Central Gallery at Burlington House, whilst everything else was divided and scattered throughout the many rooms of the show. Richard was appalled and made his feelings clear when he wrote to the committee:

> every single picture but one of mine has been placed in an obscure corner, and every trick, well known to every artist who has hung an exhibition, has been used to dissipate my strength, and handicap me in every way.[66]

On 15 December 1919, the Chairman of the Art Committee received a further letter from Richard to

express my contempt – for the ungenerous and unsporting way you have flung my altruistic efforts at co-operation into the cesspool of artistic intrigue, and the cynical lack of appreciation you have shown throughout.[67]

Kineton Parkes wasn't far off the mark when he observed 'For Nevinson there is no armistice. He is always at war.'[68] Richard was utterly convinced that he was the victim of a direct conspiracy against him by a vicious and elitist cabal, a suspicion which was confirmed by a further attack on him by Muirhead Bone. Once again Henry had to mediate between the two, and few days later 'Muirhead Bone came to see Richard and apologise. . . . He said he knew there was a violent set against Richard among a clique of artists'[69]

Now Henry could only stand and watch helplessly as his son became overwhelmed by 'a state of anger and despair',[70] even if, on visiting the exhibition he believed that his son was over-reacting to what was, all-in-all, a 'superb show'.

Though much of the triumph had been taken out of the debut of *Harvest of Battle*, the *Daily Mail* got off to a positive start saying that

It is a large, steel coloured painting. Dawn: somewhere that looks like earth's most God-forsaken region, the sodden flats north-east of Ypres. Guns are blazing away in the half-light; the first of the "walking wounded" and prisoners of the morning's attack are trailing back amid the shell-holes and brimming craters. Terrible! The man who painted that has seen; the man who has seen, that knows the bitterness of things.[71]

Others, however, felt it to be terribly distant from the youthful interpretations that his career had been built upon, and somehow removed from any real legitimacy to the lofty status of art. Ezra Pound (whom Richard called 'the Hun'), summed this up perfectly calling it 'a representation of reality and an excellent record of war', before damning it on formal grounds as a 'bad painting'.[72] Henry didn't agree and welcomed the change from the 'old sword waving, cavalry dashing pictures of Glory!'[73] Returning the following day he was especially delighted to see queues for *Harvest of Battle*, rivalled only by Sargent's *Gassed*. But his son's nervous decline had started in earnest now and at lunch on 14 December Henry, perturbed, wrote 'But the sorrows of Richard appal me & and his outbreaks of wrath against Tonks . . . and others only make things worse.'[74] Time did not alleviate the problem and on Christmas day at Downside Crescent Richard was in real trouble emotionally. The diary entry for that day reads:

Richard came to dinner . . . in terrible state of rage and depression against critics and artists. He is 'obsessed' hardly sane, utterly wretched, incapable of reason or work. He does everything that the enemy wishes him to do. Has written again to Tonks, no doubt with abuse. One of his pictures was rejected by the New English. He must have known it would be, yet he rages, I am in despair of a way out.[75]

Three days later, when Henry called at his son's flat, he found him in bed 'having a sort of cure for his distracted brain',[76] and conjectured one more time that the mastermind behind this plot against his son was Wyndham Lewis.[77]

Phillip Gibbs wrote, in 1979, about the men who came back from the war, observing that 'Something had altered them. They were subject to queer moods and queer tempers, fits of profound depression alternating with a restless desire for pleasure. Many were easily moved to passion where they lost control of themselves, many were bitter in their speech, violent in opinion, frightening.'[78] This was most certainly the case for Richard who now, abhorring his role in peace-time, declared 'Everything ought to be done to prevent a man's becoming an artist', and dramatically concluding that the artist of today was 'better dead than alive'.[79] It was a thought that concerned those who knew him.

9
New York, Prague and *The Waste Land* (1920-21)

Clive Bell was certainly not speaking for everybody when he observed with relief that innovation and originality had not been killed off by the war, but instead, 'Abruptly and unexpectedly the wheels of civilisation began to turn.'[1] Thomas Burke felt something similar, especially concerning the year 1920, when he wrote:

> Victoria's death was not the end of the nineteenth century, nor was Edward's. The true end of that century, and the beginning of the twentieth and of new age growing pains, was the end of the Great War. Not until 1920 did London enter upon its new era of structural and spiritual change.[2]

It was as if the enormous effort required to sustain the war for four long years was now going to be channelled into a new energy, a new idealism and very probably a new Britain. For the 'Third Sex', the modern women in the work place, in parliament, and loving the release of the emerging Jazz Age, there was a feeling of liberation. Ross McKibbin went so far as to say that in this new society world, glamour, fashion and wit had become the new currency for status, replacing title, land and duty. Even the Tour Eiffel restaurant underwent a face-lift, shedding the scruffy bohemianism of the pre-war days, to cater for a new 'set' which included Jean Cocteau, Constantin Brancusi, Tristan Tzara, Charlie Chaplin, George Gershwin, Michael Collins, Raoul Dufy and a host of others. And finally, with the termination of DORA (the Defence of the Realms Act) and its replacement with the Licensing Act, a frenzy of nightclub activity ensued at lively venues such as Ciro's, with its glass floor, the Kit-Kat Club in the Haymarket, the 55 Club and The Cave of Harmony. For some it was tasteless to be so frivolous in the light of the horror that had just passed and in the absence of so many of London's young men. For others it was a necessary re-channelling of a momentum into something positive and constructive, or perhaps just a stubborn denial of what they, and the nation, had been through. This 'boom', or 'release' may have been true for

an élite minority in and around the capital city, but elsewhere in England the story was very different. It is telling that in 1920 the Communist Party of Great Britain was founded, and before long, with unemployment touching 2,000,000 (having tripled in one year) there was the first in a series of widespread and very damaging strikes. Britain may have won the war, but it had yet to establish a firm foothold in the peace.

Within all of this change and re-structuring, it was clear that Richard was going to have to make a firm choice in order to prosper, or indeed survive. Should he try to make his way into the establishment with a final renunciation of all that had gone before? Should he identify a new way to be modern and original within a disorientated avant-garde art in London and Paris? Or should he have one more go at breaking America? He knew that the self-confident façade could not last much longer either, and that any sign of weakness or self-doubt, would be the signal for his enemies to move in for the kill. As a result he and Kathleen continued with their very public appearances at Desti's Nightclub on 'Montmartre Night' (where his painting of modern dance, *Gaiety,* hung), dined at the Café Royal with Augustus John, while Richard alone branched out and wrote fairly serious articles on artistic topics such as the aesthetic worth of El Greco's *Agony in the Garden* at the National Gallery (which he described as 'the fountain-head of the modern movement in art').[3] He exuded confidence through other press releases too, proclaiming boldly 'Cubism is dead',[4] and strategically offering an olive branch to the Royal Academy:

> The Royal Academy is not at all narrow-minded. It is the other modernist groups – I mean the London, the New English etc. The time has gone by when reckless attacks on the academy are amusing. Art is genuinely vital to-day, even at Burlington House.[5]

Would-be detractors were swatted out of the way too as the editor of *The Connoisseur*, Reginald Grundy, found out when Richard published a letter under the heading 'Satan Rebuking Sin'. Here he outlined forcefully how unhappy he was to have read that his work had been compared to the 'stunts' of the moderns who had all hidden behind labels of 'neo', 'post' and 'ism'. Rather, he reminded Grundy and the wider readership of the paper, that the works owned by the Imperial War Museum were 'honest performances, absolutely realistic statements – records if you like', not the imaginary visions of an insincere, dishonest and bungling aesthete who had stayed at home. The 'art parasite' responsible for the original article was reminded too that his subject was a 'Mons Star man', and suffering from permanent ill health as a result of his exertions at the Front. Grundy replied in kind, and spoke for many when he suggested

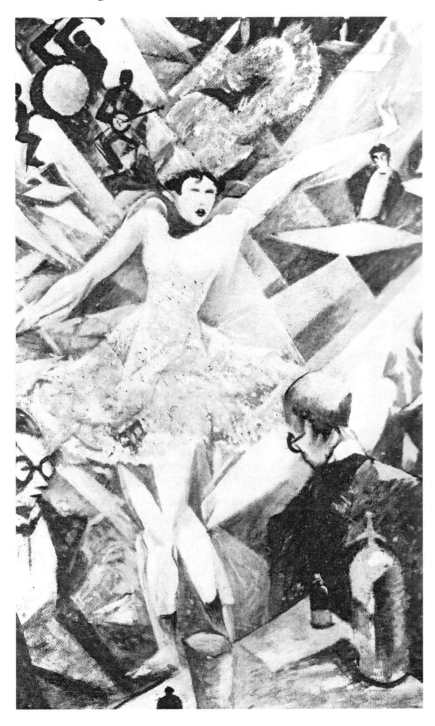

C.R.W. Nevinson, Americanism

that the artist was actually suffering from a form of paranoia which still gave no excuse for his un-gentlemanly letter, and also got in a very telling swipe of his own when he added:

> His movements from cult to cult, like a butterfly alighting on a succession of flowers: not so much insincerity as the shallow enthusiasm of youth, ever ready to seize upon a new hobby, and readier still to drop it after a brief interval.[6]

Some observers saw parallels with Whistler who had engaged in another such tussle with the conservative ideas of Ruskin half a century before, coming out moral victor – and bankrupt. Others weren't so convinced about the flattering comparison and wrote 'Certainly Mr Nevinson is not exactly like Whistler – except in his opinion of himself, but Mr Grundy's rapier compared with the painter's bludgeon is much nearer akin to Ruskin.'[7]

A much needed, and timely, boost in confidence therefore came when Richard was invited by President Masaryk to celebrate the first birthday of the Republic of Czechoslovakia at the Festival of Freedom in Prague, as the art representative of Great Britain. To some extent, Richard still *was* British Art, at least as the public saw it, and he, himself, must have taken great comfort in the national endorsement once again acting as an 'official' artist. Though busy preparing works for exhibition in Derby, Manchester, Glasgow and Copenhagan, he would have been delighted to take some time off to travel with Edward Elgar – representing music (and who was to conduct the Czech National Orchestra); Lord Dunsany (whose *Laughter of the God's* was performed at the National Theatre as well as G.B. Shaw's *Pygmalion*); and H.G. Wells – representing literature. Attired in spats, waistcoat and trilby, Richard was rightly encouraged to believe that he was, for the moment at least, still unrivalled amongst his peers, and deserved his place alongside the other giants of British culture. He wrote to Eugene Gallatin before his departure 'I am off to Prague in June with H.G. Wells, Elgar, Lord Dunsany, Mrs Patrick Campbell, St. John Ervine, I officially to represent British Art! Special train there, a red carpet and a villa in Prague.'[8] And it was quite an event, showcasing sporting events, pageants, performances of opera and drama, and other displays – which, at one point, saw over 150,000 spectators, and 17,000 performers in the national stadium. And yet, despite all of this, and the lavish attentions of the President and the great violinist Kubelik, he came back to London with a far more romantic and intriguing story, as only he might. Richard, the newspapers gushed, had found, hidden away in a top floor garret, and in desperate poverty, an artist by the name of Jaroslav Hneskovsky, whom he was sure to be the heir to none other than Paul Gauguin, or

'Freedom Festival at Prague', Liverpool Daily Courier, *May 1920. Mrs Nevinson centre front row, with C.R.W. Nevinson on her left.*

Doaunier Rousseau. Richard pronounced him the artistic discovery of the century and praised to the hilt his primitive works, painted in the wilds of India, over a five year period. Hneskovsky, quite a rebel too, had starved himself out of conscription into the hated Austrian army when the Great War had broken out and falsified health readings by drinking brandy ten minutes before his medical. Now, with the threat of war removed, and the Austro-Hungarian Empire with it, he planned to return to Ceylon (also popularised by the high profile ethnological research of Professor W.H.R. Rivers) even though Richard tried to talk him out of it, saying that the adulation of Paris and London was a certainty, and only just around the corner. The old hand was indeed an altruistic one and so, the following year, Hneskovsky made his way from Prague to show his primitive scenes at Richard's preferred location, the Leicester Galleries. Naturally, Henry attended and wrote privately 'Went to the Snevkovsky [sic] pictures of jungle life in the Leicester Gallery. Very unusual, very strange beauty of savage nakedness in forest heat.'[9] It was as if the banging and thumping of Jazz had found a primitive equivalent in the savage and unrefined imagery of this unsung painter, and the show was very successful. Strangely, however, Richard remained, in the press of the time and in his subsequent autobiography, surprisingly quiet on the whole issue of this 'discovery', while Hneskovsky vanished into the jungle, and obscurity in art history.

Returning to the practicalities of making a living, Richard began to feel that a safer, perhaps more lucrative route, might be attempted through society portraits, and soon had a client list including: Edith Sitwell, Mrs Bonner, Josef Holbrooke, Mark Hambourg, Sinclair Lewis, Sisley Huddleston and others. But he found this dull, and he was only moderately successful. Even his own father expressed doubts about his own likeness calling it 'good, but unpleasing', and later 'irritated and ungenial – not a bit as I feel'.[10] Neither did Henry like the quasi-Cézanne-esque work which was falteringly occupying his son's canvases in scenes of France and England, though he was reluctant to say anything. He wrote:

> Went with Rich to his studio but cd not like my portrait more. The expression is irritated & crooked & peevish. Nor did I like his Mediterranean towns with their doll's houses. I didn't know what to say, for at a word he would despair.

Henry stated the obvious when he wrote, 'But I am fearful lest he should have lost the kind of inspiration given him by the war.'[11] Yet even that was far from a safe haven as now, two full years after the cessation of hostilities, Richard was to discover that the war, and the morality associated with it, was still a sensitive issue. The lesson came from the most unlikely of sources when the Publicity Department of the Underground Railways of London censored his poster for Viola Tree's theatrical production of Somerset Maugham's *The Unknown* at the Lyric Theatre. The story can be picked up in the *Daily Graphic* on 27 September 1920, when it reported 'I saw Nevinson "on the Rialto", as Bohemians call the Café Royal. He was filled with indignation. . . . '[12] Maugham (who used to frequent Richard's studio) had written a play based on the 1901 novel *The Hero* in which a soldier had wrestled with his faith, and a mother had cried out in despair 'And who will forgive God?' But while Maugham's play seemed to get past any sort of post-war censorship, Richard's poster, advertising it, did not. The problem, it seemed, was that the authorities believed that the bombs bursting around the foot of the cross represented an attack on Christianity, more so than the actual play itself. Richard therefore changed the appearance of the ground but the London Underground authorities, changing tack, banned it anyway, stating now that 'as it is held to be the figure of a nude woman, we consider it utterly unsuitable for theatrical advertisement'.[13] Richard was so incensed he displayed the offending poster outside the theatre on Shaftesbury Avenue, with Viola Tree's permission, to see what the public reaction might be. Naturally the press was full of the story, with reproductions of the poster itself, rather defeating the initial intentions and objections of the censor. Richard argued that 'my drawing represents

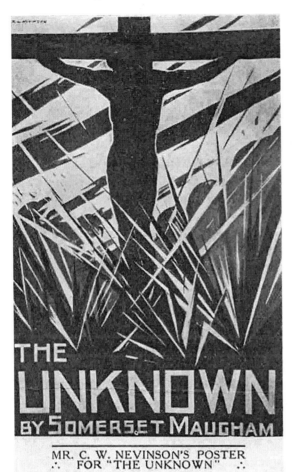

MR. C. W. NEVINSON'S POSTER
∴ FOR "THE UNKNOWN" ∴

The Unknown, 'A Banned Poster', National News, 19 September 1920

the truth that sub-conscious faith will actually triumph over any form of scientific reasoning or doubt', and despaired that, considering what filth got through at the cinema and on the common theatrical stage, 'if you have a serious idea they are down on it!'[14] The censors retorted by saying that the tube was not the Royal Academy, that the customers who used it were not a discerning 'art public' and that, as a result, it was unsuitable for the audience in mind. They argued 'If we mistook the drawing the public will do the same.'[15] The *Evening News* therefore got an angry letter from Richard's apartment at 295 Euston Road N.W.1, asking why, in a Christian country, was the sight of a crucifix so startling and why, after all the harsh realities of the Great War, did anyone think the British public needed to be spoon-fed, or for that matter, sheltered from a naked women. Though a mark of greatness to be rejected by the Royal Academy, perhaps Richard saw being rejected by the tube as a bit of a blow. Simultaneously, another of his war works, *Harvest of Battle*, was causing anxiety again, so much so that he offered to buy it back from the government. The reason is not particularly clear though his anger is certainly evident in a letter to the Imperial War Museum in which he raged 'there are only two persons I wish to avoid in life one is artists + the other American crooks unfortunately through the IWM I have got mixed up with both – I want to free myself from both'.[16] His request, predictably enough, was denied.

It was time, he concluded, for New York again, though he must now have been regretting the nature of the first impressions he had unnecessarily created there, and wondering how to disarm the critics who would surely be lying in wait. The process began gradually, re-naming some of his works to take the sting out of the anti-American sentiments they had originally carried. *War Profiteers* became *Two Women,* and with it went the implication that Americans had got rich by sitting on the fence until the penultimate year of the war – a debt that the UK, it was anticipated, would not finish paying off until 1984. *Broadway Patriotism* became *Team Work of the Cabaret,* neutralizing an otherwise harmless piece and returning his picture to a safer time when the public had welcomed his dance hall scenes and those of Severini.[17] He also leaned on Eugene Gallatin (who was, after all, the grandson of the US ambassador to the United Kingdom) to try and redress the deteriorating situation with Montgomery Flagg in advance of his return. He sent a letter to Gallatin pleading a terrible misunderstanding:

> He absolutely misquotes me & on this misquotation attacks me. If you happen to know the gentleman I shall be very glad if you will give him a slightly different opinion of me & inform him that I am not the type of man to gratuitously insult Americans, especially after the amazing kindness I received in New York & that I know my manners quite as well as he does.[18]

Next, fresh reports began appearing in the American press as news was leaked in Boston and New York City that the artist was considering a return, charismatically championing his old attitude, 'I am Nevinson and you can all go to blazes.' The American public was advised, however, to keep an open mind about a man who, in whatever medium he worked, was clear-eyed, cynical, sensitive to beauty, sensitive to humour and already a legend for a good reason in Europe. Like him or loathe him, the press warned, he would be back, only this time armed with images of New York presumably to take on the best of American artists at their own game.

It was not going to be as smooth as that however. Unfortunately, many of his key works were committed to another touring exhibition of British War Art organised by the Worcester Art Museum, Massachusetts, in conjunction with the British Ministry of Information. These would be spoken for, for the next two years at least. As this New York show was make or break, however, Richard requested, as Sir William Orpen had done, that his work be pulled from the tour and sent to New York to take a central role in his exhibition there. The organiser, Raymond Wyer refused. He argued, reasonably, that Detroit, Boston, Cincinatti, Chicago, Cleveland and Buffalo had all been promised the full catalogue

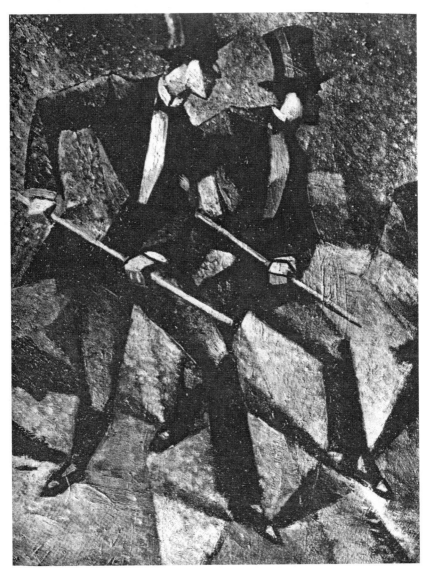

C.R.W. Nevinson, Music Hall Patriotism, *1919*

and should get it. Richard wrote furiously to Gallatin suggesting a dramatic solution:

> Who ever signed this contract (if it exists) had no right to sign away my property – as definitively stated by H.M. Government when sent to N.Y. – & I refuse to be bound by a contract I never was party to. If the Worcester Art Galleries still have the audacity to stick to my work I shall have to come to America

earlier than I intended, find the show & cut out my property
from their frames as all my pictures and prints were my personal
property & for sale.[19]

Wyer told Gallatin 'I cannot help saying that Nevinson's attitude is not
only illogical but distinctly ungrateful.'[20] In the end, the British War Art
show closed early and returned to the United Kingdom, and Richard's
work was sent directly to the galleries in time for his opening. Meanwhile,
Henry had already arrived in New York and there assessed the damage
done by his son's Kevorkian speech and now the Worcester Galleries
debacle. He analysed a deteriorating climate for any sort of triumphant
return, then, at the Bourgeois Galleries, he came across a painter by the
name of Alfred Wolmark whom he saw as a 'serious rival to Rich. espec.
in his imaginative pictures of N. York'.[21] In haste he wrote to his son
who, already aware of Wolmark, was sufficiently confident to blast him,
ironically, for his 'ignorance, arrogance and egotism'.[22] Feeling that he had
done his bit, Henry left the United States bidding 'Good-bye to frequent
and well appointed bathrooms, glory of the plumber's art!'[23] Though
innocuous in intent, his son echoed, and then modified, this simple
sentiment to imply that the American idea of art was a 'well appointed
bathroom' with their Raphael being a plumber. Before his departure for
New York, and describing the entire experiment, which had cost his
entire savings of £1000, as 'a horrible gamble',[24] he opened his studios at 9
Robert Street to guests including H.G. Wells (who purchased a New York
cityscape entitled *Twilight*), William Rothenstein, Viola Tree and hand-
picked journalists from both sides of the Atlantic. To his relief, the press
reported that the show was 'Skyscraper Art by a Champion',[25] while his
fellow artists held a 'farewell' dinner at The Temple, chaired by Chadwick
Moore, to see him on his way. Up beat, and tickled by the orchestra of
a banjo, a whistle and a biscuit box drum banged with a horny-handled
knife by Ethelbert White, Richard could flippantly remark 'life seemed
a jolly business, and well worth the income-tax'.[26] It was a frivolity that
would not last for long.

When Richard and Kathleen got to New York they stayed, he
reminisced, in the love nest of an American millionaire lawyer on the
20th floor of a building without furniture and light, surrounded only by
candles in bottles. A certain Ms Bliss was kind enough to lend them her
box beside the Vanderbilts at the Opera and so, in a typically bohemian,
yet stylish, manner, their visit started well. Richard enthused:

> Today New York for the artist is the most fascinating city in the
> world. She is like a young woman, splendid in the unconscious
> strength of her compelling beauty. Cold and hard, perhaps, but

C.R.W. Nevinson, Twilight, *c 1920*

'Nevinson for New York', Daily Express, *16 September 1920*

only as youth always is. She doesn't sooth the nerves: she stimulates to action. Her abounding vitality is a constant challenge.

Skyscrapers, he went on, were 'the most vivid art works of the day', the epitome of utility, efficiency and the spirit of the age. This, in his opinion, made New York the rightful heir to Venice.[27] Paris was merely a 'grande marquise' who had learned the hollowness of laughter from bitter experience, and London 'a sensible old housewife who goes to bed early [and] has few aspirations . . .'. The 'stormy petrel', as he was described in a South Carolina paper, was back, only this time saying what his audience wanted to hear.

His exhibition, 'The Old World and the New' opened at Bourgeois Galleries, 668 Fifth Avenue on 4 November 1920. It was introduced by Charles Lewis Hind, who made the familiar *crie de guerre*: distancing Richard from 'any possible clique, school, ist, ism, post, neo, pro, anit, academic, un-academic, conventional or unconventional'. This was an artist who sought individuality demanding that the subject should always dictate the method, saying 'I maintain it is impossible to use the same means to express the flesh of a woman and the ferro-concrete of a sky-scraper.' He simply didn't care, he professed, what the 'slimy' salon and academies of old Europe had to say about it.[28] Lewis Hind therefore

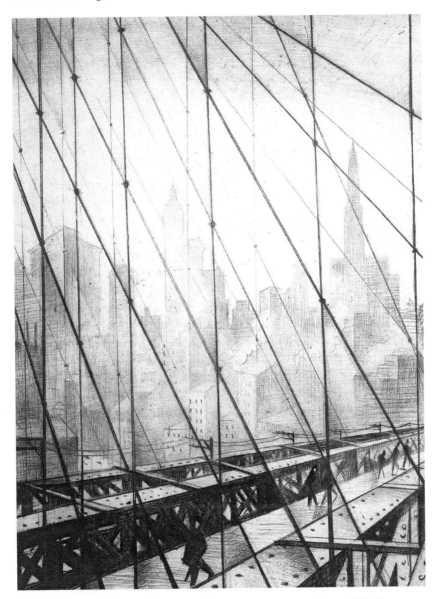

C.R.W. Nevinson, Looking Through Brooklyn Bridge, *1920-2*

could sign off the Introduction of 67 oil paintings and 31 prints with confidence:

> It is something, at the age of thirty one, to be among the most discussed, most successful, most promising, most admired and most hated British artists.[29]

The gallery-goer might then have flicked to the back of the catalogue

to read the artist's own contribution entitled 'My Art Creed'. Here old arguments resurfaced in new clothes in a statement which was signed 'Nevinson – living artist. Devoted to art, past and present, alive to contemporary civilization and barbarity.' Nothing in this would have met the slightest resistance from the New York avant-garde, though there may have been some serious doubts that his work could live up to such proclamations and hype. In fact, Richard's America on display at the gallery represented the user-friendly urban modernity of F. Scott Fitzgerald, the flapper and the speakeasy. His was the world of Jazz and of the Charleston with all its light-hearted, mischievous and sexy connotations, and of the liberated, and voting, 'It' girl. His was the intoxicated, youthful and wealthy white America (which, according to one English clergyman had the 'morals of a pig-sty'[30]), so prevalent on the cinema screens and on electronic advertisement hoardings, which boosted commercialism and consumerism, and took joy in doing so. And his was the modern appearance of New York City, from the streets, from the Hudson River, from the rooftops and from the pedestrian's perspective. The problem was, this had all been done before! So many of Richard's images from New York City gravitated towards those already known at that time, and as often as not, dating to before his arrival, by artists such as Karl Struss, Edward Willis Redfield, Jonas Lie, George Luks, Joseph Stella, Charles Sheeler, and John Marin. Frank Rutter noticed that the artist's acerbic insinuations had not entirely disappeared either in works such as *The Temples of New York*, with the spire of Trinity Church dwarfed by the newly emerging skyscrapers at the head of Wall Street, mirroring spiritual decline and the rise of the dollar worshipper. Another snide comment could be felt in *The Statue of Liberty* (viewed from the top of the New York Railroad Club, which was in turn replaced by the Twin Towers of the World Trade Center), where the subject was barely visible, almost completely out of sight. This beacon of light for millions, for the 'huddled masses', was obscured by the modern architecture which symbolized capitalism and which offered little or no liberty for communists, Catholics, immigrants or African Americans. And perhaps his own eventual isolation could be felt in the un-peopled cityscape *New York – An Abstraction*, the title of which would soon be changed to *Soul of a Soulless City*, veering close to Karl Marx's words – 'the opium of the masses, the heart of a heartless world, soul of soulless conditions'.[31]

Some popular critics were happy to give him the benefit of the doubt, referring to him as 'a man with an idea . . . an artist of a new generation . . .'.[32] But this, Richard would have been aware, was in an error riddled article that praised Roger Fry as the head of the pre-war Futurist movement in London; which accredited the latter with starting the Rebel Arts Centre with a certain N. Windham [sic] Lewis and which also claimed that the

only artist he had not fallen out with was M. Matise Severini. In other words, the writer knew nothing of his subject and was hardly to be taken seriously. In other reviews, versatility, variety and adaptability seemed to be adjectives applied to his work in place of alternatives, which could have talked of inconsistency or artistic meandering in pursuit of public acclaim. Serious and specialized journals were more forthcoming in expressing a note of concern, and demonstrated that they were not blinded by the high publicity declarations of the new arrival. Instead they warned:

> his admirers should sound a note of caution, for it must be confessed that despite this versatility and undoubted ability, the present display gives somewhat an impression of a youthful ardor still floundering around and groping, if forcibly, for a more safe and surer pathway to success. [33]

Richard knew that, despite the bravado and early optimism, this was not going to work. He was right – the exhibition was a total failure. The trouble had started, he wrote in his autobiography, in the Café Royal in London, where somebody claiming to be him had given a full interview to an American journalist for the price of a dinner. The fraud had said some lively things that had made it across the Atlantic before him; hostility awaited him from the moment he arrived. Secondly, a coloured elevator boy in Manhattan, charged with the job of stamping and posting the invitations to the show, had stolen the cash and binned the invitations, resulting in an 'absolutely empty private view'. [34] Lastly, with typical Nevinsonian pomp, he said the real problem lay in the jealousy of the New York artists, galled that this Englishman was not only the first, but the best, artist to tackle the wonder of *their* city. His enemies, he wrote, 'are just beginning to find their jaundiced spittle, I expect to be drenched soon'. [35] Soon, the affair was wound up in his autobiography with the statement that '[I] was treated as though I had some form of infectious disease'. He left for England 'second class, with Italian emigrants, wounded, disappointed, insulted'. [36] With time to reflect he probably concluded that he had suffered a variety of events, the first of which he diagnosed as a downturn in the US economy

> due to the strange, panicky, neurasthenic condition of last year's wealthy Americans, who, not content with the gold of Europe on their shoulders, still whined of poverty in their concrete palaces. [37]

He might have got the idea from John Quinn, who had written immediately to him, and sympathetically this time, offering his condolences:

> You, unluckily, have against your exhibition what is almost a panic in the country, at least a panic in the stock market and

also in the commodity market. . . . It may be [a] consolation to you that you have been, more or less, a pioneer or prospector, in holding your exhibition here and pioneers and prospectors do not always strike it rich first time.[38]

He may have got caught up also in the anti-British mood in the east coast cities following Lloyd George's handling of the Irish bid for independence, and the behaviour of the Blacks and Tans. Or perhaps – he would have been loathe to admit it – memories of his arrogance on the previous visit remained. Whatever the cause, he would not accept this passively. He started burning his bridges on his arrival back in London. His first attack came, quite surprisingly, on the editor of *The Sun* who had previously written of Richard 'We too have cubists, clever as he, but we haven't a public as clever as his to be amused by them.'[39] That was forgotten now, replaced with:

> I admit I have exhibited in the Holy City of God's own country but I can assure you it was only at the invitation of dealers & not even they or wild horses would drag me over there again to be insulted by yapping chauvinists & bragging boosters.
>
> I admit in my case I unknowingly infuriated the "citizens" because I had painted the holy city & American painters hardly at all. No wonder Whistler, Sargent, Abbey, Shannan, Epstein etc prefer London & we do not insult painters because they came from other cities – God what a people. However, I can assure you I do not seek world fame I merely wish to paint a good picture (& sell if possible) but I would sooner show my pictures to the Sahara desert or the restless waves of the Atlantic than again to the neurotic, jaded inhabitants of your so-called "young country"
>
> Good bye "Old Man"
> Yours sincerely
> Young Nevinson

Neither did he let up there, continuing publicly in an article called 'Marble Baths Instead of Art', declaring 'I hate the mob and most of all our present day Americanised "Civilisation".'[40] Then he went the full nine yards, saying that America suffered from an 'Uplift of Orgy and Optimism' in which they believed their shallow advances, not least the prohibition of alcohol, to be on a similar scale in their contribution to the development of Western Civilisation as the death of Socrates and the crucifixion of Jesus Christ. Their art, he felt, was 'neck and neck with Patagonia', and their inability to differentiate between 'value' and 'worth' the cause of their preference for gramophones instead of concerts, and illustrations instead

of art. Though London was, in his summation, awash with 'American bar tenders, banjo syncopators, and other Negroid noises', and Paris reduced to a 'wet suburb of New York', he continued with missionary zeal, telling his audience 'Don't you worry, the Americans like being kicked. That's how they are going to learn in the end.'[41] In return, the American press hit back, now with the gloves off, saying 'Mr C.R.W. Nevinson reminds us of many things, particularly of the cuckoo – the bird that doesn't lay its own eggs.'[42] Having suggested that plagiarism was his only real *métier*, they compared him to a honey bee swarming around taking honey from all the open flowers, before accidentally flying into a bottle where everyone could laugh at it buzzing around and getting nowhere. They signed off dismissively saying 'American art of today may fall twenty years short of expressing the ideals and tastes of Europe. But we don't care. Our ideals and our tastes are not Europe's and they probably never will be.'[43] It was becoming very clear that he was destined to forge his future in London, and there he might yet, if he sold the American experience with a slight spin on the truth, get away with being seen as a exponent of the age; then again – the artist who, once again, had been 'to the front', had seen it with his own eyes – and been victimised for his pioneering vision. Surely he knew more about the Original Dixieland Jazz Band, Will Cook's Southern Syncopated Orchestra, and the new dances and fashions seen at the Hippodrome, the Palladium and the Hammersmith Palais, than any other artist in London. Annoyed, ironically, by the racket coming from a newly opened nightclub on the Tottenham Court Road, Richard and Kathleen moved to Steele's Studios, Haverstock Hill. This was to be their permanent residence for the next quarter of a century. London he concluded, after all, was the right place to be, even with all its faults. Through Richard's eyes, the geographies of art elsewhere made grim viewing, as the United States was 20-30 years behind London and inspired little originality of its own; Paris had become too professional and had even come to embrace the dreaded Fauves; Russia was no more than 'pitiful'; Germany was at least hungry (the British blockade was still intact) and therefore genuine; and Dada, he felt, delivered 'a great yawn of disgust' a 'gigantic human nihilism', though he knew that, like Futurism, it could not last for long. In fact, in an interview on a café terrace in Montparnasse, despite all earlier pleas for individualism (and probably thinking back to the days of the Rebel Art Centre), he encouraged artists to unite, to pool their talent and inspiration, and collectively to make London the capital of the art world again. He knew that it could be done, if only they could feel hunger, or anger, and abandon reclusive experimentation and obscure techniques in favour of an art that spoke a language people could understand to express a relevant point. But his plea amounted to nothing and he lamented 'You

cannot make a movement by yourself'. He concluded his diagnosis: 'They [English artists] are a set of snobs.' When asked whether or not there might one day be an artists' union, he laughed and said 'You might as well talk of a teetotal Scotsman.'[44] A decade later Herbert Read would complain of the same thing when, at the height of his influence, he wrote '... we have no cohesion; our artists do not make a programme, do not present a united front or generate a common intensity of any kind'.[45] Little wonder then that in his autobiography Richard wrote of the period:

> My health started playing me up again and my nerves were all awry. I was overwhelmed by a feeling of futility that dried up my creative urge. The black pessimism to which I am always liable engulfed me now.[46]

A letter to Nancy Cunard in February 1921 rather confirms this sense of isolation and frustration. In it he described himself 'As one who has ruined his health and happiness & lost most human respect by boiling with rage over impersonal and abstract injustice, in humanity & their basic terrors.'[47]

Sales, or lack of them, were becoming an enormous concern too! Though he had had two full rooms of his work displayed at the Manchester City Art Galleries as part of a larger exhibition which over 27,000 people had attended over seven weeks, he still made no money. Elsewhere the story was similar with his work on display at the Senefelder Club, the Grosvenor Galleries, the Brown-Robertson Galleries (NYC) and Keppel's (NYC), none of which produced any sales. So grim was the situation that in a press interview Richard declared that he had made only £300 in four years which, while bad, was still not quite as desperate as his old Slade peer Adrian Allinson, whose wife had taken to parading up and down Oxford Streets wearing a sandwich board advertising her husband's work. Henry helped out when he could, buying his son's work, or encouraging others to do so, whilst inviting other artists of note, such as Paul Henry, to dine at Downside Crescent, perhaps to instigate some innovation or fire up some enthusiasm. But the reality was clear – Richard was no longer making a living from his work, and so it might have been Henry who suggested, at least in the short-term, a recourse to journalism and commentaries on art designed for a less lofty audience. Indeed, a new demand was opening up for a 'mezzobrow' culture (so very different from Henry's medium) that would appear in newspapers, not so much as news, but as gossip columns or talking points, penned by significant (and preferably controversial) public figures who could, in return, command up to £2000 a year. Under the threat of financial ruin, Richard wrote a series of such articles on English women's ankles (while bad, thrirs were mercifully better than those of the

French or the ladies in Czechoslovakia), and interviewed society beauty (Miss France) in French at the Gaiety Theatre where she was appearing in *Pins and Needles*. Kathleen and he made good press too, with newspapers (with circulation often well in excess of a million copies) reporting their attendance at society events such as the wedding of Violet Selfridge to Viconte Jacques de Sibour at the Brompton Oratory, the opening of *The Edge O' Beyond* at the Garrick, and even his being a fancy dress judge at the Everyman Theatre. It was, however, in the mind of the critic of the *Daily Mail*, a sorry affair for an artist who could yet be compared favourably to Picasso, and might even be the real survivor of the two, if the Spaniard's recent show at the Leicester Galleries had been anything to go by. Commissions for Tube posters such as *Lovers*, *Walkers* and *Lovers' Lane* were also accepted, and some elements of the press seemed to like the move saying 'It is plain that Mr Nevinson has decided to sacrifice the lofty tenets of modernism to artistic grace and easy delicacy. His many admirers will welcome the resolve.'[48] They continually reminded the British public, as if they needed reminding, who he was, or at least who he had been, though the facts (as they so often would) got twisted. This, they said, was the artist who had nearly been shot by Australian troops on the Hindenburg Line,[49] and the young bohemian who had spent seven years (no less) in Paris soaking up all it had to offer before the war.[50] No wonder they covered his speeches at the Publicity Club of London ('How and Why Commerce should make more calls upon the Artist'), at the Ham Bone Club ('Bohemian London'), and noted his presence at a party given by H.G. Wells, in which 'the high priest of absurdities'[51] was far from overshadowed by the other guests which included G.B. Shaw, Lady Ottoline Morrell, the Arnold Bennetts, the Mastermans, Countess Russell and St John Ervine. The *Daily Express* marvelled in its report of the evening and told the readers 'It is enough to make would-be founders of literary and artistic salons weep with envy.'[52] Richard's use of the press rapidly became wily and calculating, a skill he mobilised with increasing frequency for his benefit, for example, when the authorities at the Louvre, on seeing the exhibition catalogue from 1916 which had read 'C.R.W. Nevinson – Late RAMC', assumed, reasonably enough, that the artist was dead, and hung two of his works – a privilege afforded to no living artist. As a result of this mistake Richard could claim, and he did so widely, that he was perhaps the only living artist ever to have been hung in the mother of all art galleries. To his enemies, however, it was just another cheap trick and an indication of the lengths to which he would go to secure press coverage before his next Leicester Galleries show, with Eric Kennington. No matter – the press loved him and they reported, again with a reference to Whistler, 'Mr C.R.W. Nevinson is qualifying as a past

master in the gentle art of making enemies'.[53] There were times too when he out-Whistlered Whistler, especially when he claimed that the new art movements, especially the Bloomsbury Group (Roger Fry had just published his influential essay *Vision and Design*) in their puerile quest for labels and their high-brow 'amateurishness and attitudinizing', displayed only vulgarity which could (and should) be parodied and ridiculed publicly. In a nutshell, they, and other groups like them centred around Chelsea, were dismissively and disrespectfully satirised by Richard into the following categories:

DADAISM – 'The gregarious striving for peculiarity and *nouveaute* which has ended in utter monotony and the loss of individuality.'

GAGAISM – 'The international curse of the senile, who dominate all official art societies, especially in France.'

PAPAISM – 'The paternal patronage and fostering of the good boys of the Slade by the New English Art (Teachers') Club.'

MAMAISM – 'The tedious maternal boasting of Monsieur Clive Roger of the angular, deformed babe, christened post-impressionism, which is slowly dying in the grimy atmosphere of the London Group.'

BABAISM – 'The propagandist sheep who bleat of pure art and significant form and bleat inanely for little periodicals.'

TATAISM – 'The tendency of most of the moderns to group themselves together, only to break away with loud and abusive farewells.'

His own work, on the other hand, was different and he signed off confidently saying 'I hope my pictures make it clear that I paint what I love, how I like, for the joy of painting – a motive so rarely suspected in living artists, either by the public, or by its echo, the journalist.'[54] At least, he was professing honesty, sincerity, beauty and passion in his work, a rare attribute that he felt kept in keeping with that of Vermeer's *Girl in the Blue Turban*, better known today as *Girl with the Pearl Earring*. His art, he believed, staunchly defended these vital criteria which had been almost entirely forgotten, in a society where taste and judgement had become slaves to fashion and cliché.

He was quietly aware that the Leicester Galleries show was going to be a cross-roads that would see him staying in London, if successful, or finally packing up and moving to the fashionable hub of Cannes in the south of France, in the event of failure. It was all too clear to friends and foes alike, and indeed to Richard himself, that, while he was becoming the man-about-town and the celebrity with an undoubted

sense of humour, he was also seen to be without a real future as a serious painter, with a bank balance to match.

As it turned out the opening of the Leicester Galleries show was another, perhaps unexpected, triumph, crammed to the doors by notables such as Sir Philip Burne Jones, Princess Antoine Bibesco and Dowager Lady Lytton, in what was heralded as one of *the* events of 1921. The press loved it and was there in force to capture high society, and hopefully a few outlandish comments, as well as to look at the 41 oils and watercolours on the walls. Many continued to see his eclecticism as a strong point, and so comparisons emerged between his works, and a wide range of others, including Cameron, Marchand, Derain and Crome.[55] Some felt that he might be the natural successor of Lavery and Pennell, and in his portraits, a worthy successor to Holbein and Augustus John.[56] The *Daily Express* placed him shoulder to shoulder with Toulouse-Lautrec and Matisse, claiming that, by quite some way, this was his best show yet. He must, momentarily at least, have felt vindicated in his insistence on not being bullied into a trademark style, especially when a published review claimed that he was quite right not to shut 'himself up in a prison of his own making'.[57] He must also have felt that post-war England was in fact looking up a bit as there was room for a modern artist, with the faculty to meander through styles relevant to the subject of the modern world and with the competence and versatility to do so. His father did not agree, not publicly anyway, and felt that his son's name was carrying the day as opposed to his painting. Though elated at the success of the exhibition he could truthfully only vouch for about half the paintings there, which he believed to be first rate.[58] He knew that the critics in the more serious reviews would also castigate his son, and this would wound him deeply, as always. It was pure veneer that made Richard say 'I never think anything of a picture till it's been condemned by all the critics'.[59] P.G. Konody was the first to do so, launching an attack, caricature and all, in the *Daily Mirror*. Others soon followed. Even if Richard could hide from his critics, he could not hide from the reality that after the first fortnight only £200 worth of work had sold, and this for the travail of two complete years. Kennington, in the next room, had had no such problem and 'sold' was written on almost every work (mostly portraits) exhibited there. It seemed that, although people were keen to attend a 'Nevinson show', to look and comment on the pictures and to be seen to be amongst his high society guests, few were actually prepared to buy his work.

At the time of his New Years' Eve studio party at the end of 1921, Richard must have been quite confident that he was not as yet a 'has-been', but also aware that his notoriety as an artist was still based on

a fast waning momentum gathered during the war years. As a social commentator and as an analyst of all that was happening in the art world, he was certainly in demand, and valued, not least as he was clearly not afraid to condemn or criticize anyone who crossed his path. His work was not matching this, however, and soon, he knew, he would lose the right to possess the strong opinions that were keeping him at the heart of the cultural landscape of England in the 1920s. His significance, and problematic status, was perhaps captured best in an early draft of T.S. Eliot's monumental *The Waste Land*, which read:

> He, the young man carbuncular, will stare
> Boldly about, in 'London's one café',
> And he will tell her, with a casual air,
> Grandly, 'I have been with Nevinson today.'

Why did Eliot include his name specifically and what did the inclusion really mean? And why did the harsh edit of old stable mate Ezra Pound, ensure that the same name was removed, and the verse re-composed to read:

> He, the young man carbuncular, arrives,
> A small house agent's clerk, with one bold stare,
> One of the low on whom assurance sits
> As silk on a Bradford millionaire.[60]

There, in a re-written stanza, was the post-war dilemma of Richard. A celebrity of iconic status, a cornerstone in London art, yet a character whose permanence was doubted and therefore whose inclusion was not deemed a long term investment. He, like the war, might yet be consigned to a definitive past as 'his finest pictures had for their subject something that everyone was under an almost irresistible compulsion to expel from their memory'.[61] To have been selected by Eliot as the one and only contemporary reference in the poem said a lot. To have been deleted by Pound, perhaps, said even more.

10
'The Playboy of the West End World',[1] London and Paris (1922-25)

As the darling of the press, the after dinner speaking circuit and the society set in general, Richard now wrote and spoke with typically biting commentaries on, amongst other things, a dormant culture within a philistine capital city. London, he observed, was a mausoleum after 7.00 p.m. despite some relaxations of DORA. As a result, tourism had declined from the pre-war years, when at least you could get a drink. 'For heaven's sake,' Richard appealed to Lord Byng (the Chief of Police) 'give London publicans and sinners'.[2] His uncompromising attitudes were also evident when he served on a committee with Frank Brangwyn, Edwin Lutyens, Arnold Bennett and Laurence Binyon to prevent the London County Council from widening Waterloo Bridge (a favourite subject of his), which he argued should instead be demolished and replaced by a new one, so as to avoid the permanent agony of looking at the masterpiece desecrated and vandalised.[3] Sometimes the lunges were too generalised, the criticisms tactless and wildly sweeping when, for example, as Vice-President of the Brighter London Society he called Manchester 'a black monstrosity' and Wigan 'the revolting product of greed, wealth and the hideousness of self'. Sitting alongside the Bishop of Birmingham, Lord Curzon and Mr Gordon Selfridge, he campaigned for the eradication of foul factories and ugly buildings. His Futurist days were clearly a distant memory and his new attitude doing nothing to endear him to people living in the north, one of whom replied sardonically, 'Man cannot live by art alone'.[4]

Richard kept the parameters of his published commentaries wide, and turned next on the Church – this more in keeping with his own area of expertise. Westminster Abbey, he said, was more like a department store or a warehouse than a church, and should be 'cleared out' of all the memorial statuary, which obscured its original beauty.[5] Thaxted church in Essex, on the other hand, in all its humility and simplicity, was the epitome of both taste and beauty. Further attacks were soon to follow on the Bishop of Chelmsford, who had observed fearfully a resurgence

C.R.W. Nevinson, From Waterloo Bridge – the Sun Bursting through Fog, *unknown date*

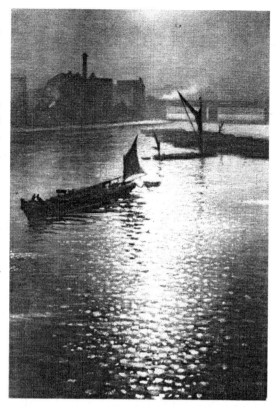

of paganism in England. He was taken to task publicly by Richard, who argued that if only this were the case the future would be bright indeed. This was, after all, the context in which Homer, Plato, Praxiteles, Socrates and Demosthenes had emerged.[6] Instead of living in an age that worshipped the spirit and the brain, as pre-Christians had done, the present day offered only unthinking doctrine, and worse, American-ism, which worshiped nothing except the dollar. Galleries too, in particular the Tate, were attacked for showing modern students' work while refusing a Cézanne on the grounds of lack of space. In some cases the focus of his attack turned to the pointlessness of art schools, which were populated with 'giggling girls' (Carrington had apparently been forgotten), and where, he claimed, the teachers just turned out more teachers, 'breeding dilettantism – the curse of art and the most depressing of all vices to fight'. America's 'hundred thousand million art schools' and dealers who bought only dead art from second-hand auction rooms in Europe, represented, in his view, the bottom of the pile. Would it not be better, he suggested, to channel funds into educating the public to appreciate beauty, as that was the only way for man to be saved from 'being the most loathsome and revolting of all living things'? The uneducated and philistine masses were now, in his opinion, strangling beauty and any hope of survival for the struggling artist.[7]

A counter attack was imminent, and when it came the press turned to mock the legend who, they said, had made up to £2000 a year as a 17-year-old student, but was now broke. The Nevinsons, they chided, did not pay their bills until they went a vivid scarlet colour, whilst the creditor

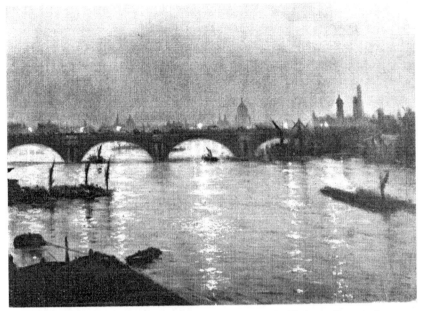

C.R.W. Nevinson, Waterloo Bridge – Summer Twilight, *unknown date*

himself went an equally impressive blue. There was some truth in this and yet Kathleen, loyal as ever, even wrote an article called 'Where it Pays to be Poor' for the *Daily Express*.[8] Another paper reported that she made all their own clothes, while her husband had converted to watercolour painting because it was cheaper than oil.[9] Lacking in sympathy, however, they finished with 'Mr Nevinson, if he cannot live by art alone should give it up and try something else or hang on and starve until better times arrive'.[10]

This was all fine – light-hearted engagements and harmless brawling on issues of the day. Behind the scenes however relations with the Tate, the Royal Academy and the Bloomsbury Group continued to spiral to the point that soon Richard became convinced that he was under siege from all those around him. Henry wrote in his journal in early 1922:

Richard came to lunch, still irritated and discouraged at persecution by Tonks, Muirhead Bone and the Chelsea Art Club . . . he is sad under the hatred of old friends.[11]

The NEAC was causing problems too, when the selection committee accepted some of his recent work, only to have the hanging committee, which included Bone, Tonks and McColl, reject it. Unable to contain his frustration any longer he left all ambiguity behind in an open letter to the press, which said 'Everything ought to be done to prevent a man becoming an artist – it is like being an old clown in a dead circus.' Now, he claimed,

Only hideousness is wanted. This especially is an age which prefers gramophones to symphonies, films to drama, snapshots to portraits, hotels to homes. Beauty is tolerated as a useless and genteel hobby for a man with more money than sense.

Reiterating that he had made just £300 in the last four years, so a little over a pound a week, he concluded that the only way he would ever be appreciated would be by dying. This was an idea, he claimed, that Rupert Brooke, Henri Gaudier-Brzeska and he had all discussed, and, sure enough, now that they were dead, they had achieved 'value' beyond their wildest dreams. Of Brooke, he said, 'His crime was that he was alive', but by dying he entered into the Cult of the Rare, and of Gaudier Brzeska he asked how else would he have got from working under railway arches to the Victoria and Albert Museum? [12] In fact, he hastened to remind his detractors, he himself had been accepted into the Louvre when they had thought that he was dead.[13]

But this romantic veneer was thin, perhaps unconvincing, and there were those who were quick to remind him that his paintings were not selling because the public did not like them – and they would continue not to like them until he did something to change the path he was on.[14] In short, if he wished to be considered an artist of merit then he would have to remain an artist of merit in his own right. Though Richard's paintings had made it onto the cover of *Drawing and Design* twice (January *Americanism* and June *Henley*) Henry was concerned that his work had become 'unimaginative and unworthy', recognising now with certainty that his son's genius had been fired by struggle and the passionate feelings aroused by conflict. He, or his art, was failing to seriously re-engage and Henry knew that simply lambasting those around him was no foundation on which to build, or rebuild, a career. Optimistically he offered to take him and Kath to Dublin, to the ferment of civil war, and there rouse some humanistic or national sentiment – but to no avail. Even the assassination of Michael Collins in Cork, and the execution of Erskine Childers, all of which would have been grist to the mill for the artist in years gone by, and which now affected Henry profoundly, made little impression on Richard. Neither did the looming war between Poland and Russia, nor the possibility of Austria joining a Czecho-Hungarian Federation, fuel any desire to return to the thick of things. Quietly Henry must have regretted his inability to whet his son's appetite for important subjects in a year that saw Mussolini's March on Rome, Gandhi's imprisonment by the British, the establishment of the USSR and the struggles of the Republic of Turkey. Even if Henry, in a letter to Phillip Webb, could say that 'it is always rather hard for me to

Mr. Nevinson painting a scene viewed through the window of the caravan.

Bunks, convertible into lockers in the day time, are provided for sleeping.

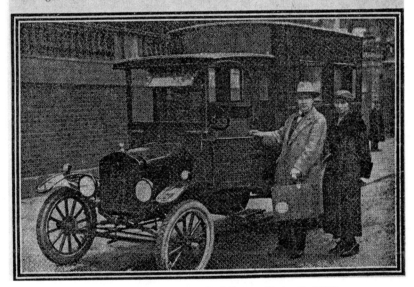

'Artist Caravanner', Daily Mirror, *18 April, 1922*

live in peace unless there is a war',[15] the same was clearly not true for his son – at least not any longer. Instead, Richard continued with his boorish attack on the British public, who 'live like pigs', wallowing in a risible society that relegated everything to third rate; and to which he offered the antidote: 'All democracy wants is destruction.' Though his parents had always encouraged reform, protest and outspoken criticism, they would hardly have condoned this. Back on safer ground he asked how art could survive in an environment where the population had houses in which 'The skeleton in the cupboard is a joy compared to what they put on the walls.'[16]

It was time, P.G. Konody, Charles Lewis Hind and even Clive Bell suggested to Henry, for Richard to leave writing alone for a while. Henry would most certainly have agreed and heaved a sigh of relief when his son agreed too. In a knee-jerk reaction, perhaps an over-reaction, Richard actually gave up on London entirely, and instead, purchased a specially converted motor caravan (which was to become his post-war trademark), and headed for the countryside.[17] The press, of course, loved it and published photographs of him lying down in it, posing in front of it with Kathleen, at the wheel like in the ambulance days, and presenting him as a motorised, perhaps Americanised, Augustus John. They also carried interviews in which he said that travelling was the key to success, and talked of how he would work through a closed window – just like the *grille* of the old masters. The *Daily Mirror* sent him on his way rather cruelly, however, with the advice that he should stitch all his unsold canvases together and have a tent to go with the caravan, which, unlike his painting, would at least be useful.[18] Of course Richard would not let his distress be seen, and instead took H.G. and Jane Wells motoring around the Chalfonts, threw a large drinking and dancing party at his studio (the spoil-sport limitations of DORA could not reach him here) at which the Who's Who of London society was present, and exhibited at the Lefevre Galleries in the heady company of Courbet, Monet and Renoir.

When he came back, his exhibition of etchings, dry points and mezzotints at the Leicester Galleries – outside which, on Leicester Square, the caravan was parked – was an unexpected success. He sold 64 etchings, generating £1,200 worth of business, of which Richard grossed about £400. The press eased up on him too, welcoming his work fairly warmly, but only in the circles that were now regarding his return to convention as their victory over the impetuousness of his own youth. The *Morning Post* gave him a resounding pat on the back for abandoning his quixotic course of old:

> He is still venturesome, as becomes one of his mental activity, but instead of tilting at windmills set on Cubistic heights, he has cast aside his blunted lance, and is now plodding hopefully and happily, to judge by his work, along old paths, which though well researched, have still much beauty to reveal to inquisitive eyes.[19]

As far as the public was concerned this was still the same self-confident artist, and loose cannon, that they had come to expect. It simply wouldn't be Nevinson if he was not attacking someone or something; taking on enemies he could never defeat. The blunted lance, despite optimism to the contrary, had clearly not been set aside. At home, however, the situation

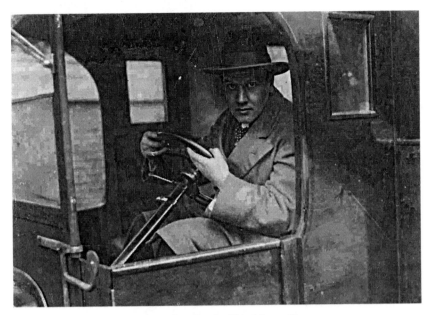

Nevinson at the wheel of his Motor Caravan

was far from humorous and deteriorating rapidly. Henry observed that his son was now 'in a very disagreeable temper – unwilling to listen or be pleased',[20] and knew also that such disenchantment and frustration could hardly stay under wraps for very much longer. Neither did it, and soon further spectacularly un-diplomatic attacks were launched again at the art world, the British public and the eternally unforgivable Americans. Sensing the newsworthiness of the relapse, the *Daily News* called him at home in search of an eye-catching headline. They got the following:

> We are all becoming Americanised. You see it everywhere. America, America, America – always creeping up – creeping out of everything – hot baths and hotels – money for everything except pictures – America, America, America! Everywhere, over everything.[21]

Richard did not stop there and went on to observe that art itself had been dying since 1870, and would survive only 20 and 30 more years before complete extinction. This, according to his theory, was because rich people, or at least the detested *nouveau riche* (the type which had recently taken to hopping around on pogo-sticks), hated beauty and suffered from an ailment of his own invention called 'Megaphonia'. The helpless artist was, as a result, now adrift in a modern aesthetic wilderness where 'The most destructive person alive is the utilitarian, and the most useful person is the thinker or the artist.' Even after a war fought for

civilization (or so the public had been told), money was leading to 'a poverty of existence' in which valuing art required no more aesthetic sensibility than that possessed by a racehorse tout offering good tips at the track. A ticket to the movies (or the 'shakies' as they were sometimes known) to see Fatty Arbuckle or Felix the Cat was something with which he could not compete. He signed off by saying that he was not in search of sympathy as he had had the life of a prince intellectually, ignoring a public who insisted on the 'worship of the sparking plug', and who seemed content to live in 'the monotony of mediocrity' that the post-war world had created.[22] H.G. Wells may have written in *Cassell's Weekly* 'I would rather be C.R.W. Nevinson than H.G. Wells', but by the end of 1923, much of Richard's celebrity, and relevance, came from events and commissions far from the 'highbrow' galleries. In fact, as W.B. Yeats picked up his Nobel Prize in the same year (George Bernard Shaw had got his the year before), Richard might have felt himself out of the big league, and drifting rather uncomfortably towards the other literary event of the year: P.G. Wodehouse's *The Inimitable Jeeves*. The *dilettante*, the giver of parties, the central celebrity with his fashionable wife without whom no London party was complete, was beginning to realise that in the absence of any serious painting, only his celebrity remained. Henry, loyal as ever, commissioned him to paint another portrait for the cover of his up-coming autobiography, but confided in his diary, 'He finished the head and I suppose it is good though I myself should hardly have recognized it.' When he saw the finished piece he wrote, 'I wish I could like it';[23] it was 'very unlike me and unpleasing, bad for him as for me'.[24] He wrote to Phillip Webb, 'Alas! I agree about the cover [of the book]. Richard has done some excellent portraits, but this is not one, though he and the publishers unfortunately liked it. I'm terribly afraid it might do him harm and he is so easily discouraged.'[25] But not everyone was pessimistic about his new direction, and his portraits in particular. American novelist, and future Nobel laureate, Sinclair Lewis, author of *Main Street*, *Babbitt* and *Arrowsmith*, wrote to his own father telling him excitedly that he was having his portrait painted by 'one of the best painters in England'.[26] In *Arrowsmith* itself the protagonist listened to a cultured character called Gustav Sondelius who 'talked of Shanghai and epistemology and the painting of Nevinson.'[27]

Attending premiers in the West End; writing a few tongue-in-cheek articles under such headings as 'Are Women's Fashions Immodest' and 'Women are Getting Uglier, says Mr C.R.W. Nevinson'; providing the dust jacket for Ronald Firbank's *Flower Beneath the Foot*; attending the premier of *Outward Bound* by Sutton Vane at the Everyman Theatre and being artistic consultant for the play *The Daredevil* by Bertie Mayer

at the Strand Theatre, may all have helped to pay the bills, but they were hardly commissions that would maintain the serious status he had once commanded. On the opening night of the Tivoli's conversion to a cinema he joked nervously that the process of watching salmon tirelessly leaping, and failing, was 'My life all over'. As Henry set off to Germany to report on a year that would witness the Kapp Putsch, the Sparticists Revolt, the Hyperinflation crisis, the Red Rising in the Ruhr and indeed Hitler's own Beer Hall Putsch, Richard was firmly sidelined at home, and apparently by his own choice. What an opportunity was surely missed for the artist, who had tackled the war to end all wars, to have given pictorial expression to the peace to end all peace. Worryingly, long-time ally and connoisseur Frank Rutter continued to publish pessimistic, and hurtful, articles with titles like 'Is Nevinson a Great Artist?' – rather than advocating this as an assumed truth as he had done so often in the past.[28]

Perhaps it was his father's influence, or just the cul-de-sac he now found himself in, that drove him back to the comparative safety of the war subject, even though he had vowed to leave this behind forever. This was at least a platform on which he had once been an enormous success and one on which he had earned admiration and respect worldwide. Now, in returning to it, after an absence of five years, he harnessed a new anger and potent frustration to his subject, for a world that had so willingly accepted the great sacrifice that so many had made, and then used it for self-satisfying ends. If he had not as yet felt, or benefited from, the peace – the great victory that had cost over 700,000 British lives – he could hardly be expected to make it the focus of his work. In fact, Henry was to see the new all consuming cynicism and anger on a visit to his son's studio, after which he wrote:

> I went to see his 3 satiric pictures. 'Success' which I know, and indeed named, 'Hats off' – two out of work soldiers singing, and 'Glittering Rewards' his fine sketch of the wounded and dead at Passchendaele, with the addition of a glass of champagne, supporting two smoking cigars in the sky, gleaming like the Holy Grail. <u>What a row there'll be.</u>

The controversial title, *Glittering Prizes*, came from the ex-Lord Chancellor's (Lord Birkenhead) Rectorial address at Glasgow University, which, to Richard's anger, suggested that 'The world continues to offer glittering prizes to those who have stout arms and sharp swords'. In response, Richard cynically entitled his new canvas *Glittering Prizes: a Peace Memorial to our Heroic (After Dinner) Speakers from a Few Unknown Soldiers*. The central Passchendaele scene was displayed in conjunction

In his forthcoming exhibition at the Leicester Galleries Mr. C. R. W. Nevinson (left), who was awarded the Mons Star in the war, "goes for" the much-discussed speech in which Lord Birkenhead said, "The world continues to offer glittering prizes to those who have stout arms and sharp swords." Above is one of three pictures to which the artist gives the title "Glittering Prizes." The title of the picture is "A peace memorial to our heroic (after-dinner) speakers from a few unknown soldiers." It was in his Rectorial Address to Glasgow University that Lord Birkenhead used the phrase "Glittering Prizes." There is a probability that exception will be taken to the inclusion of a wineglass and cigars in the picture shown above.—(Daily Sketch Exclusive.)

Lord Birkenhead.

Glittering Prizes', Daily Sketch, *11 March 1924*

with two others, triptych style, entitled *Success* and *Yes, and They Still Have Their Hats Off.* In the former, the rich were parodied as beneficiaries of the war, gilded and corpulent profiteers; in the latter, those that had actually fought, were now scroungers, begging and busking for a living, cap in hand, as parasites on the London streets. Immediately, Birkenhead's lawyer wrote to the gallery and the paper with threatening language, but suggested that, if Richard could be talked into painting out the cigars and the champagne, which hovered over the battlefield, perhaps all could be forgiven. Henry wanted to ignore the offer. He recorded in his diary, 'I should have called Birkenhead's bluff. He would not have dared to bring an action.'[29] But Richard, perhaps exhausted by controversy or perhaps in fear of a libel suit which he could ill afford, replaced the champagne and cigars with a Verey Light and re-named the composition *Peace*. Far

from ducking behind the parapet though, Richard was clearly setting out to stir up a fuss in his new Leicester Galleries show, entitled 'England'. The alterations, typically enough, were dramatically made at the very last minute, with some papers reporting that he had painted out the offensive references in the gallery itself as the series of three satires hung on the wall ready for exhibition. The *Daily Dispatch* concluded excitedly that 'The Press Censor has very plainly been at work',[30] while the *Morning Post* clearly saw it quite differently in an article entitled 'Senseless Satire', which concluded 'he has not wholly rid himself of the juvenile kinks that used seriously to affect his mental outlook'.[31] The *Sunday Chronicle* critic lamented, 'I fear that Mr Nevinson is not taken quite so seriously in the art world as he used to be'.[32] When Granville Fell called him a 'pavement artist' Henry could stand aside no longer. He wrote to the critic, telling him to withdraw his comments, which he did. But this only led to a new paranoia. Henry wrote, 'Richard perceived only new danger – critics saying he got good notices only through my influence'.[33] Another commented, perhaps smelling a rat at all the controversy that seemed to perpetually surround the artist's name, 'Mr Nevinson . . . knows that an artist sells more pictures by furnishing subjects for dinner-table talk than by beautiful paintings.'[34] When all was said and done, Richard must have felt exonerated when the painting was bought by Field Marshall Joffre for the French nation. The French, unlike the Americans and English, were at least, in his opinion, a fair and cultured people.

The opening night audience at the Leicester Galleries included the usual array of glitterati, including Princess Marie Louise, Lady Patricia Ramsay, the Duke of Marlborough, the Sitwells and Elisabeth Robbins. Kathleen, wearing a Chinese coat of gold and black, and a black felt hat trimmed with a heliotrope ostrich feather, was very much the artist's wife; with the latest Parisian 'bobbed' hairstyle, captured in a *Portrait of a Pretty Girl*. (See page 59) The eventual arrival of a cheque for £600 in sales, for the work of two years, though modest, was just enough to make Richard believe it was worth fighting on for a while longer, but hardly bridged the ever-present (and frustrating) gulf between being busy and making money. Remaining pragmatic he accepted many more diverse paying commissions, such as the 'Home Counties' series of posters for the London Underground, and even become the public face in the advertisements for Sarony's Cigarettes. Elsewhere he was exhibiting more serious works through the Senefelder Club, the Hampstead Society of Artists, the Commission for London and North-Eastern Railways and the Venice International Exhibition (where King Vittorio Emmanuele II even bought one of his prints for his private collection). Further book cover commissions came in at this time too, for Ronald Firbank's *Sorrow in Sunlight* and the *Prancing Nigger*, and a

commission to design the bus poster for the British Empire Exhibition (second season) of 1924, for which Wembley Stadium had just been built and which would be visited by some 27,000,000 visitors.

Richard would probably have agreed with Sir Lawrence Weaver, who said 'Perhaps in no seven year period has the face of London changed so much as it has since Armistice Day 1918,'[35] acknowledging that the changes were not merely cosmetic, but ran deep into an unrecognisable socio-political, and artistic, landscape. The problem was that, even as society changed around him, Richard seemed paralysed, rooted to the spot, incapable of shifting such a change into the heart of his work. The electorate, for example, had tripled, enabling Nancy Astor to take her seat in parliament; both the IRA and the Communists had caused, and continued to cause, considerable unease (not least with the Zinoviev Letter); rising unemployment had continued virtually unabated, and the first Labour government came and went in 10 months. In the arts too there was change, not least with the arrival of Surrealism (which would surely take root in the country of William Blake), the home-grown interest in the naïvety of Alfred Wallis in St Ives, the simplicity of formal relationships in the work of Ben Nicholson, and the eccentric world of his old school friend Stanley Spencer. Elsewhere, the now re-grouped Seven & Five Society (with Jessica Dismorr, Winifred Nicholson and Christopher Wood), The Grosvenor School of Modern Art and the newly formed London Artists Association, set up by J.M. Keynes and Samuel Courtauld, all began to thrive too. English art was seemingly well on track to re-establishing its composure, even if its one-time vanguard was not. Tellingly, at Sevres, where the future of the dismembered Ottoman Empire had been hammered out, Richard could find only poplar trees to rouse his interest, while nothing from the recent partition of Ireland or the French occupation of the Ruhr affected him much either. (Later, he would say of these post-war treaties, and the actions of the victorious nations from the Great War, that Hitler 'could not actually have happened had not the ground been marvellously dunged for him'.) Instead, he knew that he needed an escape from 'the aesthetic cul-de-sac which modern art had led me into'[36] (even if Spencer, who had also resisted the lure of formalism, seemed to be doing fairly well). Yet when he tried to be classical – 'a tamed lion'[37] – it seemed to yield nothing either. Henry understood that to exhibit an 'unimportant landscape'[38] and 'commonplace and unimaginative'[39] works produced while caravanning in Dolgelly in Wales could produce only anonymity:

> he grows too academic & is conscious of it, but cannot avoid it.
> His imagination seems to be failing for the time & he lives in
> imitation.[40]

Richard, it was clear, was sinking – failing to engage in either the subject matter of the day or the modern methods of working. At Downside Crescent this frustration at his own vision, or lack of it, came home to roost, notably with an outpouring of complaint and rage aimed, surprisingly, at his mother. His 'persecution mania' and depression, Henry reported, 'adds terror to every Sunday lunch'.[41] He diagnosed the problem as being rooted in 'vanity and want of self-confidence . . . due to the cursed isolation of an artist's work'. He was loyal though, and when Sullivan, the celebrated etcher, introduced Henry as the 'Distinguished father of distinguished or self-distinguished son', Henry fumed in his diary that he should 'have wrung the envious scoundrel's neck'.[42] Later, when the New English Art Club deliberately excluded Richard from their exhibition of contemporary painters of merit, Henry quizzed his host when he dined the following night at Sir William Rothenstein's (who was in the middle of painting Henry's portrait at the time – this more to the latter's satisfaction). Sir William distanced himself from the blame and allowed the suspicion to return once more to Henry Tonks, though he refused to say any more. Perhaps Richard was not being paranoid after all in his belief that he was being pushed out of the spotlight as opposed to merely drifting in that direction. He wrote to Alice Rothenstein, 'I do not intend to ever meet any English artists, especially New English ones, as I find them dull and disagreeable – with the exception of your husband whose kindness to me from the first time I exhibited in public I shall never forget.'[43] A later letter to her husband, Sir William, made it clear that Richard had got the message: 'I have come to regard all artists as my worst possible enemies & filthiest of my vilifiers, so that I run miles to avoid meeting them'.[44] He didn't always run, however, and so when Henry wrote 'as usual he wouldn't stand objection',[45] it was clear there was going to be a resurgence of his written public attacks, where the inconsistencies between his outbursts and his output would again be crystal clear. In watching the deterioration Henry dolefully wrote, 'He is growing middle-aged & losing his imagination, partly from not reading or associating with great minds.'[46] Alec Waugh even made him a character in a novel that told of the sorry decline of a once-great war artist, even if other books of the time, such as *The Art of Etching* by E.S. Lumsden, Lewis Hind's second volume of *Landscape Painting*, and *Contemporary British Artists* by Osbert Sitwell (himself a society showboater and novelist), presented him much more favourably.[47]

The latter was, in fact, a complimentary monograph by a great friend (and collector of his work), who was not going to let him sink. Instead, he hailed Richard as a 'born explorer' who had lived by the adage that 'art rules the artist', and had therefore reinvented himself every seven

years. Accordingly, his relationship with Futurism had been temporary, as he had been the first to appreciate and accept the ideology, then the first to reject it when he had 'absorbed the virtue that was in it'. Similarly, values from Cubism had been absorbed then utilised by the artist when he had most needed the medium in a hellish environment where 'no pre-Raphaelite pale men, or Greek athletes, had inhabited his scenes of modern war'. Now, in a world of peace and prosperity, Sitwell argued, could be seen Cézanne, Manet, Goya, Renoir and Watteau in work that was often attacked through 'the obvious fruit of jealousy'. Sitwell summed up Richard's legend, and perhaps his temperament, observing 'he has continued to follow his own pioneer path, unperturbed and impenitent, if slightly disgusted!'[48] Why could not art, like music, be abstract and free, unburdened with associations, and exuding a pure quality on its own, in the manner of Whistler, or to a much greater extent, Derain and Matisse? Why, he asked, did he still have to fight these battles? Were these lessons not learned generations ago? He concluded 'London is hopeless, hopeless', then packed his bags for a spring trip to Paris and an exhibition at the Lefevre Galleries, in which £3000 worth of etchings sold – which still compared unfavourably to the £100,000 a year that he believed 53-year-old McEvoy was making.

Privately Richard was almost defeated. His chronic depression could not be lifted, and he confided to his mother that he now felt suicide was the only real way out. And then, just as the situation looked as if it could hardly get worse, in the wake of a furious falling out with the Chelsea Arts Club, and the untimely death of his friend William Jemmett in a drowning accident in Biarritz, an even more newsworthy and damaging incident occurred.

When Jacob Epstein announced that his sculpted memorial to W.H. Hudson, *Rima*, which had been unveiled by Stanley Baldwin in Hyde Park, had since been attacked with green paint (and even tarred and feathered), and was now under petition to be removed by outraged locals and artists alike, he found an unexpected ally in Richard. Playing the devil's advocate, Richard praised it for its courage, vision and non-representational novelty in the mode of the Egyptians (popular since the discovery of Tutankhamun's tomb in 1923) and the Chinese. Though Epstein was more than capable of looking after himself, Richard argued in the press that it was hardly the artist's problem if the mob didn't understand art.[49] Moreover, as the calls for its removal were being led by Hilaire Belloc, Sir Arthur Conan Doyle and Sir Frank Dicksee (president of the Royal Academy who ironically had seconded his application for the Royal Societies Club), Richard relished the chance to take on the mainstays of British art and literature, and ridiculed them by suggesting

the tit-for-tat removal of the Edith Cavell Memorial.[50] In fact, inspired by the *Rima* rumpus, a very public spat with the Tate over his own most celebrated painting, *La Mitrailleuse*, now began. It is first mentioned in Henry's journal:

> Rich came to lunch excited about demanding the withdrawal of his picture 'La Mitrailleuse' from the Tate Gallery. His letter to Aitken and De Wit [sic] was marked private, but De Wit has published the upshot so that journalists have easily identified him and the picture. Hence his enemies will charge him with a fresh publicity stunt & he will suffer again.[51]

The press delighted in exposing the 'Worst Picture in the World' debacle, following the conundrum posed by Sir Robert de Witt, who, in a speech in Manchester, had mentioned that the painter of one of the Tate's most central works, a work known throughout the world, was asking for its removal. He named neither the artist nor the painting. As speculation increased and the debate heated up, de Witt said in an article in *The Times* that he was sorry he had ever mentioned it, as he had simply meant to illustrate the fact that an artist can change his ideas and priorities over time.[52] The article went on to say that as a matter of fact the painting was not hanging at the moment anyway and then quoted Sir John Lavery who, playing mischievously with the suspicion that it was Richard, said 'Whoever the artist is, he must be a very modest man.' The *Daily Graphic* inaccurately narrowed the list of suspects down to Cadogan Cowper, Sir George Frampton, Edwin Alexander and Harold Speed.[53] The *Weekly Dispatch* was not fooled and soon found its way to Richard's studio door, and here he took the opportunity of stepping centre stage again.[54] Appearing in the newspapers with an eye-catching hat and scarf, he said in an interview that he wanted the directors of the Tate to burn the painting, saying 'I was always heartily ashamed of it'[55] and 'I never want anybody to look upon it again'.[56] In fact, the renunciation went on to cover more than just one picture when, in keeping with Sitwell's seven year theory, he said, 'It is not a period of my work that I like. It is not a thing I wish to be associated with. It was an experiment. I am always experimenting and after all we grow up occasionally.' Lastly, anticipating the accusations of his own critics, he beat them to it by saying 'I have always called it an illustration, for it is not art.'[57] In Downside Crescent Henry feared the situation that would now inevitably unfold, and could even sympathise to a degree with Richard's detractors, feeling that the reason he had been given for the withdrawal of the painting (that Richard was unhappy about the brushstrokes) was ridiculous, and insufficient for the destruction of such

a well-known work. And yet when the storm broke Henry described his son as 'exhilarated with rage',[58] the collocation implying that it was for Richard at least something to be passionate about, something to grasp hold of, rather than face the interminable enemy of mediocrity. Richard made the next move and sent a 'vehement answer',[59] in the form of a letter to Professor McColl, and made several phone calls to the press, lighting the stage well for the finale which would now be played out. Muirhead Bone was quick to phone the Nevinson household and distance himself from the whole row, saying that, if anything, he thought it was a horrible shame to have such a wonderful picture removed.[60] Henry wrote back accepting Bone's word, but reiterated that if he found out he had been involved in the clique against his son, it would be the end of their friendship. Richard read the letter before it was sent, approved it, then thanked his father for his support – something so rare that Henry made a special note of it in his journal. Richard also wrote to Eddie Marsh to thank him for his support in the issue and for enclosing a copy of de Witt's letter that had helped to explain the situation. But why, he asked, when his original letter had been so clearly marked 'private' had it found its way into the press, and why then did some believe that he himself had sent it, leading to 'vile insults' which had made him 'so utterly disheartened'?[61] For his enemies this was a typical press coup by an artist who was, by all accounts, floundering and who wanted the public to go to the Tate, and to see his most accomplished work, as a reminder of how good he was, or at least had been. When Sir John Lavery was asked to comment, he trivialised the incident saying, 'Oh no! I really couldn't. You see I am right in the middle of lunch.'[62] Others delighted in agreeing that it was in fact 'the worst picture in the world', suggesting that it should go to the cellars and that the blame for its prominence should be placed at the door of the highbrow aesthetes who had also foisted the Hudson Memorial on London.[63] But despite Richard's protestations that he did not 'raise the clamour', and his pleas to be left alone, the *Sunday Independent* would not let it go, and ran an article called 'Modesty or Conceit?'. Here they levelled the accusation at the artist that he was trying to stir up public support, and maybe even horror, at the idea that such a strong piece of art might be lost to the nation at the hands of the deranged genius who had created it.[64] They speculated too what the artist's response would have been if the Tate had gone ahead and burned it, contacting him only to come in and collect the frame after the deed was done. The story drew to a close with the news that the painting had been replaced with a Gertler portrait, and signed off describing Richard's defence as 'the most arrogant and conceited piece of modesty I have ever come across'.[65]

Over a decade later in his autobiography Richard recalled that he had been in Paris when he heard Tonks was petitioning for the removal of *La Mitrailleuse* from the Tate, but laughed off the recollection saying 'I found that my work and my modesty [were] appreciated in the most unlikely quarters'.[66] But the reality was that the Tate Gallery, like the Imperial War Museum before it, had become an entrenched enemy of Richard's, which he now christened the 'Slade Gallery', the Tête-à-Tête and the National Coterie of French Art. With Bloomsbury hostility also much in evidence, the continued telegrams of Wyndham Lewis both threatening and unsigned, and the New English Art Club swaying away from him (under the influence of Tonks), Richard surely did not need another London enemy. However, feeling that he had little to lose, he continued on his belligerent course in public speeches, such as 'The Triumph of Modern Art Over the Tyranny of Democracy', given at the Soroptimist Club at the Criterion Restaurant, where he spared no-one. Infamy was now eclipsing fame and as a consequence he became suspect number one when, later in the year, a mysterious author using the *nom de plume* 'Tell' published *The Rude Book,* which contained unpleasant caricatures and verses about well-known figures of the day, such as Churchill, Epstein, the Sitwells, and Arnold Bennett. It was only when Sean O'Casey and Richard himself were added in a second edition of the book that suspicion was redirected elsewhere and found the rightful culprit in Albert Buhrer, nephew of the sculptor Alfred Gilbert, noted for his *Eros* in Piccadilly Circus. And yet Richard would always claim that, although at the heart of many a storm, he desired only tranquillity; that he was a public figure whose only longing was for independence and isolation; and that if he was an outspoken outsider it was only because he longed privately for acceptance. In the words of another established enemy, Wyndham Lewis, Richard would have had to agree reluctantly now that 'The brave new world was a mirage – a snare and a delusion.'[67]

11

The Lives of a Modern Bohemian
(1926–29)

Richard wrote in his autobiography that by this time his name was well known in China, Australia, South America, San Francisco and even Panama. His father chided him for such flippancy, 'To be known in every bar all over the world is certainly fame indeed.'[1] Henry worried that perhaps celebrity had finally replaced credibility; this he knew was both a facile and transient phenomenon. The euphoria of the Tiller Girls at the London Plaza, the mesmerising dances of Isadora Duncan and the high flying antics of shows such as *Just a Kiss* at the Shaftesbury, were all familiar to Richard in his glittering public life. In the press he was listed in the same breath as Oscar Wilde, G.B. Shaw and Augustus John, as one of the favourite sons of the now closing Café Royal – 'London's one café' in which T.S. Eliot had chosen to place him at the beginning of the decade. Across the Channel he had a bar named after him, then appeared by name as 'the' Parisian bohemian in Sisley Huddleston's novel *Mr. Paname* in a café scene where 'Well-known men, like Augustus John, with his beautiful head, and Nevinson, of the faun's face, were sometimes to be seen.'[2] Closer to home Ethel Mannin had used 'the most essentially modern artist I could think of in this country' to design the cover of her novel *Sounding Brass* then based a character within the book on the floundering Richard, in a depiction he so loathed that it had to be removed from the second edition.[3] *Drawing and Design*, the cover of which was graced with his *Conflict*, did not agree and informed its readers of 'an artist endowed with an honest man's sensibility and whose art originated in thought',[4] a sentiment echoed in both *Evolution in Modern Art* by Frank Rutter and *The New Anecdotes of Painters and Painting* by Herbert Furst, which featured Richard significantly. And though illness kept him away from the Leicester Galleries where Colonel T.E. Lawrence was exhibiting the original sketches for *The Seven Pillars of Wisdom* in the company of Eric Kennington and Augustus John, it was Richard's pictures that actually appeared in the first version of the book, which cost the princely sum of £30 each.[5] He was active at the theatre too, working alongside G.B. Shaw,

Arnold Bennett, Princess Bibesco, Noel Coward, Beverley Nicholls and Augustus John in *White Birds* at Her Majesty's Theatre. And as a public speaker he spoke authoritatively on 'Modern Art' at the Six Point Group – damning the RA for driving English artists out of England, and offering his views on the recent artefacts brought out of Tutankhamun's tomb by Howard Carter, saying that they, through lotus flowers and scarabs, represented a purity in art now lost to European painters. The same, it seemed, could not be said of Sir Leonard Woolley's discoveries at Ur. This veneer was intended to keep the public from the complexities of the manic depressive, or from discovering the truth about London's flamboyant party giver and socialite. They knew Nevinson the fighter, more than Nevinson the sensitive neurotic; they valued their critic of worth, even if the artist could not quite match his own words in paint. They had faith in the international bohemian, even if, in reality, he now rarely ventured beyond British shores. Ultimately, they believed in the genius who had survived the war, and knew little of the artist who was suffocating in the peace.

The Leicester Galleries exhibition of 1926, in the company of Joseph Southall, would certainly be a litmus test. It must certainly have surprised him then, when it drew splendid reviews, leaving only 'his Bloomsbury enemies still implacable'. But this was enough, and their cynicism soon became the source of 'much distress caused because the intellectuals remain hostile in spite of other excellent reviews'.[6] By now he should have expected to draw fire from a quarter that he had spent his life vilifying, and when he had known that victories against such influential figures came at a very high price. *The Times* hesitated a little too, but was on the whole impressed with the quality of work on display, saying that he had at least put his cards on the table, leaving the viewer to decide whether he was a greatly versatile artist or simply one incapable of concentrating. And though they lamented his early dabble with eccentricity that had cost him the formal learning time needed to perfect the sort of art he was now aiming at, they felt nonetheless that this would come with time.[7] The popular press contained no such caveat and gushed over his incisive images of both the British countryside and the capital city itself. Published comments, which Henry felt were overdone in their praise, talked about 'courage' within a 'ravishing' and 'breathless' art, by an artist who had been living in Paris for the last two years.[8] The *Daily News* spoke for many when it summed up its review: 'Nevinson is a painter of rare originality, independent of coteries and "isms" and more than probably the most interesting of the men under 40.'[9] Others applauded his straightforward and honest approach, while noting the absence of the trademark war-like manifesto – a welcome break leading to a new atmosphere in which the painting alone did the talking.[10] The *Daily Graphic* went further and attributed to him the ability

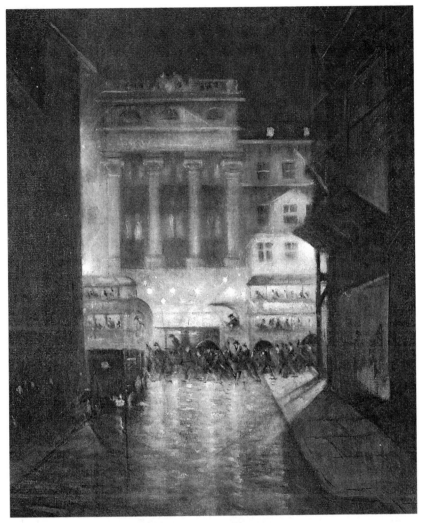

C.R.W. Nevinson, The Strand by Night, *1927*

to interpret the Englishness of the English landscape better than anyone since Crome. Here was 'vitality, sanity, simplicity, beauty and dignity', contained within a poetic reading which was said to 'have the quiet grandeur and satisfying perfection of a Miltonic sonnet'.[11] In short, apart from the contempt of a few predictable detractors, his work received the perfect reception and this had not been one minute too soon in coming. It clarified his position by 1926 and helped him to realise that, even if he loathed the 'mob', he still needed them. He knew also, as did those around him, that if he was still perceived as a rebel, it was in nothing more than rhetoric, and that if he made claims to being an international artist first and foremost, his subject was predominantly England.

Henry, dogged with ill health and worried that positive critique and sales did not always advance hand in hand, placed a bid on a tranquil image, *The Manor Gates*, before retiring to Bath to ease his sciatic pains. Richard and Kath later joined him there to take him on motoring excursions around the Cheddar Gorge, Wells and Glastonbury, before returning to the galleries to find out, to their delight, that 11 oils and 17 watercolours had sold. Perhaps the success was overshadowed a little with a *faux pas* made by Kath just prior to departure, when in her husband's defence, and clearly angry at the reduction in the prices of his work, she had wished a violent end to gallery owner, Cecil Phillips. Within the week he was dead from a shooting accident, which Richard attributed to suicide, leaving Kath to rue her ill-timed comments and unfortunately chosen words. Nonetheless, when the show closed its doors, Rich and Kath headed for Paris, Nice and Monte Carlo to spend the proceeds and to get some well-earned rest. The first postcards to filter back to Hampstead, however, continued to talk of a melancholy and a temper, which Henry believed might be brought on by a thyroid condition, and which Richard was finding impossible to shake off. A surviving letter to Gertrude Stein from the Hotel de la Regence on the Ave de l'Opera also suggests that ill health was returning as he and Kathleen were, uncharacteristically, unable to attend a function in which they would normally have been keen to participate.

At home other serious events were beginning to unfold too, with the outbreak of the General Strike, which Henry feared might be the start of a revolution (as opposed to merely an industrial dispute), perhaps even on a Europe-wide scale. Hyde Park was closed and used as a milk depot; troops were stationed in Whitehall; public transport ground to a halt; power plants were manned by government troops and rumours ran wild as newspapers were not being published. Richard and Kathleen, being in Paris, heard the wild rumours of the collapse of the pound, the mobilisation of the Royal Navy, and of street fighting at Victoria Station. Rumours also filtered through about the Leicester Galleries, which had been instructed to move paintings to relevant embassies for safe keeping, as the country, for nine days, moved closer and closer to anarchy and civil disobedience. Richard's reaction (once he was home) was suspiciously mute however, and when he did break his silence it was only to express remarkably unsympathetic sentiments in a private letter to the novelist and former *Times* correspondent in Paris, Sisley Huddleston. One letter read 'Thank God the "workers" are getting slowly broken here. Otherwise the country is putrefying quickly!',[12] a sentiment which led Henry to lament 'Why have I two reactionary children?'[13] Richard later recalled that England was being run by a socialist minority government, which

had their ideals in the sky and their fingers in the till, and it was this that had led inevitably to the strike. And when it ended, the political 'right' had been reminded of their dependence on workers, while the 'left' had learned of their inability to unite – even for a good cause. For Richard, regardless of his beliefs and the strength of his feelings, this sort of thing was simply no longer the subject of his art. The past belonged to the past and should remain firmly there, however relevant the subject for an ex-Futurist, war artist and hater of American-style capitalism in England. Besides, the art-buying public seemed only to want 'the Willow pattern and White Rosebud tied with blue ribbons by anaemic little birds'.[14] Absolutely stymied in London, and frustrated by himself and his work, Richard announced to the press 'I am a painter today because I was a failure at everything else yesterday, but I always go on painting, painting, chiefly because I am so hopelessly bored by everything else.'[15] Clearly longing for Paris again, he concluded, 'The best thing one can say about the British is at least they are dying & dying quick.'[16] Ironically, America was marginally better, due to a competent show at the Albert Roullier Galleries in Chicago in the prestigious company of Walter Sickert, and reasonable acclaim at the Kraushaar Galleries in New York City. His feelings were still very clear however when he was asked about going across the Atlantic again. He declared with finality, 'Never in all my life. I couldn't stand it. They have no idea about what art means.'[17] Henry, seeing the rudderless pronouncements and daubs of his son, 'advised making a splash in another gallery or in Paris: something big and definite',[18] then set off for Trieste, Zagreb, Istanbul, Damascus, Beirut, Jerusalem, Tel Aviv, Baghdad and Alexandria, leaving Richard to think over the proposal.

But, as was so often the case, it was a new argument, and a new public spat, that was to consume Richard's energies, this time through the seemingly harmless bequest to the Tate Gallery, by H.G. Wells, of Richard's *A Paris Studio*. The painting, effectively being used as a pawn in a wider game, put the director of the Tate, Aitken, in the awkward position of having to accept an enemy's painting because it had been offered by a friend. Initially, Richard would have delighted in this irony and would have anticipated no additional problem with his subsequent announcement that the canvas had been painted in Sisley Huddleston's studio in Boulevard Raspail. Huddleston's private written response to Richard, therefore, would have blindsided him, coming as a most unexpected and deeply personal blow, and exacerbated by an open letter to the press which clarified that he, as the editor of the *Christian Science Monitor*, had never had a nude woman in his studio in all his life. He publicly rebuked his friend:

As a painter, you have therefore taken liberties with your subject and in these days of scandal-mongering, when allegations are so lightly made and are taken so tragically, I think it well immediately to make clear that I have never . . . so much as posed a rabbit in my studio much less a full sized naked female model.[19]

Huddleston went on to reiterate that his was a 'respectable writing man's studio' and concluded 'I, therefore, vigorously repudiate the figure on the couch.'[20] Richard, exasperated, responded in the press, saying that only the window had come from Huddleston's studio, and that he had intended absolutely nothing else at all, let alone an implication of sordid or untoward behaviour in a Paris hideaway.[21] Huddleston let the tussle continue, perhaps unaware of the distress he was causing his friend, saying that it was all very well for an artist to have naked women strolling around, but not for a literary gentleman. Not enjoying the pantomime, Richard wrote to him directly pleading 'Oh how could you have done it?' then clarifying the nature of his despair saying, 'My ghastly New English and Bloomsbury enemies have been supplied with a lovely weapon to beat [me] with.'[22] Richard pointed out to his friend that this was neither the time nor the place to get involved in pedantic jousting of this nature, as he stood to lose heavily from such an encounter, however light-hearted it may have been in intent. Not only could it damage his reputation, but also his fragile health which depended so definitely on his keeping calm – something over which he knew he had little control. Huddleston backed off immediately and the friendship was soon patched up in Harry's Bar in Paris. As a peace offering Richard got to work on a 'Holbeinesque portrait drawing in pencil'[23] of Huddleston – a favour later returned by the inclusion of two of Richard's paintings, *Sur La Terrasse, Montparnasse* and *Henry IV, Ile de Paris*, as illustrations in his next book *Back to Montparnasse*. But the press were not so easily disarmed and so, ignoring the advice of James Joyce, who he consulted on the matter, Richard decided to send a 'long, insolent letter . . . threatening legal action in the most violent and extravagant language' to the art critic from the *Saturday Review* for the way, according to Richard, he had reported the whole affair.[24] The editor was stunned. No comment at all had been made in his paper (though they had earlier reported on the matter of *La Mitrailleuse*), and so he wrote to the artist asking why he was so unreasonably angry, then published an extract of the letter to let the readers see what they made of it all. The reduced passage read, 'You know nothing about me personally, Thank God! I have been spared the misfortune of either knowing you or meeting you.' Consequently, other reports began emerging elsewhere which described Richard as a 'rude, fierce and ungenial individual'[25] – so different from the

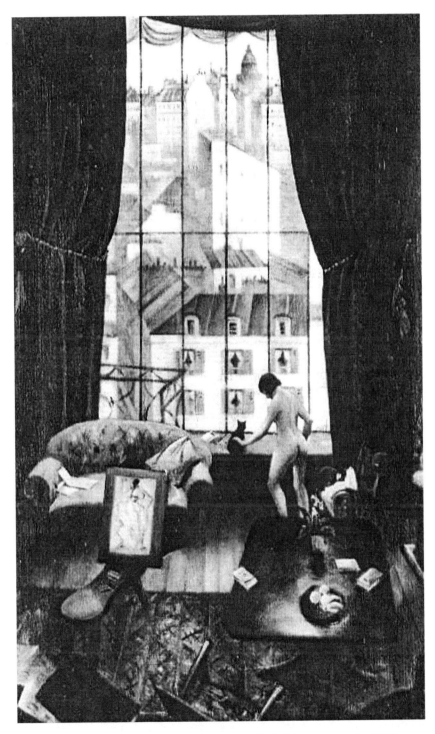

C.R.W. Nevinson, A Paris Studio (A Studio in Montparnasse), *1926*

party giver and from the artist whose roaring laugh was so well-known. Even the one lifeline thrown to him, his nomination to the Savage Club (which also boasted Sir Oswald Moseley, Somerset Maugham and Alec Waugh) following the nomination of Philip Page, Aubrey Hammond and Basil Cameron, came with a one-month probation period as he now had a reputation for being 'aggressive'. Louis McQuilland summed up the artist neatly saying that he was Prussian in appearance, akin to a stern Schubert or a clean-shaven Wagner, and, erroneously, that he was an old friend of Mussolini's (who supposedly knew him in Rome in their youth and now owned much of his work) and 'a man who loves his friends and is rather contemptuous of acquaintances'.[26] Henry was horrified, describing his son's outbursts as 'abusive' in manners and replete with 'hideous quotations',[27] and knew only too well that the backlash would be severe. He also knew that this time his son may not have the resilience to take it as he was already mentally and physically weak following another period of serious illness. Henry was right, and the attacks, when they came, brought on serious bouts of melancholia, and in time further thoughts of suicide. The 'Tate Picture Sensation',[28] reported as far away as Melbourne, came to an end when it was reported that Richard was 'lying dangerously ill', unable to defend himself fully, and that Huddleston was profoundly sorry that it had ever gone this far. Shortly after, Richard consulted a nerve specialist as, he later admitted, 'I was honestly afraid of developing a persecution mania.'[29]

But it was not all in his mind! He really did have enemies and they were regrouping now for their next action against him. This became apparent at the Lefevre Galleries, where there was a strong suspicion that a boycott of his show had been arranged, resulting in a very poor opening night. It might have reminded him of a similar time 13 years before when the Vorticists had left him high and dry, though in a more dramatic manner. Only a handful of guests were there to see a fairly timid, though certainly competent, collection of etchings and watercolours, or to read the catalogue which began with an 'Apology' penned by the artist. This, though muted, was still argumentative in its undertones; he apologised for his English name and breeding, saying that he would have been better off as MacNevin the etcher or Nevinso the painter. As an Englishman, and as a Londoner, however, he could only plead for the Locarno spirit to be applied to art, and to himself, though by now he knew better than to hope. Such maudlin ruminations fuelled the press, which ran headlines like 'The Sad Case of Mr Nevinson',[30] while others marvelled at his illogical comments and the irony that he should decide on this moment to put down his own nationality and heritage. The critics, perplexed, asked why an English artist would renounce his Englishness

'Tate Picture Sensation', South Wales Echo, *26 February 1927*

at just the time when he was delighting in the English countryside and London, and when they, in fact, were delighting in his vision too.[31] The 'Young Artists' exhibition, which followed in Suffolk Square, organised by the *Daily Express* and held at the Royal Society of British Artists, didn't help much either, dominated as it was by Stanley Spencer's triumphant *Resurrection.* Richard's *From the Woolworth Building, Night Drive* and *Any London Street* were firmly eclipsed and generated little interest. Quite tellingly, no-one denied him a place of prominence at the London Group retrospective at the New Burlington Galleries where, rightly, he hung beside Spencer, Sickert, Gilman, Gore and Epstein. But that was a retrospective – an exhibition of work done by a group of men who were young, and on the cutting edge, a long time ago.

The letter about Richard that Margaret sent Henry at the Disarmament Talks and the Naval Conference in Geneva contained little good news. In it she wrote of how the critics, headed by Tonks, were pushing him to the very brink of despair, a condition exacerbated by the death of old ally, and friend, Charles Lewis Hind. Attending the cremation of Jane Wells (H.G.'s wife) cannot have done much to lift the mood either and so in the *Times of India* it was reported that dying young had become Richard's new, and very serious, goal.[32] Death was rapidly becoming his only real avenue of release from a life and a profession he now found utterly intolerable. He wrote to Huddleston again:

> I have such a wretched mind & so utterly haunted with futility & general wickedness that solitude or decent living is utterly impossible, I have to be perpetually standing drinks to my skeleton & dodging my shadow behind the grinning fools one meets. . . . Perhaps one day I will cease to have a tortured mind & know serenity, otherwise I hope soon [to] clear out of it.[33]

His persecution mania and depression were now also crippling his family and those close to him, leading Henry to record in despair 'He makes me dread Sundays',[34] observing sadly that even Kathleen had been 'deprived of all her zest for life'.[35] Even though Henry had suffered, in this one year, the death of three personal and close friends – Thomas Hardy (whose funeral he attended with Stanley Baldwin, Ramsay MacDonald, Rudyard Kipling, and George Bernard Shaw), Emmeline Pankhurst and Herbert Asquith – he wrote that it was his children who caused him the most acute suffering. Henry, ever the optimist, believed that some of this intense emotion could be harnessed, or channelled productively, into an epic canvas simply called *Depression*, as a form of exorcism or cathartic purge that would allow Richard a return to interpretation, to personal and original art. His son had other plans though, which included disappearing to the south of France for a while, feigning his own death, then planning a great memorial show to himself in the middle of which he would re-appear alive. Henry, hating the idea, went round to Steele's Studios, and his diary entry for that day reads:

> Went to tea with Rich and Kath to thoroughly discuss the whole lamentable situation, the boycott, the depression, the consequent decline in his art and painting. I proposed various schemes for many of which I would give £100: visit to Spain or the northern towns: a shop for selling his pictures: a gallery, as the Suffolk, for a general show of his past and present work: an imaginative picture of Depression, Malignity, Exultation etc.[36]

Henry also suggested collecting and exhibiting works done over a 21-year period, to rekindle the old name and momentum, but Richard was unwilling to gamble a further £500 on such a large retrospective show.[37] Anyway, nothing was going to change, in his opinion, and so his unguarded attacks continued, this time on Sir Frank Dicksee (who, he claimed, could judge a Sunday lunch, but not art) and the Royal Academy, which was opening an exhibition of Charles Sims' 'mind pictures', done just before his suicide. Richard accused the Royal Academy of having no understanding of these important works and informed them that had they taken the trouble to consult him they would have found out that Sims and he had spent time talking about the experiment, and had had the idea together. There again, what else would he expect from an élitist 'institution that has succeeded in making English art ridiculous in the eyes of the world'.[38] When Anna Pavlova came to London to dance at Covent Garden and declared that 'England has no art', Richard, delighted, was quick to rally round and support his new ally, going on to say that 'Art and democracy can never go together, for democracy

means the minds of the greatest number of fools.'[39] Considering the situation in Italy and Russia at the time, Henry and others would surely have blanched at the statement. Richard further muddied the water by writing 'I naturally as an artist loathe socialists as I always give my best trying to construct, and socialists always destroy and try and take.'[40] With his vociferous hatred of the American system too, it was becoming difficult to attribute any coherent or defensible stance to him.

But it was the contempt of his peers, especially the elitists like Roger Fry, which hurt Richard the most. In a recently discovered draft of a letter Fry wrote, in response to 'Your remarkably outspoken letter', the critic got to work. Richard must have instigated the attack by defending his father whom Fry, he perceived, had attacked. Addressing each accusation one by one, Fry denied that he had claimed Henry had used his influence to promote his son's work, as he believed father and son were not on the same intellectual plane. Fry continued that he had indeed called Richard a journalist (which was not meant as a term of abuse), and had not then bothered to criticise his work for the last decade or so as he hadn't really thought very much of it. He clarified the point, explaining that Richard's work bore the same relation to serious art as journalism did to serious literature, a stance that he had held since the days of 'your quasi-cubist war pictures'. He finished with 'I am much too much occupied trying to understand the work which I admire to enjoy disparaging my contemporaries', then signed off with 'I would rather admire your work than not but I can do nothing to make myself do so', before taking a parting shot with 'I don't like your painting but that is no crime'.[41] Richard knew he had been defeated by perhaps the most prominent critic of the day, and so when P.G. Konody also used the words 'journalistically inclined' in a review, Henry recorded the reaction of his son, and his own subsequent distress:

> That recurrent charge of journalism drives Rich to fury & I found him hardly sane with sense of injustice. Useless arguing. . . . Children are a quiver full of arrows that pierce the parent's heart.[42]

Richard could find solace in neither the painted image nor the written word. Even the success of the seventh Leicester Galleries exhibition later in the year (at which the Museum of London bought *London Winter with St. Paul's and Seagulls*, Aberdeen Art Gallery bought *The King is Dead*, and Birmingham City Gallery bought *Steam and Steel: An Impression of Downtown*), could not lift the depression. The press billed him as the most important artist of the day, filling both rooms of the gallery with 80 images, which they felt to be 'amazingly clever' and as lively and interesting as the guest list at one of his bottle parties. The images themselves were diverse

too, including the almost abstract *Poisson d'Or*, a portrait of pianist Mark Hambourg, experimental pieces such as *Le Depart, Boulogne*, cockney scenes like *The Two Costers*, while the Victorian twinge for nostalgia was not entirely ruled out in works such as *Oh! To Be in England*. Frank Rutter enthusiastically concluded that the legacy of his Slade training had stood by him, though Richard would have loathed the idea that he owed anything to his wretched enemy Henry Tonks.[43] He would have preferred the comments of T.W. Earp who wrote that he was a 'traveller among tourists', before going on to claim him for the nation, saying that he was British and proud, despite his statements to the contrary. This show, Earp believed, was good earthy stuff, and so he congratulated Richard on preferring 'boot-leggers to boot-lickers'; the *Daily Mail* to *L'Echo de Paris*; and people to artists and dealers. Earp complimented this single mindedness, this uncompromising and inflexible attitude, which had already placed his war work in the history of art beside Goya and Callot. His post-war London scenes, he claimed, were quite simply 'Dickens in paint'. The commentary closed in no doubt saying, 'And though pedants may wag their finger, we agree with him in preferring a poem to a treatise on metre.'[44] Only a handful of papers said things like 'Perhaps Mr Nevinson needs another war: peace has tamed his art.'[45] But none of this lifted the depression that Fry and Konody had brought on and he remained 'unsatisfied and disappointed. Nothing can ever please him. He is entirely occupied with himself: almost to mania.'[46] Only the close family would have known that, at the wedding of old-time friend Alvaro Guevara to Meraud Guinness, at which the press likened Richard to a bridesmaid due to his orange shirt, flowery tie and 'wide-awake' hat, that he actively sought a release only through death.[47]

Few of those invited to the aforementioned bottle parties would have been aware of this either. As guests at an established event on the London calendar, they would have enjoyed the company of personalities such as Mark Gertler, Noel Coward, Jacob Epstein, Sinclair Lewis, Ronald Firbank, Gracie Fields and H.G. Wells. Some others, such as novelist Henry Williamson, were aware of the trouble that lurked, later portraying Richard in two of his novels as a character called Channerson, who was observed from a distance, among a throng of well-dressed people, gentlemen in opera hats and cloaks and ladies in furs and tiaras. Williamson made his characters spy on the artist and one then observed:

Channerson was about thirty six, with prematurely grey hair above eyes which remained hard during his laughter. The laughter sounded hollow; behind the eyes ... had been caution, irony, even despair.

'Hot Dogs' at a Bottle Party, unknown paper, *January 1929*

Williamson, who had earlier dedicated his book *The Wet Flanders Plain* to Richard, has the same character conclude, 'I suppose Channerson has had a fairly grim time. He suffers from the most frightful persecution complex.'[48] Later, when Channerson finally meets Phillip (Williamson's fictional protagonist) the opportunity arose, via the artist's wife to discuss the question of art and beauty.

> 'Your husband's war pictures have the truth in them, Mrs. Channerson'.
> 'They are beautiful.'
> 'Beautiful?' said Channerson. 'What is beauty?'
> 'Compassion. All beauty is truth, and all truth is compassionate. Few know that, fewer still can express it. You can, and do.'
> 'Ah!' said Channerson, gravely. 'But the problem remains, how to put paint on paint.'[49]

In real life the friendship foundered a little later with the publication of Williamson's *The Gold Falcon* which cast Richard very much in the role of the 'has-been' and which almost led to libel action.[50] Undeterred, and long after the artist's death, Williamson continued to use his old friend's work, in *The Linhay on the Downs* and on the book jacket of *A Test to Destruction*. And Williamson was not finished there either, publishing in 1965 *The Phoenix Generation* in which the 'fugacious' Channerson's New York experience was described by the fictional artist as follows:

> They drop you as completely as they take you up when the newspaper reporters push past you at Ellis Island, seeking the latest 'celebrity'. But then Americans are the only nation in history to have achieved decadence without civilisation.[51]

Richard, the consummate actor, the wearer of an impenetrable mask, could hide his private voice of despair with talk on art, with his bellowing laughter, or using his witty one-liners (on hearing that H.G. Wells had run out of drink and failed to bring a bottle of his own he quipped 'Wells gone dry').[52] And though he was flattered to be known as the giver of good parties and reminisced 'My giving of parties is an indulgence that amounts to a vice. I must have entertained thousands . . . and I hate to think what must have been consumed on the premises', he tempered the statement with 'One would never have imagined I was intensely lonely.'[53]

When *Apollo* ran a long article on Richard written by Kineton Parkes, who had known him for 12 years, and who described him as a 'determined, wilful, masterful, child of Nature' and 'the road-hog of art [and] the bull in the china-shop of art exquisites', he concluded with the legend 'Perversity, thy name is Nevinson!'

That might have been the perfect way to conclude the year 1928, but it was perhaps an unfortunate choice of words as in January 1929 Richard was blackballed from the Arts Club for having 'un-natural vices', which verged on his being labelled a 'pervert'. He may have been guilty of many things but this really was not one of them, though it did help him to identify his real friends, who now rallied to his support. For example Sir William Orpen, who had been his proposer for membership, offered £6,000 in order to sue for libel, which, it was hoped, might bring in £10,000. Henry was horrified and talked Richard out of it as firmly as he could saying that mud sticks on these matters and explaining that few would understand that often there could be smoke without a fire. In a letter to Sisley Huddleston Richard recounted:

> Orpen has been putting up a remarkable fight for me but it has ended in defeat. I have now been blackballed by some filthy artists at the Arts Club as a "well known homo-sexualist". Orpen wanted me to sue them for criminal libel, by being my proposer, wanted to come in on it too, however I refused to go to law in this country especially as an artist would be guilty in any case of anything long before he got within 100 miles of a law court. Before a British jury no artist can expect even a vestige of justice or decency, all because I paint pictures a little more powerful & personal than theirs!![54]

In his autobiography *Paint and Prejudice* he explained to those who might otherwise not have known that 'some modern art is associated with effeminate gentlemen' (by which he meant the Bloomsburies), then went on to say 'but why connect all living artists with *them*'.[55]

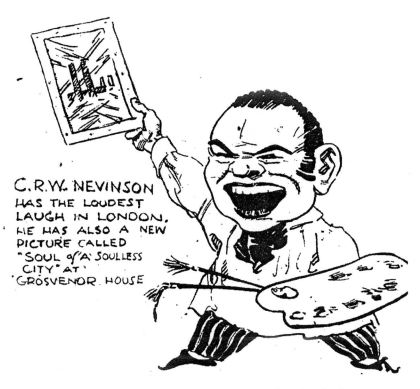

C.R.W. NEVINSON
HAS THE LOUDEST
LAUGH IN LONDON.
HE HAS ALSO A NEW
PICTURE CALLED
"SOUL of A SOULLESS
CITY" AT
GROSVENOR HOUSE

'C.R.W. Nevinson has the Loudest Laugh in London',
The Bystander, *13 May 1925*

Henry found out that it was actually three architects who had done the blackballing, and this may have stemmed from an article Richard had written in January called 'Ourselves as Others See Us', in which he had gone on the rampage against British architects (very much as Osbert Lancaster had done in *Progress at Pelvis Bay* and his *Pillar to Post: the Pocket Lamp of Architecture*) who he said cared nothing for aesthetics or beauty, but for profit, vulgarly veneered with 'ye olde English'.[56] For the moment then he had no choice but to cling to the Savage Club, and from that citadel continue outraging his enemies in the press. Firstly he threw one final glance over his shoulder at the USA saying that he had had the last laugh anyway as all but three of the works he had exhibited at the disastrous New York show of 1920 had now sold and at prices far in excess of what he had originally asked for.[57] He then refused the Crown copyright permission for his work at the Imperial War Museum as he was convinced there was still a cabal there who railed against him, before he turned on a much bigger and more pressing enemy. The first salvo in this battle was fired in an open letter entitled 'Artist in a R.A.ge', which read

Sir,

In an article in your issue of April 1st you describe me as C.R.W. Nevinson, R.A. Some twenty years ago I was a pioneer of a certain form of contemporary art, and I have therefore been called all 'the names' that British conservative intellectuals, Bloomsbury-taste mongers, Tateo-Sladesh Bureaucrats and Millbankians can mutter. Every form of epithet and all kinds of 'titles' have been hurled at me, but never, never, have I been accused of being a Royal Academician! I am not 'gaga' yet. Neither am I moribund nor comatose.

Neither is my reputation failing as an artist that I need a crutch in the form of a title, nor am I yet so overwhelmed by avarice or snobbery that I need letters after my name.

He went on to say (before signing off 'C.R.W. Nevinson – Living Artist')[58] that he, as a pioneer, could only scorn the RA, which had made British art a laughing stock abroad and which, at home, was reserved for the Royal Family and for a social public with no intention of buying anything. But the attack was by no means going to finish with an isolated letter to a newspaper, and was soon followed up with an article, 'The Exhibition of Snobbery: Farce of the Royal Academy', offering paternal advice to young artists, telling them that they didn't need such institutions anyway as art could not be judged, and certainly not by these people who would value colour photography as art if ever they could get over their petty rivalries with each other in the first place.[59] In the *Express* he went on, 'All they achieve is in painting pictures amazingly dull, amazingly alike and amazingly stupid.' He sidestepped antagonisng old friends though, by saying that when John, Orpen and McEvoy became RAs they had helped the academy, not the other way around, then unhesitatingly vowed, 'Were I asked to be one, nothing in the world would induce me to accept', as it would have the same impact as receiving the freedom of the Sahara Desert.[60] He said Nicholson, Bone, Steer and others had all rejected membership as they knew it would harm their careers, and that Spencer, Gertler, Grant, Nash, Wadsworth and Gill had not even been asked. With nothing more than this bare statement of fact he could have rested his case, as even the most uncritical of observers would have noted the seriousness of the omissions. But egged on by editors and journalists he persisted and even decided to review the 1929 summer academy, darkening the RA's doors, he said, for the first time in 20 years. The result was a piece called 'The Embalmed Academy', which he prefaced by saying that as he had never submitted any of his work to them, and thus had never been rejected, he bore no malice nor grievance, only a lack of respect. His confidence was bolstered by the

THINGS ONE FINDS DIFFICULT TO PICTURE

BY STARR WOOD

C. R. W. Nevinson being persuaded by a classical model to paint her portrait for the Royal Academy

'Things One Finds Difficult to Picture', The Bystander, *20 November 1929*

fact that he had succeeded outside of their nepotistic ways, and had even been unsuccessfully sabotaged by a cabal of artists loosely associated with the place. He went on to argue that institutions and art did not mix, and that was why there was no institute for writers or for composers. Of course the punters who dutifully and unquestioningly attended year after year and applied so little pressure for change were also to be blamed, and he

compared them to the people who waited patiently to see another symbol of state, Lenin's body. State art, in his opinion, like the nationalisation of the railways, could lead only to inefficiency and complacency and an art that is 'dreary, dilapidated and dead', like that of Alfred Munnings, whose skating scene, Richard felt, demanded an Amusement Tax. The RA was, in short, 'a backwater, far away from the mainstream of artistic and intellectual thought, and from the eddies of aesthetic experiment, progress or failure, captained and crewed by old men who have never lived, and will not die'.[61]

This, on the whole, was going to do little to endear him in London, and with that in mind he asked Huddleston whether he could use his substantial influence in Paris to get something hung at the Luxemburg, through the Salon du France. For this he was quite willing to select a 'big & important' work, representative of the art of a great artist in the company of other 'greats', and far from the pedants in London, whom he described as

> degraded in mind, body and soul. Petty, inane and futile. I would sooner be a sewer man in a small pox hospital.[62]

That said, the great anti-Academician did concede there was something to be learned from the Winter Exhibition at Burlington House of Dutch painters, where he felt Rembrandt and Vermeer shone as beacons of hope, having always lived in penury but having never lost their faith that beauty is eternal no matter who is consuming art. The critics and the auctioneers, he concluded, had always been peripheral, mere parasites feeding off real talent – an epitaph that he believed was eminently suitable to himself.

Privately, his life had become unbearable, to the point that, on hearing of the death of his old ally and colleague Sydney Carline, he could only grumble 'He's well out of it.'[63] As was so often the case, however, just at the moment when it became certain that he would abandon art, and England, for ever, he was thrown another lifeline, this time in the substantial offer of full membership of one-time foe, the New English Art Club, having been proposed many years before by Augustus John and Muirhead Bone. He recorded in *Paint and Prejudice:*

> I think no honour gratified me more, and my spirits rose. It was the first time I had ever had any recognition from any established art society, and I no longer felt the outcast of art. The miserable years after the war were, at last, drawing to a close. . . .[64]

With this eleventh hour reprieve, he and Kath packed up and headed for Antibes, coming back with a new portfolio and perhaps one last chance at the English art market. Additionally his father offered him

a commission providing 16 illustrations for his upcoming book *Rough Islanders* (then called *The Rough Island*). But, even if there was a long-overdue breakthrough in his fortunes as an artist, there was no matching change in his writing, either in content or tone. Whatever advances he had made with a brush, the pen would soon negate. When his expertise was invited, as in the controversy surrounding D.H. Lawrence's paintings, which had just been banned from public view for very much the same reasons that *Lady Chatterley's Lover* had caused a scandal in the previous year (as had the words of Aldous Huxley and Michael Arlen), his views were welcome. In his article 'Lawrence v. Art' he said that, having visited the exhibition, he was glad the police had closed it down as the painting had been truly awful, but asked what sort of misplaced morality made the British public balk on the grounds of Lawrence's 'troubled dreams of an erotic schoolgirl',[65] especially when there was much riper stuff in the Greek section of the British Museum. (Henry would later write of Lawrence, after reading *Lady Chatterley's Lover*, that he must be 'impotent and [could] only imagine the joys of copulation')[66] But other public pronouncements were much less welcome, and infinitely less credible, like the substantial fracas which was now emerging with his father's friend George Bernard Shaw – himself a loose canon, who had not been allowed to broadcast on the BBC on his 70th birthday as he refused to avoid controversy. This began when Richard took Shaw to task over the introduction he had written for the catalogue of the exhibition of Mrs Gertrude Harvey, in which he had said how tired he was of 'Seedy artists, starving artists, borrowing artists, begging artists, stealing artists, drinking and drugging artists, despairing artists and dying artists', concluding that £5 seemed the maximum price any artist could legitimately charge for the effrontery that was modern painting. Shaw had gone on to say of such an artist 'Why does he not get rid of [his paintings] for whatever they will fetch? Even if it is only tuppence he is that much to the good,' and pointed out that a studio full of unsold paintings was not only a total loss, but also a humiliating reminder of the artist's worthlessness.[67] Richard, perhaps feeling that this was too close to the bone, took up arms and replied, 'Mr Shaw is talking utter nonsense and living in the age of the dodo, as frames alone cost more than £5.' Perhaps, Richard suggested, Shaw could match the offer by making seats for 'The Apple Cart' (an entwined critique of orthodox socialism and what was now known as 'leftism') one farthing each.[68] So far, so good – merely a lively, if heated, debate between two respected figures of the day. Before long, however, Richard swung the nature of the attack onto a much more personal level saying 'Shaw is now a very old man . . .' who would be better advised to learn to fly rather than to go rushing into print telling artists how not to make money, especially as he was notorious for squeezing every

last penny out of his copyright and publishers. In the *Daily Mail,* Shaw replied with an article entitled 'Sell Paintings by the Foot', and started: 'Mr C.R.W. Nevinson shows the most deplorable imbecility in his article in yesterday's *Daily Mail*'. While conceding that he was not a bad painter, and was normally an intelligent man, he now worried that if this was the sort of thing he had come to in search of publicity then what hope was there for British art and artists in general? Delivering a schoolmaster's slap he ended, 'His father certainly brought him up very badly. His arithmetic is unsound and his arguments deplorable. I must really talk to his father about him'. As a footnote he agreed that no play was worth more than five shillings for a night out, not even for Shakespeare nor indeed his natural successor (himself), but that if he made a modern painter, like Richard, his manager then he would probably charge five guineas a night, resulting in empty houses, or merely theatres full of the wealthy, who were imbeciles.[69] Richard, infuriated, responded that 'it is high time that decrepit old man was put in his grave'.[70] Simultaneously he wrote to Huddleston in Paris saying, 'Nothing but death will silence his muddle headed "humanitarian" outpourings'.[71] Posterity, Richard felt, would judge whether his war pieces in the Imperial War Museum would outlive 'the garrulous and dated plays' of his father's friend. At Downside Crescent, Henry was distraught at Richard's 'unmannerly retort to Shaw in the Mail' and concluded, 'If only each would stick to his trade and leave writing to writers!'[72] But they would not, and round one had only just been slugged out.

Such was the atmosphere Henry left behind as he sailed with Ramsay MacDonald, popular for his withdrawal of troops from the Rhinelands and tackling the French on the subject of war debts, for a trip to America which, coincidentally, found him in New York City at the time of the Wall Street Crash on 29 October 1929. How, he wondered, would his son have dealt with such an emotive subject, when he observed that 'people are seized with infection of fear and run like wild cattle before the shadow of wolves'?[73] Richard would surely have loved to be present to witness the fall of the American capitalist system that he so loathed and which had been merciless concerning the UK's war debts, to see the end of the Prohibition-riddled Roaring Twenties in the city that had rejected him, and to usher in the Great Depression (or the 'Threadbare Thirties') that he had long suspected was coming – and deservedly so. But instead he remained at home, designing costumes and scenery for *Wake up and Dream* at the Palace Theatre, finalising pieces for the exhibition at the Academy of Art in Stockholm and sending off work for the Carnegie International Art Exhibition in Pittsburgh. There would have been others who would have enjoyed the poetic justice in the news of the wreck of *S.S. Manuka* in New Zealand, in which a collection of British art worth £25,000, including one

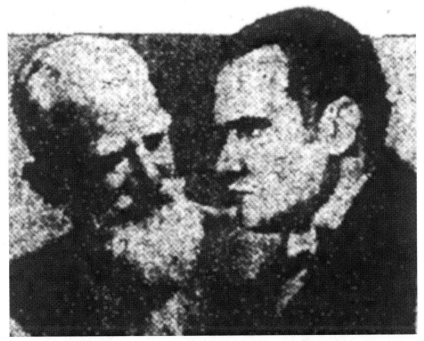

'Mr Bernard Shaw and Mr. Nevinson', Daily Mail, *25 September 1929*

of Richard's Parisian scenes, had gone irretrievably to the bottom.

Richard was determined not to go down with the *Manuka* and leaned ever increasingly on Kathleen to keep him away from utter despair. He acknowledged his debt publicly, explaining:

> You see, I married a modern girl fifteen years ago, and all friends tell me she is much too good for me, which annoys her and hurts me. After all, I found and married the girl, which showed a certain intelligence, and she has been able to bear with me, in spite of war, sickness, poverty and success, with its attendant hatreds and boycotts – an ideal to me in my blackest and most despairing moments.[74]

Some years later, and as a veiled compliment, he would write in the press, 'If a man is henpecked it is because he glories in his inferiority, and is proud to be mated with his superior',[75] while Kathleen divulged the secret of a good marriage, which was to stay faithful, but to retain the right to walk away if things got very bad.[76] It was a self-awarded privilege that she must have felt like using on more than one occasion.

But Richard's mind had turned to graver issues about the future, leading him to write 'We hear a great deal about the terrors of modern invention, with its power of indiscriminate slaughter, but what terrifies me far more

C.R.W. Nevinson, Place Blanche

is the modern mind.'[77] London in the 1920s had not, for Richard, been epitomised by the Jazz Age, but by the irresponsible dance upon the grave of a once-great civilisation during the 'long weekend' between two world wars. Despite the optimism of the Kellogg-Briand Pact which outlawed war, and the European 'Locarno honeymoon', another more serious war, he felt certain, was now on the horizon.

12
Visions of the Apocalypse and the Warnings of Cassandra (1930-32)

In *Poor Little Rich Girl*, Noel Coward sang, 'Cocktails and laughter, but what comes after that . . ?'; and this was the question that was on the lips of many in London as they watched the American market crumble, in the full knowledge that the same fate would soon, inevitably, befall their own. The party, it seemed, was over; the seductive veneer of British society had been stripped away to reveal a politically divided and extreme nation, and an economic freefall that could only augur doom for, amongst other things, the arts. Soon unemployment would reach four million, a National Government would take office, The British Union of Fascists would be established, unemployment benefits would be cut (leading to nationwide riots and Hunger Marches over the Means Test), and the navy would mutiny at Invergordon. The depression would lead to a collapse in the art market, or at the very least to a re-evaluation of the relationship between art, society and politics. Artists and gallery owners alike would have to consider market requirements seriously, as opposed to purely aesthetic ones, if they were to weather the coming storm. A glance at some statistics says it all: in 1929 the Goupil Gallery sold 20% of their summer show paintings; the number fell to 5.85% in 1930, and 2.64% in 1931; in 1933 nothing sold at all. At Tooth's Gallery, a hire purchase/instalment scheme was even offered to potential clients, while, in the auction room, British works dropped by up to 66% of their previous value. Little wonder some artists, Richard included, kept their hand in at journalism, theatre design and poster making, as a serious and reliable form of income.[1] When Britain came off the Gold Standard in 1931 the situation only got worse, leading Paul Nash to comment:

> Whether it is possible to 'go modern' and still 'be British' is a question vexing quite a few people today. . . . The battle lines have been drawn up: internationalism versus an indigenous culture; renovation versus conservatism; the industrial versus the pastoral; the functional versus the futile.[2]

In short, Richard was not alone when he assessed the damage and concluded that the over-theorising of art, the disappearance of subject matter and apparent technical virtuosity, and its élitism combined with crass over-pricing, had steered modern art into a corner from which it could not now respond to a society so rapidly changing. For better or for worse, Dennis Farr claimed, the 1930s would be 'one of the most decisive in the History of English art since the turn of the century'.[3] Richard was not far behind, and in a surprisingly upbeat article called 'Art – for Whose Sake?', he claimed 'The public doesn't know it, but we are living today in one of the most thrilling epochs of artistic exuberance.'[4] He had, after all, just emerged from a fairly grim decade, and felt now that an opportunity was presenting itself to become relevant again, either through a convergence of art and industry, which Paul Nash also advocated through the Society of Industrial Artists, or by responding to the politically charged environment, as an independent thinker, visionary and artist who could work comprehensibly and relevantly. If anything, the two themes that had made his reputation in the past, the city and war, also looked as if they might be merging, as war seemed imminent, to him, over the skies of London. Even if other artists like Ben Nicholson were heading towards abstraction, while Paul Nash and Edward Wadsworth were reinventing themselves by dabbling with ideas of metaphysics and continental Surrealism, Richard sought only a prophetic and politically engaged art, rooted in social relevance, just as his war painting had been almost two decades before. But such optimism did not come immediately and was exacerbated, as always, by poor physical health, depression, and a sense of exclusion to the point that he wrote to Eugene Gallatin (who was still exhibiting his work in the Gallery of Living Art at New York University) suggesting a return to New York, as 'arty types' were making his life unliveable in London. He signed off by saying 'I wish I could be a nice painter fitting in with a nice school of painting',[5] but both Gallatin and he knew that this was unlikely anytime soon. Neither was he breaking even financially, leading fellow painter, Alfred Praga, to jibe (in relation to the old Futurist manifesto of 1914) that Richard would never grow tired of drafts – especially overdrafts. But this was far from humorous, especially as almost 100 of Richard's works were currently travelling from city to city throughout Britain, generating a lot of interest but next to nothing in terms of sales. In Northampton, for example, 3,387 visitors came to study his works – yet none of them made any purchases.

In fact, the public face of the 'modern painter', undaunted by pragmatics, had scarcely ever looked more confident and he reminded his public that he was still here, and primed to go, saying:

> It would be mock modesty on my part not to mention that Picasso considers me the best English painter, because my work has great élan, a quality, according to Picasso, which is too often lacking in English art, and his opinion is far from valueless.[6]

If his critics and would-be detractors had the courage to chastise him and his self-appointed role of 'grand old man', they were going to have to criticise Picasso too, and for that matter both Whistler and Sargent, whom Richard relegated from the lofty status of artists, to mere painters. In another self-confident article entitled 'ME', he reminded his readers that he had always been a rebel through no choice of his own, and that 'In my riotous but idealistic life I have always seen the "lost cause" win, the "crank" to be right, the "rebel" to be justified, and contemporary public opinion invariably wrong'.[7] The warning was there for all to see that, after a decade in the doldrums, he was going to prevail, and those who opposed him would in the end look foolish. Quite naturally, the press found he made for irresistible copy – a likeable, but arrogant and slightly delusional asset to London life. Who could not have smiled when he told a court that he would rather have bitten the policeman for the same £5 fine he had just received for driving around Hampstead with no silencer on his car? Or who would not have felt he was up to his old tricks again when he light-heartedly taunted women in articles with titles like, 'The Worst Women in the World – and Alas – They are British!' ('Brains versus lipstick');[8] 'There are Far too Many Ugly Women!'[9] and 'Ugly Men Get Away With It'?[10] He even called the inhabitants of the House of Commons 'misfits', and extolled the merits of the Wall Street Crash, which had at least emptied Paris of the Americans who had been choking it since the war. The press also reported – and Richard would have liked this – that the Cardinal Patriarch of Venice had advised priests (and their flock) to stay away from the 'immoral' 17th Biennial International Art Exhibition at which he was exhibiting. He remained ever present in novels too, including Ethel Mannin's *Confessions,* though this would have pleased him less, as it charted the demise of a once-great painter, who had a 'slightly contemptuous manner and outbreaks of bitterness, and . . . [a] sardonic smile',[11] – even if Henry felt it was a fairly reasonable portrait of his son. And of course his famous bottle parties continued, indeed they too became the focus of a series of articles for *The Graphic* entitled 'Wild Parties in Three Countries', which recounted, rather arbitrarily, his adventures in London, Paris and New York. Regarding the USA he was able to reinvent one of the weakest episodes in his own history in the knowledge that he would never go back anyway, telling his British audience:

I have been an immense success there in my time and I have also known great failure – chiefly because I have been too popular, and I was young, and it was seen to that I had a good snubbing by chauvinist artists who had started a movement of American Art for the American People – and to hell with the condescending Englishman.[12]

He took another gentle swing at the Americans in an article called 'New Art in the Americas',[13] saying that they might as well hang cheques on their walls instead of pictures as the value was all they cared about, then went on to admit that although they had drummed him out of town they ought now to be forgiven as they were, in his opinion, really growing up rather well. And there were innovative roles too that only a very modern artist would be offered, or undertake, such as creating the scenery for the first television play, entitled *The Man With the Flower in his Mouth* by Luigi Pirandello, which was broadcast on 14 July 1930.

But it would be wrong to think that all his appearances in the press were frivolous. Both he and his old Slade peer Paul Nash continued to write about the need for a much closer alliance between art and industry, necessitating a practical modern art, which was no longer insular nor isolated but pragmatic as it had been in the Renaissance. Other ideas appeared in articles such as 'Make Your Home Reflect THIS Age',[14] which was echoed by Nash in statements like 'When the day comes for a more practical, sympathetic alliance between architect, painter, sculptor and decorator, we may see the acceleration of an important movement.'[15] Later Richard was asked to write what the British house would be like in the 1950s, to which he responded 'Nature will be banished', then went on 'We shall go back to simpler forms, to cubes: our paintings will be patterns, symphonies of form and colour'.[16] Because he predicted it did not mean he condoned it, and so he made it clear that he no longer revelled in the machine aesthetic, blaming industrialisation for leaving the population with an intellectual age of 12, an inability to enjoy work or play and a mentality of enslavement which characterised the age in which he was now living.[17] The Futurist was, most certainly, gone. Or at least, gone for the moment, as shortly after in 'Beauty in Modernity' he professed, rather inconsistently, that factories were the most beautiful structures built in the last 200 years, alongside planes and ships. This sounded more like the old Richard, especially when he attacked the editor of the *New Statesman* in a letter entitled 'Art and Immortality',[18] in which he damned contemporary artists for their perverse desire for immortality and their erroneously placed respect for Belloc, and Aristotle, who had said that painting was, in essence, imitation and mimicry. Richard

objected strongly to this saying that there was no more useless form of art than that which directly copied, as a camera might, the real world, or that had no other function than to relate some sickly sweet anecdote. In fact, going back to his old pre-war days, and to the debates that he had had on Whistler and Kandinsky, and on the relationship between music and art, Richard once again endeavoured to enlighten his public. His point was simple. In music the original inspiration would have come from the sounds of nature – the beat of the heart and the breath of the lungs. This, in time, had evolved into an autonomous creative discipline that no longer mimicked, but developed, elaborated and arranged, to create beauty at the hands of the composer and musician. Likewise, actors had learned to interpret, to create characters and pathos, rejecting the idea of a set rule for performance. Why then, he asked, was art caught in the stagnancy of imitation? Why had colour, rhythm and form been imprisoned within representation, and not liberated years ago in pursuit of spirituality and a higher meaning than the visual? Why were only the Surrealists today toying with the idea that art might deal with a world beyond 'the thing seen'?

Momentary inspiration had probably come with the welcome return of his old friend Gino Severini to London, even if Henry felt the Italian 'approached insanity nearer than common'. The event induced in Richard a 'return[ed] to abstract forms and arrangements'[19] and may have influenced his next article 'The Italian Moderns', which focused on Modigliani, Severini, Segantini and De Chirico,[20] and in which old, familiar pronouncements resurfaced. Richard appealed for an art of today and a final break with an unquestioning reverence for the past, especially when taste and snobbishness had become inseparable, and linked irrevocably to the hammer price. He concluded, as an old Futurist might, that art and industry could coincide perfectly well together to create the timelessness of beauty in a dynamic yet utilitarian world.[21] Richard was clearly identifying two distinct roles for art in society, even if he was unsure which one to pursue himself: the first, to be free, auto-nomous, experimental, intellectual and independent along the road to Severini's 'abstract forms and arrangements'; the second, to be functional and useful in a pragmatic alliance between art and daily life on a level that would be comprehensible and useful to all. Of course the decision could be misjudged, he felt, as it had been by the Bloomsbury Group which had lost any real claim to social relevance by becoming obsessed with the pursuit of purity in line, colour and form, ending up, as a result, with nothing. This, he reminded the reader, was a case of 'the parasite growing bigger than the tree'.[22] 'The Bloomsburies,' he claimed later, 'are a very able coterie who well deserve a great deal more than their

own mutual admiration'; however, 'They are not merely rogue Quakers content with sanding the sugar, stoning the raisins, and dusting the tea, but go to prayers and thank themselves they are not as other men are. ' He concluded dolefully by saying, 'Poor Cézanne, poor Baudelaire, poor Whistler. May the ages yet deliver them from their supporters.'[23]

Another option for artists, but not for him, was to follow the line advocated by the Royal Academy, which had reduced art, in his opinion, to a society event and an unthinking pursuit of narrative content and mimicry. He continued:

> There is nothing but acres of amateur pictures of sugary senti-mentality, dribbling inanities, or uninspired representation of some scene at which the artist should never have looked, much less tried to paint. These are the ghastly pictures that year after year debase the British public, debauch their souls with sloppy compromise, and cause mental diabetes by cramming their minds with a sticky, sugary prettiness. That is why modern artists of virility boycott this institution, and will never submit their work.[24]

Instead he proclaimed, as Marinetti might have done some years earlier, 'Let us abolish the poet laureate; let us abolish the Royal Academy (another state institution); let us abolish all our national galleries; let us divorce art entirely from the state.'[25] He went on:

> the RA is worse than a useless institution: it is a blight and a loathsome centre of decay and stagnation that does more to pollute living art than any other institution in the world. It drags the art of England in the dirt and covers English artists with ridicule.

The Royal Academy came in for another swipe too in a questionnaire circulated by the *Architectural Review* which Richard completed as follows:

> 1. Do you ever submit your work to the Royal Academy? If not, why not?
> A. Never. Because when I was young prejudices and reactions were even greater in those days than today. I also associated myself with living things and not dead old gentlemen.
>
> 2. What useful purpose, if any, do you think the RA as at present constituted, serves?
> B. None.

3. In the event of your answering Question 1 in the negative, what reforms, if any, in the Royal Academy, would lead you to submit your work to it for exhibition?

C. The institution in my opinion is too old and rotten to be in any way underpinned or bolstered up. Nothing but its complete removal will be of any value to living art in this country

Even when writing an obituary for Sir William Orpen, who had recently died of heart failure, Richard could not resist saying that Orpen, though great, could have been even greater had society, and the RA, not put so much pressure on him to paint conventional pieces.[26] Later Richard told the RA that they had got what they deserved when the scandal broke concerning Mr Reginald Eves (RA) who was found to have cheated by painting over a photograph in order to get exhibited. Richard, charitable to the humiliated painter, asked whether there was really that much difference between painting from a photograph and painting on a photograph, especially when Canaletto had used a Camera Obscura and Millais a 'magic lantern'. Algernon Talmadge, at the end of his patience with Richard, then opened a can of worms by revealing publicly that the outspoken renegade had actually exhibited there (or at least submitted) and that his name had been down for membership for years. This lead to absolute silence from Richard as he had confidently proclaimed earlier, 'If I should lose all my ideals and accept, if asked to become an ARA I would lose all my money, as my good will would go, and my clientele would never – and rightly – purchase a work of mine again'.[27]

To his surprise though, some other artists rallied round to say that they felt the same way as he did, especially after he penned an article entitled 'The State Kills Art'. In this he suggested uniting British artists for exhibition purposes at the Grafton Galleries as a means of side-stepping the RA and of beating the impossibility of going it alone.[28] Just as the New English Art Club, the Allied Artists Association and the London Group had done in the past, this new alliance would stand defiantly against the old, the 'knacker's yard' (auction houses which, he declared, parasitically fed off impoverished talent), and prescription theories which had self perpetuated *ad nauseam* in England. Almost immediately there was a positive response and this led to the founding of the National Society, of which he was appointed Vice-Chairman, under the Directorship of Stanley Mercer. This society, with a membership of 140 artists, would permit no jury, and would allow each member 5 feet 'on the line', to exhibit a total of 450 paintings and 50 sculptures in an annual show. Lavery, Talmadge, Epstein, Dobson, Schwabe and a host of others joined, but emphasised diplomatically (presumably to Richard's

disappointment) that this was not an anti-RA society *per se*, simply one that had a more catholic vision. Under the moniker of 'British Art for Britain' it would open its exhibitions to coincide directly with those of the Royal Academy, and in a tightening of ranks between independent British artists, exercise some collective muscle.

In May 1930, their first exhibition opened, which Richard couldn't attend due to illness, though Henry took the opportunity to visit and described the exhibition as 'A very fine and original, but not outrageously modern, show.'[29] In combating the stagnancy of the RA, and in helping establish such an important society, away from conservatism, élitism and absolutism, Richard had no doubt that he had 'done more than any other living Englishman to change this outlook . . .'.[30] It did not, therefore, go down well at all when the Tate Director, Manson, effectively wrote Richard out of any meaningful discussion on the arts in Britain – past or present – in the *Encyclopaedia Britannica*. Enraged, Richard's thoughts turned to libel action, and once again Henry talked him out of it. Instead, he told the *Daily Express*:

> For days and days I thought of nothing but MURDER . . . MURDER . . . MURDER – the murder of a certain curator of one of our national galleries. The result was that I could not sleep, eat nor even think of anything else but the murder of this man.[31]

The same paper did what it could to make sense of the jumbled personalities embodied in this one larger-than-life character and concluded, 'He is a strange man, this Nevinson, and I think he might have proved a greater writer than an artist, but for the violent feelings that often overtake him. His power to hate is enormous.'[32] Convinced that Kathleen was right, and that Manson was not worth hanging for, Richard re-focussed his energies on the preparations for his eighth exhibition at the Leicester Galleries, and their 500th. In the press he got to work talking himself up, and others down, with statements such as:

> I think it was Picasso who once told me I was the greatest painter since Cimabue. I could be greater still if I wanted to but I am proud enough of being as great as I am. The intelligentsia hate me because I am more interested in myself than in them. I don't care. I regard myself as more important than them. 'You are our greatest painter' Paul Nash is always saying to me, and I have the highest respect for his opinions.[33]

He told the press, too, that Mussolini and Gabriel d'Annunzio wanted him as an art instructor in Italy. At a time like this in Europe, few would

C.R.W. Nevinson by Barney Seale

have failed to notice headlines like these and, consequently, the opening of his exhibition in October 1930. In fact there was a bottle party beforehand, followed by a record-breaking crowd at the Galleries, at the door of which was a bust of Nevinson by Barney Seale, which scowled at the visitors as they entered. His father, loyal as ever, wrote in his journal of that precarious balance between the emotional and the intellectual in the works on show on opening night:

> very fine & powerful, espec. the streets & town scenes. Two dream-
> like fantasies beyond my understanding: portrait of himself, Kath
> & cat in jumbled surroundings of port interests, good without
> beauty. All were pleased and admired, at least outwardly.[34]

Reviewers truly hoped for an exhibition of 'Brushes and Boxing Gloves',[35] to match the fighting talk which had preceded it, but for P.G. Konody, 'The pugilistic element in his painting jeopardizes their aesthetic value and prevents them from being really supreme works of art.' Richard, he said, saw the world through the eyes of a gargoyle – sullen, antagonistic and angry.[36] Others, like R.H. Wilenski jumped into the fray with titles like 'Nevinson the Merciless: Enjoying Making the Art Lover Wince', in which he said 'I dislike all Nevinson's pictures intensely. In spirit they strike me as harsh and superficial.'[37] Newspaper reports used words like 'journalist', 'illustrator', 'publicist', 'graphic' (not plastic), 'novelty', 'variety', 'topical', 'erratic', 'facile', 'flippant' and 'provoc-

ative', to describe what they were seeing. None of this would have pleased Richard at all as it was clear the critics who meant to criticise both him and his art had turned out in force. Roger Fry would not even sit with Henry at a dinner in Oxford hosted by Michael Sadler (at which an early painting by Richard hung), such was the strength of feeling he had developed against Henry's wayward artist son and his work. But Richard's supporters were there too, like T.W. Earp, who wrote a long piece in *The Studio* hailing him as a great master. The critic lauded him as the artist who did not disappoint; the genius who had risen above laborious theory and art for art's sake; and the intellectual who had become priceless as the conduit for a synthesis, and a compression, of experience. His was not an instantaneous realism but an emotional and epic response based on the priceless experience of life, where hand and eye worked in unity. Such vision could only have been acquired through a lifetime of logical and consistent growth, utilising a fertility of method with a fidelity to subject, where the message was, rather unfashionably, as important as the technique. Earp concluded enthusiastically that Richard's work 'captures a beat in the rhythm of time'.[38]

By the end of October, 12 paintings had sold and 60 prints, with the Museum of London acquiring *St Paul's* (which Manson had rejected from the Tate) and *Fitzroy Street*, and the National Gallery in Dublin accepting *Henry IV.* Other work was about to ply the Atlantic in a novel exhibition opened by HRH Prince George on board the *Aquatania* (Richard had previously written in praise of the *Bremen*)[39] which was about to make its way, with 300 paintings on board, to New York City, where Richard was now considering a joint exhibition with Barney Seale. At first his father liked the idea, writing to Florence Lamont (who had purchased *From the Adelphi to the Coleseum* [sic] for £126), to ask her for the keys of her apartment for Richard to stay in when he arrived. Then a little later he expressed his relief 'at [the] postponement of [the] American show'. Richard's derogatory article 'New Art in the Americas' was simply too hot off the press to risk another financial calamity like his last visit, not least as, once again, he had attributed little to Americans other than their love of the worm-eaten, and their successful copying of European art, which they could still not surpass.[40] It was easier to stay put and build on what he had achieved, even if that too was far from plain sailing.

The massive pains on the right hand side of his head that had kept him away from the National Society debut, now moved to his eyes and most of the doctors he consulted believed that only the removal of all his teeth could alleviate it. A certain Doctor Stanmer, on the other hand, felt that the problem stemmed from an entirely different

source, being the result of a persecution mania and 'brooding over his wrongs',[41] combined with the sudden news of the death of his old friend and aviation mentor Sir Sefton Branker in the R101 disaster at Beauvais. In fact, Downside Crescent in general was far from a happy place at this time, and Henry looked around him at a family falling apart, writing 'Unhappy about M[argaret]'s long illness; Richard's pain in the head; E[velyn] S[harp]'s failures and penury + Phil[ippa]'s idiot boy'.[42] Of Richard's situation he commented 'If only we cd. all learn by heart Bertrand Russell on persecution Mania'.[43] No wonder Richard's compositions, both painted and written, now began to evolve in a more sinister, brooding and melancholic manner; away from the preserve of nature and beauty; away from the bon viveur of the city; and towards the forebodings of a grim future for both himself and mankind. But not everyone was listening to these grave pronouncements, or his views on aesthetics, as his father observed at his son's speech 'Beauty, Prettiness and Ugliness in Art' at the Foyle's Literary Luncheon at Grosvenor House which was chaired by Sir Ernest Benn. This, Henry wrote in his journal, 'received a deaf silence & some boredom as people didn't follow it'.[44] Gone, it seemed, were the days of the *conferenze* and the audiences who had had to flee from the onslaught or who, outraged, had attacked the speakers. But far from beaten, and perhaps trying to re-inject some of that emotion back into the debate, Richard upped his efforts in the press, penning, amongst other things, articles on Surrealism. He also, ill advisedly, taunted George 'Barnum' Shaw again when he accused him of being a Narcissus, blinded by excess vanity, and calling him a reactionary, an old fashioned icon of passéism, that may have wrangled membership of London's best clubs, but who was loathed by the younger generation, for whom Richard spoke when he concluded 'Stop Clown, Stop!' This was too personal for most readers, especially when Richard told the old man that his very survival was pathetic, reminding Londoners only, and daily, of his insignificance, and the fact that Charlie Chaplin was his academic superior.[45] But Richard was alone in this. Few could understand why the attack had come, and why it was both so vitriolic and in such bad taste.

Changing tack, on a much more positive and congenial note, and also demonstrating his propensity to swing from one mood to another, Richard wrote an article called 'These Men Taught Me How to Live', in which he publicly declared his admiration for, and debt to, Wyndham Lewis, Marinetti, Freud, Van Gogh and Socrates.[46] Beginning with Freud, who had recently published *Some Psychological Consequences of the Anatomical Distinction Between the Sexes,* he evaluated his contribution not only to his own development but to that of society:

I feel that Freud has been to my generation what Darwin was
to my father's ... and even more epoch making. ... Freud has
taught us a certain hope for reason and an escape from the
pent up miseries of much religious teaching especially when
it is combined with the sadistic hypocrisies of so called social
reformers and other seekers after power. Poor English socialists,
Shavians and Fabians! If only they would realise that they are in a
pathological condition, overwhelmed with the mother complex,
which their poor feeble minds will call 'State Control'.

Marinetti got his pat on the back too with 'To him I owe my escape
from the degenerate education of a public school, with its pomposities,
its asinine amateurism and its unprintable traditions'. More importantly,
it was Marinetti who had taught him how to love the present and loathe
the past, alongside another, surprising, name.

I owe my original interest in modern art to that confused genius,
Percy Wyndham Lewis, whose vivid tongue first spoke to me of
Derain and helped me to fathom Picasso a quarter of a century
ago. I feel that I owe this to him, although no doubt he will
greatly resent it.

All of this, combined with Van Gogh's conviction that public approval
was not important, and the 'know thy self' dictum of Socrates, had given
him the strength, he said, to carry on in the face of terrible adversity. A
combination of these teachings, combined with his natural aversion to
directionless theories and studiotic practices that had necessitated his
departure from the London Group twelve years before, had kept his art
relevant and meaningful while those around him had experienced the
reductio ad absurdum which had left in its wake only sterility. From his
own stand-point he thanked his mentors for leaving him with a belief in
God (but not Christianity); a knowledge that greed, luxury and sex are all
good; a non-judgemental attitude to the man in the street; a faith in hope
and positive thinking and a realisation that life is, after everything else,
hard.[47] Perhaps most important of all, he proclaimed, courage was more
important than wealth. It was just as well he thought this as on the eve
of the 82nd NEAC exhibition at the New Burlington Galleries, Henry
could only look longingly at *La Patrie* hanging above the fireplace in the
studio and hope that that sort of *brio* might yet return. Certainly there
seemed to be a demand internationally for his son's work, even if at home
sales were predictably slow. In fact, *The Charlady's Daughter* was bought
by Henry for a not unsubstantial £40, and given to his partner Evelyn
Sharp,[48] before he rushed off for his appointment with newsworthy

Mahatma Ghandi at Gower Street.[49] As a further 20 of his canvases were boxed up and sent across the Atlantic to a joint show (in absentia) with Barney Seale at J. Leger and Son in the 5th Avenue Galleries in New York City, he and Kathleen headed the other way, setting sail for Venice. Elsewhere, his work also went on display at a large British Exhibition at the National Gallery in Ottawa, while some others were on their way to Tokyo on board the *P&O Mantua*. Ambassador Sir John Tilley had personally made the request for an exhibition of British art (to diffuse diplomatic tensions aroused by the Manchuria crisis), and so a strong showing of artists, including Bone, Cameron, Clausen, Dobson, Fry, John, Lavery, MacColl, Munnings, Orpen, Rothenstein, Sickert, Steer and Stokes, had released their work. Richard had even secured an advanced sale of the etching *Blackfriars Bridge* to Prince Tokugawa.

At home, and almost completing another u-turn, Richard's review of the French Exhibition at Burlington House rallied round to defend English art and Englishness again, as it now seemed to have lost 'that tameness, that effeminacy and gentlemanliness, which has been their curse for generations. . .'.[50] Renoir, he felt, had been the highpoint, no matter what the 'Gloomsburies' said, while he believed John and Brangwyn matched up to Delacroix, who in turn had owed a great debt to both Constable and Turner. So respected were his views, and so palatable his critique, that he was asked to address the Oxford Arts Club at the SCR in New College where the Slade Professor, Randolph Schwabe, whose portrait he had just finished, would be in the chair. Paul Nash had done this the year before and booked for future presentations were Eric Gill and Jacob Epstein. He also managed to get back from Venice in time for the opening of the Second Exhibition of the National Art Society at the Royal Institute, Piccadilly, where he unveiled the first in a series of prophetic and apocalyptic works entitled *Pan Triumphant*. This major canvas, no longer trying to appease market forces but instead encapsulate courage and social engagement, finally addressed some of the fears that both he, and his close friend H.G. Wells, had shared concerning the British Empire, the economy, socialism, capitalism, and the future of civilisation. The scene, described by Konody as a crossword puzzle, was set in a modern metropolis, possibly New York City, in a composition that celebrated none of the enthusiasm of the pre-war years, but seemed to warn of the triumph of evil, and the slavery of mankind. Henry had felt the same stirring as he had watched, euphoric, the *Graf Zeppelin* sailing over London, then mused on what might be the logical outcome of it all, in the light of the failing Disarmament Conference, the termination of German reparations (but not British war debts), the movements of the Japanese towards Shanghai, and the seeming ineptitude of the

League of Nations. War, it was clear, was coming again, and this could be felt elsewhere in Vera Brittain's *Testament of Youth*, Edgar Mowrer's *Germany Puts the Clock Back*, Vernon Bartlett's *Nazi Germany Explained* and even in the arts in the publication of *British Artists and the War* by John Rothenstein. On the big screen (talkies since 1929) the Milestone production of Remarque's *All Quiet on the Western Front* and Borgaze's version of Hemingway's *A Farewell to Arms*, collectively suggested that instead of being relics of a now clearly defined, and regretted, past, these paintings, films, books and other relics of the Great War, were in fact harbingers of another great crisis to come.

At this time Richard began to experience a terrible succession of nightmares of executions and other macabre images, stemming from his frustration at being unable to convince others of the gravity of the situation. He wrote, 'I am neither a fool nor a courageous man, so that ever since I reached maturity I have lived somewhere near the border line of despair.'[51] This in turn led to nervous exhaustion and soon it was reported that he was 'Too ill to be moved'.[52] Concern deepened two days later with the appearance of a notice on his studio door saying not to knock, or ring either, while the local telephone exchange was instructed not to forward calls. Inside, Richard wrestled with a temperature of 103, while Kathleen was little better at 101; and so, the first of the obituary style reports appeared in the press, which began to talk about the 'formidable and scorching rebel', who had been 'such a likeable fellow, despite his violent antipathies to modes of expression savouring on the unconventional'. In what seemed like a deathbed farewell one report concluded 'Nevinson was born to cause a commotion'.[53] The same week, and seemingly as a gesture to a dying man, Richard was elected to full membership of the Royal Society of British Artists, having been forwarded by Bertram Nicholls. The Watercolour Society was not so altruistic, however, rejecting his membership application on the third ballot, which was especially poor timing as it came on the eve of the opening of his show entitled 'Watercolours From Nature' (with the works of Dame Laura Knight) at the Leicester Galleries. Richard was unable to attend the opening and private view, but Kathleen could, and she introduced, to a newly sympathetic public, fifty paintings of the Riviera, the open country, pools, sunshine and rain in a tranquil return to nature which was most welcome. The press were indeed generous, if shallow, calling him 'a showman of London', and an artist with a 'Fleet Street reputation' who displayed both 'versatility and rare strength'.[54] Henry liked what he saw too, but Sir Ian Hamilton was a little perturbed by the depiction of pubic hair on the female models, and preferred the depictions of Venice and London. Sales were, as usual, very slow indeed,

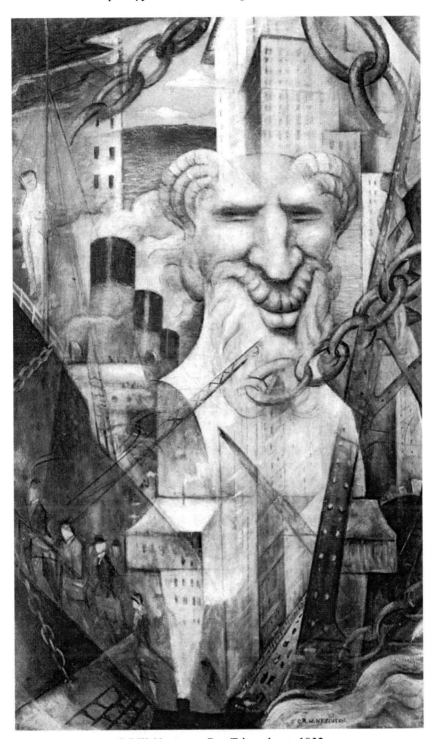

C.R.W. Nevinson, Pan Triumphant, *1932*

leading the galleries to extend the run by two weeks in order to encourage a few more. When Richard did finally resurface and appear in public he did not disappoint his audience, saying 'I am wearing clothes instead of the wooden suit I expected and taking an interest in life again.'[55] In another newspaper he confirmed 'Yes, I had pleurisy, pneumonia and a mastoid' and joked that 'even when I was in a coma, you newspaper fellows were calling up on my telephone, near by, asking was I dead yet'.[56] In *Paint and Prejudice* he remembered with humour a journalist who had phoned:

> 'Yes,' I quavered.
> 'Daily Blank speakin',' announced a very cockney voice. 'Is 'e gone yet?'
> It hurt me to laugh and I maintained my gravity by thinking they should not have left it to the office boy.
> 'No,' I said. 'He's still with us.'
> 'Good-bye,' said the voice. 'An' if 'e goes within the next hour give's a scoop, will yer?'

Having received kindness and get well wishes from the King and Queen, the Prime Minister, and a host of others, from 'peers to potmen, from princesses to prostitutes . . . ',[57] a further surprise occurred when someone pushed £50 through his studio door, with a note, but no signature, saying that he should use it to buy one of his own pictures, to present to a gallery of his choice. It was rumoured that he would choose *Saturday Afternoon in England*, which he had earlier unveiled at the National Society of Painters, Sculptors, Engravers and Potters at the Royal Institute Galleries at 195 Piccadilly, and which Henry described as 'a fine and unusual one of Saturday Afternoon: footballers with a factory town as background'.[58]

Even if he needed financial assistance, his reputation was something he was determined to look after for himself. Though he would have been delighted to appear in significant publications such as *English Painting: From the Seventeenth Century to the Present Day* by Charles Johnson, *Warrior* by Lt.-Col. Graham Seton-Hutchison, and *Masters of Etching* by M.C. Salaman, he was also quick to rectify misrepresentations or omissions, as was clearly seen when he wrote rebuking John Rothenstein for his *Modern Painters* Vol. II. In a strongly worded letter he deplored Rothenstein's inaccuracy, which had denigrated his war service to a few visits paid to the Front. Richard, a Mons Star holder, an ex-serviceman, discharged twice for health reasons, an outspoken defender of freedom of speech in the censorship issue, an aviator and an Official War Artist, was not going to tolerate this and said he would rather have been left out of the book altogether.[59] In a further letter to Rothenstein he warned him not to succumb to the legacy of the 'Tonks and Bone Period of

1919-1920' when they had vilified him and done everything in their power to bring him and his career down. Suspecting he had tuberculosis now, and sure that his days were numbered, he forgave Rothenstein, signing off with 'However I am a disagreeable, disappointed man. . . .'[60] Additionally, just as his direction was becoming clearer, and just as he became gripped with a subject matter for which he felt eminently suited, he noted with despair, 'My hand seemed to have lost its cunning and I was doing work that would have shamed an amateur.'[61]

At this time, he and Kath also took leave of the capital permanently, moving to a bungalow in Shepperton, opposite The Ship Inn. Richard highlighted the significance of the move, saying 'I have broken every chain that bound me to any social, political, ethical or moral sphere. I am entirely outside society – not against it, mind you, for I am not a criminal – but right away from it.'[62] But tranquillity did not follow as, at Downside Crescent, his mother Margaret's mental and physical health went into a rapid decline, leading to discussions on her possible committal to a nursing home. This induced a parallel deterioration in Richard's health to the point that, within days, he was spitting blood and showing renewed signs, in his opinion, of tuberculosis, which led Henry to offer his savings of £1000 to put him into a foreign sanatorium. Richard said he did not want the money, only a speedy death, as he realized his work was now over as an artist, especially as the glimmers of hope that had appeared with an overwhelming subject matter had in fact only intensified both his mental and physical deterioration. The situation got worse too when Margaret locked herself in the bathroom, lay in the bath full of bedclothes and turned on the gas at the mains. A Dr Fletcher, whose professional opinion had been sought, said that this was not a suicide attempt as she had actually lit the gas but acknowledged, all the same, that it was worrying behaviour. The next day she took an overdose of sleeping tablets, but again recovered, and so the remaining family held a crisis meeting to discuss what to do next. Henry, though totally estranged from his wife for many of their 48 years of marriage, and long established with Evelyn Sharp, loyally said '. . . but I hold it cruel to banish her to a strange home, espec. a mental home.'[63] Soon she became delusional and started to believe that there was a plot afoot to poison both her and Richard, instigated by those at the Tate and Wyndham Lewis, and the next day the paranoia got worse resulting in 'imaginary fears and images'.[64] On 7 June 1932 she slipped out of consciousness and Henry wrote: 'M. still weaker, but breathing and heart continue: mind and soul entirely gone: no dreams even: real death but for a shadow of unconscious life in the body. Read her instructions about cremation & a few legacies.' The following day it was all over.[65] Henry's diary reads:

At midnight M. quietly stopped breathing: a fairly energetic woman, little suited to me, being by nature a traditional catholic & conservative, always inclined to contradict me on every point & all occasions: eloquent, always on the melancholic and unhopeful side, but often humorous & full of observant stories. I sadly recalled all we had been through together since our sudden and mistaken engagement in 1880: our dismal marriage in '84, Weimar, Jena, the Squalor of Queens Square, the years in Whitechapel, removal to Hampstead in John St., Savernake Rd. & Downside Close: my overwhelming passion for a woman which broke her heart: her entire concentration upon Richard & grief at his frequent disasters among artists. My absences in wars were indifferent or pleasing to her & she never welcomed me back or cared to hear of my journeys: felt jealous of any success espec. in writing, for her chief ambition was to write. For Richard she laboured incessantly & cared for no-one else. Up to five years ago she had fine energy for travelling, but was seldom content and liked few men & fewer women: was a merciful guardian & magistrate, but had little sense of logic or evidence, forming a fairly just opinion without it. And now she lies terrible still in a black box. . . .[66]

Remarkably, Henry carried on with his life normally, attending a lecture on Goethe that very same evening, and recording coldly on his return, 'Came back to the house where the cold form lies coffined.'[67] The next day, as the letters of condolence flooded in from Ramsay MacDonald and other notables, he attended a meeting on the issue of German Reparations, and on the following day, before the funeral itself, was out in public with Evelyn Sharp at Sotheby's on New Bond Street. On 11 June Margaret Nevinson was laid to rest:

The funeral. Wrote many more notes of thanks. The men arrived about 11.10 & carried the cold, silent form downstairs and into the hearse. Phil & child Marg. came & Rich and Kath in their grey car – flowers heaped on the coffin – at slow march we went up the familiar road to St. Stephens. All passers standing at attention and raising hats. Church crowded with old friends, Freedom League + magistrates. I followed the purple coffin – to the top of the seats & sat there alone.

Hymns were 'Lead Kindly Light', 'The Fight is O'er', 'The Lord is my Shepherd' and a reading from Corinthians.

Then we followed the coffin down the aisle again. I ordered all the flowers to be put in the porch for the hospital. Rich followed

in his car but not entering the chapel. Sharp read part of the Burial Service ('commit to the flames' he said) and the cold form was slid away through doors into the fire. Too horrible to realize, but better than cold clay and worms. Sharp and I drove back, taking aged Mary Nevinson who had insisted on following us in a taxi that I might not be alone. . . .'[68]

The obituaries read that she was the mother of the famous artist, in addition to being the first womea to sit on the Criminal Bench in the County of London and one of the first three to sit on the Lord Chancellors London County Justices Advisory Committee. She had been a suffrage campaigner, a writer and lecturer, and so it could be said of her 'She was a brilliant woman of extraordinarily wide sympathies, and almost fanatically intolerant of unfairness or injustice of any kind.'[69] Richard later wrote in his autobiography 'It was some consolation to know that she had been beloved by some of the noblest thinkers in the land, and that her erudition, her wit, her integrity, and the life which she had devoted to great causes had not been as wasted as she thought.'[70] In her estate she left £2,830, of which £200 was to go to her maid Kate Andrews, and an early portrait of her by her son, which was to be presented to the Tate. When Henry went out for dinner with Evelyn Sharp that evening 'in the lovely summer air', the days of an unhappy marriage were finally behind him and the ability to breathe freely his at last, though many of his friends felt such immediate and obvious sentiments to be in bad taste. Margaret would not have been surprised at his attitude and, in fact, Henry found out after the funeral that he had been excluded as the executor of her will, leaving Richard and the bank in charge of everything. Going through her personal belongings Henry found hundreds of cuttings of Richard's shows and of her own failed attempts to be a writer.

Henry was not given much time to adapt to the death of his wife, as within days he received a telegram from Kath instructing him to come immediately to his son's bedside as he was now critically ill with suspected cancer and very possibly facing death. A day later Henry clarified what had happened saying, 'Last Monday he motored alone – 5 ½ hours (210 miles) almost unconscious + disabled with pain. Operation for ulcer in bowel on Tuesday night'.[71] An abscess on the peritoneum had almost led to peritonitis, and stemming from diverticulitis, resulted in ten days where he suffered 'the agonies of the damned'.[72] But far from being relieved at having pulled through, Richard came round complaining at being alive, a failure in art, money and reputation; surrounded only by enemies and hatred, and certain that he should have gone the way of his

mother. Henry captured the situation in a letter he wrote to Elisabeth Robins in response to her anxious enquiries:

> How sweet of you to write, adorable woman! The terrible news brought me back from a few days' holiday last Thursday. The illness is very dangerous, and last nights' report bad. I am not allowed to call just yet, but will add a word when I have been round. The home is close by. It will be terrible if so much genius just fades out at forty. The pain is severe, but he is more patient of pain than ever I was.[73]

Characteristically, though on his 'death bed', Richard still managed to keep a sense of humour and even penned a further article called 'I Warn the Nudists',[74] which was followed by 'The Modern Woman Criticised'.[75] In the former he reminded the public to differentiate between 'nude' and 'naked', while in the latter he lamented that Hollywood had turned women into flat-chested and narrow hipped 'shrimps and freaks', with the 'modern Eve' being merely an 'ill-formed dwarf'. At home he was no kinder, saying 'The average society beauty [who] is a splay-toothed creature dressed in untidy tweeds which her maid has forgotten to brush, and who is always squatting upon a stick.'[76] He may have been down, but he was, as yet, far from out.

When, eventually, he was up and about again, and the thoughts of cancer dispelled, the establishment, it seemed, began slowly to reel him in, and in declining health, and utterly tired of being the outsider, he was no longer putting up the characteristic fight. Making his debut, as a member this time, at the 49th Exhibition of the Royal Institute of Oil Painters, seemed to be a valuable tonic to getting back to tolerable health, as was his inclusion in the 83rd NEAC exhibition which was billed (presumably to his disgust) as a 'Homage to the Slade'. Soon after, he turned his attention to the 178th exhibition of the Royal Society of British Artists at Suffolk Street, and also undertook a few 'fun' commissions such as painting the pub sign for The Old Mill, West Harnham in Salisbury, and designing the cover for Cadbury chocolate boxes with a painting called *Exotic*. One critic couldn't resist the idea of chocolate box art and concluded 'If the plebs like this design Cadbury's may give up all hope of improving their taste.'[77] In the end-of-year review in the *Sunday Times* Frank Rutter astutely noted that 'Mr Nevinson has made a new advance this year and has distinctly added to his reputation'. His father, for a change, seemed to be the one making the diplomatic blunders, by announcing his intended marriage to long-time partner, Evelyn Sharp, so soon after the death of Margaret.[78]

13

'The Strangest Manifestations' (1933–35)

At first, when they realised how quickly Evelyn Sharp had replaced Margaret, Richard and Kath stopped attending the Sunday lunches that had been such a feature of Nevinson family life. Though there had been no secret that Henry had met Evelyn in 1901, and had shortly after begun a relationship, planning to get re-married within seven months of his wife's death caused unease. The wedding date was set for 18 January 1933 and so it became clear, if Richard had been hasty in his matrimonial arrangements 18 years earlier, now his father was following suit. Nonetheless, it only seemed fair to Richard and Kathleen to offer their support to the man who had consistently supported them, and so Henry was relieved when soon they 'received me graciously, a vast relief to much anxiety. . . . Both very kindly and anxious to please'.[1] In fact Richard's solidarity was demonstrated publicly too when, in a rare tribute to his father, he told the assembled guests of Sir Ian Hamilton at the Criterion, how honoured he was to be 'your son and [as] your guest, to pay my homage. I think it is to you I owe the fact that I am, as well as a pioneer, such an unruly rebel. I only hope the mantle I inherit from you will be worn by me as becomingly as it has always been worn by you'. Henry, flattered, wrote in his journal 'Coming from Richard that is a very remarkable tribute'.[2]

Back at the easel, however, Richard's mind was unsettled and he found it hard to focus on any one thing. Even while a wider re-orientation seemed to be returning with artists elsewhere in 1933 (in the formation of collectives such as the Modern Architectural Research Group (MARS), the Artists' International Association, Unit One, and the Ashington Group), Richard's contributions to The 4th National Society Exhibition at the Royal Institute Galleries, demonstrated a continued eclecticism, or disorientation, that many found bewildering. The old Futurist sculpture *Machine Slave* re-emerged (inspiring a young, socially engaged, W.H. Auden to write an article called 'Be Masters of the Machine'[3]), alongside a painting called *A Decorative*

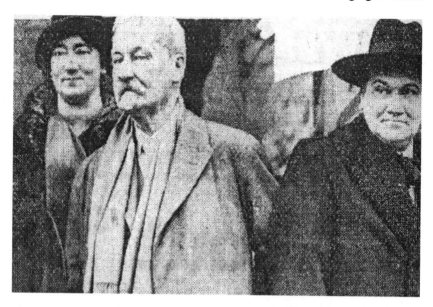

'Journalists Marry', Daily Herald, *19 January 1933*

Landscape (which *The Observer* called 'early-Victorian romanticism'), and this was, in turn, next to *Design for a White Room – Souvenir de la Bretagne*, which the same paper felt had all the 'decorative virtues of Cubism'.[4] Richard meandered not only from subject to subject, from urban to rural, from narrative to abstract; but even from medium to medium. Some critics hailed it as 'An Exhibition of Vigour', saying that for all it might be far from conventional, it was even further from absurd. Others, such as Frank Rutter in the *Sunday Times*, were not fooled for a minute, saying that despite the group's rather grand title, it was little more than a 'marketing association for professional artists and craft workers'.[5] Richard's work was scattered elsewhere too: from the Pastel Society Show, to the Colnaghi Galleries (where his lithographs were shown beside those of Ingres, Clausen, Copley and Rothenstein); from Agnew's 'Exhibition of Watercolours and Drawings' (where his *Villefranche* hung in the grandiose company of Michelangelo, Leonardo, Correggio, Raphael, Veronese, Rubens, Van Dyck, Rembrandt, Turner, Girtin, Constable), to the opening of the Northampton Town and County Art Society, where, as President, he was delighted that some of the works on display were done by bricklayers. Elsewhere in the United Kingdom he had pictures showing in Birmingham, Hampstead, Eastbourne, Bradford, Aberdeen, Sunderland, Liverpool, Glasgow, Sheffield, Lincoln, Uxbridge, and Burton. And if his paintings were scattered far and wide then so too were his written and spoken pronouncements on an equally wide range of issues – from his horror

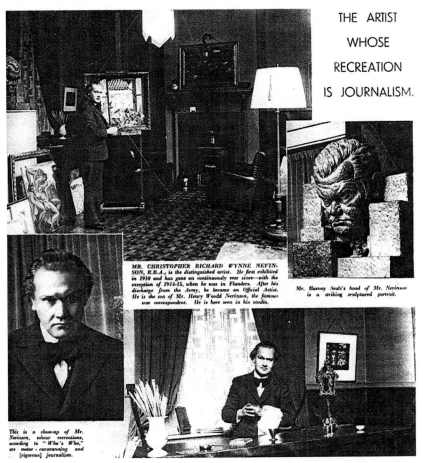

THE ARTIST
WHOSE
RECREATION
IS JOURNALISM.

MR. CHRISTOPHER RICHARD WYNNE NEVIN-
SON, R.B.A., is the distinguished artist. He first exhibited
in 1910 and has gone on continuously ever since—with the
exception of 1914-15, when he was in Flanders. After his
discharge from the Army, he became an Official Artist.
He is the son of Mr. Henry Woodd Nevinson, the famous
war correspondent. He is here seen in his studio.

Mr. Barney Seale's head of Mr. Nevinson
is a striking sculptured portrait.

This is a close-up of Mr.
Nevinson, whose recreations,
according to " Who's Who,"
are motor - caravanning and
[vigorous] journalism.

'The Artist Whose Recreation is Journalism', Daily Sketch, 23 August 1933

at the emaciated women's fashions of the day to supporting Nancy
Cunard's crusade to free nine African Americans in the 'Scottsboro
Defence'. In fact Richard produced more articles in 1933 than in any
other year, and the following list gives an idea of the range of subjects
he tackled: 'Thus I Would Rebuild London';[6] 'In Search of the Typical
English Woman';[7] 'If Your Child Wants to Draw';[8] 'Despised Artists:
Triumphant in Revolt';[9] 'C.R.W. Nevinson Re-Plans our Seaside';[10]
'Women's Seven Virtues';[11] 'In Defence of Camping: A Common
Sense Craze';[12] 'Museums – not Mausoleums';[13] 'Don't be Humbugged
by Experts'.[14]

Although his writing was prolific, Richard insisted that he was first and
foremost an artist, rather than a journalist. His name was also used as a
measure of greatness when the press announced the premature death of
the great ballerina Dolores, who had studied under Pavlova, danced for

the Kaiser and had her portrait painted by Nevinson. And he even had himself wired up to the new lie-detector or 'psychograph' experiment at the Savoy Hotel, to see how he would respond to the following words: Work, Young Artists, Epstein, Beauty, Illness, Conservatism, Augustus John, Death, Nurse Cavell Memorial, Cubism, Royal Academy. The results, they said, produced 'Reactions that nearly smashed the apparatus'.[15] It would have been interesting to see how it would have reacted when, in the same year, he told the *Oxford Mail* another of his war stories which went like this:

> One day during the war I was sitting in an observation balloon having a snack when I was suddenly attacked by an enemy plane. I finished the meal as I floated towards earth in a parachute and digested it, bleeding profusely, hanging from the branch of a tree in which I landed.

Back on civvy street, he provided the cover for *Crime de Luxe* by Elizabeth Gill, and also contributed a chapter on Sir William Orpen in *The Post-Victorians*, which his father said threw 'into shade my stodgy Haig',[16] in his son's astute perception of 'the double nature in the man. . . .'[17] This is rather confirmed by Orpen's own biographer who wrote, 'More than Konody, more than Rothenstein, more really than any of his critics, it was C.R.W. Nevinson who understood the Orpen of the last years.'[18]

Away from his public, however, Richard's agenda was extremely serious, as he wrestled with questions on the existence of God, and tried to comprehend the visions he had been having, even if 'I am not a Christian and I do not believe in life after death'. 'I am often victim', he said, 'of the strangest manifestations, the host of several of the dead, the onlooker of occurrences in far distant countries, and the recipient of prophetic visions that deal with the affairs of man'. He went on to say that as he got older he found it harder to distinguish between

> my waking and sleeping conditions, so that often reality veers on hallucination, and my hallucinations upon reality, and when I am concentrating hard upon my painting I fall into a condition in which I seem guided by a power or sub consciousness which is above or beyond reality, often completing a picture which I had no original intention of painting.[19]

Though often not pleased with the canvases which resulted from these 'manifestations', he still felt it important to exhibit them anyway as they contained all the power of that feeling, the embodiment of that exhausting emotion. And whether people had liked his Futurist

works or not, was it not true that they had been prophetic visions for the doomed generation of 1914–1918? Now, violence and intolerance was returning to Europe and most certainly another war was brewing. Hitler had just become Chancellor of Germany and immediately closed the Bauhaus, while simultaneously the *fascisti* were clamping down on cultural freedom and expression in Italy. Richard and his disconcerting subjects, therefore, acted as a reminder of all that the nation had already been subjected to, and served as a premonition of the inevitability of what, in his opinion, was only a matter of time away. The persona of the 'man-about-town', and the opinionated journalist, was counterbalanced by the grimly serious visionary at home, who was working, then re-working, a major work which would become the centrepiece of 1933: *The Twentieth Century*. In contrary motion to the experiments of Moore, Hepworth, Nash and Nicholson, Richard steered his painting towards a more socially, politically and morally engaged destination, conveying a message that was both comprehensible and responsible to people whose futures were tied up with his own. The point was clarified at a lecture he delivered at the London Schools Guild of Arts and Crafts, where he went on the attack against highbrow critics, identifying their utter unimportance, and disparaging their efforts to make their audience feel incompetent in understanding art. The common person, who loved art for the right reason, he demanded, should be allowed back into the picture, especially at a time like this. It was the caveman, after all, who had produced pure art, not 'The monstrous "mumbo-jumbo" of aesthetics' which had 'created a gulf between the creator and the audience'.[20] He followed this up in *The Times* saying that 'Education in art should be manual rather than cerebral. The next step should be visual rather than literary. . . . Pictorial representation should be looked at rather than written, read or talked about.'[21] Later, at the Glasgow School of Art he reiterated the sentiment, telling the students that, in time, they would have to de-educate themselves, to get away from art's 20,000,000 theories and thousands of tastes, its hundreds of laws and traditions, which had clogged the thoroughfare between artist and viewer. He got a good laugh as well for saying that the plagiarism and copying of the past 'had landed many a man into the Academy'.[22]

When *The Studio*, in its 40th anniversary issue, reproduced a lithograph of his called *The Spirit of Progress*, an initial insight was afforded of the ideologies that the artist now seemed to serve, even if this was just the first in a series of prototypes. Away from his escapist experiments with nature and flowers, this image contained a mix of urban, military and feminine motifs, where bayonets jostled with guns, planes, ocean liners and skyscrapers for prominence over a nude, a

couple of paint brushes and two cathedrals. H.G. Wells, working on *The Shape of Things to Come*, obviously shared Richard's concerns about the threat posed by aerial bombardment and gas attack on large cities, and the future use of chemical and viral warfare on the streets of London. It had only been the previous year that Stanley Baldwin had said 'the bomber will always get through', then suggested a mock air attack on London (which happened in1934 and demonstrated that more than 70% of the aircraft got to their targets unmolested). Little wonder, then, that plans were immediately set in motion to double the size of the air force, to fit everyone with gas masks and to try out the idea of a 'black out'. Later when his father visited the studio the composition had changed, yet still elicited a strong response: 'Called in on Rich and saw his new imaginative pictures: one of war: too horrible for sale. But I am glad of his new departure which I have always advised.'[23] In time, and with future revisions, the nude would be replaced with 'God', which a reporter, having visiting his studio, described:

> It is one of the most blood-curdling indictments of modern war one could imagine. All the picture contains is an evil looking monster with immense arms and legs. From his mouth runs a tube, and over his face is a gas mask. All around are the blades of bayonets and the muzzles of huge cannons.

Richard told the reporter, 'I have not decided on a title yet, but I'm dedicating it to the armament manufacturers!'[24] By November the press had another revision which was exhibited at the Royal Society of British Artists at the Suffolk Galleries, this time under the moniker *Ave Homo Sapiens* in which the fingers of the monstrous central figure clutched gold coins. The London press were eager to copy both it and the accompanying article, prophetically called 'An Artist's Warning'.[25] One newspaper even ran a full page article called 'C.R.W. Nevinson and His Olympian Laughter: Greatest War Artist of All Time' in which they said that 'Nevinson managed to produce a series of pictures and drawings of war, the equal of which has never been seen, and, God willing, never will be seen'. Only Goya and Vereschtschagin had done anything like it before and Richard attributed that to his roots: 'That's what we Celts are in the world for. We have to help the slower Saxon and Teuton to run their own affairs. Every big change, every innovation comes from the Celt.'[26] If there was another war coming, and it seemed there was, it would be him that the public would turn to.

In the meantime he exhibited some other, gentle, pieces such as *Saturday Afternoon in Dockland* and *Josephine (A Cacophony)* at the Jubilee Exhibition of the Royal Institute of Oil Painters; *Monte Carlo*,

Marne and *Dunstable Downs* (especially admired by Gwen Raverat) at the NEAC; and was selected to exhibit at the 'World Art Show' which was to be held in Venice in 1934. A new confidence, and seriousness, was apparent as he entered a new European age, casting a final glance over his shoulder at a world fast disappearing. In an article called 'The Decline and Fall of Bohemia' he got to work shoring up his own bohemian credentials before facing the inevitably humourless days to come, recalling:

> It has been my privilege to have known Bohemia at its zenith when I was a student in Paris, London, Munich and New York. . . . Though bohemianism was often adopted as a pose or as a defiant compensation and an aggressive desire to shock the smug and the self-complacent. . . . Even the Bohemian failures were triumphs, as they managed to exist to the end in a very romantic dream world, often surrounded by good fellowship, even if their death was on an uncomfortable bed.

Then later:

> The essential of Bohemianism was a life led almost entirely in wandering about public places and knowing all manner and conditions of men and women: and having a knowledge of how to behave in a salon or a cellar without any class-consciousness.[27]

It was a happy (if somewhat fictional) glance at a world now poised for extinction. Before that came though, the self-confident, ever-present, high-profile Nevinson had to be kept alive with a prestigious commission designing scenery for Sir Thomas Beecham's *Tristan and Isolde* at the Aldwych, and through numerous local exhibitions at The Pastel Society, The Senefelder Club Exhibition of Lithographs in Fulham, Luton, Bath, Liverpool, Brighton, Newcastle, Bradford, Stockport, Warrington, and Birmingham. For many he was still 'Nevinson the portrait-pastellist, the lyrical dreamer, the graphic artist and the satirizing moralist who does not shrink from combating evil with evil'.[28] For others there was a strong feeling that he would be well advised to shrink away from 'combating evil with evil', especially when, once again, George Bernard Shaw, became the focus of his vitriol. This time he started his attack in response to Shaw's statement that he might yet change from being a Fabian to an Imperialist – an idea sufficiently repugnant to make Richard flare up again and rage, 'Cannot he be returned to the land where treachery is the only reliable human product?' It got worse too, when he remembered 'In the Great War, from the security and comfort of London, sheltering behind the

corpses of his hated young Englishmen, he wrote his pamphlet on "The Last Spring of the Old Lion".[29] This was unsophisticated, but Shaw knew how to deal with Richard and saw no real threat from him anyway – just an irritation. He replied: 'That is the sort of thing that Mr Nevinson is always saying. I have practically devoted my life to slaving for the English, trying to make them behave sensibly, to speak sensibly and this is the result. Posterity must judge whether Mr Nevinson's paintings or my writings are the more use to the English.[30] As a parting nugget of advice, he said, 'When he sticks to his painting he does himself credit, but when he starts to talk about me and other subjects which he does not understand he is a disgrace to his father.'[31] Richard, of course, would not let it go and was certainly not content to let Shaw have the last word, and so made him the centre of numerous attacks, starting with an after dinner speech at the foundation of the United Artists' Society. Here, Richard told his audience how Shaw had profited from making the English detest the English and from running down British art overseas, an idea which had then been seized upon by the Bloomsbury Group. Since the last war, he offered, was it not the English alone who had kept civilization intact up to, and including, the present?[32] In defending Englishness, something he did not often do, Richard eulogised:

> though we are conservative, we are always the pioneers; though we are insular, we know the world; though we are experimentalist, we are stable; though we are defeatists, we always win; . . . though we are hypocrites, we are clear thinking; though we are idealists, we are always practical; though we are literary-minded, we are the magnet of all dreamers, painters and musicians; though we are Puritans, we are rakes; though we are mercenary, we are generous; though we are snobs, we are democratic. . . .[33]

Several years later, in *Paint and Prejudice*, he concluded that Shaw's 'hatred of beauty and artists always [has] made him talk nonsense', and concluded remorselessly that 'It was high time somebody attacked him.'[34] But of course these attacks had a tendency to backfire, exacting a terrible toll on Richard's mental and physical health, with surgeons now debating whether or not to remove a suspected twisted piece of intestine, or to attribute the artist's declining physical condition to a permanent exposure to mental stress. Richard, of course, wrote an article about it called 'Famous Artist Wins Fight With Death', in which he said: 'You see in me a living miracle of Modern British surgery. To face life again after preparing for death is an extraordinary experience.' In true Nevinsonian fashion he related that, having talked to the surgeons, he had gone home

'C.R.W. Nevinson', T.P.'s & Cassell's Weekly, *19 June 1926*,

to his studio, painted his last and greatest painting, settled up his affairs, written a will and even his own obituary. But then he hadn't died, as promised, and so lamented, dramatically, his own survival, saying that for an artists to die between the ages of 45 and 50 would have been perfect. Ironically, he said, it was because he was not afraid of death that he recovered – the calm, the first in years, having brought with it health.[35]

But soon illness returned requiring the removal of several teeth and even part of his jaw. He faced the second anniversary of his mother's death in misery to the point that H.G. Wells, after a chance encounter on a London street, described Richard as 'showing so dismal & pitiful a visage that no heart could have refrained from comforting words'.[36] Perhaps the mood was buoyed up a bit with the 'News that Roger Fry has died from mere accident in shipping: the best of after-dinner speakers: a good critic & bad painter: great enemy of Richard.'[37] In death, Richard offered an amnesty to both Fry and Konody (who had also just died), albeit posthumously, saying 'I still think both Fry and Konody loved art and really had no intention of ruining the livelihoods of artists by the setting up of theories as standards by which pictures must be judged.'[38] It had been, in his summation, their problem all along!

His tenth show at the Leicester Galleries, and first major show in four years, would hopefully act as a continued remedy for his ever-frayed nerves, though Henry had observed months before that his son was 'distressed and full of apprehension about criticism of his next show'. This was exacerbated by the fact that his work was to be exhibited alongside that of Mark Gertler, whom he knew the Bloomsburies liked and would openly support, at his expense. But on the opening night, Henry liked what he saw, though was not always keen on the subject matter, calling one piece 'a large picture of Vulgarity for Pittsburgh'.[39] This was *Comment on Vulgarity (or World Definition of Beauty and Grace)*

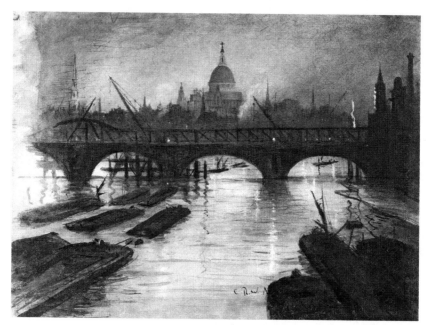

C.R.W. Nevinson, City of London From Waterloo Bridge, *1934*

– an image of an actress lying on her back, being bawled at through a megaphone by a director. Images like these made Henry as uneasy as he had been while reading *Gentlemen Prefer Blondes,* which he described as the 'ill-written jottings of a brainless harlot'.[40] He much preferred a composition of a Venus in a churchyard, plus other harmless studies of Loch Lomond, Lilies, St Paul's, the Thames Barges, and the Venetian Lagoons. Overall, though, he could write:

> Went to Richard's oil paintings at Leicester Galleries: a big crowd: Lady Ottoline Morrell . . . pictures all fine, the water scenes best as usual, Greenwich especially & Thames Barges, which were readily bought: good brown canvas much favoured and bought by Princess Troubetzkoy. Gertler's heavy brown nudes with solid breasts in next room – not pleasing. R's allegories fine but not saleable.[41]

The critics responded favourably too and claimed: 'Possessed of a restless spirit, burning with something of the Crusader's ardour, Mr C.R.W. Nevinson seems determined to shake the complacency out of anyone who may feel satisfied with the state of the world today.' They noted too that in front of nature he was calm, a different artist, and believed that this was where his real talent lay, as it offered the solace of landscape, rivers and estuaries, which he personally needed so much.[42]

Frank Rutter was also complimentary, observing that over the last four years Richard had developed a much greater understanding and empathy with colour, harnessed to an enhanced sense of *impasto* which was, he was certain, an overall indication of improvement in craftsmanship. In images such as *Green Water*, Rutter claimed, the artist was not copying nature, but interpreting it. Anthony Blunt, on the other hand, spared neither Gertler, ('disagreeable but serious'), nor Richard ('facile and frivolous'), having as he did a 'wonderful gift for picking up some passing trick and exploiting it without any understanding of its proper application'. Richard had heard it all before! Blunt went on to say that the exhibition was merely '. . . an anthology of all the unimportant achievements of English painting for the last twenty years'.[43] This stung, and so Henry upped his efforts to escort people into the gallery, to convince them to buy, and even when things got tight, to purchase works himself. *Any Wintry Afternoon in England* was one such picture, and Henry felt it would make an admirable gift to Manchester City Galleries. He was surprised therefore, having purchased the canvas and upon making the offer, that 'Haward of Manchester Gallery . . . says they are already sick of Richard's pictures, but will come on Tuesday to see the footballers'.[44] Without enthusiasm they took it at the end of the month. Henry was probably unaware of the stinging article Richard had written on Manchester a few weeks before and would therefore have sheltered his son from the unflattering truth concerning the bequest. Had he known the contents of the article he might have been less charitable. Because a group of Manchester businessmen were proposing to block a £280,000 project for a new art gallery, Richard had written in solidarity:

> After all, Manchester is the result of Manchester. It is a symbol of everything that is degrading: that is loathsome to live in and loathsome to meet. It is the artist who has made civilization. Those who have despised the artist deserve to live in something even worse than a Manchester slum. Let us forget such hypocrisy, and encourage the people to grow more animal, more degraded since that is all they seem to wish to do.[45]

He might usefully have paused to acknowledge that some of his closest allies and staunchest supporters, including Frank Rutter, William Rothenstein, the Sitwells, Edward Wadsworth, Frederick Etchells and Michael Sadler were from the 'artisinal' north and may not have liked to hear this of themselves and their home.[46] Sometime later he continued the barrage in a national paper saying, 'Beauty is ultimately the only thing of value. That is why no-one wants to live in Wigan or Manchester.'[47] It

seems possible that this was the source of the hesitancy with which the city of Manchester accepted their new canvas.

Princess Troubetzkoy, mentioned in Henry's journal at the opening of the exhibition, was a caravanning friend, with whom Richard now started work on the novel *Exodus A.D.: A Warning to Civilians* – a natural accompaniment to the new direction in which his painting was moving. Pen and brush were working together to express a conviction, and an almost hysterical realisation, that it was already too late to stop the inevitable destruction of London from the air, despite an enormous (yet inadequate) £60 million budget increase for the Royal Air Force by the government that year. Troubetzkoy had previously published two other novels, *Storm Tarn* and *Gallows Seed*, and so may very well have taken the majority of the writing duties, while Richard probably provided the gruesome scenarios as they unfolded in his mind. With Germany out of the Disarmament Conference, Winston Churchill, then in the 'wilderness years', made a speech in which he said that by 1935 the German air force would be the same size as the British, that by 1937 it would be almost double and concluded 'Beware: Germany is a country fertile in military surprises.'[48] National endorsement of the General Act for the Pacific Settlement of International Disputes was seen to be utopian in the extreme. And so the book, like the paintings, was bleak. In it London was attacked from the air by an unknown enemy using aeroplanes carrying gas, chemicals and plague, in a phenomenon Richard called 'third dimensional warfare'.[49] The resultant stampede to get out of the doomed city led to a massacre and soon there was left only an eerie, empty, capital in which even the pigeons were silent. The protagonist was, appropriately enough, called Richard, a Londoner, comfortable in the East End of the city where the action took place, and both philosophically and politically aware of what had led to this catastrophe. Both Richard the artist and Richard the fictional protagonist had watched the disastrous diplomacy after the First World War and the Versailles Treaty; both had watched poverty and unemployment sweep the defeated and the victorious countries alike (in Britain under the 'Starvation Government'); both had watched the collapse of Disarmament Talks, the rise of the ultra-right, mirrored by communism in the east; while both had worried about the rapid development of technology, science, aviation and weaponry (unaccompanied by any advance in related morality) that had made this apocalyptic vision inevitable. And yet, neither of the Richards had been able to dampen the gaiety of the age, nor successfully warn the socialites who remained ignorant of the seriousness of the situation, in the midst of their world of cocktails and flash bulbs. How could they

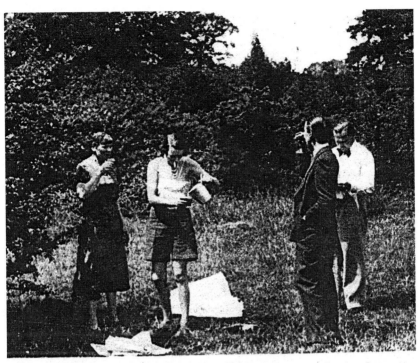

The caravanning habit makes its appeal very strongly in heat-wave weather. MRS. NEVINSON, PRINCESS PAUL TROUBETZKOY, MR. PATRICK GARRETT, and MR. C. R. W. NEVINSON, the artist, are here enjoying the delights of a temporary "gypsy" life. Cool drinks are the word!

'Cool Drinks are the Word!', Daily Sketch, 25 July 1934

ignore the plight of the Abyssinians, and the misery they were suffering at the hands of airborne gas attacks by the Italians? Why, when his friend Sisley Huddleston wrote *War Unless* (in which he blamed the press for hiding the realities of war, the League of Nations for being spineless, the powers for not undertaking treaty revisions and Central Europe for becoming Balkanised) was the press devoting more column space to the debate over the Loch Ness monster, or the unsporting body line bowling crisis in the Ashes series in Australia? Could they not foresee the potential for the destruction of London itself, in the immediate future? For both Richards the frustration came, not so much in the fact that it was coming, but in the infuriating reality that nobody was even doing anything to prepare for the inevitability. In articles and books Richard (the real one) warned of the preparations that were needed, while the government not only did nothing, but actually sold the weapons to their would-be enemies for short-term profit. Why was the Underground (which Henry Moore would later immortalise)

not being readied for the inevitable arrival of the *Luftwaffe*? Why was
he treated as a crank for suggesting that contingency plans should be
drawn up for moving the important ministries (High Court, the War
Office, the Admiralty, the Foreign Office and the Bank of England)
to Bristol (later to Canada) and out of reach of the bombers? Did the
artist, who had seen the searchlights, the planes, the dying and the
dead for himself in the Great War, not have the right to paint and
speak about this subject of which he had so much personal experience?
And was it not true that there would be those who would get rich again
from the suffering of others when the catastrophic implications of
runaway nationalism and xenophobia descended upon the nation as it
had done only two decades before? The novel's protagonist was driven
to absolute frustration, which mirrored Richard's own, on hearing the
rumour that Japan's march through China had been achieved using
British weapons:

> 'And it's our own bloody fault!' Richard thought bitterly. 'We've
> gone on exporting planes, guns, anything; we haven't cared who
> assembled them, where, or how – we laughed at those who
> warned, who begged in the name of humanity, who foresaw – we
> set up the golden calf of prosperity and worshipped it'[50]

His macabre vision continued:

> 'And did they know?' wondered Richard as his ears registered
> that ghastly droning, 'did they, in their flying arrogance, their pur-
> poseful planned swoop, know what resulted from their attack?
> Had men become so vile that they would so deal death to the
> helpless?'[51]

In *Ave Homo Sapiens* the monstrous central figure, God, is attacked by
Richard (in the novel) shortly after London has been bombed:

> God, to Richard's surprise, did not wear flowing vestments nor
> a beard. He peered through wicked slits of a mask-like cover-
> ing which protruded in a snout, hiding, to Richard's imagin-
> ation, intolerable hideousness. He was almost naked, with great
> knotted arms hanging limply at His sides, and His hands were
> vast, giant-like, with clawing curved talons.[52]

Surrounded by destruction, by crosses and aeroplanes, and by the
smoke and stench of destruction, Richard accused God of enjoying
the massacre, to which he got only a hissing sigh of greed and content.
Away from the novel, in the finished canvas *The Twentieth Century*,
God was replaced by Rodin's *Penseur* and the calvary replaced with the

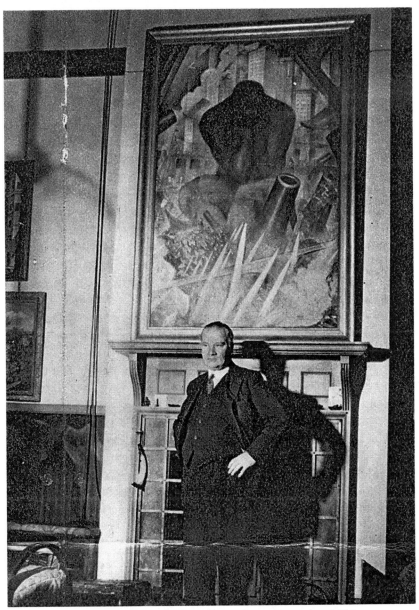

"Let's Mobilise Art", The Bystander, *1 November 1939.*
Nevinson posing in front of The Twentieth Century

modern industrial city, while the chaos wrought on the metropolis from
the air remained. Old motifs re-appeared but now to the detriment
of mankind: planes no longer inspired excitement and optimism, but
carried destruction to the great urban masses who, as victims of their
own ingenuity, rushed blindly to their doom, in an environment of

skyscrapers that could only symbolise America. Elsewhere, in *The Unending Cult of Human Sacrifice*, images of capitalism were bound up with chains, while the Mater Dolorosa overlooked, again, the depressingly familiar history of mankind. Ultra-nationalist symbols, such as the red flag, the swastika and the Union Jack, were prominent, beneath which the mindless, and dangerous, mob protested their right to speak and act from a position of impassioned ignorance, to demonstrate beyond doubt what had not been learned. In another of these brooding compositions, *With Nothing to Lose – Not Even Chains*, Richard placed himself at the heart of scattered images of bayonets, embarking soldiers, a telephone and a bat, while a definite nihilism could be felt in other compositions with titles like *Crucify*, *Sacrifice*, and *They All Know the Way*. The latter was a 'Symbolic Satire on Fascists, Socialists, Capitalists, Hedonists, Ascetics, Intellectuals and Priests', set in an astral context where a procession of seven figures, representing the principal forces, beliefs and creeds driving mankind, walked in a clockwise direction, over all of which the weeping face of Christ was superimposed. One character carried money and was chained to the intellectual, who in turn was chained to the labourer, who lived under the raised arms of a dictator and yet in the company of a clown. From the dictator, the chains led to the fanatic, which then passed on to the priest, implying 'the Clash between Thought, Mechanical Invention, Race Idolatry, and the Regimentation of Youth'. Whatever the (questionable) artistic merit of this work, there can be little doubt as to its intellectual sincerity and the artist's profound concern for a civilisation now doomed, once again, to a destiny of war. As Beverley Nicholas dolefully lamented, it was now possible, with the assistance of technology, to 'blow up babies in Baghdad by pressing a button in Birmingham'.[53] *Paint and Prejudice* offered one final comment of interest on this digression into the fantastic and into the imagined fate of mankind, when Richard talked of how the 'belladonna and other pain-killing drugs' he was taking had led to a 'weird quality' in his work.

On a much lighter note, Richard was invited to design the decorations at the Chelsea Arts Club Annual Ball (having been proposed for membership in 1934) at the Royal Albert Hall on New Year's Eve, using for his theme 'Speed'. For this Richard and Barney Seale (who had also just sculpted a bust of Henry) hung 6,000 square feet of canvas over the organ, and this was later covered with witches on broomsticks, which in medieval lore were the fastest thing to move. In front of a blue and yellow sky backdrop was placed a train, a speedboat, drive shafts, cranks of pistons, and flashes of lightning designed to shoot from one side to the

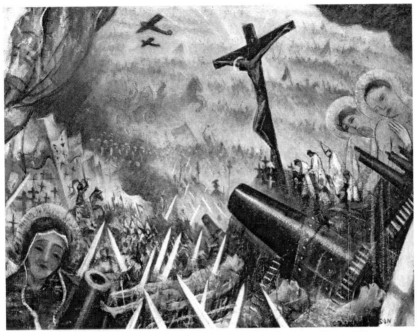

C.R.W. Nevinson, The Unending Cult of Human Sacrifice, *1934*

other, using 3,000,000 candle power (The *Daily Herald* upped the figure to 8,000,000 candle power). Either way, it must have been quite a sight as 4,000 guests watched the 'sun arc' light up, a replica of Stevenson's 'Rocket' enter, and a giant stork arrive with 1935 in its beak. Recovering in the nick of time from pleurisy again, Richard and Kath both attended and stayed until 7.00 a.m. on New Year's Day. But if the atmosphere at the Albert Hall Ball had been optimistic, enraptured in revels, pranks and innocence, Richard knew that events would soon claim the lives of many of those present.

When the *Sunday Mercury* ran an article called 'Who are the Great Men of Today?' and Richard appeared on the list with G.K. Chesterton, Sir Thomas Beecham and Frank Brangwyn, he must surely have felt some gratification, even if he knew his trailblazing and pioneer days were over. Ben Nicholson and Barbara Hepworth, the 'next generation', were visiting Picasso, Braque, Brancusi, Arp, Giacometti, Mondrian and Miró, on their continental jaunts, and getting invitations to join groups such as Abstraction-Creation in Paris. Other European artists and architects, such as Naum Gabo, Walter Gropius and László Moholy-Nagy, were arriving in London, leading Herbert Read to observe that the capital was becoming 'what Paris has always been – an international art centre'.[54] Simultaneously

the first issue of *Axis* appeared as did David Gascoyne's *First Manifesto of English Surrealism*. Richard, whatever he had been in the past, was in no position to compete with, or fully comprehend, the trajectory and pace with which art was now headed from its Hampstead base. Instead, he remained trapped between his private depression and his flamboyant and confident public persona, and between his increasingly philosophical works and his escapist landscapes. In public he might talk at Claridges to the Fruit Trades Federation on the subject of oranges, insisting that on a diet of only meat he had lost 42 pounds, and advising women to go onto a diet of tomatoes, hard-boiled eggs and coffee; then return to his studio to touch up the next stage of what was to be his masterpiece of the pre-war era – *The Twentieth Century* – in all its macabre overtones. He could, one day, be a judge at the *Bal de Beauté* held at Covent Garden Opera House, then go home and very seriously contemplate giving up art and London completely. He could represent Britain internationally in major galleries with all the swagger and pomp associated with his name, then sell nothing for months, to the point of permanent bankruptcy. But whatever his successes or failures in terms of sales, he never doubted his right, authority and importance in commenting on art in Britain, even when it did not directly affect him. Was he not the artist with exhibitions in Glasgow (with H. James Gunn and James Pryde); at Le Groupe d'Artistes Anglo-American at La Galerie Renaissance, Rue Royale, Paris; at the Mayor Gallery on Cork Street (to celebrate 25 years of British painting 1910-1935); and with the Empire Art Loan Collection Society at the Melbourne National Gallery in the company of John, Knight, Nash, Orpen, Sickert, Sargent, Flint and Brockhurst? In addition, was he not lecturing, even at his alma mater, the Slade School of Fine Art, in which he said that American films were 'the wish-dreams of charwomen' and later Victorian paintings 'pictures with good little morals made for big bad merchants'?[55] And when that was done, did he not find himself working in a film studio painting a portrait of Matheson Lang even as the cameras rolled to make 'The Cardinal' at Welwyn? He went further, and offered his services in making London beautiful for King George V's 25th jubilee celebrations, saying that people should hang out their carpets instead of bunting (an old Chinese tradition), decorate street cars and the trees on the Embankment with fairy lights.[56] Later, at a society event at Selfridges, he even had the confidence to tease Charlie Chaplin (whom he had met years before as a student), saying to him that 'You above all men should realise that no successful man has a sense of humour.'[57]

But it was when there was a real case, a legitimate injustice, that he

C.R.W. Nevinson, They All Know The Way, *c 1934*

could not be silenced, for example when a storm kicked up between Stanley Spencer and the RA, after the rejection of two pictures out of the five he had submitted, and following his demand then that all five should be returned. The RA refused to give the three accepted works back until the exhibition was over, and so Spencer resigned his ARA status and threatened to take them to court. Richard of course elbowed in saying that Spencer was quite right, that he was too good for the RA anyway, and better off out of it. This then spilled over into the press in his articles like 'Things I Hate', which included: 'the anti-English English intellectual; the pot-bound old Royal Academician; the prig; the snob; the didactic; the middle-aged adolescent; the namby-pamby aesthete; the ugly-ugly modern art; and pretty-pretty commercial art.'[58] In a similar incident a few months later he offered his opinions on the removal of Epstein's statues from the top of the British Medical Association building which had recently been bought by the Southern Rhodesian Government. Epstein protested and said that the RA should help him to get this stopped, but when the RA would not do anything, Sickert in sympathy, resigned his membership too. Richard went to the press, one more time, and warned the RA that they could not afford to keep losing artists at this rate. What the public did not know was that his name had been on the RA books for some years now and was, even

at that time, being discussed for future membership, though his antics can have done precious little to enhance his chances of joining the ranks at Burlington House.

But the significant work of 1935 came in October with the final unveiling of *The Twentieth Century*, in which Richard hoped to express his terror at 'the modern mind'.[59] Though early versions had been seen in 1933 and 1934, *The Twentieth Century* exploded onto the scene at the Royal Institute of Oil Painters and was reproduced very widely indeed. Richard described the £300, 10ft x 6ft, picture by saying 'Man is no longer an intellectual being. He is merely an animal using mechanical means, and he is now frightened of his own inventions.'[60] But critical reaction was mixed, with one paper exclaiming 'The impact ... fails to impress mind or spirit, and as decoration it is ineffectual in design, for one's eyes are forced to the lower left hand corner where a crowd of people forms the only artistic part of the composition.'[61] For all that it sorely lacked formal refinement, it certainly spoke with a comprehensible voice, though Richard can't have liked the comparison much when one reviewer said, 'Mr Nevinson is becoming the George Bernard Shaw of the painting world, and here his flair for biting satire, never for long restrained, has been given its head.'[62] Frank Rutter said, 'It puts to the spectator that pregnant question, *Quo Vadis?*', then concluded that it was the sort of appeal made by both the artist's mother and father in the past; intelligent and gifted but against overwhelming odds of success. As such he gave it his full support saying that it was technically good, thoughtful, melancholic, timely, in keeping with the Nevinson family tradition, and on the same artistic scale as the work of Hogarth and Daumier.[63] The literary comparison was kept alive too when it was described elsewhere as 'a thriller'. Later it became an important painting in the 1936 De Olympiade onder Dictataur (DOOD) exhibition in Amsterdam organised by The Association of Artists for the Defence of Cultural Rights and the Committee for the Protection of the Olympic Idea, in the run up to the Berlin Olympics. As with the exhibition entitled 'Artists Against Fascism and War' the previous year in London, which had been organised by the Artists International Association, DOOD was a stark warning of the state of the world, fuelled by race theories and power quests, in which Richard's work seemed the most eloquent and audible voice. Richard himself might have coined their slogan 'Unity of Artists for Peace, Democracy and Cultural Development.' And yet, for all he was commenting on the re-militarisation of Europe, the Saar Plebiscite, the fall of the League of Nations, and the inertia that would lead Europe one more time into war, he distanced himself from any

of the active pressure groups who were now making their collective voices heard. It was an interesting position to take, or not to take, not least when he called Mussolini (who was outraging Europe with gas attacks on villages in Abyssinia) a 'dictatorial, theatrical braggart', then observed, perhaps a little admiringly, that the Italian had at least whipped up an 'enthusiasm which makes all the tragedy and stupidity of everyday life tolerable'.[64]

On a more personal level, further troubles were never far away and allegations of a concerted campaign against him re-appeared one more time when Henry wrote:

> Rich read an abject letter of apology from some art critic who had libelled him as a charlatan and a quack. I think in the *English Review*. I said he ought to demand a public apology but he is inclined to take no action as usual. Clive Bell, Muirhead Bone and Wyndham Lewis are behind all this hostility.[65]

Perhaps this accounted for why only five people turned up at the private view of an exhibition of 40 of his new paintings at Coolings Gallery the following month, and why only 15 people attended the opening night, despite 300 invitations being sent. Henry wrote in his diary:

> A very beautiful collection of rather small pictures, chiefly landscapes. Only five [few] people there [for which he blamed the 3 p.m. start, the wretched weather and the elections] Liddell-Hart and his wife were hoping to see the large 20th century but it was not there. . . . No critics or artists. Rich terribly disappointed and talks of letting studio & giving up painting.[66]

Though the images were mostly landscapes of Sussex, paintings of rain, barges, rivers, apple blossoms, brown earth, and caravanning in Kent, it hardly warranted such a poor turnout. Clearly he had not seen it coming either as the catalogue introduction had spoken confidently saying '. . . this collection will prove at least that I wish thoroughly to dissociate myself from all geometric mumbo-jumbo, mathematical metaphysics, [and] the pretentious Bloomsbury Belles. . .'. It had gone on to say that he would make no apology for being an individual, an Englishman, and an upholder of all that he held dear in the tradition of English painting – but little did he think he would be so isolated in this stance. Had the cabal of theorists, literary critics, affreux intelligentsia, and those that exploited insecurity in order to pass off nonsense as great art, at great prices, really beaten him at last? A little later it was proved that they had not and soon Henry could record a turn around, leading to a 'Great party at Coolings for Richard's show, very crowded. . . . Rich seemed

well content with sales'.[67] He would also have been delighted to see the publication of the book *Modern Masters*, which showcased his work in a special issue, as part of a larger series, which dealt with other greats such as Laura Knight, Philip Wilson Steer, Walter Sickert and Vincent Van Gogh. A fine accolade indeed.

14
A Prodigal's Return (1936-39)

It was now Kathleen who began to crumble, though like Richard, she made sure that her decline into depression never became public. Henry felt the seriousness of the situation acutely and, fearing a total collapse lamented in his journal, 'The most unhappy day in my long life. Richard arrived unexpectedly in the morning and told me that Kath has lately taken to drink. . . .'[1] The news was a veritable bombshell for the teetotal Henry who learned of her outbursts of foul language (which were then totally forgotten the following day), her inability to work at anything, and of the negative impact this had on his son's ability to get anything done. Even though Kath called round to see Henry and had been 'quite sane and sober',[2] it was clear she was caving in under the stress that her husband, and his career, was inflicting upon her, to the point that:

> Richard came in the morning with an appalling account of how dim . . . Kath is and behaviour to him, contradicting and discouraging all his attempts to do . . . even abusing him for his . . . to traditional art instead of following the present tendency to abstractions and mass patterns: also for leaving the Leicester Galleries. He thinks there has always been a despair of cruelty and callous selfishness in her nature as shows in her mockery of him at his terrible illnesses from inflammations and dentistry. Sometimes she weeps for days together. He argues that this present state may be due to 'changes in life' but this trouble goes further back.[3]

Henry was suspicious and felt that at 44 years old it was too early for menopause ('changes in life'), and felt, instead, that nothing had really got back to normal since the 'great illness' of his son just over three years before. In order to offer a little relief he called them to purchase two more paintings for £50 as his contribution to lifting the pressure, if only a little. It must have seemed an age ago that Richard had written very publicly of his love for his supportive wife, saying 'she

has been able to bear with me, in spite of war, sickness, poverty and success, with its attendant hatreds and boycotts – an ideal to me in my blackest and most despairing moments'.[4] Keeping up the public façade, as a Fellow of the Royal Horticultural Society (FRHS), and seemingly an unwavering public supporter of her husband's work, Kath even wrote the introduction for the new exhibition of flower paintings, and garden scenes, complimenting in words the serenity and tranquillity he had managed to capture in paint – if not in his life. But, as usual, the exhibition did not go according to plan, and events conspired against him once again, not least with the death, on the opening night, of King George V at Sandringham, causing Henry to write 'The heap of good pictures stand in the studio very disheartening. The King's death has ruined the show of flowers: only 3 sold.'[5] In *Paint and Prejudice* Richard recalled 'Nobody came to see my flowers. Nobody was expected. And so the hopes of two years withered and died.'[6] Soon, and perhaps as a result, the situation at home deteriorated further. His father recorded:

> Another of my most miserable days. Rich came in hopelessly despondent on Kath's crazy and cruel treatment, always contra-dicting and discouraging, ruining his work and estranging his friends, forgetting an engagement to dine with [H.G.] Wells & refusing Clive Bell's approach to renewed friendship. He even speaks of separation. We suggested his going to France for a time, but advice seems hopeless.[7]

Henry allowed himself to daydream about a more simple, peaceful and hopeful time when he 'recalled to mind the scene in Swiss Cottage 47 years ago when M. was so delighted by the birth of a son'.[8]

Writing was still, by far, the most lucrative way to make a living and Richard's views, when controlled, were widely respected. One example was his lengthy essay 'The Arts Within This Bellicose Civilisation', which was published in a collection called *The Seven Pillars of Fire.* [9] Writing three years before the outbreak of the Second World War, Richard lamented the fate of the culture he had known: apathy, snobbery, élitism, one-up-man-ship, Christianity, 'good taste', tradition, sophistication and manners, had all replaced the traditional values of 'civilisation'. The 'progress' of the interwar years, far from working for the betterment of society, had merely brought that same civilisation to the brink of its own destruction, though this in itself was not entirely a bad thing. The next war, for it was inevitable, because of its global nature, would not be isolated and fought in a distant field between the male representatives of rival nations. Instead it would come to the cities and homes; it would not discriminate between men, women or children; it would spare neither the

'Mr Nevinson stands by the window of his studio on Haverstock Hill',
The Bystander, *1 November 1939*

rich nor the poor and so would wipe out many of the existing distinctions
within society. In short, the hero and the coward, the communist and the
capitalist, the gentry and the working classes, would be gassed together.
In the meantime, the unstoppable regimentation of youth, the creation
of state identity, the undermining of reason and individualism, would
lead only to destruction – and take with it any form of creativity in
the arts. Any advance in that sphere of cultural activity, he believed,
would lie in the hands of the Irish, Armenians, Poles or Jews, as they
had a history of being misunderstood and, as a result, pushed on anyway,
regardless of what others thought of them. But the English had, in the
interwar years, created 'a time which seems more forgotten than any

other, but was nevertheless the fallow ground from which the weeds of sensationalism, exploitation, and disillusionment sprang; the weeds which now choke us'.

Politically the situation was hardly any better as the interwar years had brought with them, not peace, but 'racial worship, and economic fallacies, intermingled with revenge and pomposity, it was a nightmare, a weird combination of political exploitation and commercial opportunism, all couched in terms of idealism for democratic consumption'. Elsewhere, 'Italy obeys, Germany hails, Russians dare do nothing, America worships the crook'. And even if the 'day of the clown is over', and despite all earlier negativity, he finished with a pat on the back for the English, saying 'We are at present the only race, even including the Americans, who whole-heartedly believe that man is capable of living a life without incessantly provoking or robbing his neighbour, and we also know that differences of thought and opinion are human and desirable.'[10] As Spain descended into Civil War, little of the hysteria of *Exodus AD* remained, replaced now with a serenity that came with the acceptance that the future was now out of his control. His warnings had been ignored and his experiences in the last war, dismissed, and so he felt no remorse in giving up and returning to nature. Around him, opinion polarised into heated debates on Fascism versus Communism; Totalitarianism versus Democracy; Force versus Liberty; Rebels versus Constitutional governments; Barbarism versus Culture; Christianity versus Atheism; and ultimately, us versus them. But Richard no longer seemed to care.

There soon followed a most unexpected report that the Royal Academy had accepted some of his work for their upcoming show: surprising of course that they had accepted anything from his brush, but more surprising still that, behind the scenes, and despite all his public proclamations to the contrary, he had submitted work for review at all. Perhaps this had been forced upon him by the realisation that he simply was not making it alone and that his father was still buying his paintings when times got tough. Perhaps it was a manifestation of a lifelong desire to become an 'insider', or perhaps in the knowledge that war now lay ahead, he felt it best to take cover behind something that would prevail. Or perhaps he knew that Kathleen could take no more of his antics and needed the security and stability that the RA might yet offer. Of course, even this did not run smoothly, as a hoaxer took the opportunity to write to him saying that the pictures had, at the last minute, been rejected after all, provoking the predictable furious and outspoken response in a letter to the Royal Academy, full of 'scorn and vehemence'.[11] But this misunderstanding was put to rest when he received an even more surprising letter from Francis Dodd:

C.R.W. Nevinson painting a landscape in front of The Twentieth Century

My Dear Nevinson,

I boldly put down your name on the candidature list for the R.A. yesterday. . . . I need not say what an advantage I think your presence would be to the Academy. . . . I should like you to agree to let your name go forward. . . .[12]

Richard agreed, and the press loved it, running dramatic headlines all over the nation, interpreting and reinterpreting what had happened and asking who had met whom in the artistic *rapprochement* of the decade. The *Daily Express*, for example, ran a full header 'Academy Rebel Returning After 25 year Feud', as if 'returning' was a homecoming to the place where he naturally belonged. The writer felt that compromise had been employed by both parties, saying 'Thus the Mother of British Art turns her other cheek to Mr Nevinson . . .';[13] the *Daily Mail* proclaimed ' "Rebel" Paints for the Academy' in which Richard elaborated, 'Thinking it over later I came to the conclusion that the Royal Academy was making a gallant gesture in the face of all its old traditions, and it was up to me to meet them more than half way.'[14] The *Daily Express* ran the story too under the banner of 'War With the Academy Ends' in which Richard said 'If any man deserved rejection I did, because I have been extremely nasty in my criticisms of the academy

and its works.'[15] The *Evening News* went on to report this historic u-turn quoting the artist as saying, 'After all, the Royal Academy is the best shop window in the world – the best in the world.'[16] Elsewhere a story ran called 'The RA is Becoming Up-To-Date'[17] in which the writer felt the shift to the centre had been undertaken by the RA and not the artist, leading others to welcome the fact that 'The Academy [was] Waking Up at Last'.[18] The *Daily Mail* didn't share this view at all and reported instead that 'Mr Nevinson Relents'.[19] Either way, *Battersea Power Station at Twilight, Waterloo Bridge: Hail and Farewell, Chelsea Embankment* and *St Paul's* were hung and Richard was reported widely, escorting visitors around the prestigious corridors of Burlington House. The rebel was finally breaking into the fortress and full ARA status seemed only a matter of time away. Not wasting a moment Richard chaired a Savage Club dinner at which Sir David Llewellyn, President of the RA, was guest of honour, with H.G. Wells. From within this bastion he would have watched, with contented detachment, the adventurous experiments of those younger and more adventurous than himself, and would have seen echoes of his own youth in the days leading up to the last great war. As in 1914, there seemed a tangible optimism within the arts in the late 1930s as the massive 'Abstract and Concrete' Exhibition drew crowds and headlines, and as coteries re-emerged in Hampstead (Nicholson, Moore, Hepworth, Read, Nash, Gropius, Gabo, Penrose, Grigson), Fitzroy Street (Coldstream, Gore, Pasmore), and Hammersmith (Trevelyan, Bawden, Ravilious, Piper *et al*). On a different tack there seemed to be a place for a utilitarian realism in the emergence of the Euston Road School, and of pragmatism in the establishment of the Central Institute of Art and Design, while academic and introspective debate was hardly lacking either in the tangential developments of Constructivism and Surrealism (whereby *Axis* folded and *Circle – International Survey of Constructive Art* appeared). Richard may even have read, with a hint of nostalgia, Herbert Read's introduction to the International Surrealist Exhibition (which over 20,000 people attended), which demanded, very much as he had done 20 years before:

> Do not judge this movement kindly. It is not just another amusing stunt. It is defiant – the desperate act of men too profoundly convinced of the rottenness of our civilisation to want to save a shred of its respectability.[20]

For their call to revolution, their intention to shock, their contempt for passéism and bourgeois standards; and for their challenge to all concerned to wake up and face the reality of modern life, Richard might even have harboured some residual sympathy. But he had done all of this before

and had no desire, and certainly not the energy, to show more than a passing interest, even if he did deliver several lectures on the Surrealists, and in particular on the work of Salvador Dali, which he had just seen in Paris. He even defended the Spaniard in the press against an attack by Lord Ullswater by saying, 'My life was blighted almost to middle-age by the Ullswaters of my generation dismissing me as "tosh" though I was a grim and sincere artist and experimenter.'[21] Though he admired Dali, he finished with 'I hate his art. It is horrible, it is terrifying, but his painting is superb.'[22] His father too wrote in his diary of the new interest, and the relevance of the depictions, saying his son talked enthusiastically of a Spaniard 'who paints a woman eating her own flesh with a spoon: I suppose a symbol of Spain'.[23] In *Paint and Prejudice*, which Richard was writing at this time, he concluded that:

> The Surrealists prove this to be the exhaustion of sensationalism, culminating in a vulgarity, regimentation of affectation, and mutilation that can please only the little minds who have obviously never known pure aesthetic emotion, but mere jaded theory.[24]

Later he concluded his assessment saying:

> Surrealists are of course merely illustrators, sentimentalists in reaction, indulging in Freudian nightmares, displaying a pseudo-scientific malnutrition of psychology, a mawkish adolescence, and exaggerated egotism usually found in erotic youth of all ages.[25]

But having one foot inside the establishment did not mean the creation of a *tabula rasa,* whereby all former enemies were forgiven. On the contrary, he declared, 'I am going to do better than ever, and I will fight the Bloomsbury artistic school, with their precocious poseurs, their amateurs and their vulgarity (all of which I detest) more ruthlessly than ever before'.[26] At a Foyle's Lunch he addressed a bemused audience of 1,500 who heard him speaking 'from notes, in good voice, witty, violent against his enemies – the Perfect Old Women Tonks & Roger Fry and Charles Marriott, the shepherds of Bloomsbury: well received, with silence on those points'.[27]

Around him there was certainly much to comment upon: Stanley Baldwin's replacement by Neville Chamberlain (who in turn could do little to arrest the deteriorating situation in Abyssinia), Hitler's re-occupation of the Rhinelands, the reinforcement of British troops in Palestine, the Japanese advance and the horrors of events in Spain. As Chamberlain lamented the 'incredible folly of civilization', Richard resigned himself to the fact that 'there is no hope for a European peace'.[28]

Despite the tens of thousands of signatures on the Peace Pledge Union, including the words 'I renounce war and never again will I support or sanction another, and I will do all in my power to persuade others to do the same', he concluded 'And the result is bound to be War – with a capital W – unless we alter our mind.' The interviewer summed up grimly, 'But the need for peace is very urgent with him. It is an unusual devastation that he sees ahead.'[29] Otherwise, he warned, as he had done in *The Twentieth Century*, 'London lies naked to attack'. And if anyone still doubted the sincerity of his convictions, they would surely have been convinced when he quite shockingly stated:

> I am glad my son is dead. Anthony would have been 17 now. . . .
> It was better that way. He would only have been slaughtered. . . .
> Once he would have stood a chance. But not today, not now.
> Science has got ahead of human thinking – my boy would just
> have been a cog.[30]

He also found time to work on more pragmatic and lucrative commissions, designing adverts for the Dunlop Rubber Corporation, decorating a room at the Savage Club, and even creating the cover for the Coronation of George VI issue of the *Radio Times*, which had a circulation of over 4 million copies. Additionally, he had time to participate in the 50th anniversary show of the NEAC, and to exhibit a topless women sitting at a cocktail bar at the Contemporary Nude Art exhibition at the Leger Gallery. His stepmother, Evelyn Sharp, finally had a major success too, in writing the libretto for *The Poisoned Kiss*, with music by Vaughan Williams, which had opened at Sadlers Wells, in the presence of Henry, Kath and Richard (and later travelled to the Juillard in New York City). There could have been no better 80th birthday present for Henry than these successes. Richard also learnt at this time that his old enemy, Henry Tonks, the 'great teacher' who had advised him to give up art so many years ago, had just died. What would Tonks have thought of the fact that his wayward pupil was now one of the guests of honour, with Princess Marie Louise, Sir William Llewellyn, Sir John Lavery and Dame Laura Knight, at the Arts Club 25th anniversary dinner at Claridges, where he was seen now as one of the grand old men of British art? He was a guest too at the Savoy as part of the welcoming committee for Louis B. Mayer of the Metro-Goldwyn-Mayer Film empire later in the year, and honoured, with his wife, father and stepmother, as the guest of honour at the 54th dinner of the Society of Authors, Playwrights and Composers, where John Masefield, the poet Laureate, was in the chair. But accolades and honours, however welcome, were not going to change Richard, and so when asked to comment on Hitler's ability as an artist in the light of

the purge of degenerate art which was happening in Germany at the time, he was unable to stop himself from having a swing at the dictator saying 'Certainly Hitler himself is no artist; his watercolours are about the worst I have ever seen.'[31]

It was time, Richard felt, having broken down some of his enemies, or simply having waited for them to die, to sum up and assess what had been achieved to this point; and so he organised, then presented, at the Redfern Galleries at number 20 Cork Street, *Twenty Five Years of Painting: by C.R.W. Nevinson*. This was done in conjunction with well-timed press leaks that the ink was drying on his autobiography, which, if anyone had failed to notice, was accompanied by an announcement in the exhibition catalogue itself reading, 'Admirers and critics of C.R.W. Nevinson's paintings are informed that he is engaged upon the final revision of a volume of reminiscences. . . . It is the autobiography of a fearless, creative spirit moving through a busy and turbulent career to a high goal.' In anticipation of *Paint and Prejudice*, the parting shot in the *Sunday Dispatch* was 'His paintings were too real: What will his book be?'[32] In fact, in the year of his autobiography he also appeared in *Modern English Art* by Christopher Blake and *The Significant Moderns and Their Pictures* by C.J. Bulliet, in which he took his place beside Renoir, Cézanne and Picasso.

The opening of the exhibition was as high-profile as would have been expected, with 200 guests invited to inspect the 42 works on display, including Princess Marie-Louise, Princess Helena Victoria, Lord Dunsany, Lord Amherst, Ramsay MacDonald, H.G. Wells, Countess Poulett, Mark Hambourg, Viola Tree and Alec Waugh. Never one to miss a chance to shock he proclaimed, whilst mixing his own 'Nevinson Special' cocktail at the purpose built bar, and brushing off a rousing chorus of 'For He's a Jolly Good Fellow', that he would 'rather be a Jew in Germany at this time than an artist in England'.[33] He also told a journalist of his own legacy, saying 'I am really responsible for Mussolini' and backed this up by claiming had it not been for Marinetti, d'Annunzio and himself, the intellectual revitalization of Italy would never have happened and that now Fascism, however much he frowned upon it, was the natural outcome.[34] As Oswald Moseley's Blackshirts paraded in Olympia, and as he took the adulation of the masses standing beside Mussolini in Italy, this was a risky move. Artistically the critics were not all convinced either and, offering insult in the guise of veiled compliments, said that the show was a triumph in that he had overcome his natural weakness at being an artist by using opportunism and ingenuity to 'triumph over natural disabilities'.[35] Old ally T.W. Earp stuck by him, even if he was no longer one of *les jeunes*, writing that there

was no monotony and certainly 'no sign of fatigue with advancing age'. He signed off, 'Both as a subjective and an objective artist he has always kept the courage of his convictions, and the liveliness of this retrospect is a result of which he may be proud.'[36] This was the man, after all, who in his late forties was still going flying (it was the year Amelia Earhart was lost over the Atlantic), and taking delight in loop-the-loops, causing his admiring father to write 'Rich came in after his two mile flight of spirals straight up into air: much delighted with it as was Kath, who was with him'.[37] Richard, it appeared, was poised for a significant return – a perfect moment, therefore, to release his autobiography. *Paint and Prejudice* was going to be personal, straightforward and a unique chance to condense his decades of grief, euphoria, hatred, love and disappointment between the covers of one book, as told by himself and no-one else. Perhaps sensing what lay just around the corner, Muirhead Bone wrote to the press, 'I am still ashamed of myself having referred in an unkind and quite unjust way to his large war picture now in the Imperial War Museum.'[38] Richard of course replied, saying that it touched him greatly that the great artist would apologise to him publicly after so many years, but re-iterated how he had been hurt by that group of people who 'robbed me not only of my good name, but of everything I valued in life'. He went on to say, typically tongue-in-cheek, 'The worst part of writing one's autobiography is that one has to dig up so many old bones, which as far as I am concerned, I have buried years and years ago.'[39] The pun would hardly have been lost on anybody close to either artist.

Paint and Prejudice was published in April 1937, just before *Blasting and Bombardiering*, the autobiography of his one time partner in crime, and now enemy, P. Wyndham Lewis, which came out in October. Richard's memoirs, from the alliterative title, and association to Jane Austen's classic *Pride and Prejudice*, set a clear and unapologetic agenda, as his public would surely have expected. He must have known as he submitted the final manuscript to Methuen Publishers that he was about to stir up a hornets' nest that might yet return him to the bad old days when he had been ostracised and persecuted by those around him. But from the comfort of the club, he may have hoped that his reminiscences might be received instead as nostalgic, and perhaps, amusing reflections on a fight now over. And, of course, he had his admirers too, a legion of youthful and middle-aged writers and artists who knew they could depend on him, now centre-stage, to say the things that needed to be said – as his father, mother and step-mother had spent a lifetime doing. But first blood went to his enemies, who got in an early, scathing, review published in the *Times Literary Supplement*, which took him by surprise. In this broadside, they said that the only amazing thing about him was

'Mr Ramsay MacDonald and Mr C.R.W. Nevinson',
The Bystander, *24 February 1937*

his failure to appreciate that he was not, indeed, a great artist, nor any kind of artist at all. Though eloquently put, the insinuations were biting in passages such as, 'It would be unfair to call Mr Nevinson a "trick" painter, but there is much in his work which reminds one of the "trick" pianist – the abuse, for instance, of the sustaining pedal to play a *legato* passage smoothly.'[40] And it had the desired result, as his father's journal clarified:

> Rich called in despair about a cruel review of his Paint and Prejudice in Times Literary probably by the venomous Charles Marriott. He talked of withdrawing his book which is bound but he would not be comforted. I read some on his misery at Uppingham and his happier student life in London and Paris showing how little I really knew of him then. It is all brilliantly written.[41]

The next day he wrote, 'Read more of Richard's book with admiration, but terribly depressed at the virulent attack on him in the *Times Literary*, a shameful instance of personal or Bloomsbury hatred.'[42] It got no better and he added, 'Could do nothing owing to Richard's terrible misery over Charles Marriott's review in Times Literary. He shivers and sweats

perpetually and does not know what to do. I was incapable of happiness in any form.'[43] Henry concluded that Marriott had probably been put up to the task by the Bloomsbury Group and had simply done their dirty work for them, though he was far from surprised that his son's book should have elicited such a response. In more than one review Richard was spoken of as the new Whistler, tackling his own equivalent of Ruskin, in very much the same style of showdown. Henry picked up on this, with more than a touch of pride, saying that he was enjoying 'Richard's admirable Paint and Prejudice, a tremendous assault on the Bloomsburies, the first attack in art since Whistler.'[44] But Henry was not exempt from his own share of criticism either and was learning in these pages of his son's early life, which he felt he had missed, of his ghastly mistake in sending him to Uppingham and indeed of his son's opinion of him, which, in fairness, was not particularly complimentary. Henry, now confronted, had to reflect on his role as a father and to feel shame that he should only be finding out about the full extent of his son's childhood misery 35 years after the event and from a widely published book. In fact Henry decided to go public too, writing a letter to the *New Statesman* justifying his decision to put him into the hands of the headmaster at Uppingham.[45] More objective readers could see in the overall tone of the memoir, the intense tragedy of the artist, calling it 'a sad book because it shows, with startling clarity, the essential loneliness and egotism of a creative artist . . .'.[46] *The Spectator* concentrated on the melancholy too, saying it was inevitable given the kind of person he was by nature and the life he had lived up to this point:

> His tragedy is that of a born revolutionary afflicted with a morbidly sensitive temperament. His blasts have recoiled on him and he has gone down in the Vortex he helped to stir up. Persistent ill-health and the debilitating effect of living the Bohemian life of the late Decadence and its Edwardian hangover have evidently contributed to his morbidity. . . .[47]

Others chose not to dwell on this undeniable side to his character and instead celebrated 'a high-spirited, swashbuckling, hearty adventurer, a high-Renaissance character of the stamp of Benvenuto Cellini, a man who in order to fulfil himself must have myrtle strewn in his path like mud'.[48] Neither was this mere bravado, rather the reminiscences of an artist who had proved himself to be 'the master of all trades and jack of none',[49] providing, in Edith Sitwell's words, a 'witty and veracious portrait of the time in which we live'.[50] Honesty was a quality which was praised, both in the publication and in the nature of the man, when one reviewer observed:

He writes with verve and vitality, as a rebel against convention, as a man of acute sensibilities who has been often hurt, as an artist to whom art is the most important thing in the world, as a terrific worker who has found most days too short for all he has wanted to do.[51]

The *Western Mail* informed its readers, 'Mr Nevinson's memoirs are like his fine paintings, bitter yet generous; sensitive and troubled, yet sane and affirmative; instinct with energy, movement and life'.[52] Importantly, the *Evening Standard* saw it as marking the end of an era, and the beginning of a brighter future, describing the publication as 'a bustling, bellicose book: the tale of a rebel who is now anxious to settle down and leave his feuds behind him'.[53]

The art scene nicely stirred up, and his name absolutely to the fore one more time, Richard departed with Kath for Paris, leaving the press to fight over his outspoken views. But as always with this temperamental and volatile character, the good, indeed the outstanding, reviews, were utterly eclipsed by Marriott's negative one, and in time his sense of persecution led to a fury which would require another attack. Even though Richard's German doctor had told him to write as much as he could as a means of purging anger, Henry was beginning to feel that that advice had found its way into the wrong hands. In fact, he took it upon himself to ask for silence to be maintained in *The Times* (as he feared his son's letter had already been sent), in return for which no libel action would be taken against the paper. But then there were the American reviews too which, when they arrived, were unsurprisingly harsh in return, at last, for all the comments he had made about them. Thomas Craven from the *New York Herald Tribune* for example remarked 'for sustained defensiveness, rudeness, and indiscriminate boasting, Nevinson's book takes the biscuit', then went on to say that it merely reminded everyone that the artist had now, as he had back then, no followers in the USA.[54] Harry Emerson Wilde's views were a bit more diplomatic: 'I think you'll like his *Paint and Prejudice*. It is gay and witty and filled with delicate malice; it's smooth and gentle and it packs a punch; it's sophisticated and urbane and filled with the vindictiveness of outraged innocence.' Everyone would have known what he meant when he concluded, 'The book bares a personality which it is a real delight to know but which, it must straightaway be confessed, must also be a trifle trying to endure.'[55]

To others Richard displayed 'the bias of an injured man',[56] in trying 'to bolster up bad theory with worse history',[57] while another quipped, perhaps a little more optimistically, 'Paint is his life and prejudice is

the thing that was powerless to destroy him.'[58] But this was, in the press's summation, *l'apache qui rit*: the stocky Napoleonic character who, as London knew only too well, had the temperament suggested by the famous bust of Beethoven, and who 'From his caravan writes of a world that is gradually approaching an understanding of his work.'[59]

Perhaps all of this would have bothered him more, had not the French government offered him, much to his own surprise, the accolade of Chevalier of the Legion of Honour at precisely this time. The citation said that he had served both England and France as an interpreter in peace and in war, that Field Marshall Joffre had bought the large Passchendaele piece (*Glittering Prizes*) for the nation, while, in peace, he had been a loyal supporter of France and the French and an asset to their culture. Henry, delighted, 'Called with Kath to warn Rich to take no notice of Charles Marriott's attack on him in the Times, and not to write about the Legion of Honour for which he received the certificate today.'[60] Richard would not have been surprised that it was the French who acknowledged his work and recognised his achievements long before the British and the Americans, and so, when the blow came that his application to be an Associate of the Royal Academy (ARA) had been rejected for the fourth time, despite all the hype and optimism to the contrary, he must have been almost ready for it. The *rapprochement*, it became clear, was not yet absolute, and so, while the Royal Academy was ready to hang his pictures on their walls, they were clearly not ready to allow him to swagger in as a full Associate. The French, he had always known, had a greater appreciation for the artist and his art than the English poseurs, whom he loathed, and so his return to Paris was triumphant when he was invited to work on the hanging committee at the Georges Petit Gallery – even if it was for a show organised by the NEAC.

Following his debut on the television in a programme called 'Picture Page' (with a viewing public now reaching almost 50,000), he got down to the serious debate surrounding the resignation of Augustus John from the Royal Academy because of their rejection of Wyndham Lewis' portrait of T.S. Eliot. Richard called Lewis (who was at this time engaged in writing a book entitled *Hitler*) his absolute 'best enemy', but added that as the former had never offered him any support over a similar crisis three years ago, he could expect none in return now. After the resignations of Sickert and Spencer a few years back, however, he warned the RA that this represented yet another mortal blow, something they could scarcely afford. But far from swinging wildly this time his tone was different, indeed he seemed to pull his punches, presumably as he had come so near to his Associate membership, and declared instead, rather

surprisingly 'I have always been treated well by the Academy.' Besides, his next application for ARA might yet be accepted and reminders of past differences were best brushed under the carpet. If anything, he rather hoped the press would tone it down and not remind people of '. . . that distinguished *beau saboteur*, C.R.W. Nevinson, [who] fought the Academy single handed some time ago, whirling his lonely blade like Roland or Cyrano and calling on the chicken hearts to rally'.[61] To make matters worse, having asked his father to make a gift of *The Twentieth Century* to the Tate, an unusual choice and an old enemy, the painting was predictably rejected. Henry said of the declined offer, 'I expected it – but it paralysed me'.[62] The large canvas was returned to its sender on the same day that Richard's application for membership of the Arts Club was also rejected. Under enormous pressure he now surpassed himself with a physical attack on a fellow member of the Savage Club following an insulting comment aimed at him. Henry's diary recorded:

> He told how at the Savage Club an actor had recited a cruel sentence against him by Armstrong (R.R. of Munich). R. waited long till R.R.'s guest had gone and then demanded an apology wh. RR refused. R. then caught him a fine blow on the cheek which made it bleed. . . .

Such were the injuries to the man's face that he had to be driven to Harley Street by a doctor who happened to be in the club at the time. Not long after this, a similar, more serious attack took place at the Gargoyle Club as described in Henry's journal:

> Rich came in, narrating another disturbance, this time in the Gargoyle Club: his own guest David Tennant of great wealth insulted his sincerity by calling all his recent work a failure and therefore Rich, indignant, struck his face and broke his nose: mad bloodshed: . . .[63]

No longer the joker and no longer tolerated with a fool's pardon, Richard was now getting a dreadful reputation for being a violent and dangerous man, which his father put down to his self defence at Uppingham or indeed to Kathleen's continued problems with alcohol at home. It was, in short, time to lie low for a bit, and he did so, exhibiting at the Royal Academy, staying with the Sitwells in the countryside and painting, in his father's words, 'many small landscapes from his recent trip to Derbyshire, some very beautiful, but I wish he would return to his more imaginative and satirical subjects, even though they do not sell'.[64] Henry felt compelled to write at the end of 1938, 'So the map of

Europe is again rolled up',[65] and Richard, believing that the bombing of London would start in a matter of days, despaired that 'Mankind stands for destruction instead of construction. When the creative powers dominate, then the ideal of Christianity will come into being, and then, and then only, will a Utopia be made possible.'[66] In a political climate where peace with dishonour reigned, Sir Stafford Cripps warned 'The Independence of Austria has disappeared. . . . Germany's next act of aggression will be directed towards Czechoslovakia, and then the people of Great Britain will find themselves back in the days of 1914.'[67] Henry understood fully what this meant and concluded his diaries for his last year in a peaceful Europe by saying 'so we sleep in fear'.[68]

There were a few months in 1939, however, before Europe slid irrevocably into war, when Richard could enjoy the last few peaceful moments in paintings such as *Hark! Hark! The Lark!*; could address the Brighton Arts Club on the subject of Constable and Turner being the roots of all modern painting; and prepare for the all important Leicester Galleries show which would be opening in the second half of February. A month before, Henry had seen all of the framed paintings in the studio and commented:

> A very fine lot, all panel size, mainly English and French archi-
> tecture & landscapes about six of unusual excellence. Kath also
> there, apparently sane, sober and helpful, but Rich, in returning
> told me he might find her in a raging fury when he got back.[69]

Indeed, the 'problems at home' were becoming very serious and Henry wrote:

> Kath drinking so horribly that she utterly neglects him and he
> has to go out even for meals and dreads to return: she insults and
> humiliates before his pictures so that he lives in isolation: and
> she shuts herself up to drink. Also no-one takes any interest in
> pictures now owing to fear of war & he dreads the failure of his
> show on which he has spent £200 already. Says Kath's mother
> died of drink in same manner and Kath is now showing signs of
> it in her appearance.[70]

The exhibition opened on Valentines Day in the presence of Princess Marie Louise, Sir John Masefield, Stanley Spencer, the French Ambassador, the High Commissioner for Canada and countless others. His father too reported much happiness at the event when he wrote:

Richard's fine show of recent pictures at the Leicester galleries: the most beautiful show he has ever had: all small to suit a medium flat: the scenes of London and Paris streets the finest espec. a tall upright of Soho at night, a masterpiece. A good crowd there. Oppenheimer the S. African millionaire bought six straight off & others sold.[71]

The press wasn't universally convinced, however, and talked of 56 paintings that were 'competent, intelligent but unexciting'.[72] Richard wouldn't have cared though as, after much press speculation, it was finally announced that he was formally to be offered the status of Associate of the Royal Academy (ARA). His father recorded a 'Splendid Triumph' and that his son was 'Full of joy',[73] while the newspapers reported that Richard had not even known that his name had been proposed. Another headline ran 'R.A. Enrols its Worst Critic', and in this same interview reported Richard as saying 'I am as surprised as I am honoured. The hatchet between myself and the Academy was buried some years ago. I am absolutely bewildered', and then 'one gets awfully tired of being a rebel'.[74] His new commitment and sense of responsibility was immediately obvious when he stated, 'Now that I am an ARA I shall do all that loyalty can do for the Academy, and serve it to the best of my ability,' as 'I believe it is the duty of all modern artists to support the Academy instead of fighting it, because the Academy is the stronghold of art against commercialism.'[75] As bygones now seemed to be bygones it was felt by some that there never should have been such a vicious contest between the two as Richard had always been a born classicist and a through and through Englishman. He had, from the outset, displayed self-discipline, control and learning (in his painting if not in his behaviour), and this led many to wonder why it had taken until his 50th birthday for the RA to realize this.[76] Rather supporting this notion, Richard wrote an article for the *Sunday Dispatch* called 'The Royal Academy DOES mean a lot to you' in which he explained to readers why the RA was indispensable. It opened with a conversation he said he had had when 'I was challenged by a friend with the mentality of an ostrich. He said the Royal Academy did not matter to the Man-in-the street.' Though this was exactly the sort of thing he himself had said so often in the past, he now defended the institution, explained why it was vital to everyone, and emphasised that to rebel against it was counter productive. When it was brought to his attention that he had built a reputation on being a rebel, he responded 'This is rubbish. I have never been a "rebel" ', and claimed that he had always been simply an artist who had had beliefs that, as it turned out, the Royal Academy

shared. Together they would now stand against the 'merchant painter', the 'dealers' and the 'yes-man', and would do so with pride, as they had always done (albeit separately). His feet were clearly under the table, to the point that those who knew him may have had to read his comments twice to make sure it was the same Richard who had just said 'Rebellion is an uncomfortable and unbecoming attitude.'[77] His father concluded with some satisfaction, 'In spite of all troubles, abuse and failures he has earned high distinction at last'.[78]

In the dying days of peace, Richard was as active, perhaps, as at any other stage in his career, exhibiting very favourably at the 'Artists of Fame and Promise' exhibition (in the company of Brangwyn, Nicholson, Sickert, Lassore, Cundall, Steer, John and Epstein); at the Royal Scottish Academy and at the Royal Society of British Artists; and enjoying the society of his 'shaggy unkempt Bohemian' friend from Slade days, Stanley Spencer.[79] After one such meeting Richard wrote to him saying:

> Stan, I would like you to know how glad I am that we have met again. My gratitude to you is boundless. It has been an experience to me to talk and share not only jokes but those problems which eat at so much of my energy. You have a clarity which is superb; I feel like a giant refreshed after being in your company. . . . As you know, I consider you the only man with that indefinable touch of genius. I felt it for Picasso years ago. . . . I have met most of the so-called great men during the last twenty years, so I hope you will take this bouquet in the spirit in which it is offered.[80]

Richard was still very much the 'artist – celebrity', having one of his pictures mentioned in Agatha Christie's *Murder is Easy*,[81] exhibiting six paintings at the Royal Academy and enjoying their banquet, chaired by Sir Edwin Luyens. As war clouds gathered, however, Kathleen's father, 'a great store keeper in Islington', died, on her birthday.[82] The press got this confused and wrote and published an obituary for Henry, with which he was very pleased. But that effectively was the note on which Richard's career in peace-time Britain, and his reasonable health, came to an end. There had been no secret about the decline of European order and, predictably enough, Hitler had marched into the rest of Czechoslovakia in 1939, wiping out the innocent simplicity of Munich at a stroke (the umbrella had not, in the end, been mightier than the sword). The Italians too were causing unrest as Mussolini, supported, according to Pope Pius X, by 'God's full protection', cast his glance in the direction of Albania and Greece. The catastrophic proportions of modern warfare, as if anyone needed reminding, had been fully demonstrated in Spain which had experienced the loss of 400,000 of its citizens in its Civil War. Henry

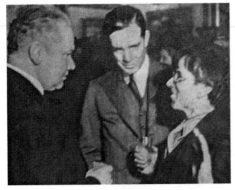

Stanley Spencer has
the Last Word

now observed that his son was lapsing into both physical and mental deterioration, leading to long periods where he was bed bound, brought on by stress and the certain knowledge that war would begin 'next Tuesday'.[83] As Chamberlain called for one million army volunteers (who could have forgotten Kitchener's call only 25 years before?), and as the British defence budget was hiked up to a staggering £477 million, his anxiety increased in the agonising wait for the inevitable. Henry was horrified to see his son

> in a state of terrible collapse, sweating continuously and trembling ... in absolute despair about the future, war ending all point of painting and destroying all interest in art. I never knew him in such absolute despair and misery.[84]

On the eve of war, at 50 years old, in notoriously poor health and suffering from 'violent pains in [the] head and body'[85] (which Henry now thought could be glandular), Richard offered his services to the Police Reserve, for which he was offered £3 a week. The following day, 1 September the wait was over and Henry recorded 'War at last begins in terrible reality. Richard brought the first news of Danzig's occupation and bombing of important Polish towns from the air.'[86] Henry and Evelyn spent the day taping up their windows in case of shattered glass causing injury in the inevitable attacks to come, while Richard dissolved into 'a suicidal misery, unable to attempt anything. He blacked out all lights in evening and listened in to repeated orders for calling up reserves.'[87] Mass evacuation got underway immediately, and this included both Richard and Kathleen, who headed (with their cat Tuff) for the Sitwells in Derbyshire. A letter from Edith to Georgia Sitwell captured the mixed feelings of the arrival:

> Richard Nevinson phoned through on Friday evening ... giving Osbert details of his last terrible illness (such a moment to choose), asked if he and his wife Kathleen could come down here in their caravan and camp in the stable yard. They came on Saturday but were shown nicely, but firmly, that if they were intending to stay for ages the caravan would be their home and

that we were not bound to see each other every day (I do think Richard is rather a sickening spectacle). He is such a *monstrous* egoist, that he had no time to think of the wretched boys who have to go into that hell, but could only moan about his own purely imaginative diseases.[88]

Henry, unaware of his son's departure, stayed at home and started to fill sandbags as the first air raid warnings wailed over London and as Chamberlain's fateful message was broadcast for the waiting nation, in which he said, 'It is evil things that we shall be fighting against, brute force, bad faith, injustice, oppression and persecution. And against them I am certain that the right will prevail.'[89] Henry must certainly have been a little surprised when he walked down to his son's studio to find Richard and Kath gone and 'all windows locked and shuttered'.[90] The next day Henry put the finishing touches to his air raid shelter under a sunny sky, now full of barrage balloons, and lunched with the Polish and German refugees who had helped him to build it. But bad news continued to come in with the Russian invasion of Poland, and with the loss of the Donaldson Liner *Athenia* sunk off Donegal, and so Henry observed mournfully, 'New moon appeared, soon to be full for London's destruction'.[91] Even so he could still muster the enthusiasm to attempt to bolster his son's confidence, saying: 'I wrote with difficulty to Richard, urging him not to despair of his genius, for art has a way of surviving all wars & disasters.'[92]

Within days, with his niece, Margaret, already in the Medical ARP (Air Raid Precaution) in Norfolk, Richard's name became closely associated with an Official Artist post, related to the Air Ministry. His father wrote privately 'to encourage him as he seems inclined to accept proposal as a war artist again. But where could he go in this war?'[93] while rumours circulated in the press suggesting that the brush, in the right hands, might yet be mightier than the sword, as it had been in the last war. Further fuelling such speculation, Richard went on the record saying that he would love to work for the Ministry of Inspiration (Information) and declared that artists should be mobilized immediately, even under a general who was himself an artist. This Ministry, founded shortly before the war as the agent of government propaganda and publicity, defined itself as defending truth, fact and unbiased reporting, unobtainable elsewhere in Europe, based on justice and human rights. This was precisely the sort of body Richard could work for, and accordingly he published an article entitled 'Mobilise Art: Demands C.R.W. Nevinson: Tell the world what Britain is doing', in which he reminded the public that the Charge of the Light Brigade

was only known, and now remembered, because of 'the poet'. Therefore he proposed, as British art was respected all over the world, its artists under 50 years of age – he was 50 – had a duty to perform, telling the world about, and immortalising, the days which were passing, and which lay ahead.[94] Sir Kenneth Clark, however, rather dampened this enthusiasm when he wrote a piece called 'The Artist in Wartime' in *The Listener*, in which he agreed that artists should concentrate on producing good art and should not think of becoming firemen, for example, but noted too that Richard had produced great records of war in the *last* war, but that not much more could really be expected from him now. The article went on to say that Richard and Bomberg were, after all, merely 'painters', while Lewis, John and Nash were 'artists'.[95] And that was Richard put very firmly in his place, even if the press was talking about the possibility of him flying over the Siegfried Line, taking photographs and sketching. His father, though not keen on the comments of Sir Kenneth Clark, fundamentally agreed, writing:

> he has painted nothing since the last war. No inclination to go out this time & is right for illness has weakened him, and 'Twice is impossible'! No repetition of last war should be attempted though it would bring money and restore his position.[96]

The following month when the War Artists Advisory Committee (WAAC) was set up, it was done so under the auspices of none other than Sir Kenneth Clark himself, and that ruled out any real chance of participation. Clark, as a friend of Chamberlain, an advisor to Winston Churchill, the Director of the National Gallery (at the age of 29), the Keeper of Fine Art at the Ashmolean and even a friend of the Royal Family, was also appointed Head of Films and Controller of Home Publicity, and this made Richard irrationally nervous. But Clark was also notable for his apolitical stance and stated very reasonably that he was setting out to undermine 'the current idea that modern painting is unintelligible and that modern art galleries are for the few selected initiates'[97] – a view very much in keeping with the 'Art For The People' exhibition which the Artists International Association opened in the same year. He did, however, adopt a superior tone in the *Cornhill Magazine* when he said, 'No doubt it will be necessary to tempt the people with scraps, but they must not be spoon fed or they will never learn to feed themselves, and will soon become too lazy even to open their mouths.' This is what Richard would have objected to and he was not alone in his reservations, which were shared by Herbert Read, George Orwell, Osbert Sitwell, Graham Bell, Adrian Allinson and H. Granville Fell (editor of *The Connoisseur*). Of even greater concern was

the fact that the WAAC was made up of Percy Jowett, Walter Russell (Keeper of the Royal Academy Schools) and that old nemesis, Muirhead Bone. Sensing hopelessness, Richard's public attacks began on Kenneth Clark, equalled only by those on Muirhead Bone, Roger Fry, G.B. Shaw and Clive Bell in years gone by. '[C]rimson with rage and distress',[98] his father observed him speaking

> in fury and loud laughter about Sir Kenneth Clark of the National Gallery who plays the dictator over all societies. He had been at the meeting of the Royal Societies to denounce him & had sent him a very strong letter. Muirhead Bone and Clive Bell are now his chief enemies in Bloomsbury.[99]

But very few would have been listening to the bickering of artists, as the *Royal Oak* and the *Graf Spee* went to the bottom and as Finland was invaded by Russia. Richard's gloomy prognosis from 'The Arts in This Bellicose Civilisation', from *Exodus AD*, and from his grand painted works, had become a reality.

15
C.R.W. Nevinson's Second Great War
(1940-45)

The year 1940 began surprisingly well for Richard. Not only did the Phoney War prove a most welcome respite to his nerves, but privately his *rapprochement* with the establishment seemed to be holding too. In fact, at the United Artists' show ('The War Exhibition') at the Royal Academy, he shone, even with an old painting, now entitled *The Twentieth Century: The Conflict Between Human Thought and Man's Predatory Instincts*, which was exhibited with a swastika flag on one side, and the hammer and sickle on the other. One journalist wrote of its new iconic status saying that 'Such a picture would get an artist sent to a concentration camp in Germany. Here it emphasises the freedom artists enjoy and will go on enjoying in spite of the war.'[1] The fact that Richard was happy to let it be auctioned on behalf of the Red Cross and St John Fund, said it all in terms of what this great struggle, which was soon to intensify, was all about. And yet he had hardly the mental or physical strength to continue, indeed hardly the will to live as he looked, almost enviably, at the 'quick and silent' suicide of family friend Humbert Wolfe, and the loss of another friend on board the torpedoed *Glow Worm*. Being blackballed from the Grosvenor Club at the hands of Muirhead Bone (who had even physically attacked a 'Nevinson poster' hanging on the wall there), didn't help at all, and neither did his continued exclusion from current and retrospective art exhibitions, at the hands of Sir Kenneth Clark. Later, when a feature written by Blaikely (the director of the Imperial War Museum) appeared in *The Times* discussing the art of the first war but omitting his name entirely, Richard saw red. Henry wrote to the author, diplomatically pointing out the error and reminding him of the national importance of his son's 35 war pieces which were housed at the Imperial War Museum, but this was eclipsed by Richard's gunboat diplomacy which undid any possible benefit. The letter Blaikely received read:

Sir

I have heard from my father who reads *The Times*, which I do not, as I do not like to pollute my mind with views of officials, government servants etc., that you have deliberately indulged yourself in treating me with all the usual chicanery and boycott that I associate in the past with your Muirhead Bone, Henrietta Tonks, and other official war intriguers. I now hear that you are no longer the curator of your own museum, but under the dictatorship of Sir Kenneth Napoleon Clark of Bloomsbury and the National Gallery, king of snobs both intellectual and social.

I only write to inform you of my contempt for your petty favouritism, and how deeply I regret I ever presented you with one of my beautiful pictures or my copyrights, or showed you any courtesy that I, as a gentleman, have always been prepared to give, and you as a representative of Bonehead Muir and Napoleon Clark can only exploit.

Yours with grim sincerity

C.R.W. Nevinson.[2]

Blaikely, clearly reeling from the letter, and indignant that Richard seemed to be blaming him for his exclusion from a war artist's post in this war, when it was in fact the decision of the Ministry of Information over which he had no control, wrote back with:

You really must try and get your facts right before putting pen to paper. I like your work but I don't always like your letters.

And signed off with

Yours with even grimmer sincerity.[3]

Stepping back slightly, and realising that he may have just swung for the wrong man, Richard explained:

I have had to fight one of the most vindictive, libellous and scandalous and slanderous cabals for the last twenty years. . . . It has simply broken my heart.[4]

But that was not the end of it and he got back to work, writing a letter called 'The Artist in Peace and War' to The *Daily Telegraph*, in which he reminded everyone that he was a soldier, an artist and an intellectual and so knew, beyond any doubt, that it was his job to embrace modern history, with an equally modern art. He wrote of those who would have it otherwise and who, for personal reasons, would destroy both art and careers for petty triumph, and concluded 'It would be better to be buried

alive by a German shell than to live under a Chelsea-Bloomsbury anti-British English intellectual dictatorship.' In this he was referring to a debate which had suggested, as the Bloomsburies had done in the last war, that artists should be exempt from military service as they were too valuable an asset to risk, being the protectors, indeed the future, of the nation's culture. Richard had railed against such élitism then and he would do so again now. But it irritated him that certain people who seemed to be making the national policy, in which neither he nor Stanley Spencer seemed to have any place, valued their own skins more highly than any other 'normal' Englishman. He signed off, C.R.W. Nevinson A.R.A. (Chevalier, Legion d'Honneur), using his foreign title to give him a bit more punching power against Clark and the hated Bloomsburies, and emphasising that, though excluded from their groups, he was far from excluded elsewhere. His father, always able to see the negative consequences of such outbursts, wrote 'He shows no sign of conciliation but gets a full blow back at his enemies',[5] then two days later noted 'A distressful day owing to the prolonged persecution of Richard by the Bloomsbury critics. Called him on the phone to find him full of "bitter rage" especially after Kenneth Clark had omitted him from the show of British artists at the National Gallery.'[6] Henry wrote later 'Rich came and took away his picture of the Lower Thames to bring to the Royal Academy. He was terribly distressed by the . . . spite of the gang led by Muirhead Bone and Kenneth Clark who exclude him from every show and mentions his continual misery. . . .'[7] The exhibition in question was *British Art Since Whistler*, which had opened at the National Gallery, had been selected by Clark and a team of his choosing, and which, naturally, made scarcely any mention of Richard or his work. Initially some parallel protests had been led by Alfred Munnings, who had argued that the National Gallery was the property of the nation, and asked why then an understanding of British art history should be bulldozed by a group of influential individuals who chose what to accept and what to reject. J.B. Manson, former director of the Tate, lent some weight to the argument saying that re-writing art history was a very serious thing and that it should be treated with the utmost caution.[8] At that point Richard got involved, with a traditionally angry letter to *The Times*, which must have buried forever any hope of reconciliation between himself and his enemies. His opening salvo claimed that there was Nazism in the National Gallery, which in itself was an anti-British institution. Specifically he pointed his finger at the individuals there whose criteria for enlightened and intellectual art were based, almost exclusively, on the superiority of the foreign mind and brush, and on the resultant obscure theories which, by their very nature, were alien to

England and the English. There was no greater culprit for this than the Bloomsbury Group, which put no value on 'Englishness, democracy and freedom'.[9]

The rift was now both deep and intensely personal, to the point that Henry wrote in his journal, 'I saw Eddy Marsh with Kenneth Clark, the slimy, rich eel, no doubt discussing the problem of the inclusion of Rich in the Exhibition of Contemporary British Artists, I hope so.'[10] Though Edward Marsh, in the end, lent one of his small images by Richard, a Cornish scene which the artist himself referred to as a 'postage stamp' (Michael Sadler offered another, but to no avail), there was little doubt that Richard was going to get nowhere so long as Clark and Marriott were at the helm.[11] For the moment, ironic as this may once have seemed, he would have to rely on the RA and the NEAC as a steady and reliable window for his work. Meanwhile, Clark got a letter that would have left him in very little doubt as to how Richard was feeling:

> Naturally, my blood boils that artists in this war should be under a dictatorship. I do not suppose that you can understand any man fighting for principles that are essentially un-dictatorial, democratic and cleansed from petty personalities; therefore I suppose I shall have to continue in opposition until you succeed in putting me in a 'concentration camp'!!

Having lambasted Clark's professional integrity, Richard went to great lengths to point out that Sickert, Lawrence, Brangwyn, Grant, Matisse and Gertrude Stein had all admired his work enormously, and even that 'Picasso considers me the best of living English artists, as my work has great élan, especially in my later American pictures.' He also reminded Clark of his own version of British art history which stated that 'I brought over most living French paintings in 1912-14; with the Camden Town Group of which I was a member I started the London Group'. With that slightly delusional reminder he enclosed a copy of *Paint and Prejudice*.[12]

The May 1940 show at the RA got a variety of work from Richard, which the critics had come to expect and which the press in general viewed favourably. The old eclecticism was far from dormant in his submissions: *The Unending Cult of Human Sacrifice*, *Suburbia 1939*, *The Thames from the Old Ship*, *Any Old Iron* (a portrait of cockney comedian Harry Chapman), *The March of Civilisation* and *The Thames in Black and Silver*. The press appreciated too that he, alongside Norman Wilkinson, was at least acknowledging that there was a war on, however badly it may be going. Denmark and Norway had fallen in the same month as the RA show, and before long the British aborted the campaign at

C.R.W. Nevinson, The March of Civilisation, *1940*

Narvik. A matter of weeks later Holland, Luxemburg and Belgium fell, as did the Chamberlain government, which cleared the way for Churchill's Wartime Coalition. Though all of this must have weighed heavily on the artist, and though some of it filtered into his work, he remained obsessed with his own personal grievances. For example, in the week that the armada of small ships were plying their way across the English Channel to rescue hundreds of thousands of marooned British and French soldiers at Dunkirk, Henry reported that his son's mood was dictated by something much more personal. 'Called on Rich who was in black, almost suicidal despair, chiefly at the open hostility of his old enemies: Muirhead Bone, John, Clive Bell and the rest.'[13] Perhaps as a result of this, and the news of the fall of Paris, the abscess on his bowel flared up again, for the first time in eight years, rendering him bed-ridden one more time. The Paris that he had known and loved was now defeated and London, he was well aware, would be next.

When the Blitz came, Richard offered his services as a driver, but was turned down on account of ill health, whereupon he gave his car to the government as the next best thing. By August the duels in the English sky had begun and indeed the RAF had started their probing raids as far away as Milan and Turin, before the bombs came to London itself. And this became Richard's subject – his home, the great capital and the next shameful page in the history of western civilisation, co-existing with powerful reminders of the England that

they so desperately needed to defend. An early image was described by his father as follows:

> As a protest against persons who are applauding war and its fine effect upon character he has painted a terrible picture of refugees in flight along a road, a woman screaming over her machine gunned husband, while their little daughter looks on in bewilderment. I made a few criticisms but as usual they were received in silence.[14]

A version of this work made it into the Leicester Galleries in September, where Richard hobbled around suffering with a pulled tendon from his exertions as a stretcher bearer. No doubt the horrors of The Shambles came back to him in the same month when, working as a hospital orderly, he was exposed to the reality that the Blitz had brought with it. His father recorded in horror a phone call in which Richard spoke of his anxiety and depression, having worked with 'wounds in the hospital [which] were ghastly, gashes in faces of women, one girl with chin cut off so that she had no mouth or lower jaw from which she vomited.'[15] Now, fully committed to the hospital, as he had been in 1914-15, sleeping there by night and working by day, the war had come to Richard, even if this time he had not gone in search of it. Once again, he was certain that London had been infiltrated by spies who were flashing signals to the aircraft overhead. Before long his studio took a direct hit, though the oil bomb failed to explode and the majority of the building, and works within it, were salvageable. The new airscapes he had been working on, which included an image of Spitfires returning over the Kent countryside, emerged unscathed, while a few Parisian sketches were deemed beyond repair. He and Kath knew it was time to move on, outside of the metropolitan area and to another studio in Hemel Hempstead. All doubt about this would have been removed when three bombs fell on Downside Crescent, blowing the windows out of the family home. On Henry's 84th birthday, another bomb fell, nearly killing him, Evelyn Sharp and granddaughter Margaret, but they stayed in the damaged house anyway until, on a Sunday afternoon in mid-October, a 250 lb bomb fell in the back garden, making the house, finally, uninhabitable. With extreme misery the old man began his 'exile' in Harpenden, which he knew would be his final destination, writing 'I have seldom touched such depth of misery and age quenches hope.'[16] Returning to London only sporadically, he took what he wanted from his bombed out house, gave a few selected bits and pieces to those nearest and dearest to him, and reflected on a life spent at this now ruined address. These rare visits back into the city were precious to him and he maximised his time, never wavering in his support for his son. The now

C.R.W. Nevinson, The Return

virtually illegible diary entries recorded visits to the NEAC at the Suffolk Galleries to see the refugee scene *Flight,* and two other aviation scenes, 'one of three planes over fertile English country and fields, one of them flying among masses of white clouds with glimpses of the coloured distant countries through clouds. Both very fine'.[17] Richard was not so frequent in his visits to Henry, though, and soon the exile became even more distant with a further move to Campden in the Cotswolds. London, and Richard, were effectively out of reach and so Henry descended into a 'sorrow at the thought that I shall never live in my house . . . again and shall probably never see Rich and his work.'[18] Over the telephone, and by letter, he kept abreast of the problems that surrounded his son, as best he could, even as London burned. For example in December he got a letter from Richard which told him that

> the Savage have been openly abusing him as a failure, whose brief success was due to my influence in journalism. He has resigned from the club: a mistake. Kenneth Clark and Muirhead Bone are also spiteful as ever, resolved to 'exterminate' him. I cannot imagine why this jealous spite continues.[19]

Though Richard and Kathleen actually hosted a dinner for Clark, it seemed to make little difference and the two left on traditionally poor terms. Simultaneously, and clearly frustrated at his lack of official status, Richard got another letter off to a different member of the WAAC, who perhaps might be more forgiving in spirit, and who might yet open a back door to the national scheme.

> In spite of art cliques, tete-a-tete, bric-a-brac, and chit-a-chat of the English art circles, I am the only English artist internationally famous as a War artist, if galleries, sales and letters by and from really educated people, and press cuttings from all over the world, prove anything. I revel in the fact that I am condemned by the Bloomsburies, whose exquisite, civilised, pansy taste I despise. . . . In fact I am cursed with my English birth, outlook, and sincerity; my un-English, democratic, hatred of birth, privilege, and favouritism, the real cause of all my trouble with the English Art Snobs. I have three war paintings I should like to submit to your Advisory Art Committee. Is it useless for an artist such as myself to try, and how can I? I have been bombed, and I am naturally suffering through it, and therefore I wish to give myself every chance of selling my work.[20]

Before the answer came Richard suffered what he thought might have been a mild stroke, which Henry felt had been brought on by the severe

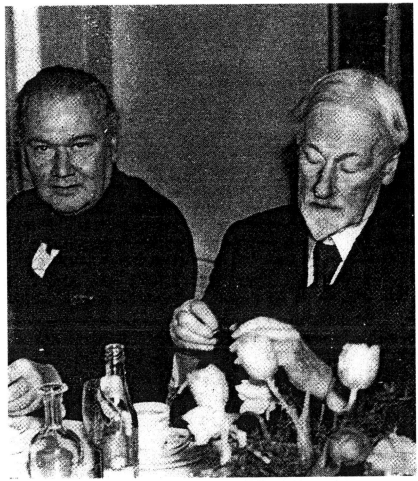

'Mr C.R.W. Nevinson and his Father, Mr H.W. Nevinson', Tatler, *6 March 1940*

cold his son had been suffering while sleeping at the hospital. Knowing that his own death might not be far behind his father's, or might even come before it, Richard continued to paint feverishly, especially scenes of the wounded like *Tormented Cockney Children* and Aristotle's figure of *Pity*.[21]

In time, though never an Official War Artist, Richard became associated with the Royal Air Force through affiliation with Bomber Command. Clark had made his appointments earlier – these had seen Bone and Cundall attached to the Admiralty; Ardizzone, Bawden, Eves and Freedman to the War Office; and Henderson and Nash to the Air Ministry (Eric Newton described Nash's appointment as being about as appropriate as asking 'Stravinsky to compose a march for the Grenadier

Guards').[22] Graham Sutherland had been employed elsewhere as had Henry Moore and Francis Bacon, while Patrick Heron had registered as a conscientious objector, so Richard was working unofficially in York from early 1941, from which came *Air Defences, Whitley – Moonlight Sonata*, and *All Our Aircraft Returned Safely*. Also, no longer a passive and peripheral observer, but now an integral part, in his opinion, of the war effort, stories began once again to circulate around the Café Royal of sketching trips in high-security zones by moonlight, of trigger happy guards and of an artist who was edging, not for the first time, right to the limit of what he was, and was not, permitted to do. There was talk too of his disappointment at not being able to fly with the bombers to Germany because of his ill health. When asked whether he felt a bit old for all of this and for possible flights over the Ruhr, he retorted that he was the same age as Hitler, who, on the whole, seemed to be doing fairly well for his age. And when the works were completed, the debate continued as to whether or not they should be bought in an official capacity, as was seen when Clark received the following from fellow committee member Dickey:

> Mr Nevinson told me this morning that he had been requested by the Secretary of the RA to let your Committee have the first refusal of any pictures he would paint as a result of the facilities he has been given by the Air Ministry. As you already know he considers it an insult for your Committee not to have recommended any of his pictures for purchase.[23]

In the end the WAAC purchased *December 29th – An Historic Record* for 50 guineas, and then later *Anti-Aircraft Defences*. In fact Richard wrote back in mid-July 1941 telling the committee:

> I am pleased to say that I have sold 4 out of 5 of my war pictures and they have been reproduced like anything in spite of paper shortage and are being used for propaganda by BBC and other organisations for the Near East and Australia (where one is going) and the Americas both N & S.[24]

Indeed, his passion and despair could be felt in other canvases such as *The Fire of London 1941*, in which the dome of St Paul's towered over the illuminated destruction in an inferno, where symbols of Christianity, the arts and civilisation became helpless observers and victims of the 'advances' of humankind.[25] And in *The Thames From a Balloon*, he even returned to the London sky to sit amidst the planes which brought their destructive forces to his home. It was now no longer the rogue Gotha, but the full might of Goering's *Luftwaffe*, which brought destruction to London and caused the frantic search lights to dart across the night

C.R.W. Nevinson, All Returned Safely, The Artist, *August 1943*

sky once again. From his vantage point in the balloon Richard must
have reflected on his boyish enthusiasm, pondered on his euphoria at the
outset of the machine age and wept at the apocalyptic reality of global
conflict catalysed by aviation, which he had so accurately predicted.
Luckily the onslaught abated before the destruction of London was
complete, and the *Luftwaffe* turned its attention on the ill-fated Russian
campaign. With some relief, coupled with a minor sense of triumph,
Richard changed the tone of his work (exhibited at the RA in May) to
comply with the ethos 'London can take it'. The images, based on his
hospital experiences and seen in works like *Cockney Stoic* and *Camden
Kids Don't Cry*, hung beside the ever-present reminder of the England
they were all engaged in defending in *Peaceful Rhythm of the Downs*. The
first storm, it seemed, had passed.

The disastrous reports from Crete and the loss of *HMS Hood* affected
Henry profoundly, as did his exile from London to an unfurnished
vicarage, cut adrift from the world that he knew he could no longer be
a part of. Richard was unable to stay in touch for weeks at a time and
Henry, knowing that it was 'the end of my active life and interests',[26]
simply wanted the process of dying to begin. Putting his affairs to rest, he
bequeathed the contents of his bombed out home, 'to which I shall never
return',[27] to his son and Kathleen, and on Richard's return from a trip to
Thirsk with Bomber Command, told him about the bank account where

his mother's money was, and how to retrieve it after his death. With one final effort he proposed his son's name for the Athenaeum Club, spoke with Kathleen about her drinking problem, which now seemed to have abated, and learned with delight of the love affair of his granddaughter Margaret. Then retiring to bed, the old man simply lost the will to live. Without London, Richard, his home, his health, and certain that the war would outlast him, he complained bitterly, 'Why can't I die quickly. The doctor promised I should die in a coma and I don't.'[28] His condition did however deteriorate quickly from that time on. Evelyn Sharp, now writing his journals and in recording the last moments of her husband's life, found humour even as he muttered in his delirium.

> So I laughed and I quoted, as I used to do on such occasions, the lines from the Ancient Mariner, purposely <u>mis</u>quoting one word which he used to tease me about – 'Sleep is a <u>blessed</u> thing' + he just opened his eyes + murmured '<u>gentle</u>' + then went into a coma from which he never roused.

Her description of his last moments continued:

> I sat with his hand in mine all the time, he breathing quite peacefully and without effort. There was a flaming red sunset right across the sky + the reflection of it was across his room. . . .He just stopped breathing; without opening his eyes. His face did not change or become less beautiful. I sat there holding his hand till they came and took me away.

As a post script she added:

> A great hurricane rose that night + blew until dawn. It seemed appropriate to the passing of his great stormy grand soul.[29]

Henry Woodd Nevinson was cremated by his own wish at Golders Green with no religious service.[30] On his coffin was Evelyn's laurel chaplet which read simply 'O, my darling'. She later wrote of the final execution of his will: 'He left in my hands his written wish that his ashes might be scattered on "any field or mountain or river of the England I loved so well".' She saw to it that this last desire was carried out in full and so his ashes were scattered at Tewkesbury where the Avon meets the Severn in a current that would take him towards his home town of Shrewsbury.

Richard was now without his greatest and most loyal ally, his benefactor and confidant. In a BBC radio broadcast called 'I knew Nevinson' he paid homage to the great old man, but elsewhere took care not to go too far in his appreciation, telling the *Birmingham Weekly Post* 'We met, on average about once in seven years, it was quite obvious that I had to

make my own career.'[31] Privately, he wrote to Aleister Crowley telling him that, on the whole, he only felt envy at the peace his father must now be experiencing, in comparison to the wretched life he continued to live.[32] He also wrote to Rothenstein saying, 'It is a great gap in my life but really I envy him out of this vile world of politicians', then added that Rothenstein alone from the British art world had written to offer condolences.[33] Evelyn, on the other hand, had received 330 letters.

Meanwhile the war in the air was giving Richard a firm subject, containing not only the drama of the dog fight, but the totality of war which he had anticipated in *Exodus AD: A Warning to Civilians*. As he had done in the First World War he turned his attention to the consequences of air war, and addressed subjects of innocence and entertainment in images like *Children in Safety*. He also looked at anti-aircraft posts on the south coast and made them the subject of many sketches which appeared at the Civil Defence Artists Association at Coolings Gallery. But the strongest pieces came in a series called *Battlefields of Britain*, begun in 1942, and some of which were previewed at the 'War Over Britain' exhibition at the National Gallery of Scotland and at the 'Exhibition of War Pictures' at Mansfield Gallery. He was still excluded, however, from the 'Britain at War' Exhibition at the Museum of Modern Art in New York; the 'New Movements in Art: Contemporary Work in Britain' at the London Museum and 'Imaginative Art Since the War' at the Leicester Galleries. Instead, he touched up exhibits for the summer exhibition at the Royal Academy – chosen, he said, by Mrs Gilby, his cleaning lady of 22 years – including *Bombers at Dispersal Points* and *Opus III: One Fine Day*, which attracted a great deal of attention and praise. The epic, however, was felt to be *Opus IV: Where Never Lark nor Even Eagle Flew*. Inspired by the words of John Gillespie, a Canadian pilot and ex-Rugby School boy, recently killed in the Battle of Britain, Richard got to work converting the words, and essence, of the poem into paint. The pilot had written:

Up, up the long, delirious, burning blue
I've topped the wind-swept heights with easy grace,
Where never lark, nor even eagle flew –
And while with silent lifting mind I've trod
The high, un-trespassed sanctity of space,
Put out my hand and touched the face of God.

It was indeed a powerful sentiment and Richard allegedly took ten flights to capture the mood of the verse on canvas, which then ended up in the Central Hall of the 174th Royal Academy Show. It was a fine reward for an artist who, despite all doctors' warnings, had not stopped working both day and night, until he had ended up bedridden with exhaustion for

six weeks. Though his sight had failed in the finishing stages of the work, and though his hand trembled with exhaustion, he had managed to apply the finishing strokes before his final collapse. When he was strong enough again he made a gift of the canvas to Winston Churchill who, accepting it directly from the artist and thus avoiding all forms of committees and a host of enemies, immediately donated it to the nation, and requested that it be hung in the Air Council Room at the Air Ministry. Churchill wrote to Richard saying that it gave him very great pleasure to accept the gift, urging him to get well soon and reiterating that 'I am sure the young men who are fighting regard you as part of the England they defend.'[34]

Elsewhere, Richard was happy that his other work should be exhibited or auctioned for all kinds of benevolent fund raisers too, for example the Artists' Aid to Russia Exhibition; the Wallace Collection Auction (where he donated *The Plea of Pan* and *Less Settled after Sunshine, S.W. Winds Undulating*); the YMCA in Cheltenham; and The Red Cross in Bond Street, where his *Peaceful Rhythm of the Downs* went for just under £90. His work appeared widely in the press, and also 'in the flesh' too, all over the regional cities of the United Kingdom, creating the image of the artist who was central, yet regional; benevolent, yet struggling; relevant, yet argumentative; modern, yet accessible; and ever a rebel, but now within the establishment. The image he had created of himself, and indeed of London (painted from the roof of the Dorchester Hotel which he called his Dorchester Beach), was enigmatic and ultimately victorious. He had endured and so had the city – indeed they had done so together. Italy had, after all collapsed and the Russian tide was turning after the sieges of Stalingrad and Leningrad – all London had to do was wait. One writer, unrestrained, remarked

> Wherever British painting is known, he is known, and everybody from everywhere who thinks themselves anybody hope to meet him when they visit London. He is a public figure whom Legend has as her child, while Rumour has played her part in helping Scandal to defame him.[35]

It was at this moment that he suffered a debilitating stroke. The tragedy was perfect, that in this, the final hour of triumph after a lifetime of struggle and survival through war and depression, and on the eve of his final acceptance by the establishment, fate should intervene to deprive him of the accolades that society now wished to heap upon him. And the plot thickened further when the press started to report that this stroke had been brought about through over-exertion on the beaches of Dieppe with the commandos during their fateful raid.[36] The *Daily Express* interviewed him sitting up in his bed, surrounded by canvases, and in this

he dispelled the rumour that he had been to 'the front', clarifying instead that he had been to the south coast to sketch the preparations for the raid. But they had no desire to play the legend down too far and revelled in reporting the exploits of a great, though weak, man who laboured incessantly as a stretcher bearer, who dug with his bare hands in the Blitz in search of life, who had not slept for days on end, and who had given his health for his country. There was also room for one little quip, a glimmer of the old Richard, when he said to the departing reporter, 'Say that I am going to get better, even if it is only to spite the Royal Academy.'[37] He was, as the title of the article suggested, 'The Grand Old Man of British Art', even if his right hand was now disabled. Privately, he admitted to Edith Sitwell, that he wished the second stroke had killed him as he had run out of the energy necessary to fight, and lost the resilience to take the punches that he said never stopped, being rained upon him. To other friends and enemies, with Kathleen typing the text, Richard sent long letters from his bed, musing on life's ups and downs. Through these it became clear that he had at least regained the use of his voice, and that he had a back catalogue of pictures which would keep him going for about a year, by which time he hoped to be working again. But of course that could only happen if he were given a chance by the Sir Kenneth Clark/Clive Bell dictators, who, he claimed, had even cut off his supply of canvas and colours (to little effect as he had outsmarted them and stockpiled them in anticipation). In this war, he continued, art was at the mercy of the dictators who sat in Court, handing out favours only to their favourites, while artists themselves were like Jews, who 'will not make a move in the beginning, as they all expect themselves to profit by the persecution of others, or their suppression'. What annoyed him more was the fact that these dictators had been 'far too dignified to fight in the last war, and did not care whether' they lived 'under English or German policemen'. That said, and even though his stroke had been brought on by stress and depression at the hands of this cabal, he felt he was getting somewhere against the 'Boneheads, the Bells and the Clarks, "King" Kelly [Sir Gerald Kelly, President of the RA], cats in Virginia Woolf's clothing ... and that buffoon Lutyens.'[38] Another letter, passionately written and unrestrained in its anger, despaired 'What is the good! No one seems now to care about justice, freedom or beauty any more, only snobbery & fashion' where 'the wealth and vanity of Clark forgives all'.[39] And so he concluded one of his letters, to Sir Hugh Walpole:

> Here am I, insulted, ignored and workless just because of that vile clique Dictator Clark, Bonehead Muir & MacColl & Marriott ... the evil of that vile virgin Henrietta Tonks. ...

He signed off by saying that he was going to fight on undeterred in the name of freedom, until Clark put him in a concentration camp, amid mass book burning. His parting shot was to scrawl in the margin of his letter 'Heil! Heil! Heil!'[40] Walpole must have written back as a further letter survives in which Richard took the time to actually explain the source of much of this vitriol. This letter recounted his fight for justice 'against this vile dictator who uses the press & the radio & the censor, besides his dealers & his snob friends & the National Gallery & his 700 committees & the Ministry of Information & the Queen'. Richard then compared Marriott to Goebbels, calling him 'the filth thrower of The Times' who had worked with Clark and Bell to ensure that justice, freedom and beauty were all things of the past, and snobbery, fashion and vanity their replacements. It was the 'Lords' of the National Gallery, fallen under the spell of Nazism, the dealer racket, and the influence of Jewish businessmen and 'homo-sexualist[s]' that had taken art to this very sorry state.

In a letter to Laura Knight in the same year he shared some other feelings of disorientation and frustration, though here he toned it down a bit:

> I wish artists had some standard ... a banker can prove by money that he is a good banker, we poor artists have no standards: tradition is no good, officialism via abstraction no good; box-office no good; lack of box-office no good; public appreciation no good; esoteric art and commercial exploitation of the 'misunderstood' no good; posing and posturing no good; sincerity no good; ... 'to know what you like' no good; to know what you do not like, no good; though at the moment the latter seems the correct and fashionable thing to buy!

He finished up in typical Nevinsonian style:

> I love painting for its own sake too much, and I detest all the lying Curators, and Officials, Courtiers and general 'art' chi-chi so much that it makes me loathe the profession of painting.[41]

By the end of the year he had got enough feeling back into his right hand to sign his name but not to paint, and so he exhibited at the United Artists' Exhibition at the RA, which opened on the last day of 1942. He showed *Liquid History: Opus III* and *Battlefields of Britain: Opus V* and an updated older painting called *Hope*, which was presented with a quotation from William Cowper's poem of the same name:

> Hope with uplifted foot, set free from earth
> Pants for the place of her ethereal birth.

But these were perhaps eclipsed by the unveiling of his latest ambitious project: a panoramic series called *London Triumphant in the Fourth Year of the War*, which he intended as a large historical document for the nation, even if realistically he knew he would probably never finish it. The Royal Academy, he felt, was at least supporting a dying man in his final great endeavour, unlike the National Gallery, which had fallen utterly by the wayside at a time when the nation had needed it the most:

> As for the Academy being a representative home of British art, it can at least be stated that, year after year, it offers a far higher and more catholic standard than the three years of continuous showing of the official abstract art at the National Gallery. There, at government expense, weak examples of French art find feeble English imitators and, at the best, incompetency and affection are the only standards.[42]

But that kind of intensity of argument had almost gone out of him now and illness, combined with the realisation that the end was near, saw him making presentations of his paintings to the major collections of the United Kingdom or to other benevolent funds, as unlikely as those for the relief of the Chinese. *Cockney Stoic* went to London County Council as a reminder of the Blitz and the fortitude of those who endured and survived it – the tear of blood on the child's face a poignant reminder of an innocence lost and a permanent scar that Londoners would wear long after the city had been rebuilt. The Laing Art Gallery and Museum in Newcastle accepted *The Twentieth Century*, perhaps his most prophetic work from the 1930s. Beyond that there was only the illness, which

> is worse than death. It is a living death. But I regard this paralysis as a combat, and I am going to fight on. I may win the fight yet.[43]

And fight he did, not only against his own ailments, but with protest groups like 'Hampstead and Reconstruction', which held an exhibition (opened by none other than Sir Kenneth Clark) to demonstrate artists' objections to the construction of an arterial road through Hampstead. But he was getting weaker now to the point that he had to be carried into the summer show of the Royal Academy, where his painting turned away from conflict and gave way to the pastoral, idyllic English haven, despite what was happening in Normandy. He exhibited *Crab Pots*, *A River in England*, *Home of the Otter* (his friend Henry Williamson had written 'Tarka'), *The Downs Near Goodwood*, *Sand Dunes–East Coast*, and *Meadowsweet and Beeches in Norfolk*. Even the euphoria of VE day, and the hard-fought-for triumph over the Axis Powers, when it came,

did not inspire him to return to the war theme. Instead he continued to focus on the English landscape, birds, flowers and on Paris, which was now only a distant memory, and to which he knew he would never return. Little more was expected of him, even after the closure of the dreaded WAAC and the return of Picasso, Matisse and Klee to London galleries. The fight, as far as the press was concerned, was over and some even got to work putting the finishing touches to the 'Nevinson story' before he died. *The Studio*, in particular, ran a large piece on him, which sounded more like an obituary, in which F.G. Mories eulogised the man who had fought but had now stopped (and maybe even won); the artist who had devoted a lifetime to art and aesthetics; the grand old man of a generation now long gone. Mories also assured the ailing artist that his place in art history was assured as, in addition to his paintings, his intelligent and outspoken remarks had always provoked an opinion, positive or negative, and had always stirred something up, encouraging debate, even heated argument, in a society that did not naturally lend itself to that. He had been an international artist and bohemian, a radical in art and a personality who had delighted in diversity and adversity, even when it had left him so desperately lonely and in shattered health. Haunted with both genius and madness, which had been combined with severe morbidity and fashionable vanity, the outspoken, sensitive and very public personality had never been a lover of anything other than art and beauty.

16
The Death of a 'Beau Saboteur' (1946)

By early 1946 the press were reporting that Richard's right arm had stopped working completely and that he was learning to paint with his left hand in order to get his next three landscapes ready for the RA show in the summer. These were not new, but pre-1943 works from his studio, which he could touch up with minimal exertion. When the exhibition opened in May he arrived in a wheelchair, sporting a beard (he could no longer shave), and was much photographed. The press reported that the paralysed artist was not going to be held back even by infirmity and was going to contribute, and fight, until his last breath had left him. Neither would he back down from his eclecticism based on 'art rules the artist', both in subject matter and technique, and so, on display at this exhibition were views of New York, Venice, France, and England. But having faced two world wars and countless battles within the art world, he now faced his own private conflict with paralysis and knew that this time he would not triumph. His old Slade peer and War Artist colleague Paul Nash had died just weeks before and Richard must have appreciated that his own time was drawing near. Kath and he were invited to a garden party at Buckingham Palace, but tellingly their unused tickets remain in a scrapbook in the Tate Archive, suggesting that illness was now moving into its final stages.

An uncharacteristic silence from his studio for several weeks finally led to the announcement on 7 October that Richard had died, at the age of 57, with Kathleen at his side. The death certificate recorded that he had succumbed to uraemia, arteriosclerosis, right hemiplegio and hypertension. He left behind a well organised will, drawn up over four years previously, that requested that his body be left to University College Hospital London and that there should be 'no funeral rites, flowers, memorial service or mourning'. As it turned out, he was cremated on October 10th. The following day the press started to report the death of this champion of the outspoken and of a generation now almost forgotten. The eulogies were genuinely moving and sincere, saying that this was indeed a loss to the world of art in Britain, even if some of the comments, traditionally

enough, were tongue in cheek. The *Manchester Guardian* described him as 'a witty man, often in bad health and much at the mercy of his moods, and reckless in statement',[1] while the *Evening Standard* claimed 'Nevinson was a rebel. He was at perpetual loggerheads with the respectable and conventional in art'.[2] On the same day the *News Chronicle* ran 'Nevinson, the fighting artist, dies', while the *Liverpool Daily Post* remembered him as 'one of the most provocative artists of the century'. One paper even carried a traditionally inaccurate, though dramatic, headline, 'ARA dies of war wounds' while the *Daily Mail* applauded him as 'C.R.W. Nevinson, fearless artist and commentator on life . . .'. *The Scotsman* concluded with the overall assessment that he had been 'A rebel in art who lived to be acclaimed as a classic. . .'. Richard would have been delighted to know what was written about him the morning after his death.

When the 99th NEAC show at the Suffolk Galleries opened on 17 October, seven of his works were on show in a 'Memorial Corner'; and likewise in April 1947, there was a special memorial section at the National Society's 14th Exhibition at the centre of which was *Pan Triumphant* with a laurel wreath draped over it. The bronze bust by Barney Seale was similarly draped and scowled, head drooped, at those who entered the exhibition and paused to study the face they had known so well. And then there was his own memorial show, which he had asked Kathleen to organise for him, and to pay for with some of the £8,154 he left in his will. This opened in May 1947, appropriately enough at the Leicester Galleries, where 60 pictures were lent to remember, one last time, the life and work of an English artist. Sir Osbert Sitwell wrote the preface for the exhibition catalogue, in which he said that 'Nevinson painted with his heart', which was why he had been as 'prolific as he was varied'. He then went on, with some passion, to say that 'the extent of the loss we have suffered, as well as the extent of the rich harvest this painter of vision had already so expertly and feelingly garnered for us' was Richard's true, and permanent, legacy. The critics had sheathed their swords too, calling him a sentimental cubist and even a romantic; an uncertain character and almost certainly an artist *manqué*. Others celebrated the 'Prodigal's Return: a Romantic Painter who strayed but came back to the English Tradition'.[3]

Of course Richard could not trust anyone other than himself and Kathleen to create the memory of both his life and his work. F.G. Mories had observed in the penultimate year of the artist's life that Richard and Kath had remained

> a radiant 'Double', and seeming always to have been in conjunction they have raised their luminosity to its greatest power. Time is not likely to efface that glow.[4]

'Memorial show – Pan Triumphant'

To Kath then, Richard entrusted 14 volumes of selected press cuttings collected over a lifetime which she, in time, donated to the Tate Archive. In his last will and testament he instructed her to go through his work carefully, to select an exhibition that would honour his memory. Whichever paintings she disliked, or whatever else she felt would discredit his reputation after death, he instructed her to burn. Forgetting neither the paint nor the prejudice he concluded his last request to her by warning that, should she find herself in any doubt as to the nature and value of any of these paintings, she should 'consult any judge of art – but not an artist'.[5]

Notes

Introduction

1. Hugh Stokes, *Queen* 15 October 1921.
2. Reproduced in: C.R.W. Nevinson, *Paint and Prejudice* (London: Metheun, 1937), p. 251.
3. Winston Churchill to C.R.W. Nevinson, 7 October 1942 (Char 2/458). Churchill Archives Centre, Churchill College, Cambridge University.
4. *News Chronicle*, 8 October 1946.
5. *New York Times*, 8 October 1946.
6. *Sunday Times*, 16 January 1938.
7. *Burlington Magazine*, April 1916, p. 35.
8. P. W. Lewis, *Blasting and Bombardiering* (London: Eyre & Spottiswoodie, 1937), pp. 112,145.
9. Thomas Caraven, 'Bouncing Autobiography', *New York Herald Tribune*, 27 March 1938.
10. *Manchester Guardian,* 30 November 1937.
11. *The Western Mail,* 18 November 1937.
12. Professor Angela V. John has recently published the biography of H.W. Nevinson, entitled *War, Journalism and the Shaping of the Twentieth Century: The Life and Times of Henry W. Nevinson* (I.B. Tauris, 2006).
13. 'The Old World and the New' Exhibition catalogue, Bourgeois Galleries, 10 November – 4 December, 1920.
14. *Nottingham Evening News,* 30 April 1930.
15. *The Scotsman,* 8 October 1946.
16. *West Lancashire Evening Gazette* 17 February 1937.
17. Sir Osbert Sitwell, *C.R.W. Nevinson* (London: Ernest Benn, 1925).
18. The *Strand Magazine,* January 1933.

Chapter One: The Nevinsons (1898-1908)

1. F. Rutter, *Art in my Time* (London: Rich & Cowan, 1933), p. 166.
2. *The Listener,* 24 November 1937.
3. C.R.W. Nevinson, *Paint and Prejudice* (London: Methuen Press, 1937), p. 2.

4. Cited in: Angela V. John, *War, Journalism and the Shaping of the Twentieth Century: The Life and Times of Henry W. Nevinson* (I.B. Tauris, 2006), p. 87.

5. C.R.W. Nevinson, *Paint and Prejudice*, p. 18.

6. *T.P.'s Weekly*, 7 August 1915.

7. W.R. Titterton, *A Candle to the Stars* (London, 1932), p. 178.

8. C.R.W. Nevinson, *Paint and Prejudice*, p. 18.

9. C.R.W. Nevinson to Carrington, July 1912. Harry Ransom Humanities Research Center, University of Texas at Austin (Hereafter: H.R.H.R.C.).

10. C.R.W. Nevinson to Carrington, undated. H.R.H.R.C.

11. C.R.W. Nevinson to Carrington, 14 January 1913. H.R.H.R.C.

12. H.W. Nevinson Journals, 1 August 1902. Bodleian Library, Oxford University (Hereafter: H.W.N. Journals).

13. Evelyn Sharp Nevinson Papers, Diary 1, d668, 21 September 1942. Bodleain Library, Oxford University.

14. M. Wynne Nevinson, *Fragments of Life* (London: Black, 1922), p. 70.

15. M. Wynne Nevinson, *Life's Fitful Fever* (London: Black, 1926), p. 113.

16. Cited in: David Haycock, *A Crisis of Brilliance* (Unpublished – ms p. 23).

17. C.R.W. Nevinson, *Paint and Prejudice*, p. 2.

18. C.R.W. Nevinson, *Paint and Prejudice*, p. 11.

19. C.R.W. Nevinson, *Paint and Prejudice*, p. 10.

20. M. Nevinson, *Life's Fitful Fever*, p. 117.

21. H.W.N. Journals, 24 June 1899.

22. *Ibid.* 7 April 1901.

23. *Ibid.* 13 September 1901.

24. C.R.W. Nevinson, *Paint and Prejudice*, p. 7

25. H.W.N. Journals, 21 March 1903.

26. *Ibid.* 18 September 1903.

27. *Ibid.* 19 September 1903.

28. *Ibid.* 26 September 1903.

29. *Ibid.* 22 September 1903.

30. *Ibid.* 4 October 1903.

31. *Ibid.* 5 October 1903.

32. *Ibid.* 10 October 1903.

33. *Ibid.* 11 October 1903.

34. *Ibid*, 20 May 1903.

35. *Ibid.* 18 February 1904.

36. *Ibid.* 18 December 1903.

37. *Ibid.* 23 February 1907.

38. *Ibid.* 15 November 1907.

39. C.R.W. Nevinson, *Paint and Prejudice*, p. 7

40. H.W.N. Journals, 10 May 1905.

41. *Ibid.* 6 October 1906.

42. *Ibid.* 6 October 1906.

43. H.W. Nevinson, *More Changes and More Chances* (London: Nisbet, 1925), p. 173.

44. H.W. Nevinson, *Changes and Chances* (London: Nisbet, 1923), pp. 309-10.
45. *T.P's and Cassell's Weekly*, 19 June 1926.
46. *Daily Express*, 18 November 1931.
47. *New Statesman*, 11 December 1937.
48. C.R.W. Nevinson, *Paint and Prejudice*, p. 9.
49. H.W.N. Journals, 23 February 1907.
50. C.R.W. Nevinson, *Paint and Prejudice*, p. 14.
51. A. Eyre, *St. John's Wood: Its haunts, its houses and its celebrities* (London: Chapman and Hall, 1913).
52. C.R.W. Nevinson, *Paint and Prejudice*, p. 14.
53. Who later married the film producer Maurice Elvey.
54. H.W.N. Journals, 20 December 1908.
55. C.R.W. Nevinson, *Paint and Prejudice*, p. 16.
56. C.R.W. Nevinson, *Paint and Prejudice*, p. 18.
57. H.W.N. Journals, 8 October 1908.
58. *Ibid.* 19 December 1908.
59. C.R.W. Nevinson, *Paint and Prejudice*, p. 20.
60. C.R.W. Nevinson, *Paint and Prejudice*, p. 18.
61. C.R.W. Nevinson, *Paint and Prejudice*, p. 30.
62. Henry Nevinson to Gilbert Murray, 18 January 1909. Gilbert Murray Papers, MSS 15, fol. 87. Bodleian Library, Oxford University.
63. Cited in H.N. Schneidau, *Ezra Pound. The Image and the Real* (Louisiana State University Press, 1969).
64. C.R.W. Nevinson, *Paint and Prejudice*, p. 19.

Chapter 2: Made at the Slade (1909-1912)

1. Now in Stoke-on-Trent Art Gallery.
2. C.R.W. Nevinson, *Paint and Prejudice* (London: Metheun Press, 1937), p. 23.
3. Margaret Wynne Nevinson, *Life's Fitful Fever* (London: Black, 1926), p. 119.
4. Randolph Schwabe, "Reminiscences of Fellow Students", *Burlington Magazine* 82 (1943). Schwabe succeeded Tonks as Professor of Drawing and then as Director of the Slade.
5. Cited in: M. Woodall, *The Early Years of the N.E.A.C. 1886-1918* (London: NEAC, 1952), p. 9.
6. P. Nash, *Outline*, p. 90.
7. C.R.W. Nevinson, *Paint and Prejudice*, p. 23.
8. C.R.W. Nevinson, *Paint and Prejudice*, p. 24.
9. Paul Nash to Gordon Bottomley, 15 November 1910. Cited in: Claude Colleer Abbott and Anthony Bertram (eds.), *Poet & Painter: Being the Correspondence Between Gordon Bottomley and Paul Nash, 1910-1946* (London: Oxford University Press, 1955), p. 13.

10. Gilbert Spencer, *Memoirs of a Painter* (London: Chatto & Windus, 1974), p. 31.

11. William Rothenstein, *Men and Memories: Recollections of William Rothenstein, 1900-1922* (London: Faber & Faber, 1932), p. 166.

12. H.W. Nevinson Journals (hereafter H.W.N. Journals), e. 616/1, 10 April 1910.

13. Letter from C.R.W. Nevinson to Sir Hugh Walpole, 25 April 1940, Harry Ransom Humanities Research Center, University of Texas (hereafter H.R.H.R.C.).

14. Paul Nash, *Outline: An Autobiography and Other Writings* (London: Faber and Faber, 1949), p. 89.

15. C.R.W. Nevinson, *Paint and Prejudice*, p. 27.

16. K. Pople, *Stanley Spencer* (London: Haper Collins, 1997), p. 517.

17. Paul Nash, *Outline: An Autobiography and Other Writings* (London: Faber and Faber, 1949), p. 90.

18. K. Pople, *Stanley Spencer*, p. 15.

19. C.R.W. Nevinson, *Paint and Prejudice*, p. 41.

20. *Ibid.* p. 23.

21. *Ibid.* p. 24.

22. A. Allinson, *Memoirs* (Unpublished). Cited in: J. Woodeson, *Mark Gertler: Biography of a Painter, 1981-1939* (London: Sidgwick and Jackson. 1973).

23. C.R.W. Nevinson, *Paint and Prejudice*, p. 26.

24. Max Beerbom, quoted in: Leslie Frewin (ed.), *The Café Royal Story*, (London: Hutchinson Benham, 1963), p. 27.

25. A. Allinson, *Memoirs.* Cited in: J. Woodson. *Mark Gertler.*

26. G. Cannan, *Mendel* (London: Lloyds, 1920). A further fictional account can be found in the recent publication of the novel *Life Class* by Pat Barker (London: Doubleday, 2008).

27. *Ibid.* p. 56.

28. *Ibid.* p. 58.

29. Mark Gertler to William Rothenstein (Undated). Cited in: N. Carrington (ed.), *Mark Gertler – Selected Letters*, p. 33.

30. H.W. Nevinson to Professor Sadler, 9 May 1911. Wyndham Lewis Collection, Division of Rare and Manuscript Collections, Karl A. Kroch Library, Cornell University.

31. C.R.W. Nevinson, *Paint and Prejudice*, p. 26.

32. G. Cannan, *Mendel*, p. 124.

33. Nevinson to Carrington, 12 June 1912. H.R.H.R.C.

34. Roger Fry to G.L. Dickinson, 15 October 1910, Denys Sutton (ed.), *Letters of Roger Fry* (London: Chatto & Windus, 1972).

35. *Pall Mall Gazette*, 10 November 1910.

36. Robert Ross, *Morning Post*, 7 November 1910. Cited in: J.B. Bullen (ed.), *Post-Impressionists in England* (London: Routledge, 1988), pp. 100-104.

37. Paul Nash, *Outline*, p. 93.

38. By 1920 Tonks had decided he was 'quite unable to appreciate modern

art'. Henry Tonks to Mary Hutchinson, April 1920, H.R.H.R.C.

39. For a complete, though unpublished, understanding of the history of the Slade, see: S. Chaplin, *Slade School of Art* (Slade School of Art Archive), p. 123.

40. F. Rutter. *Revolution in Art* (London: Art News Press, 1910), p. 1.

41. The lecture was delivered in French as Marinetti could not speak English.

42. *The Vote*, 31 December 1910. This was the journal of the Woman's Freedom League, a suffrage organization of which Margaret was a part.

43. M. Nevinson, *Life's Fitful Fever* (London: Black, 1925), pp. 241-242.

44. Boccioni, Carra, Russolo, Balla and Severini, 'Manifesto of the Futurist Painters' , *Poesia*, February 1910.

45. Cited in: R. Banham, *Theory and Design in the First Machine Age* (London: Paeger, 1960), pp. 123-124.

46. Mark Gertler to Dorothy Brett, August 1913, H.R.H.R.C.

47. C.R.W. Nevinson, *Paint and Prejudice*, p. 11.

48. C.R.W. Nevinson, *Paint and Prejudice*, p. 19.

49. G. Cannan, *Mendel*, p. 59.

50. C.R.W. Nevinson to Dora Carrington, Undated note from the Café Royal, H.R.H.R.C.

51. 'Round the Galleries', *Sunday Times* (Month and reviewer unknown). T.G.A.

52. C.R.W. Nevinson, *Paint and Prejudice*, p. 40.

53. H.W.N. Journals, e.617/1, 25 February 1912. ' "M" is Nevinson's mother, Margaret.'

54. C.R.W. Nevinson to Dora Carrington, 28 March 1912, H.R.H.R.C.

55. H.W.N. Journals, e.616/4, 27 August 1911.

56. *Ibid.* e.616/4, 17 October 1911.

57. *Ibid.* e.616/4, 26 August 1911. 'Dined alone at "Gustaves" reading R's final essay on Mona Lisa. . . .'

58. *Ibid.* e.615/4, 1 December 1911.

59. C.R.W. Nevinson to Dora Carrington, 28 March 1912, H.R.H.R.C.

60. *Ibid.* 2 April 1912.

61. *Ibid.* 28 March 1912.

62. *Ibid.* 28 March 1912.

63. *Ibid.* 8 April 1912.

64. *Ibid.* April 1912. From #2, Toronto Terrace, Lewes.

65. *Ibid.* Undated note from the Café Royal. Probably early 1912.

66. *Ibid.* May 1912.

67. *Ibid.* 10 June 1912.

68. *Ibid.* 2 April 1912.

69. *Ibid.* Undated letter.

70. *Ibid.*

71. *Ibid.* 2 April 1912.

72. *Ibid.* June 1912.

73. *Ibid.* May 1912.

74. *The Towing Path, Camden Town* is currently housed at the Ashmolean Museum, Oxford.
75. Nevinson to Carrington, 28 March 1912. H.R.H.R.C.
76. The *Evening News,* 4 March 1912.
77. J.A. Black. Estorick Lecture, unpublished MS
78. F.T. Marinetti, 'The Founding and Manifesto of Futurism', *Le Figaro,* 1909.
79. A. Bozzola & C. Tisdall, *Futurism* (London: Thames & Hudson, 1977), p. 8.
80. C.L. Hind, *Daily Chronicle,* 4 March 1912.
81. *The Times,* 19 March 1912.
82. C.R.W. Nevinson, *Paint and Prejudice,* p. 57.
83. C.R.W. Nevinson to Carrington, 23 May 1912. H.R.H.R.C..
84. *Ibid.* June 1912.
85. *Ibid.*
86. *Ibid.* 23 May 1912.
87. *Ibid.* August 1912.
88. *Ibid.* Undated letter.
89. *Ibid.* June 1912. Tonks, in *Mendel,* is Edgar Froitzheim. The novel explains how he had collected £50 so that the girl should go away. Calthrop gave £20.
90. Nevinson to Carrington, Undated. H.R.H.R.C..
91. *Ibid.,* May 1912.
92. *Ibid.,* 21 June 1912.
93. Gertler to Carrington, 7 July 1912. H.R.H.R.C.
94. Gertler to Carrington, 19 June 1912. Cited in: N. Carrington (ed.), *Mark Gertler – Selected Letters,* p. 36.
95. *Ibid.* p. 37.
96. *Ibid.* pp. 38-39.
97. Gerzina, p. 39
98. J. Woodeson, *Mark Gertler,* p. 87.
99. *Ibid.* p. 98.
100. G. Cannan, *Mendel,* p. 105.
101. Nevinson to Carrington, 5 July 1912. H.R.H.R.C.
102. *Ibid.*
103. *Ibid.* Undated.
104. C.R.W. Nevinson to Carrington, Undated. Probably July 1912. H.R.H.R.C..
105. N. Carrington (ed.), *Mark Gertler – Selected Letters,* p. 41.
106. C.R.W. Nevinson to Dora Carrington, June 1912, H.R.H.R.C.
107. *Ibid.* Undated.
108. Stanley Spencer to Jacques and Gwen Raverat, 12, 15, and 17 July 1914, quoted in Glew (2001), p. 49.
109. C.R.W. Nevinson, *Paint and Prejudice,* p. 30.

Chapter 3: Paris, London and the *Bon Viveur* (1912-1913)

1. C.R.W. Nevinson, *Paint and Prejudice* (London: Metheun, 1937), p. 48.
2. M. Bradbury and J. McFarlane (eds.), *Modernism* (London: Penguin Books, 1976), p. 172.
3. P. W. Lewis, *Rude Assignment* (London: Hutchinson, 1950), p. 115.
4. C.R.W. Nevinson, *Paint and Prejudice*, p. 35.
5. *Ibid.* p. 37.
6. Nevinson to Carrington, July 1912. Harry Ransom Humanities Research Center, University of Texas (hereafter H.R.H.R.C.).
7. *Ibid.*
8. H.W.N. Journals, e.617/ 2, 22 July 1912.
9. Nevinson to Carrington, 24 July 1912, from Hotel de la Place de L'Odeon, Paris. H.R.H.R.C.
10. *Ibid.*
11. C.R.W. Nevinson, *Paint and Prejudice*, p. 42.
12. *Ibid.* p. 43.
13. *Ibid.*
14. *Ibid.*
15. Nevinson to Carrington, July 1912, from Rouen. H.R.H.R.C.
16. *Ibid.*
17. *Ibid.*
18. *Ibid.* August 1912. Possibly from Havre.
19. *Ibid.*
20. Nevinson to Carrington, 24 July 1912 H.R.H.R.C.
21. *Ibid.*
22. Nevinson to Carrington, August 1912. H.R.H.R.C.
23. H.W.N. Journals, e.617/2. 16 August 1912.
24. Nevinson to Carrington, August 1912. H.R.H.R.C.
25. *Ibid.* 14 August 1912.
26. *Ibid.*
27. *Ibid.*
28. *Ibid.* 14 August 1912.
29. *Ibid.* Undated. Probably August 1912.
30. Nevinson to Carrington, 28 August 1912. H.R.H.R.C.
31. *Ibid.* Undated, 1912.
32. *Ibid.* 14 August 1912. H.R.H.R.C.
33. *Ibid.* Undated, from Bradford.
34. *Ibid.* 4 September 1912.
35. *Ibid.* September 1912.
36. *Ibid.* 28 August 1912.
37. *Ibid.* 8 September 1912.
38. *Ibid.* 17 September 1912.
39. *Ibid.* 22 August 1912.
40. *Ibid.* 28 August 1912.
41. *Ibid.* September 1912.

42. *Ibid.* September 1912.
43. *Ibid.* 17 September 1912.
44. C.R.W. Nevinson, *Paint and Prejudice*, p. 13.
45. *Ibid.* 12 October 1912.
46. Nevinson to Carrington, 13 October 1912. H.R.H.R.C.
47. *Ibid.* October 1912.
48. Nevinson to Carrington, 26 December 1912. H.R.H.R.C.
49. Gertler to Brett, undated letter, 1912. H.R.H.R.C.
50. Nevinson to Carrington, 24 August 1912. H.R.H.R.C.
51. R. Fry, *Catalogue of the Second Post-Impressionist Exhibition* (London, Grafton Galleries, 1912), p.3.
52. C. Bell, 'The English Group', *Catalogue of the Second Post Impressionist Exhibition* (London, Grafton Galleries, 1912).
53. C. Harrison, *English Art and Modernism, 1900-1939* (London: Allen Lane, 1981), p. 65.
54. H.W.Nevinson Journals (hereafter H.W.N. Journals), e. 617/3, 4 January 1913.
55. C.R.W. Nevinson, *Paint and Prejudice*, p. 56.
56. *Ibid.*
57. *Ibid.* p. 57.
58. Nevinson to Carrington, 14 January 1913. H.R.H.R.C.
59. Nevinson to Carrington, 16 January 1913. H.R.H.R.C.
60. *Ibid.* 17 January 1913.
61. *Ibid.* 19 January 1913.
62. *Ibid.*
63. *Ibid.* 20 January 1913.
64. *Ibid.* 17 February 1913.
65. *Ibid.* 17 February 1913 (second letter of that date).
66. *Ibid.* 2 April 1913.
67. *Ibid.* 26 March 1913.
68. H.W.N. Journals, e.617/4, 15 March 1913.
69. *Ibid.*
70. *Ibid.* 21 April 1913.
71. J. Rothenstein, *Modern British Painters. Volume 2* (London: Eyre & Spottiswoode, 1956), pp. 96-97.
72. A. Hanson, *Severini Futurista: 1912-1917* (Yale Univesity Art Gallery, 1995), p. 158.
73. A. Hanson, *Severini Futurista: 1912-1917* (Yale Univesity Art Gallery, 1995), p. 21, 147.
74. *Ibid.* p. 37.
75. H.W.N. Journals, e.617/4, 22 May 1913.
76. Nevinson to P.W. Lewis, dated 5 November 1913, Cornell University.
77. Nevinson to Lewis. 14 November 1913, Cornell University.
78. F. Rutter, 'Forward', Exhibition catalogue, 'Post-Impressionist and Futurist Exhibition', 1913.
79. F. Rutter, *Art in my Time* (London: Rich & Cowan, 1933), p. 150.

80. Cited in: R. Cork, *Vorticism and Abstract Art in the First Machine Age* (London: Fraser, 1976), p. 243.

81. *Daily Graphic*, 18 October 1913, p. 5.

82. C. Bell, 'The New Post-Impressionist Show', *The Nation*, 25 October 1913.

83. *Ibid.*

84. H.W.N. Journals, e.618/1, 16 October 1913.

85. A. Hanson, *Severini Futurista: 1912-1917* (Yale Univesity Art Gallery, 1995), p. 119.

86. *Ibid.* p. 134.

87. A. D'Harcourt, *Futurism and the International Avant-Garde* (Philadelphia Museum of Art, 1980).

88. O. Sitwell, *Great Morning* (London: MacMillan, 1948), p. 208.

89. H. Nevinson, *Newark Evening News*, 17 January 1914.

90. W. C. Wees, *Vorticism and the English Avant-Garde* (Toronto: University of Toronto Press, 1972), p. 99.

91. W.K. Rose (ed.), *The Letters of Wyndham Lewis* (Norfolk, USA, 1963), pp. 53-54.

92. Nevinson to Lewis, 19 November 1913. Cornell.

93. Marinetti to Severini, 30 November 1913. Museo di Arti Moderna e Contemporanea di Trento e Rovereto, Italy.

94. *Daily Chronicle*, 20 March 1912.

95. W. C. Wees. *Vorticism and the English Avant-Garde* (Toronto: University of Toronto Press, 1972), pp. 94-96.

96. Boccioni to V. Baer, 15 March 1912. Cited in: L. Somigli, *Towards a Theory of the Avant-Garde Manifesto* (Ph.D. diss. Unpublished. State University of New York at Stony Brook, 1996), p. 200.

97. F. Wadsworth to Lewis, Undated. Cornell.

98. H.W.N. Journals, 19 November 1913.

99. P.W. Lewis, 'Man of the Week: Marinetti', *New Weekly*, 30 May 1914, p. 329.

100. Nevinson to Lewis, 19 November 1913. Cornell.

101. *Ibid.* 5 November 1913. Cornell.

102. *Ibid.* 4 December 1913. Cornell.

103. *Ibid.*

104. Nevinson to Severini, 11 December 1913. Cornell.

105. 'Omaggio a Severini', *Critica d'Arte* (May-June 1970), p. 25.

Chapter 4: The Distinction of Abdiel, London's Only Futurist (1914)

1. C.R.W. Nevinson, *Paint and Prejudice* (London: Metheun, 1937), p. 64.

2. 'Some of the Manifestoes of "Futurism"; Amazing, Absurd, Amusing – As You Like', *Evening News*, 17 January 1914.

3. 'Art & Artists: The London Group', *The Observer* (Day and month unknown,

1914). Tate Gallery Archive (hereafter T.G.A.).

4. There are two surviving cuttings of this painting, both in the Tate Gallery Archive. Neither record the name of the newspaper or the date of publication.

5. 'The London Group', *Westminster*, Day and month unknown, 1914. T.G.A.

6. 'Art and Artists: The London Group', *The Observer*, 1914. T.G.A.

7. *Ibid.*

8. W. Sickert, 'Post-Impressionism and Cubism', Letter to the Editor, 11 March 1914 (Newspaper unknown). T.G.A.

9. W. Sickert, *'The Futurist "Devil-Among-The Tailors"'* Publication, author and date unknown). T.G.A.

10. C.R.W. Nevinson, Letter to the Editor, 'Post-Impressionism and Cubism', *Pall Mall Gazette*, 13 March 1914.

11. Sir C. Phillips, 'Art in Whitechapel: Twentieth Century Exhibition', *Daily Telegraph*, 1914. T.G.A.

12. G.R.S.T., 'Reflections', *The Limit*, 9 March 1914.

13. 'Solemn Insanity of Futurists', *Daily Herald*, 12 June 1914.

14. Marinetti to Severini, 16 May 1914. Museo di Arti Moderna e Contemporanea di Trento e Rovereto (henceforth M.A.R.T.), Italy.

15. *The New Statesman*, 2 May 1914, p. 115.

16. R.W. Flint (ed.), *Marinetti: Selected Writings* (London: Secker and Warburg, 1972), p. 147.

17. W.C. Wees, *Vorticism and the English Avant-Garde* (Toronto, University of Toronto Press, 1972), pp. 104-105.

18. P.W. Lewis, *Blasting and Bombardiering: An Autobiography 1914-1926* (London: Eyre and Spottiswoodie, 1937), p. 33.

19. H.W.Nevinson Journals (hereafter H.W.N. Journals), e.618/2, 4 April 1914.

20. *Ibid.* e.618/2, 29 April 1914.

21. C.R.W. Nevinson, *Paint and Prejudice*, p. 61.

22. R. Cork, *Vorticism and Abstract Art in the First Machine Age: Vol. I* (Berkeley and Los Angeles: University of Califormai Press, 1976), p. 158

23. W. Wees, *Vorticism and the English Avant-Garde*, p. 103.

24. R. Cork, *Art Beyond the Gallery* (New Haven: Yale University Press, 1985), p. 205.

25. H.W.N. Journals, e.618/2, 3 May 1914.

26. H.W. Nevinson, *More Changes and More Chances* (London: Nisbet, 1925), p. 405.

27. Nevinson to Carrington, 8 April 1912. Harry Ransom Humanities Research Center, University of Texas at Austin (hereafter H.R.H.R.C.).

28. T.E. Hulme, 'Modern Art III: The London Group', The *New Age*, 26 March 1914.

29. H. Gaudier-Brezska, 'Allied Artists Associations Ltd', *The Egoist*, 15 June 1914.

30. 'Rebels in Art', *The Times*, 16 June 1914.

31. J. Rothenstein, *Modern English Painters* 2 (London: Eyre & Spottiswoodie, 1956), p. 131.

32. H.W.N. Journals, e.618/2, 29 May 1914.

33. 'Futurism', To the Editor, *New Weekly*, June 1914.

34. 'The Asceticism of the Futurists', *T.P.'s Weekly*, 4 June 1914.

35. G. Chesterton, 'The Futurists' Chapter in: *The Uses of Diversity: A Book of Essays* (London: Metheun, 1920), p. 82.

36. P.W. Lewis, *New Weekly*, 30 May 1914.

37. W. Lewis, *Blasting and Bombardiering*, p. 35.

38. M.J. Manicave, *Daily Mirror*, 16 March 1914.

39. Douglas Goldring, *Odd Man Out: The Autobiography of a "Propaganda Novelist"* (Chapman and Hall, 1935), p. 120. Nevinson would later advise Goldring on the 'life' of Modigliani he was writing.

40. C. Lewis Hind, 'An Appreciation', *The Old World and the New. Exhibition of Paintings, Lithographs and Woodcuts by C.R.W. Nevinson of London, England* (Bourgeois Galleries, New York. November-December 1920).

41. 'The Futurists Again', *Manchester Courier*, 13 June 1914.

42. *The Atlantic Monthly*, November 1914. Cited in: H.W. Nevinson, *Visions and Memories* (O.U.P., 1944), pp. 81-82.

43. H.W.N. Journals, e.618/2, 12 June 1914.

44. P.W. Lewis, *Blasting and Bombardiering*, p. 33.

45. This account of events was related in a lecture by J. Black at the Estorick Collection, London, in March 1999, entitled 'The "Caffeine of Europe Hits England": F.T. Marinetti (1876-1944) & The Futurists in England c. 1910-1914' (Unpublished).

46. G.K. Chesterton, The *Illustrated London News*, 11 July 1914.

47. *Nottingham Guardian*, 10 June 1914.

48. C. Tisdall and A. Bozzola, *Futurism* (London: Thames and Hudson, 1996), p. 105.

49. C.R.W. Nevinson, *Paint and Prejudice*, p. 61.

50. C.R.W. Nevinson, *Paint and Prejudice*, p .83.

51. Marinetti to Severini, 30 June 1914. M.A.R.T.

52. *The Times*, 16 June 1914.

53. H.W.N. Journals, e.618/2, 19 June 1914.

54. The *Atlantic Monthly*, November 1914. Cited in: H.W. Nevinson, *Visions and Memories*, p. 85.

55. 'Shocking Pictures Designed to Jolt the Senses: Cubist reproductions in Regent Street', *The Star* (undated).

56. A.J. Finberg, 'Allied Artists Association', *The Star*, 30 June 1914.

57. Cited in: R.W. Flint (ed.), *Marinetti: Selected Writings* (London: Secker & Warburg, 1971), p. 336.

58. Nevinson to Lewis, June 1914. Cornell University. I have quoted the letter using Nevinson's use of capitals and underlining.

59. P.W. Lewis, *Blasting and Bombardiering* (London: J. Calder, reprint, 1982), p. 33.

60. Nevinson to Lewis, 13 June 1914. Cornell University.

61. Nevinson to Lewis, 13 July 1914. Cornell University.

62. *Yorkshire Observer*, 15 June 1914.

63. *English Review*, 23 July 1914.

64. G.K. Chesterton, *Illustrated London News*, 11 July 1914.

65. *Illustrated London News*, 4 August 1914.

66. F.T. Marinetti, *Initial Manifesto of Futurism*, 20 February 1909 (trans).

67. H.W.N. Journals, e.616/3, 25 October 1914.

68. J. Ruskin, 'War' in *The Crown of Wild Olive. Three lectures on Work, Traffic and War* (London: Smith & Elder Co., 1866), pp. 143-145.

69. S. Hynes, *A War Imagined: The First World War and English Culture* (New York: Atheneum, 1991), p. 15.

70. J.D. Symon, 'War and Creative Art', *English Review*, December 1915, p. 520.

71. W.S. Sparrow, 'Middle Articles: Is War Necessary to Social Progress', *Saturday Review*, 17 April 1915, pp. 397-399.

72. St John Ervine, 'The War and Literature', *North American Review*, July 1915, p. 98.

73. C.S.H., 'After the War', *New Age*, October 1914, p. 635.

74. Letter from Albert Rutherston to Dora Carrington dated 17 August 1914, Carrington Papers, Harry Ransom Humanities Research Center, University of Texas at Austin.

75. 'Art after Armageddon', *Athenaeum*, 12 September 1914, p. 269.

76. H. Taylor, 'War and Art', *Colour*, September 1914, p. 46.

77. P. Hamilton. *The Role of Futurism, Dada and Surrealism in the Construction of British Modernism, 1910-1940* (Ph.D Diss. University of Oxford, 1987).

78. C.R.W. Nevinson, *Paint and Prejudice*, p. 64.

79. F.T. Marinetti. 'War, the world's only hygiene' (1915).

Chapter 5: The Western Front I: Nevinson's War (1914-1915)

1. C.R.W. Nevinson, *Paint and Prejudice* (London: Metheun, 1937), p. 71.

2. *Ibid.* p. 70.

3. *Ibid.*

4. C.R.W. Nevinson, 'When the Censor Censored "Censored"', *British Legion Journal*, October 1932.

5. *The Observer*, undated. Tate Gallery Archive (hereafter T.G.A.).

6. Cited in: S. Hynes, *A War Imagined: The First World War and English Culture* (New York: Atheneum, 1991), p. 64.

7. *Ibid.* p. 14

8. C.R.W. Nevinson, *Paint and Prejudice*, p. 71.

9. C.R.W. Nevinson, *Paint and Prejudice*, p. 99.

10. M. Tatham and J.E. Miles (eds.), *Friends' Ambulance Unit, 1914-1919* (London: Swathmore, 1920), p. 7.

11. *Ibid.*

12. H.W.Nevinson Journals (hereafter H.W.N. Journals), e.618/3, 14 November 1914.
13. *Ibid.* e.618/4, 14 December 1914.
14. *Ibid.* e.618/4, 19 December 1914.
15. *Ibid.* e.618/4, 23 December 1914.
16. C.R.W. Nevinson to Miss K.M. Knowlmann, 24 November 1914. Artist's Estate.
17. H.W.N. Journals, e.618/3, 24 November 1914.
18. C.R.W. Nevinson, *Paint and Prejudice*, p. 74.
19. H.W.N. Journals, e. 618/3, 15 November 1914.
20. C.R.W. Nevinson, *Paint and Prejudice*, p. 78.
21. Society of Friends, Friends House Library, London (Temp. Mss 81-1-1-397).
22. C.R.W. Nevinson, *Paint and Prejudice*, p. 78.
23. Margaret Wynne Nevinson to Edith How Martyn, 11 February 1915. The Women's Library, London.
24. 'Painter of Smells at the Front. A Futurist's View of the War', *Daily Express*, 25 February 1915.
25. *Ibid.*
26. C.R.W. Nevinson, 'A Futurist's Nerves', *Daily Express*, 26 February 1915.
27. C.R.W. Nevinson, 'Red Cross Orderlies', *Manchester Guardian*, 20 February 1915.
28. C.R.W. Nevinson, Letter to the Editor of *The Times*. Copy – Unsent. T.G.A.
29. C.R.W. Nevinson. Letter, 'War Notes and Queries', *Daily Graphic*, 11 March 1915.
30. Gretchen Gertzina, *Carrington* (London: John Murray, 1989), p. 64.
31. P.W. Lewis, 'The Six Hundred, Verestchagin and Uccello,' *Blast 2*, July 1915, p. 25.
32. E. Storer, 'London Groups', *New Witness*, Date unknown. T.G.A.
33. 'The Passing of the Battle Painter: No Inspiration in the Trenches', *The Times*, 30 April 1915, p. 15.
34. P. Fussell, *The Great War and Modern Memory* (Oxford University Press, 1975), p. 59
35. *Blast 2: The War Issue*, p. 77
36. E. Storer, 'The London Group', *New Witness*, 11 March 1915.
37. 'Cubist Masters. Works of Art that Look Like Meaningless Daubs', *The Star*, 6 March 1915.
38. *Tatler*, 24 March 1915.
39. *Daily Express*, 25 February 1915.
40. 'The Unconscious Humorists. The Art of Coloured Stripes and Mining Tolls', *Evening News*, 13 March 1915.
41. C.R.W. Nevinson, *Paint and Prejudice*, p. 107.
42. P.G. Konody, *Modern War Paintings by C.R.W. Nevinson* (London: Grant Richards, 1917), p. 24.
43. F. Rutter, 'Round the Galleries', *Sunday Times*, 21 March 1915.

44. J.M., *Evening Standard and St James Gazette*, 16 March 1915.
45. C.R.W. Nevinson, 'Dry Rot in Art', *Manchester Guardian*, 20 April 1915.
46. J.M.M., 'Vorticists and Others', *Westminster Gazette*, 18 June 1915.
47. 'Art of Yester-year', *Daily Graphic*, 31 July 1915.
48. H.W.N. Journals, e.619/1, 20 May 1915. 'He determined to return to Quakers unit in June.'
49. *Ibid.* e.619/1, 28 May 1915.
50. C.R.W. Nevinson, *Paint and Prejudice*, p. 78.
51. H.W.N. Journals, e.619/1, 5 June 1915.
52. C.R.W. Nevinson, *Paint and Prejudice*, p. 106
53. *Ibid.* p. 80.
54. F.T. Marinetti & C.R.W. Nevinson, *A Futurist Manifesto: Vital English Art*, June 1914.
55. K. Parkes, *Apollo*, November 1928, p. 259.
56. There are two comments in *Paint and Prejudice* of this nature. The first is when he talks of his wedding and says 'My own father, of course, was in Gallipoli', p. 81, and also, later when he says 'My father was then with the forces in Egypt, and I don't think had even heard of my marriage.' p. 84.
57. H.W.N. Journals, e.619/2, 11 October 1915.
58. *Ibid.* e.619/2, 19, 21 October 1915.
59. *Ibid.* e.619/2, 30 October 1915.
60. *Ibid.* e.619/2, 5 November 1915. It is not clear if he meant to work or to recuperate from some illness.
61. D. Holman-Hunt, *Latin Among Lions: Alvaro Guevara* (London: Michael Joseph, 1974), p. 83.
62. C.R.W. Nevinson, *Paint and Prejudice*, p. 78.
63. Sir C. Phillips, 'The London Group', *Daily Telegraph*, 27 November 1915. T.G.A.
64. P.G. Konody, 'Art and Artists: The London Group', *The Observer*, 28 November 1915. T.G.A.
65. F. Rutter, 'The Galleries. The London Group at the Goupil Galleries', *Sunday Times*, 28 November 1915. T.G.A.
66. C. Marriott, 'London Group. Cubist Eccentricities Modified', *The Standard*, 3 December 1915.
67. O.R.D., 'The London Group', *Westminster Gazette*, 1 December 1915. T.G.A.
68. P.G. Konody, 'Art and Artists. The New English Art Club', *The Observer*, 12 December 1915.
69. C.R.W. Nevinson to Prof. Sadler, 23 December 1915. T.G.A. Correspondence.
70. S. Watney, *English Post-Impressionism* (London: Studio Vista, 1980), p. 142.
71. 'Vortex Gaudier-Brzeska (Written from the Trenches),' *Blast 2*, pp. 33-34.
72. Gertler to Brett, 6 September 1914. Brett Papers, Harry Ranson Humanities Research Center, University of Texas at Austin.

Chapter 6: The Western Front II, *Le Beau dans l'Horrible* (1916)

1. C.R.W. Nevinson, *Paint and Prejudice* (London: Metheun, 1937), p. 85.
2. C. Lewis Hind, 'Four Pictures', *Daily Chronicle*, 9 March 1916.
3. *Queen*, 3 June 1916.
4. 'Lady Cunard's Views', *Pall Mall Gazette*, 8 June 1916.
5. C.L. Hind, *The Old World and the New: Exhibition of Paintings, Lithographs and Woodcuts by C.R.W. Nevinson of London, England* (Bourgeois Galleries, New York, 1920)
6. Sir Ian Hamilton, *Catalogue of an Exhibition of Paintings and Drawings of War by C.R.W. Nevinson (Late Private RAMC)*, (London, Leicester Galleries, September-October 1916).
7. *Ibid.*
8. 'The Royal Academy. War Pictures. A Rombeaux Masterpiece', *Morning Post*, 1 May 1915.
9. J. Salis, 'The Reward of the Patriot', *New Witness*, 11 March 1916.
10. C.L. Hind, 'True War Pictures. Mr Nevinson's Moralities at the Leicester Galleries', *Daily Chronicle*, 30 September 1916.
11. C.R.W. Nevinson, *Paint and Prejudice*, p. 88.
12. J.D. Symon, 'The Grotesque in Modern War,' *Land and Water*, 18 September 1915, p. 15.
13. *Ibid.*
14. 'Mr Nevinson as War Artist', *The Observer*, 24 September 1916.
15. F. Rutter, 'The Galleries', *Sunday Times*, 24 September 1916.
16. J. Ferguson, *The Arts in Britain in World War I* (Open University, 1980), p. 26.
17. C.L. Hind. 'Nevinson and his War Pictures', *Land and Water*, 28 September 1916.
18. A. Clutton-Brock, 'Process or Person?', *Times Literary Supplement*, 5 October 1916.
19. E. Pound, 'The War and Diverse Impressions', *Vogue*, October 1916.
20. 'London Diary', *The Nation*, 30 September 1916.
21. H.E., 'Mr Nevinson's Pictures', *Daily News*, 6 October 1916.
22. 'War Pictures', The *British Architect*, October 1916.
23. H.M.T.,'War Pictures. Mr Nevinson's Work at the Leicester Galleries', *The Star*, 3 October 1916.
24. 'Over the Top', *Daily Mail*, 22 December 1916.
25. Sir Ian Hamilton, *Catalogue of an Exhibition of Paintings and Drawings of War by C.R.W. Nevinson (Late Private RAMC)*, (London, Leicester Galleries, September-October 1916).
26. C.R.W. Nevinson, *Paint and Prejudice*, pp. 91-2.
27. 'Warrior and Artist', *West Sussex Gazette*, 26 October 1916.
28. 'Art and Artists', *The Observer,* 28 November 1915.
29. Cited in: D. Franck, *The Bohemians* (Weidenfeld and Nicolson, 2001), p. 226.

30. C. Lewis Hind, 'Man and His Machine', *Evening News*, 16 March 1916.
31. C. Lewis Hind, 'Four Pictures. Developments in Modern Art', *Daily Chronicle*, 9 March 1916.
32. This literally translates into 'Even in Arcadia, I, death, hold sway'.
33. P.G. Konody, 'Art and Artists. The Allied Artists Association', *The Observer*, 12 March 1916.
34. *Burlington Magazine*, April 1916, p. 35.
35. C.R.W. Nevinson, *Paint and Prejudice*, pp. 71-72.
36. 'War and the Artist' *Glasgow Herald*. 15 February, 1917.
37. F. Rutter, 'The Galleries' ,*Sunday Times & Sunday Special*, 4 June 1916.
38. C.L.Hind, 'Rebel Art', *Daily Chronicle*, 13 June 1916.
39. C.L. Hind, *Daily Chronicle*, 30 September 1916.
40. 'The London Group', *Morning Post*, 20 June 1916.
41. E. Pound, 'The War and Diverse Impressions', *Vogue*, October 1916.
42. C.A.P., 'The War From a New Angle: The Nevinson Pictures at the Leicester Galleries', *The Graphic*, 30 September 1916.
43. B.D.T., 'War in Art', *Manchester Guardian*, 7 March 1917.
44. H.W. Nevinson Journals (hereafter H.W.N. Journals), e.620/1, 26 September 1916.
45. P.G. Konody, *Modern War Paintings by C.R.W. Nevinson* (London: Grant Richards, 1917), p. 30.
46. 'All Done', *Daily Mirror*, 18 October 1916.
47. Nevinson to Rothenstein, 22 October 1916. Houghton Library, Harvard University, BMS. Eng. 1148-1080-2 (Harvard).
48. H.W.N. Journals, e.620/1, 4 November 1916.
49. J. Black, 'A Curious Cold Intensity' *C.R.W. Nevinson: The Twentieth Century* (London: Merrell Holberton in association with the Imperial War Museum, 1999), p. 33.
50. H.W.N. Journals, e.619/4, 3 May 1916.
51. *Ibid.* e.619/4, 5 May 1916.
52. *Ibid.* e.619/4, 11 May 1916 & e.620/1, October 1916.
53. *Ibid.* e.620/1, 17 October 1916.
54. *Ibid.* e.620/1, 9 November 1916.
55. *Ibid.* e.620/1, 15 November 1916.
56. *Ibid.* e.620/1, 11 December 1916.
57. H.W. Nevinson, *Visions and Memories* (Oxford University Press, 1944), p. 143.
58. H.W.N. Journals. e.620/1, 12 December 1916.
59. *Ibid.* e.620/1, 15 December 1916.
60. *Ibid.* e.620/1, 19 December 1916.
61. *Ibid.* e.620/1, 20 December 1916.
62. *Ibid.* e.620/1, 21 December 1916.
63. Severini to Nevinson, 18 December 1916, Correspondence. T.G.A.
64. 'Personality or Process. Mr. Nevinson's Pictures of Men as War Machines', *The Times,* September 1916.

Chapter 7: The Western Front III,
'From the Barren Wilderness of Abstraction' (1917-1918)

1. H.W.Nevinson Journals (herafter H.W.N. Journals) e.620/2, 5 April 1917.
2. *Ibid.*
3. *Ibid.*, e.620/2, 29 March 1917.
4. Nevinson to Sir Edward Marsh, 1 April 1917. Berg Collection, New York Public Library (hereafter NYPL).
5. Nevinson to Sir Edward Marsh, 17 April 1917. NYPL.
6. H.W.N. Journals, e.620/2, 10 April 1917.
7. *Ibid.* e.620/2, 11 April 1917.
8. *Ibid.* e.620/2, 13 April 1917.
9. Nevinson to Mond, 30 April 1917. Imperial War Museum Archive, C.R.W. Nevinson, First World War Correspondence, 1917-1918. [226A/6]. Imperial War Museum (hereafter I.W.M.).
10. Nevinson to Marsh, 24 April 1917. NYPL. In the previous letter dated 17 April he had added a p.s. to the bottom of his letter which had stated 'Some people have been trying to get me in as an Artist . . . but I have heard nothing of it so far & don't suppose I will!'
11. Nevinson to Marsh, 26 April 1917. NYPL.
12. H.W.N. to Masterman, 1 May 1917. IWM.
13. Masterman to Nevinson, 2 May 1917. IWM.
14. Masterman to Charteris, 3 May 1917. IWM.
15. Masterman to Buchan, 18 May 1917. IWM.
16. C.R.W. Nevinson, *Paint and Prejudice*, p. 93.
17. *Ibid.* p. 94.
18. *T.P.'s and Cassell's Weekly*, 19 June 1926.
19. C.R.W. Nevinson, *Paint and Prejudice,* p. 95.
20. The exhibition of these works first appeared at the Fine Arts Society in July 1917, and later toured Paris, New York and Los Angeles.
21. Masterman to Nevinson, 2 July 1917. IWM.
22. Nevinson to Masterman, 30 June 1917. IWM.
23. Severini to Nevinson, 7 June 1917. Tate Gallery Archive (henceforth T.G.A.), C.R.W. Nevinson, Correspondence.
24. H.W.N. Journals, e.620/2, 3 July 1917.
25. S. Malevern, *Art, Patronage and Propaganda: An History of the Employment of British War Artists 1916-1919* (Ph.D. diss. Reading University, 1981), p. 99.
26. Nevinson to Derrick, 21 June 1917. IWM.
27. Nevinson to Masterman, 24 July 1917. IWM.
28. Grant Richards Papers, Box 2, Folder 15, Special collections, Georgetown University Library.
29. C.R.W. Nevinson, *Paint and Prejudice*, p. 137.
30. *New York Times*, 24 May 1919. T.G.A., 7311, pp.1-14.
31. C.R.W. Nevinson, 'When the Censor Censored "Censored"' *British Legion Journal*, October, 1932, p. 115.

32. The term was coined by Rutter in the *Arts Gazette*, 28 June 1917.
33. Nevinson to Masterman, Undated. T.G.A., C.R.W. Nevinson, Correspondence.
34. *New York Evening Post*, 31 May 1919.
35. H.W.N. to W. Rothenstein, 26 July 1917 (Houghton Library, Harvard University, BMS. Eng. 1148-1081-27).
36. C.R.W. Nevinson, *Paint and Prejudice*, p. 167
37. H.W.N. Journals, e.620/2. 16 August 1917.
38. *Ibid.* e.620/2, 13 September 1917.
39. H.W.N. Journals, e.620/3, 5 October 1917.
40. *Ibid.* e.620/2, 14 September 1917.
41. Derrick to Masterman, 16 October 1917. IWM.
42. Masterman to Hudson, 29 October 1917. IWM.
43. Hudson to Masterman, 26 October 1917. IWM.
44. S. & M. Harries, *The War Artists: British Official War Art of the Twentieth Century* (London: Michael Joseph, 1983), pp. 44-45.
45. J.E. Crawford-Flitch, *The Great War, Fourth Year: Paintings by C.R.W. Nevinson* (London, 1918), p. 15.
46. From Newbolt's *Vitae Lampada*.
47. H.W.N. Journals, e.620/3, 22 November 1917.
48. Nevinson to Lee, Undated. IWM.
49. Lee to Masterman, 13 December 1917. IWM & two letters from Lee to Yockney, 3 March & 23 March 1917. T.G.A., C.R.W. Nevinson, Correspondence.
50. Major Lee had difficulty with other war artists too and commented on the work of Paul Nash by saying 'I cannot help thinking that Nash is having a huge joke with the British public, and lovers of 'art' in particular. Is he?' Lee to Yockney, 2 May 1918. I.W.M.
51. Nevinson to Masterman, 3 December 1917. I.W.M.
52. Masterman to Nevinson, 26 November 1917. I.W.M.
53. Masterman to Lee, 27 October 1917. I.W.M.
54. C.H. Collins Baker, *Saturday Review*, 16 March 1918.
55. H.W.N. Journals, e.620/3, 22 December 1917.
56. *Ibid.* e.620/3, 26 December 1917.
57. This was Sir Henry Head, neurologist, lecturer, and editor of the neurological journal *Brain* from 1905-1921.
58. F. Rutter, 'The Galleries. New English Art Club', *Sunday Times*, 13 January 1918.
59. Nevinson to Masterman, 4 January 1918. I.W.M.
60. H.W.N. Journals, e.620/3, 5 & 8 February 1918.
61. *Ibid.* e.620/3, 18 February 1918.
62. *Catalogue of an Exhibition of Pictures of War by C.R.W. Nevinson (Official Artist on the Western Front)* (London: Leicester Galleries, March 1918), p. 107.
63. B.H. Dias [Ezra Pound] 'Art. The New English Art Club', *New Age*, 22 January 1918.

64. *Catalogue of an Exhibition of Pictures of War by C.R.W. Nevinson (Official Artist on the Western Front)* (London: Leicester Galleries, March, 1918), p. 109.
65. *Ibid.*
66. *Ibid.*
67. H.W.N. Journals, e.620/3, 16 February 1918.
68. *Ibid.* e.620/3, 1 March 1918.
69. 'The War Pictures', *Westminster Gazette,* 23 March 1918.
70. 'At the Leicesters', *The Sketch,* 13 March 1918.
71. Nevinson to Masterman, 10 & 17 March 1918. I.W.M.
72. 'Mr Nevinson on Himself', *Saturday Review,* 13 April 1918.
73. Lee to Yockney, 3 March 1918. T.G.A., C.R.W. Nevinson, Correspondence.
74. Taken from 'The Volunteer' by Herbert Asquith. Cited in P. Fussell, *The Great War and Modern Memory* (Oxford University Press, 1975), p. 59.
75. *London Mail,* 16 March 1918.
76. Nevinson to Masterman, 17 March 1918. I.W.M.
77. *Evening Post,* New York, 31 May 1919.
78. C.R.W. Nevinson, 'When the Censor Censored "Censored"', *Royal British Legion Journal,* October 1932, p. 114.
79. J. Turner, Lieut, Letter to the Editor, *Saturday Review,* 25 May 1918.
80. H.W.N. Journals, e.620/3, 15 March 1918.
81. *Ibid.* e.620/3, 10 March 1918.
82. Nevinson to Masterman, 10 March 1918. I.W.M.
83. C.R.W. Nevinson, *Paint and Prejudice,* p. 112.
84. H.W.N. Journals, e.620/3, 3 April 1918.
85. *Ibid.* e.620/3, 3 April 1918.
86. *Ibid.* e.620/3, 8 April 1918.
87. Nevinson to Ross, 21 April 1918. I.W.M.
88. Nevinson to Ross, 7 April 1918. I.W.M.
89. *Ibid.* 21 April 1918. I.W.M.
90. J.E. Crawford-Flitch, *The Great War: Fourth Year* (London: Country Life, 1918), p. 8.
91. *British Permanent Memorials Committee. Memorandum by Arnold Bennett,* 9 March 1918. I.W.M: 486/12.
92. 'Protective Mimicry', *Saturday Review,* 16 November 1918.
93. Cited in: M. Hall, *Modernism, Militarism and Masculinity: British Modern Art Discourse and Official War Art During the First World War* (PhD. dissertation, State University of New York at Binghampton, 1994), p. 624.
94. Louis J. McQuilland, 'The Man Who Paints Motion', *Lloyds Magazine,* 1918.
95. C.R.W. Nevinson, *Paint and Prejudice,* p. 115.

Chapter 8: The Post-War Dream (1919)

1. Cited in: David Peters Corbett, *The Modernity of English Art 1914-1930* (Manchester University Press, 1997), p. 60.
2. 'Bolshevism in Art: Catering for the Intellectual Snob', *Daily Express*, 10 March 1919.
3. C.R.W. Nevinson, *Paint and Prejudice* (London: Metheun, 1937), p. 117.
4. F. Rutter, *Sunday Times*, 5 January 1919.
5. *Sunday Times*, 5 January 1919.
6. C.R.W. Nevinson, 'Mr Nevinson's War Pictures', *Sunday Times*, 26 January 1919.
7. 'A Backslider', *Daily Mirror*, 6 March 1919.
8. Sir Claude Phillips, 'Royal Academy. Canadian War Memorials', *Daily Telegraph*, 7 January 1919.
9. 'Are Futurists Mad?', *Illustrated Chronicle*, 22 January 1919.
10. 'Bolshevism in Art: Catering for the Intellectual Snob', *Daily Express*, 10 March 1919.
11. C.R.W. Nevinson, 'Modern Art', *The World*, 4 October 1919.
12. A.O. Bell (ed.), *The Diary of Virginia Woolf. Vol. 1: 1915-1919* (London: Harcourt Brace, 1983), p. 240.
13. 'Movements in Art', *Sunday Evening Telegram*, 29 June 1919.
14. C.R.W. Nevinson, *Paint and Prejudice*, p.158.
15. *Ibid.*
16. Nevinson to Ross, 21 April 1918. Imperial War Museum, Nevinson, C.R.W., First World War, Correspondence, 1917-1918 (226A/6) (Hereafter: I.W.M.).
17. T. Hardy, 'And There Was a Great Calm' in C. Ward (ed.), *World War One British Poets* (New York: Dover Publications, 1997), p. 58.
18. Yockney to Nevinson, March 1919. I.W.M.
19. Yockney to Central Press Photos Ltd, 28 March 1919. I.W.M.
20. *Evening Standard & St. James Gazette*, 9 April 1919, joked that he might also have provided information concerning taxi fares.
21. *Daily Express*, 28 March 1919.
22. 'A Great War Picture', *Glasgow Evening Citizen*, 28 March 1919.
23. 'As You Were', *Sunday Evening Telegram*, 2 February 1919.
24. 'A Painter Among the Poets', *Daily Sketch*, 27 February 1919.
25. 'A Celebrity Dances', *Sunday Pictorial*, 23 February 1919.
26. H.W.Nevinson Journals (hereafter H.W.N. Journals) e.621/1, 11 April 1919.
27. 'An Artist's War Cry', *The Observer*, 13 April 1919.
28. 'Hansoms, Pictures, Books, Plays', *Bristol Times & Mirror*, 16 April 1919.
29. Gerald Cumberland, *Written in Friendship: A Book of Reminiscences* (London: Grant Richards, 1923), p. 249.
30. 'A Nevinson Dinner', *Daily Mirror*, 15 March 1919.
31. C.R.W. Nevinson, *Paint and Prejudice*, p. 130.
32. *Evening Post*, 31 May 1919.
33. *Ibid.*

34. 'Mr Nevinson, British Artist, thinks New York is too modest', *The Herald*, 18 May 1919.

35. *New York Times Magazine*, 25 May 1919, p. 13.

36. *Eagle*, 25 May 1919.

37. Cited in: Chloe Johnson, 'C.R.W. Nevinson: The Soul of a Soulless City', *British Art in Focus* (Tate Publishing, 2001), p. 4.

38. Lisa Messinger suggested that this speech was also delivered on 29 May 1919 at the Kelekian Gallery (40 West 57th Street; Dikran Kelekian) in 'Nevinson in New York', a lecture delivered at the Yale Center for British Art, 1 March 2000. I suspect this is just a mix up with the name of the galleries.

39. *Pittsburgh Gazette*, 23 June 1919.

40. C.R.W. Nevinson, *Paint and Prejudice*, p. 136

41. John Quinn to Wyndham Lewis, 16 June 1919. Letter Box 21. New York Public Library. Thanks to Jonathan Black for finding and sharing this letter with me.

42. C.R.W. Nevinson, *Paint and Prejudice*, p. 180.

43. Frederick Keppel & Co., 4 East 39th Street, New York City.

44. C.R.W. Nevinson, *Paint and Prejudice*, p. 135.

45. *Ibid.* p. 137.

46. 'Notes From New York', *Evening Standard & St. James Gazette*, 3 July 1919.

47. *Ibid.* e.621/1, 4 June 1919.

48. *Ibid.* e.621/1, 6 June 1919.

49. *Ibid.* e.621/1, 8 June 1919.

50. C.R.W. Nevinson, *Paint and Prejudice*, p. 140.

51. H.W. Nevinson Journals, e.621/1, 18 June 1919.

52. C.R.W. Nevinson, *Paint and Prejudice*, p. 142.

53. 'Echoes of the Town', *Daily Sketch*, 17 November 1919.

54. H.W.N. Journals, e.621/2, 19 October 1919.

55. *Daily Sketch*, 25 October 1919.

56. *Catalogue of an Exhibition of New Works by C.R.W. Nevinson* (London, Leicester Galleries, October-November 1919).

57. ' "Peace" by Nevinson', *Daily Herald*, 27 October 1919.

58. 'No Believer in "isms"', *Daily News*, 27 October 1919.

59. 'The Nevinson Palace of Varieties', *Westminster Gazette*, 4 November 1919.

60. 'A Painter of Modern Life', *The Observer*, November, 1919.

61. C. Marriott, 'Stunting in Art', *The Outlook*, 8 November 1919.

62. 'Off to Paris', *Pall Mall Gazette*, 30 October 1919.

63. 'Art and War', *Liverpool Courier*, 12 December 1919.

64. 'Pictures of the War', *Daily News and Leader*, 12 December 1919.

65. 'War Artists' Pictures: Triumph of Young Men in Realizing Strife', *Daily Express*, 15 December 1919.

66. C.R.W. Nevinson to Imperial War Museum, 15 December 1919. I.W.M.

67. I.W.M. – file 266 B/6 C.R.W. Nevinson 1919-1963.

68. K. Parkes, 'Nevinson', *Apollo*, November 1928, p. 259.
69. H.W.N. Journals. e.621/2, 10 December 1919.
70. *Ibid.* e.621/2, 10 December 1919.
71. 'Young Artists' Triumph', *Daily Mail*, 12 December 1919.
72. B.H. Dias [Ezra Pound] 'Art Notes', *New Age*, 1 January 1920.
73. H.W.N. journals, e.621/2, 12 December 1919.
74. *Ibid.* e.621/2, 14 December 1919.
75. *Ibid.* e.621/2, 25 December 1919.
76. *Ibid.* e.621/2, 28 December 1919.
77. *Ibid,* e.621/2, 29 December 1919.
78. Phillip Gibbs, *Now it can Be Told*, pp. 547-548, cited in: Eric J. Leed, *No Man's Land: Combat and Identity in World War I* (Cambridge University Press, 1979).
79. *Evening News*, 13 June 1922.

Chapter 9: New York, Prague and *The Waste Land* (1920-21)

1. C. Bell, *Old Friends* (London: Chatto & Windus, 1956), p. 44.
2. T. Burke, *London in My Time* (London: Rich & Cowan, 1934), pp. 16-17.
3. 'Nightmare Picture or Masterpiece', *Weekly Dispatch*, 15 February 1920.
4. *Evening Star*, Washington DC, 18 January 1920.
5. 'Ultra-Modernism Bad: Futurist Artist Upholds Academy Art', *The Globe*, 14 April 1920.
6. 'Satan Rebuking Sin', *The Connoisseur*, date unknown. Tate Gallery Archive, (hereafter T.G.A.).
7. 'Rapier versus Bludgeon', *Birmingham Post*, 3 July 1920.
8. Nevinson to Gallatin, Undated. Gallatin Papers. Reels 507, 508, & 1293. New York Historical Society, MS Division. Copies at Archives of American Art, Smithsonian Institution, Washington D.C., U.S.A. (Smithsonian-Gallatin)
9. H.W.Nevinson Journals (hereafter H.W.N. Journals), 11 March 1921.
10. *Ibid.* 16 March 1920.
11. *Ibid.* 1 April 1920.
12. 'This Man was Angry', The *Daily Graphic*, 27 September 1920.
13. *Daily News and Leader*, 28 September 1920.
14. 'A Banned Poster', *National News*, 19 September 1920.
15. 'Mr Nevinson Shocks the New Critics', *Daily Express*, 28 September 1920.
16. Nevinson to Yockney, 25 March 1920. Imperial War Museum.
17. See: M. Walsh, 'Vital English Art: Futurism and the Vortex of London 1910-14', *Apollo*, February 2005, pp. 64-71.
18. C.R.W. Nevinson to Albert Eugene Gallatin. Gallatin Papers. Reels 507, 508, & 1293. New York Historical Society, Manuscript Division. Copies at Archives of American Art, Smithsonian Institution, Washington D.C., U.S.A. (Smithsonian-Gallatin).
19. C.R.W. Nevinson to Albert Eugene Gallatin, 4 August 1919 (Smithsonian-

Gallatin). A further letter to Gallatin show that the Worcester Art Galleries affair still was not resolved by the end of February 1920. Richard had tried to get the government to intervene, but to no avail. C.R.W. Nevinson to A.E. Gallatin, 29 February 1920. Smithsonain-Gallatin.

20. Wyer to Tracey, 29 October 1919.
21. H.W.N. Journals, e.621/3, 24 April 1920.
22. *Ibid.* 24 May 1920.
23. The sentiment would later appear in the *Baltimore Sun* and the *Nation*.
24. Nevinson to Gallatin, 29 February 1920 (Smithsonian-Gallatin).
25. 'Nevinson for New York', *Daily Express*, 16 September 1920.
26. *Truth*, 13 October 1920. Also present were: C. Wilkinson, Boyd Cable, Louis Tracey, Hon. Alex Carlisle, Bruce Winston, Alvaro Guevara, John Everett and a number of American journalists.
27. 'Some Famous Figures in the Foreign News', *Union*, Springfield, Mass., 31 October 1920.
28. C.R.W. Nevinson, 'My Art Creed', *The Old World and the New* (Bourgeois Galleries, 10 November-4 December, 1920).
29. C. Lewis Hind, 'An Appreciation', *The Old World and the New* (Bourgeois Galeries, 10 November-4 December 1920).
30. Graves, R & A. Hodge, *The Long Weekend: A Social History of Great Britain 1918-1939* (New York: W.W. Norton and Co., 1941), p. 32.
31. K. Marx, *Towards a Critique of Hegel's Philosophy of Right: An Introduction* (1844). Later in his autobiography Richard said that the classic film *Metropolis* had been inspired by this image, even if he mistakenly claimed that the film had been produced by Stromberg, not Lang.
32. 'Our Great Buildings Inspire Nevinson', *Evening Post*, 13 November 1920.
33. 'Nevinson – a Painter who is Developing', *American Art News*, 20 November 1920.
34. C.R.W. Nevinson, *Paint and Prejudice* London: Metheun, 1937), p. 151.
35. Nevinson to Gallatin, undated (Smithsonian-Gallatin).
36. *Ibid.* p. 152.
37. Cited in: Gresty, H., *C.R.W. Nevinson: Retrospective Exhibition of Paintings, Drawings and Prints* (Kettle's Yard Gallery, Cambridge, 1988), p. 38.
38. John Quinn to C.R.W. Nevinson, 23 November 1920, New York Public Library.
39. C.R.W. Nevinson to the Editor of *The Sun* (NYC), 18 May 1919.
40. C.R.W. Nevinson, *John O'London's Weekly*, 1922.
41. 'Nevinson with a Horsewhip', *Daily Express*, 9 September 1921.
42. *American Art News*, 29 October 1921.
43. *American Art News*, New York, 25 June 1921.
44. *Morning Post*, 4 January 1921.
45. Herbert Read, 'Art in Two Countries', *The Listener*, vol.4, 22 October 1930, p. 660.
46. C.R.W. Nevinson, *Paint and Prejudice*, p. 154.
47. C.R.W. Nevinson to Nancy Cunard, February 1921. Nancy Cunard

Papers, Harry Ranson Humanities Research Center, University of Texas at Austin.

48. *Liverpool Daily Courier,* 9 July 1921.
49. *Dundee Courier,* 3 October 1921.
50. 'Artists of Two Cities', *The Observer,* 9 October 1921.
51. *Jewish Guardian,* 7 October 1921.
52. *Daily Express,* 8 October 1921.
53. *Daily Express,* 30 September 1921.
54. C.R.W. Nevinson, *Paint and Prejudice,* p. 205.
55. *Architect and Builders Journal,* 12 October 1921.
56. *Yorkshire Observer,* 12 October 1921.
57. The *New Statesman,* 8 October 1921.
58. H.W.N Journals, 29 August 1921.
59. *Daily News,* 6 October 1921.
60. T.S. Eliot, *The Waste Land: A Facsimile and Transcript of the Original Drafts including the Annotations of Ezra Pound,* edited by Valerie Eliot (London: Faber, 1971), pp. 33, 45.
61. J. Rothenstein, *Modern English Painters,* Vol. 2 (London: Eyre & Spottiswoode, 1956), p. 120.

Chapter 10: 'The Playboy of the West End World', London and Paris (1922-25)

1. The expression appeared in the *Daily Express,* 8 October 1921 and was re-used by Bertha Jordan in the *Sunday Chronicle* in 1930.
2. *Manchester Evening Chronicle,* 23 January 1922.
3. *Evening Standard,* 10 April 1924.
4. *Manchester Evening Chronicle,* 23 January 1922.
5. *Westminster Gazette,* 15 January 1924.
6. *Liverpool Echo,* 15 January 1924.
7. *Morning Post,* 30 May 1922.
8. *Daily Express,* 3 February 1922.
9. *Yorkshire Evening News,* 7 June 1922.
10. *The Bulletin,* 15 June 1922.
11. H.W.Nevinson Journals (hereafter H.W.N. Journals), 26 February 1922.
12. *Evening News* 13 June 1922
13. *Evening Standard,* 5 December 1922.
14. *The Bulletin,* 15 June 1922.
15. Henry Nevinson to Phillip Webb, 13 July 1922. Ms. Eng. Lett. C. 278. Bodleian Library, Oxford University.
16. *Evening Standard,* 5 December 1922.
17. *Daily Graphic,* 12 February 1924 suggested that his mother bought it as a birthday gift for him and Kathleen.
18. *Daily Mirror,* 9 June 1922.
19. *Morning Post,* 3 February 1923.

20. H.W.N. Journals, 30 September 1923.

21. *Daily News*, 9 March 1923.

22. *Daily Mail*, undated press cutting from 1923. Tate Gallery Archive.

23. H.W.N. Journals, 13 June 1923.

24. H.W.N. Journals, 3 October 1923.

25. H.W.N. Journals, 11 October 1923.

26. Mark Schorer, *Sinclair Lewis: An American Life* (London: Heinemann, 1961), p. 395.

27. Sinclair Lewis, *Martin Arrowsmith* (London: Cape, 1925), p. 400.

28. *John O'London's Weekly*, 9 March 1923.

29. H.W.N. Journals, 24 March 1924.

30. *Daily Dispatch*, 14 March 1924.

31. *Morning Post*, 14 March 1924.

32. *Sunday Chronicle*, 16 March 1924.

33. H.W.N. Journals, 29 March 1924

34. *Daily Express*, 14 March 1924.

35. Cited in: Cathy Ross, *Twenties London: A City in the Jazz Age* (London: Phillip Wilson Publishers, 2003), p. 99.

36. C.R.W. Nevinson, *Paint and Prejudice* (London: Metheun, 1937), p. 158.

37. *Daily Dispatch*, 14 March 1924.

38. H.W.N. Journals, 23 June 1924.

39. H.W.N. Journals, 13 July 1924.

40. H.W.N. Journals, 15 February 1925.

41. H.W.N. Journals, 17 May 1925.

42. H.W.N. Journals, 16 December 1924.

43. R. Speaight, *William Rothenstein* (London: Eyre & Spottiswoode, 1962), p. 324.

44. Houghton library Harvard – bus. Eng. 1148 (1080) letter to Sir William Rothenstein, 20 March 1924.

45. H.W.N. Journals, 25 January 1925.

46. H.W.N. Journals, 1 March 1925.

47. *Weekly Westminster*, 28 November 1925.

48. Osbert Sitwell, *C.R.W. Nevinson* (London: Ernest Benn, 1925).

49. The *Teachers World*, 26 August 1925.

50. *Daily Herald*, 23 November 1925.

51. H.W.N. Journals, 25 October 1925.

52. *The Times*, 24 October 1925.

53. *Daily Graphic*, 24 October 1925.

54. *Weekly Dispatch*, 25 October 1925.

55. *Daily Express*, 28 October 1925.

56. *Daily Chronicle*, 28 October 1925.

57. *Daily News*, 26 October 1925.

58. H.W.N. Journals, 8 November 1925.

59. H.W.N. Journals, 9 November 1925.

60. H.W.N. Journals, 28 October 1925.

61. C.R.W. Nevinson to E. Marsh, 5 November 1926. Marsh papers, Berg

Collection, New York Public Library.

62. *Westminster Gazette,* 28 October 1925.
63. *Daily Mirror,* 28 October 1925.
64. *Sunday Independent,* 8 November 1925.
65. *Westminster Gazette,* 9 November 1925.
66. C.R.W. Nevinson, *Paint and Prejudice,* p. 162.
67. P. W. Lewis, 'The Skeleton in the Cupboard Speaks', in *Wyndham Lewis the artist from Blast to Burlington House* (London: Haskell House Publishers, 1939).

Chapter 11: The Lives of a Modern Bohemian (1926-29)

1. C.R.W. Nevinson, *Paint and Prejudice* (London: Metheun, 1937), p. 230.
2. Sisley Hudleston, *Mr Paname: A Paris Fantasia* (New York: Doran, 1927), p. 197.
3. Ethel Mannin, *Confessions and Impressions* (London: Jarrolds, 1930), p. 197.
4. *Drawing and Design,* January 1926, p. 254.
5. Henry went to the exhibition and was later delighted to receive a letter from Lawrence saying 'I am one of the several legions of men of my generation in your debt, for the very soundest of doctrine – which perhaps excuses my writing, unprovoked, to one who can only regard me as a stranger.'
6. *Ibid.* 20 March 1926.
7. *The Times,* 6 March 1926.
8. *Westminster Gazette,* 5 March 1926
9. *Daily News,* 6 March 1926.
10. *Daily Mail,* 6 March 1926.
11. *Daily Graphic,* 17 March 1926.
12. C.R.W. Nevinson to Sisley Huddleston, Undated. Harry Ransom Humanities Research Center, University of Texas at Austin (hereafter H.R.H.R.C.).
13. H.W.Nevinson Journals (hereafter H.W.N. Journals), 16 May 1926.
14. *Drawing,* 1 May 1926
15. *Cassell's Weekly,* 19 June 1926.
16. C.R.W. Nevinson to Sisley Huddleston, 23 June 1929. Huddleston Papers, H.R.H.R.C.
17. *Daily Sketch,* 16 February 1926.
18. H.W.N. Journals, 31 August 1926.
19. S. Huddleston, *Paris Salons Cafes Studios* (New York: Blue Ribbon Books, 1928), p. 309.
20. *Ibid.*
21. *Evening Standard,* 25 February 1926.
22. C.R.W. Nevinson to Sisley Huddleston, 20 March 1927. Huddleston Papers, H.R.H.R.C.
23. Christopher Martin, 'Nevinson and Fiction: A Survey' in: *A Dilemma of*

 English Modernism: Verbal and Visual Politics in the Life and Work of C.R.W. Nevinson (University of Delaware Press, 2006).
24. *Saturday Review,* 14 March 1927.
25. *Popular Pictorial,* 9 April 1927.
26. Louis McQuilland, *Everybody's Weekly,* 1 September 1928.
27. H.W.N. Nevinson, 26 April 1927.
28. *Westminster Gazette,* 26 February 1926.
29. C.R.W. Nevinson, *Paint and Prejudice,* p.219.
30. *Evening News,* 26 April 1927.
31. *Country Life,* 30 April 1927.
32. *Times of India,* 16 December 1927.
33. *Ibid.*
34. H.W.N. Journals, 19 February 1928.
35. *Ibid.* 27 April 1928.
36. H.W.N. Journals, 12 September 1927.
37. *Ibid.* 18 September 1927.
38. *Everybody's Weekly,* 12 May 1928.
39. Unidentified paper cutting, August 1927. Tate Gallery Archive (hereafter T.G.A.).
40. I.W.M. 'C.R.W. Nevinson: 1919-1963' File 266 B / 6.
41. Roger Fry to C.R.W. Nevinson, 28 August 1928. Roger Fry Papers, Kings College Archive, Cambridge.
42. H.W.N. Journals, 14 May 1928.
43. *Sunday Times,* 9 October 1928.
44. *New Statesman,* 13 October 1928.
45. *Sporting Times,* 6 October 1928.
46. H.W.N. Journals, 6 October 1928.
47. Richard Ingleby, *Christopher Wood: An English Painter* (London: Allison & Busby, 1995), p. 204
48. H. Williamson, *The Power of the Dead* (London: MacDonald, 1963), p. 210.
49. *Ibid.* p. 217.
50. Anne Williamson, *Henry Williamson: Tarka and the Last Romantic* (Stroud: Sutton, 1995), p.156.
51. Henry Williamson, *The Phoenix Generation* (London: MacDonald, 1965), p. 233.
52. *Evening Standard,* 30 November 1928.
53. C.R.W. Nevinson, *Paint and Prejudice,* p. 216.
54. C.R.W. Nevinson to Sisley Huddleston, 23 June 1929. Huddleston Papers, H.R.H.R.C.
55. C.R.W. Nevinson, *Paint and Prejudice,* p. 188.
56. *Building,* January 1929.
57. *Everybody's Weekly,* March 1929.
58. Letter to the Editor of *The Star* (no date). T.G.A.
59. *Pearson's Weekly,* 4 May 1929.
60. *Daily Express* (no date – 1929) T.G.A.

61. 'The Embalmed Academy' Unknown date and source. T.G.A..
62. C.R.W.. Nevinson to Sisley Huddleston, 23 June 1929. Huddleston Papers, H.R.H.R.C.
63. H.W.N. Journals, 17 February 1929.
64. C.R.W. Nevinson, *Paint and Prejudice*, p. 186.
65. *Daily Express,* 10 August 1929.
66. H.W.N. Journals, 22 January 1932.
67. See: Stanley Weintraub (ed.), *Bernard Shaw on the London Art Scene 1885-1950* (Penn State University Press, 1989), p. 443.
68. *Evening Standard,* 18 September 1929.
69. *Daily Mail,* 25 September 1929.
70. *Daily Mail,* 26 September 1929.
71. Huddleston/Lake Collection, H.R.H.R.C.
72. H.W.N. Journals, 25 September 1929.
73. *Ibid.* 29 October 1929.
74. *Daily Mail,* 25 October 1929.
75. *Yorkshire Evening Post,* 8 February 1932.
76. *Daily Chronicle,* 8 February 1932.
77. C.R.W. Nevinson, *Paint and Prejudice*, p. 205.

Chapter 12: Visions of the Apocalypse and the Warnings of Cassandra (1930-32)

1. A. Stephenson, 'Strategies of Situation: British Modernism and the Slump c. 1929-1934', *Oxford Art Journal* Vol. 14, No. 2, 1991, pp. 30-51.
2. *Ibid.* p. 42.
3. D. Farr, *English Art: 1870-1940* (Oxford University Press, 1984), p. 271.
4. *Nash's Magazine,* January 1934.
5. C.R.W. Nevinson to E. Gallatin, 8 November 1930. A.E. Gallatin papers, reel 507-508, Philadelphia Museum of Art.
6. *Daily Express,* 16 January 1930.
7. *Daily Express,* 1 April 1930.
8. *Sunday Chronicle,* 23 February 1930.
9. *Sunday Express,* 23 March 1930.
10. *Daily Dispatch,* 3 April 1930.
11. Ethel Mannin, *Confessions and Impressions* (London: Jarrolds, 1930), pp. 197-8.
12. C.R.W. Nevinson, *The Graphic,* 17 May 1930.
13. C.R.W. Nevinson, 'New Art in the Americas', *The Graphic,* 3 August 1930.
14. C.R.W. Nevinson, 'Make Your Home Reflect THIS Age', *Daily Express,* 31 January 1930.
15. *The Listener,* 16 March 1932.
16. *Daily Herald,* 13 January 1928.
17. 'Humanity is Enslaved by the Machine', *Derby Daily Telegraph,* 21

December 1929.

18. *New Statesman*, 27 March 1930.
19. H.W.Nevinson Journals (hereafter H.W.N. Journals), 16 May 1930.
20. *Harper's Bazaar*, March 1931.
21. *The Graphic*, 14 March 1931.
22. *Fortnightly Review*, November 1930.
23. *Daily Express*, 7 July 1932.
24. *Nottingham Journal and Express*, 9 February 1933.
25. *Evening News*, 24 April 1930.
26. The silver lining of the death of 'Orps' was that Richard took over as President of the Coventry and Warwickshire Society of Artists.
27. *Nottingham Evening News*, 30 April 1930.
28. 'The State Kills Art', *The Star*, 21 March 1930.
29. H.W.N. Journals, 9 May 1930.
30. *Daily Express*, 3 March 1930.
31. 'Confessions of a Noted Artist', *Daily Express*, 5 August 1932.
32. *Daily Express*, 6 September 1932.
33. *Daily Express*, 27 September 1930.
34. H.W.N. Journals, 4 October 1930.
35. *Evening Star*, 30 September 1930.
36. *Daily Mail*, 6 October 1930.
37. *Evening Standard*, 3 October 1930.
38. *The Studio*, October 1930.
39. *Daily Mail*, 30 January 1930.
40. C.R.W. Nevinson, 'New Art in the Americas', *The Graphic*, 3 August 1930.
41. H.W.N. Journals, 15 February 1931.
42. H.W.N. Journals, 15 April 1931.
43. *Ibid.* 12 Feb 1931.
44. *Ibid.* 5 June 1931.
45. 'I Have Had Enough of Shaw', *Daily Express*, 9 March 1931.
46. *Daily Express*, 26 May 1931.
47. *New Statesman and Nation*, 31 October 1931.
48. C.R.W. Nevinson to Evelyn Sharp, 3 December 1931, MS. Eng. Lett. D. 278, fol.21. Bodleian Library, Oxford University.
49. H.W.N. Journals, 3 December 1931.
50. *Daily Express*, 17 February 1932.
51. *Sheffield Daily Telegraph*, 16 February 1932.
52. *Evening News*, 25 February 1932.
53. *Sunday Dispatch*, 28 February 1932.
54. *Daily Record*, 30 March 1932.
55. *Daily Record*, 30 March 1932.
56. *Daily Herald*, 7 April 1932.
57. C.R.W. Nevinson, *Paint and Prejudice*, p. 254.
58. H.W.N. Journals, 6 February 1932
59. C.R.W. Nevinson to Sir William Rothenstein, 24 April 1932, bus. Eng.1148 1080.Houghton Library, Harvard University.

60. C.R.W. Nevinson to Sir William Rothenstein, 27 April 1932 Harvard.
61. C.R.W. Nevinson, *Paint and Prejudice* (London: Metheun, 1937), p. 254.
62. *Evening Telegraph*, 7 May 1932.
63. H.W.N. Journals, 30 May 1932.
64. *Ibid.* 3 June 1932.
65. The death certificate of Margaret Nevinson indicates that she died of Chronic Nephridia (uraemia) and hyperpiesia. She was not attributed with a career in her certificate, instead identified as the wife of H.W. Nevinson 'a war correspondent'. Henry was present at the death.
66. *Ibid.* 8 June 1932.
67. *Ibid.* 9 June 1932.
68. *Ibid.* 11 June 1932.
69. *Evening Standard*, 9 June 1932.
70. C.R.W. Nevinson, *Paint and Prejudice*, p. 256.
71. H.W.N. Journals, 21 August 1932.
72. C.R.W. Nevinson, *Paint and Prejudice*, p. 258.
73. Letter to Elisabeth Robins from H.W.Nevinson., 28 August 1932. Fales Library, New York University.
74. *Daily Express*, 27 August 1932.
75. *Daily Mail*, 2 November 1932.
76. *Cavalcade*, 30 April 1938.
77. *Advertisers' Weekly*, 28 September 1933.
78. *Yorkshire Post*, 29 December 1932.

Chapter 13: 'The Strangest Manifestations' (1933-35)

1. H.W.Nevinson Journals (hereafter H.W.N. Journals), 8 January 1933.
2. H.W.N. Journals, 30 June 1933.
3. *Daily Herald*, 28 April 1933.
4. *The Observer*, 12 February 1933.
5. *Sunday Times*, 19 February 1933.
6. *Evening Standard*, 16 March 1933.
7. *Daily Express*, 29 March 1933.
8. *Evening Standard*, 30 March 1933.
9. *Daily Mirror*, 9 May 1933.
10. *Evening Standard*, 5 June 1933.
11. *Daily Mirror*, 15 June 1933.
12. *Daily Mirror*, 15 July 1933.
13. *John O' London's Weekly*, 28 October 1933.
14. *Sunday Graphic and Sunday News*, 26 November 1933.
15. *Daily Express*, 8 August 1933.
16. W.R. Inge, *The Post-Victorians* (London: Nicholson and Watson, 1933).
17. H.W.N. Journals, 15 April 1933.
18. Bruce Arnold, *Orpen: Mirror to an Age* (London: Jonathan Cape, 1981), p. 405.

19. Originally in the *Strand Magazine*, January 1933 (date unknown).
20. *Birmingham Gazette*, 2 January 1934.
21. *The Times*, 2 January 1934.
22. *Daily Record and Mail*, 21 April 1934.
23. H.W.N. Journals, 25 August 1933.
24. *Daily Dispatch*, 12 September 1933.
25. *Daily Sketch*, 24 November 1933.
26. *Western Mail*, 17 October 1933.
27. *Daily Mirror*, 29 November 1933.
28. *Daily Mail*, 14 February 1934.
29. *Morning Post*, 23 May 1934.
30. *Yorkshire Evening Press*, 15 June 1934.
31. *News Chronicle*, 15 June 1934.
32. *Belfast Telegraph*, 15 June 1934.
33. *Harper's Bazaar*, November 1934.
34. C.R.W. Nevinson, *Paint and Prejudice* (London: Metheun, 1937), p. 261.
35. *Sunday Chronicle*, 8 October 1933.
36. David C. Smith (ed.) *Correspondence of H.G. Wells* Vol.3, *1919-1934* (London: Pickering & Chatto, 1998).
37. H.W.N. Journals, 10 September 1934.
38. C.R.W. Nevinson, *Paint and Prejudice*, p. 261.
39. H.W.N. Journals, 20 June 1934.
40. H.W.N. Journals, 22 May 1926.
41. H.W.N. Journals, 6 October 1934.
42. *The Connoisseur*, November 1934.
43. *The Spectator*, 19 October 1934.
44. H.W.N. Journals, 3 November 1934.
45. *Sunday Dispatch*, 13 October 1935.
46. Michael Saler, 'Making it New: Visual Modernism and the "Myth of the North" in Interwar England', *The Journal of British Studies* Vol. 37, No.4, October 1998, pp. 419-440.
47. *Evening Chronicle*, Date unknown.
48. R. Graves and A. Hodge, *The Long Weekend: A Social History of Great Britain 1918-1939* (New York: W.W. Norton and Co., 1941), p. 395.
49. C.R.W.. Nevinson, *Paint and Prejudice*, p. 270.
50. Princess Paul Troubetzkoy & C.R.W.. Nevinson, *Exodus AD: A Warning to Civilians* (London: Hutchinson and Co., 1934), p. 112.
51. *Ibid.*
52. *Ibid.* p. 145.
53. Graves, R. and A. Hodge, *The Long Weekend: A Social History of Great Britain 1918-1939* (W.W. Norton and Co, NYC, 1941), p. 258.
54. Herbert Read, *London Bulletin*, January/February 1939, p. 5.
55. *Varsity Weekly*, 25 May 1935.
56. *The Star*, 20 February 1935.
57. C.R.W.. Nevinson, *Paint and Prejudice*, p. 271.
58. *Daily Sketch*, 8 June 1935.

59. C.R.W.. Nevinson, *Paint and Prejudice*, p. 269.
60. *Daily Mirror,* 8 October 1935.
61. *Morning Post,* 10 October 1935.
62. *Birmingham Daily Mail*, 10 October 1935.
63. *Christian Science Monitor,* 5 November 1935.
64. *Daily Record and Mail,* 26 August 1930.
65. H.W.N. Journals, 19 September 1935.
66. H.W.N. Journals, 8 November 1935.
67. H.W.N. Journals, 11 November 1935.

Chapter 14: A Prodigal's Return (1936-39)

1. H.W.Nevinson Journals (hereafter H.W.N. Journals), 16 April 1936.
2. H.W.N. Journals, 17 April 1936.
3. H.W.N. Journals, 21 April 1936.
4. *Daily Mail,* 25 October 1929.
5. H.W.N. Journals, 1 February 1936.
6. C.R.W. Nevinson, *Paint and Prejudice* (London: Metheun, 1937) p. 281.
7. H.W.N. Journals, 18 December 1936.
8. H.W.N. Journals, 12 August 1936.
9. 'The Arts Within This Bellicose Civilization' by C.R.W. Nevinson, *The Seven Pillars of Fire* (London: Herbert Jenkins Limited, 1936), pp. 181-220.
10. *Ibid.*
11. H.W.N. Journals, 24 April 1936.
12. C.R.W. Nevinson, *Paint and Prejudice*, p. 283.
13. *Daily Express,* 25 April 1936.
14. *Daily Mail,* 29 April 1936.
15. *Daily Express,* April 1936. Tate Gallery Archive (hereafter T.G.A.).
16. *Evening News,* 29 April 1936.
17. *Ibid.*
18. *Nottingham Journal and Express,* 2 May 1936.
19. *Daily Mail,* 2 May 1936.
20. Cited in: Frances Spalding, *British Art Since 1900* (London: Thames and Hudson, 1986), p. 116.
21. *Evening News,* 2 July 1936.
22. *Evening News,* 2 July 1936.
23. H.W.N. Journals, 4 November 1936.
24. C.R.W. Nevinson, *Paint and Prejudice*, p. 280.
25. 'Studio Reminiscences' by C.R.W.. Nevinson, A.R.A. *The Studio,* date unknown, p. 198.
26. *The Star,* 31 December 1936.
27. H.W.N. Journals, 25 April 1938.
28. 'What Next?', *Morning Post,* 12 June 1936.
29. *The Star,* 2 July 1936.



30. *Daily Sketch*, 23 November 1937.
31. Press cutting of unknown origin at the T.G.A.
32. *Sunday Dispatch*, 28 March 1937.
33. *West Lancashire Evening Gazette*, 17 February 1937.
34. *Sunday Dispatch*, 21 February 1937.
35. *The Times*, 10 February 1937.
36. *Daily Telegraph*, 16 February 1937.
37. H.W.N. Journals, 21 August 1937.
38. *Sunday Dispatch*, 29 March 1937.
39. *Sunday Dispatch*, 5 April 1937.
40. *Times Literary Supplement*, 20 November 1937.
41. H.W.N. Journals, 22 November 1937.
42. H.W.N. Journals, 23 November 1937.
43. H.W.N. Journals, 24 November 1937.
44. H.W.N. Journals, 28 November 1937.
45. *New Statesman and Nation*, 18 December 1937.
46. *Sheffield Telegraph*, 10 December 1937.
47. *The Spectator*, 17 December 1937.
48. *Manchester Guardian*, 30 November 1937.
49. *Daily Express*, 25 November 1937.
50. *Sunday Times*, 25 November 1937.
51. *Daily Mail*, 18 November 1937.
52. The *Western Mail*, 18 November 1937.
53. *Evening Standard*, 25 November 1937.
54. *New York Herald, Tribune*, 27 March 1938.
55. *Art Alliance Bulletin*, April 1938.
56. *Christian Science Monitor*, 16 February 1938.
57. Louis Lozowick, *New Masses*, April 1938.
58. *Brooklyn Eagle*, 3 April 1938.
59. *Glasgow News*, 1 January 1938.
60. H.W.N. Journals, 18 May 1937.
61. *The Bystander*, 11 May 1938.
62. H.W.N. Journals, 9 November 1938.
63. H.W.N. Journals, 19 October 1938.
64. H.W.N. Journals, 8 September 1938.
65. H.W.N. Journals, 13 March 1938.
66. *Daily Sketch*, Date unknown.
67. Graves, R. and A. Hodge, *The Long Weekend: A Social History of Great Britain 1918-1939* (New York: W.W. Norton and Co., 1941), p. 404.
68. H.W.N. Journals, 31 December 1938.
69. H.W.N. Journals, 18 January 1939.
70. H.W.N. Journals, 17 January 1939.
71. H.W.N. Journals, 14 February 1939.
72. *Daily Herald*, 14 February 1939.
73. H.W.N. Journals, 28 February 1939.
74. *Evening News*, 1 March 1939.

75. *Daily Herald,* 1 March 1939.
76. T. McGreevy, *The Studio,* May 1939.
77. *Daily Herald,* 1 March 1939.
78. H.W.N. Journals, 13 August 1939.
79. H.W.N. Journals, 22 March 1939. Unity Spencer remembers Richard in a trilby and a camel hair overcoat. Apparently he said to her 'Oh but Stanley – she's so good looking' and then he followed it up with 'But I'm good looking aren't I Unity'. Conversation between Unity Spencer and Michael Walsh, 2002.
80. T.G.A., Stanley Spencer Collection, 733.1.1.107, 15 June 1939.
81. Agatha Christie, *Murder is Easy* (London: Collins, 1939), pp. 32-33. In this the quotation is; 'Her black hair was blown off her head by a sudden gust and Luke was reminded of a picture he had once seen – Nevinson's "Witch".'
82. H.W.N. Journals, 6 April 1939.
83. H.W.N. Journals, 17 August 1939.
84. H.W.N. Journals, 29 August 1939.
85. H.W.N. Journals, 7 July 1939.
86. H.W.N. Journals, 1 September 1939.
87. H.W.N. Journals, 1 September 1939.
88. Geoffrey Elborn, *Edith Sitwell: A Biography* (New York: Doubleday, 1981), p. 141.
89. Cited in: Charles L. Mowat, *Britain Between the Wars 1918-1940* (University of Chicago Press, 1955), p. 650.
90. H.W.N. Journals, 2 September 1939.
91. H.W.N. Journals, 17 September 1939.
92. H.W.N. Journals, 10 September 1939.
93. H.W.N. Journals, 19 September 1939.
94. *Evening Standard,* 2 October 1939.
95. *The Listener,* 26 October 1939.
96. H.W.N. Journals, 31 October 1939.
97. Brian Foss, 'Message and Medium: Government Patronage, National Identity and National Culture in Britain, 1939-45', *Oxford Art Journal,* Vol. 14, No. 2, 1991, p. 56.
98. H.W.N. Journals, 7 December 1939.
99. H.W.N. Journals, 20 December 1939.

Chapter 15: C.R.W.. Nevinson's Second Great War (1940-45)

1. *Birmingham Post,* 5 Jan 1940.
2. Imperial War Museum (hereafter I.W.M) Archive: C.R.W. Nevinson: 1919-1963 File 266 B/6, 19 March 1940.
3. IWM: 23 March 1940.
4. IWM: 27 March 1940.
5. H.W.Nevinson Journals (hereafter H.W.N. Journals), 17 March 1940.

6. H.W.N. Journals, 19 March 1940.
7. H.W.N. Journals, 12 March 1940.
8. See: Meryle Secrest, *Kenneth Clark: A Biography* (New York: Holt, Rinehart and Winston, 1984).
9. *The Times*, 22 April 1940.
10. H.W.N. Journals, 21 March 1940.
11. Edward Marsh had bought *Cornish Landscape* in 1933 from Leicester Galleries.
12. C.R.W. Nevinson to Sir Kenneth Clark, 31 March 1940. Clark Papers, Tate Gallery Archive.
13. H.W.N. Journals, 1 June 1940.
14. H.W.N. Journals, 15 August 1940.
15. H.W.N. Journals, 10 September 1940.
16. H.W.N. Journals, 19 October 1940.
17. H.W.N. Journals, 24 October 1940.
18. H.W.N. Journals, 13 December 1940.
19. H.W.N. Journals, 18 December 1940.
20. War Artists Archive – GP/55/143 – Correspondence between Nevinson and War Artist's Advisory Committee: Letter to Dickey (member of the WAAC), 14 November 1940.
21. One of which he hoped might become a Chantrey Bequest painting – none did, but *A Star Shell* was purchased under the scheme in 1962.
22. Brian Foss, 'Message and Medium: Government Patronage, National Identity and National Culture in Britain, 1939-45' *Oxford Art Journal*, Vol. 14, No. 2 (1991), p. 65.
23. War Artists Archive – GP/55/143 – Correspondence between Nevinson and War Artist's Advisory Committee, 20 March 1941 – Dickey to Sir Kenneth Clark.
24. War Artists Archive – GP/55/143 – Correspondence between Nevinson and War Artist's Advisory Committee, July 1941. Nevinson to Dickey.
25. C.R.W. Nevinson to Aleister Crowley, 8 December 1941. Crowley Papers, Warburg Institute.
26. H.W.N. Journals, 28 December 1940.
27. H.W.N. Journals, 11 August 1941.
28. H.W.N. Journals, 7 November 1941.
29. H.W.N. Journals, Written by Evelyn Sharp, 9 November 1941.
30. The death certificate of H.W. Nevinson recorded that he died at The Vicarage, Chipping Campden, Cotswolds, Gloucester, and described him as a 'writer and war correspondent'. The death was witnessed by N. Griggs of Dovers House, Chipping Campden. H.W. Nevinson died of diabetes mellitus.
31. *Birmingham Weekly Post*, 13 March 1942.
32. C.R.W. Nevinson to Aleister Crowley, 8 December 1941. Warburg Institute Archive.
33. C.R.W. Nevinson to Rothenstein, 22 November 1941. Sir William Rothenstein Letters, Bus. Eng. 1148 (192). Houghton Library, Harvard

University.

34. Winston S. Churchill to C.R.W. Nevinson, 7 October 1942. CHAR 2/458, Churchill Archive, Cambridge University.

35. 'C.R.W. Nevinson, ARA, NEAC, RBA, Legion dHonneur.' By F.G. Mories in *The Artist*, August 1943, p. 133

36. *Daily Mail*, 19 October 1942.

37. *Daily Express*, 19 October 1942.

38. C.R.W. Nevinson to Edith Sitwell, 15 November 1942. E. Sitwell Papers. Harry Ransom Humanities Research Center, University of Texas at Austin.

39. Letter to Marita Ross thanking her for publishing his attack on the dictator during this war for democracy. T.G.A. 7916.1.4.

40. C.R.W. Nevinson to Sir Hugh Walpole Thursday 25 (month and year unknown). Harry Ransom Humanities Research Center, University of Texas at Austin.

41. Janet Dunbar, *Laura Knight* (London: Collins, 1975), p. 159-60.

42. *The Times*, 28 April 1943.

43. *Sunday Chronicle*, Date unknown.

Chapter 16: The death of a beau saboteur (1946)

1. *Manchester Guardian*, 8 October 1946.

2. *Evening Standard*, 7 October 1946.

3. *Cavalcade*, 31 May 1947

4. 'C.R.W. Nevinson, A.R.A.' by F.G. Mories (1945).

5. The Last Will and Testament of C.R.W. Nevinson was drawn up on 12 May 1942, over four years before his death.24

Select Bibliography

Abbott, C. and Anthony Bertram (eds.) *Poet & Painter: Being the Correspondence between Gordon Bottomley and Paul Nash, 1910-1946* (London: Oxford University Press, 1955).

Agnese, G. *Marinetti: Una Vita Esplosiva* (Milano: Camunia, 1990).

Agnese, G. *Vita di Boccioni* (Milano: Camunia, 1996).

Anscombe, I. *Omega and After: Bloomsbury and the Decorative Arts* (London: Thames & Hudson, 1981).

Apollonio, U. (ed.) *Futurist Manifestoes* Trans. Robert Brain, R.W. Flint, J.C. Higgitt, Caroline Tisdall (New York: Viking Press, 1973).

Arnold, B. *Orpen: Mirror to an Age* (London: Jonathan Cape, 1981).

Arts Council of Great Britain. *Decade 1910-1920* (Leeds, Leeds City Art Gallery, 1965).

Arts Council of Great Britain. *Vorticism and its Allies* (London, Hayward Gallery, 1974).

Baker, S. 'Describing Images of the National Self: Popular Accounts of the Construction of Pictorial Identity in the First World War', *Oxford Art Journal,* 1990.

Banham, R. *Theory and Design in the First Machine Age* (MIT Press, 1960).

Baron, W. *Perfect Moderns: A History of the Camden Town Group* (Aldershot: Ashgate, 2000).

Baron, W. *Sickert* (New York: Phaidon, 1973).

Baron, W. *The Camden Town Group* (London: Scolar Press, 1979).

Base Details: British Artists of the First World War (Nottingham, University Art Gallery, 1972).

Bell, A.O. (ed.) *The Dairy of Virginia Woolf Vol. 1, 1915-1919* (London: Harvest Books, 1983).

Bell, C. *Art* (London: Chatto & Windus, 1914).

Bell, C. 'How England Met Modern Art', *Art News,* October 1950.

Bell, C. *Old Friends* (London: Weidenfeld and Nicolson, 1956).

Bell, Q. and Stephen Chaplin, "The Ideal Home Rumpus," *Apollo,* October 1964: and (same authors), "Rumpus Revived," *Apollo,* January 1966.

Black, J. "A Curious, Cold Intensity: C.R.W. Nevinson as a War Artist, 1914-1918," in Richard Ingleby and others. *C.R.W. Nevinson: The Twentieth Century* (exhibition catalogue, London: Merrell Holberton in association

with the Imperial War Museum, 1999).

Black, J. *Neither Beasts, nor Gods, But Men: Constructions of Masculinity and the Image of the British Soldier (or 'Tommy') in the First World War Art of: C.R.W. Nevinson (1889-1946); Eric H. Kennington (1888-1960) and Charles Sargeant Jagger (1885-1934).* [PhD diss. University College London, 2003.]

Black, J., Michael J.K. Walsh, Chris Adams and Jon Wood. *Blasting the Future! Vorticism in Britain 1910–1920* (London: Philip Wilson, 2004).

Booth-Jones, T. 'Pictures from the Front', *Antique Collector*, September 1980.

Bradbury, M and J. McFarlane, *Modernism* (London: Penguin, 1976).

Braun, E. (ed.) *Italian Art in the Twentieth Century* (London and Munich: Prestel, 1989).

Broer, L. and J. Walther (eds.), *Dancing Fools and Weary Blues: The Great Escape of the Twenties* (Ohio: Bowling Green State University Popular Press, 1990).

Bullen, J.B. (ed.) *Post-Impressionists in England* (London: Routledge, 1988).

Burke, T. *London in my Time* (London: Rich and Cowan, 1934).

Canaday, J. *Mainstreams in Modern Art* (New York, Rinehart and Winston, 1959).

Cannan, G. *Mendel: A Story of Youth* (London: T. Fisher Unwin, 1916).

Carey, F. Anthony Griffiths and Stephen Coppel. *Avant-Garde British Printmaking: 1914-1960* (London: British Museum, 1990).

Carrington, N. *Carrington: Paintings, Drawings and Decorations* (London: Thames and Hudson, 1980).

Carrington, N. (ed.) *Mark Gertler: Selected Letters* (London: Rupert Hart-Davis, 1965).

Chamot, M. *Modern Painting in England* (London: Country Life, 1937).

Chesterton, G.K. 'The Futurists' Chapter in *The Uses of Diversity: A Book of Essays* (London: Methuen, 1920).

Christie, A. *Murder is Easy* (London: Collins, 1939).

Clark, Sir K. 'Foreword' *The War Artists* (Folkestone, New Metropole Art Centre, 1964).

Clough, R.T. *Futurism: The Story of a Modern Art Movement. A New Appraisal* (Philosophical Library, 1961; repr. New York: Greenwood Press, 1969).

Compton, S. *British Art in the Twentieth Century. The Modern Movement* (Munich: Prestel-Verlag, the Royal Academy of Arts, 1986).

Conway, M. *A Concise Catalogue of Paintings, Drawings and Sculpture of the First World War, 1914-1918* (London, 1963).

Corbett, D.P. *The Modernity of English Art, 1914-30* (Manchester: Manchester University Press, 1997).

Cork, R. *A Bitter Truth: Avant-Garde Art and the Great War* (London and New Haven: Yale University Press, 1994).

Cork, R. *Art Beyond the Gallery in Early 20th Century England* (New Haven: Yale University Press, 1985).

Cork, R. *David Bomberg* (London: Tate Gallery, 1988).

Cork, R. *Vorticism and Abstract Art in the First Machine Age*, 2 Vols (Berkeley and Los Angeles: University of California Press, 1976).

Corn, W. *The Great American Thing* (Berkeley and Los Angeles: University of

California Press, 1999).

Cournos, J. *Autobiography* (New York: G. P. Putnam's Sons, 1935).

Crawford-Flitch, J.E. *C.R.W. Nevinson: The Great War, Fourth Year* (London: Grant Richards, 1918).

Cross, T. *et al. The Fallen. An Exhibition of Nine Artists Who Lost their Lives in World War One* (Oxford, 1988).

Cumberland, G. *Written in Friendship: A Book of Reminiscences* (London: Grant Richards, 1923).

Cummings, R. *Artists at War, 1914–1918* (Cambridge, Kettles Yard Gallery, 1974).

Curtis, P. (ed.) *Dynamism: The Art of Modern Life Before the Great War* (London, Tate Gallery, 1991).

D'Harcourt, A. *Futurism and the International Avant-Garde* (Philadelphia, Philadelphia Museum of Art, 1980).

Dangerfield, G. *Strange Death of Liberal England* (London: Perigee Trade, 1935).

Darracot, J. and B. Loftus, *First World War Posters* (London, 1972).

Denvir, B. in *The Café Royalists: An Exhibition of Café Royal Artists* (London: Eyre and Spotiswoode, 1956).

Doherty, C. *Nash, Nevinson and Roberts at War: A Catalogue Raisonne of first World War Paintings, Drawings and Prints by Paul Nash, C.R.W. Nevinson and William Roberts* (Ph.D. diss. University of Madison, Wisconsin, 1989).

Dokter, B. and Carry van Lakerveld (eds.) *Een Kunstolympiade in Amsterdam. Reconstructie van de tentoostelling D.O.O.D. 1936* (Amsterdam: Gemeentearchief, 1996)

Dunbar, J. *Laura Knight* (London: Collins, 1975).

Edwards, P. "Wyndham Lewis and the *Rappel à l'ordre*: Classicism and Significant Form, 1919-21", *The Geographies of Englishness: Landscape and the National Past 1880-1940*, David Peters Corbett, Ysanne Holt and Fiona Russell (eds.) (New Haven and London: Yale University Press, 2002).

Edwards, P. "Wyndham Lewis at the Second Post-Impressionist Exhibition: Reproductions of Three Lost Works", *Wyndham Lewis Annual* 9-10, 2002-3.

Edwards, P. *Wyndham Lewis: Art and War* (London: Lund Humphries, 1992).

Edwards, P. *Wyndham Lewis: Painter and Writer* (New Haven and London: Yale University Press, 2000).

Eksteins, M. *Rites of Spring: The Great War and the Birth of the Modern Age* (New York: Doubleday, 1989).

Elborn, G. *Edith Sitwell: A Biography* (New York: Doubleday and Co., 1981).

Eliot, V. (ed.) *The Waste Land: A Facsimile and Transcript of the Original Drafts including the Annotations of Ezra Pound* (London: Faber, 1971).

Eyre, A. *St. John's Wood: Its haunts, its houses and its celebrities* (London: Chapman and Hall, 1913).

Farr, D. *English Art 1870–1940* (Oxford: Clarendon Press, 1978).

Ferguson, J. *The Arts in Britain in World War I* (Southampton: The Camelot Press, 1980).

Ferrall, C. " 'Melodramas of Modernity': The Interaction of Vorticism and Futurism before the Great War", *University of Toronto Quarterly*, Vol. 63, No. 2, Winter 1993-4.

Fewster, K. (ed.) *Gallipoli Correspondent. The Front-line Diary of C.E.W. Bean* (Sydney: Unwin Hyman, 1983).

Fine Arts Society. *The Great War: Britain's Efforts and Ideals* (London, Fine Arts Society, 1917).

Firbank, R. *Prancing Nigger* (New York: Brentano's, 1924).

Firbank, R. *Sorrow in Sunlight* (London: Brentano's, 1924).

Firbank, R. *The Flower Beneath the Foot* (London: Grant Richards, 1923).

Fletcher, P. "Masculinity, money and modern art: 'The Sentence of Death' by John Collier," in David Peters Corbett, and L. Perry, (eds.) *English Art 1860-1914. Modern artists and identity* (Manchester: Manchester University Press, 2000).

Flint, R. W. (ed.) *Marinetti: Selected Writings* Trans. R. W. Flint and Arthur A. Coppotelli (New York: Farrar, Straus and Giroux, 1972).

Foot, M.R.D. *Art and War. Twentieth Century Warfare as Depicted by War Artists* (London: Headline Book Publishing, 1990).

Ford, B. (ed.) *The Cambridge Guide to the Arts in Britain, Vol 8: The Edwardian Age and the inter-War Years* The Cambridge Guide to the Arts in Britain Series (Cambridge: Cambridge University Press, 1989).

Ford, M. 'C.R.W. Nevinson', *Arts Review,* 14 August 1971.

Foss, B. 'Message and Medium: Government and Patronage, National Identity and National culture in Britain, 1939-45', *Oxford Art Journal* Vol. 14, no. 2 1991.

Frank, D. *The Bohemians* (London: Weidenfeld & Nicolson, 2001).

Freeman, J. *Made at the Slade: A Survey of Mature Works by Ex-Students of the Slade School of Fine Art, 1892-1960, exh. cat.* (Brighton, The Gallery, Brighton Polytechnic, 1979).

Frewin, L. *The Café Royal Story* (London: Hutchinson Benham, 1963).

Fuller, P. 'The Arts at War', *New Society,* 24 June 1982.

Fulleylove, J. *Pictures of Classic Greek Landscape and Architecture* (London: Dent, 1897).

Fulleylove, J. RI and H.W. Nevinson, *Pictures of Classic Greek Landscape and Architecture* (London, 1897).

Fussell, P. *The Great War and Modern Memory* (London: Oxford University Press, 1975).

Gertzina, G. *Carrington* (London: John Murray, 1989).

Gibbs, P. *The Street of Adventure* (London: Heinemann, 1909).

Gilder, R.W. *The Poems of Richard Watson Gilder* (Boston: Riverside Press, 1908).

Giles, S. (ed.) *Theorizing Modernism. Essays in Critical Theory* (London and New York: Routledge, 1993).

Glew, A. *Stanley Spencer: Letters and Writings* (London: Tate Publishing, 2001).

Goldring, D. *Odd Man Out: The Autobiography of a Propaganda Novelist* (Chapman & Hall, 1935).

Graves, R and A. Hodge, *The Long Weekend: A Social History of Great Britain 1918-1939* (Norton, 1940).

Greenwood, J. and Richard Cork. *The Graphic Work of Edward Wadsworth* (London: Wood Lea Press, 2002).

Gresty, H. *C.R.W. Nevinson: Retrospective Exhibition of Paintings, Drawings and Prints* (Cambridge, Kettle's Yard Gallery, 1988).

Grigson, G.E.H. *A Master of Our Time. A Study of Wyndham Lewis* (London: Methuen, 1951).

Guichard, K. M. *British Etchers: 1850-1940* (London: Robin Garton, 1977).

Hall, M. *Modernism, Militarism and Masculinity: British Modern Art Discourses and Official War Art During the First World War* (Ph.D. diss. State University of New York at Binghamton, 1994).

Hamilton, P. *The Role of Futurism, Dada and Surrealism in the Construction of British Modernism 1910–1940* (Ph.D. Diss. University of Oxford, 1987).

Hanson, A. *Severini Futurista: 1912-1917* (London: Yale University Art Galleries, 1995).

Harries, M. and S. *The War Artists: British Official War Art of the Twentieth Century* (London, Michael Joseph in Association with the Imperial War Museum and the Tate Gallery, 1983).

Harris, W. "H.W. Nevinson, Margaret Wynne Nevinson, Evelyn Sharp: Little-Known Writers and Crusaders", *English Literature in Transition* 45, 3, 2002.

Harrison, C. *English Art and Modernism 1900-1939* (Bloomington: Indiana University Press; London: Allen Lane, 1981).

Haskell, B. *The American Century* (New York City: W.W. Norton and Co., 1999).

Haste, K. *Keep the Homefires Burning: Propaganda in the First World War* (London: Allen Lane, 1977).

Hertz, R. and N.M. Klein. *Twentieth Century Art Theory: Urbanism, Politics and Mass Culture* (Englewood Cliffs, Prentice-Hall, 1990).

Hewitt, A. *Fascist Modernism. Aesthetics, Politics, and the Avant-Garde* (Stanford: Stanford University Press, 1993).

Hichberger, J.M.W. *The Military in British Art 1815-1914* (Manchester: Manchester University Press, 1988).

Higginbottom, W.H. *The Frightfulness of Modern Art* (London: Cecil Palmer, 1928).

Hind, C. L. *The Post-Impressionists* (London: Metheun, 1911; Freeport New York: Books for Libraries Press, 1969).

Holman-Hunt, D. *Latin Among Lions: Alvaro Guevara* (London: Michael Joseph, 1974).

Huddleston, S. *Back to Montparnasse* (London: Harrap, 1931).

Huddleston, S. *Mr Paname: A Paris Fantasia* (New York: Doran, 1927).

Huddleston, S. *Paris: Salons, Cafes, Studios* (New York: Blue Ribbon Books, 1928).

Hulten, P. (ed.) *Futurism and Futurisms* (New York: Abeville Press, 1986).

Hulten, P. *Italian Art 1900-1945* (Milano: Bompiani, 1989).

Hynes, S. *A War Imagined – The First World War and English Culture* (London: Bodley Head, 1990).

Imperial War Museum. *A Concise Catalogue of Paintings, Drawings, and Sculpture of the First World War 1914-1918* 2nd ed. Introduction by Martin Conway. (London, Imperial War Museum, 1963).

Inge, W.R. *The Post-Victorians* (London: Nicholson & Watson, 1933).

Ingleby, R. *Christopher Wood: An English Painter* (London: Allison & Busby, 1995).

Jeffrey, I. "C.R.W. Nevinson: Artist Celebrity," in *C.R.W. Nevinson, 1889-1946: Retrospective Exhibition of Paintings, Drawings and Prints* (exhibition catalogue; Cambridge: Kettle's Yard Gallery, n.d. [1988]).

John, A.V. *Evelyn Sharp: Rebel Woman 1869-1955* (Manchester University Press, 2009)

John, A.V. "Imag(in)ing H.W. Nevinson: war correspondent, literary journalist and rebel," in M. Hewitt, *Representing Victorian Lives* (Leeds Centre for Victorian Studies, Leeds, 1999).

John, A.V. "Margaret Wynne Nevinson: Gender and National Identity in the Early Twentieth Century," in G.H. Jenkins and R.R. Davies, *From Medieval to Modern Wales: Historical Essays in Honour of Kenneth O. Morgan and Ralph A. Griffiths* (Cardiff: University of Wales Press, 2004).

John, A.V. *War, Journalism and the Shaping of the Twentieth Century: The Life and Times of Henry W. Nevinson* (I.B. Tauris, 2006).

Johnson, C. *C.R.W. Nevinson: The Soul of a Soulless City* (London: Tate Publishing, 2001).

Jones, M.W. *Fragments of Life: Tales and Sketches* (London: Allen and Unwin, 1922).

King, J. *Interior Landscapes: A Life of Paul Nash* (London: George Weidenfeld and Nicolson, 1987).

Kirby, M. *Futurist Performance* With manifestos and playscripts translated from the Italian by Victoria Nes Kirby (New York: E. P. Dutton & Co. 1971).

Knowles, E. *C.R.W. Nevinson* (Cambridge, Kettle's Yard, 1988).

Konody, P.G. 'The Art of C.R.W. Nevinson' *Art in Australia* (15 February 1931).

Konody, P.G. *Modern War: Paintings by C.R.W. Nevinson* (London: Grant Richards, 1917).

Laffin, J. *The Western Front Illustrated 1914-1918* (Pheonix Mill, Allen Sutton, 1991).

Leed, E. *No Man's Land: Combat and identity in World War I* (Cambridge: Cambridge University Press, 1979).

Levy, M. 'C.R.W. Nevinson: Undertones of Peace', *Studio*, August 1961.

Lewis, P.W. *Blast: Review of the Great English Vortex* No.1 (London: John Lane, 1914; Santa Barbara: The Black Sparrow Press, 1981).

Lewis, P.W. *Blast: Review of the Great English Vortex*. No.2 (London: John Lane, 1915; Santa Barbara: The Black Sparrow Press, 1981).

Lewis, P.W. *Blasting and Bombardiering* (London: Eyre & Spottiswoode, 1937).

Lewis, P.W. *Rude Assignment* (London: Hutchinson, 1950).

Lewis, S. *Martin Arrowsmith* (London: Cape, 1925), published in U.S.A. as *Arrowsmith* (New York: Harcourt Brace and Co., 1925).

Lewis, W. "A Review of Contemporary Art," (1915), *Wyndham Lewis on Art* C. J. Fox and Walter Michel (ed.) (London: Thames and Hudson, 1969).

Lewis, W. Letter to Charles Handley-Read, 2 September 1949, *The Letters of Wyndham Lewis* W. K. Rose (ed.) (London: Methuen, 1963).

Lipke, W. C. 'Futurism and the Development of Vorticism' *Studio International* (April 1967).

Lumsden, E. *The Art of Etching* (London: Seeley, Service & Co., 1925).

Lyon, J. "Militant Discourse, Strange Bedfellows: Suffragettes and Vorticists before the War," *Differences: A Journal of Feminist Cultural Studies* 4, 2, 1992.

MacDougall, S. *Mark Gertler* (London: John Murray, 2002).

Malvern, S. 'War as it is: The Art of Muirhead Bone, C.R.W. Nevinson and Paul Nash, 1916-17' *Art History* (December 1986).

Malvern, S. *Art, Patronage and Propaganda: British Modern Art discourses and Official War Art During the First World War* (Ph.D. diss. Reading University, 1981).

Malvern, S. *Modern Art, Britain and the Great War* (New Haven and Yale: Yale University Press, 2004).

Malvern, S. *Things to Come. Eric Kennington's 'War God'* The Henry Moore Institute. Essays on Sculpture, 33 (Leeds: The Henry Moore Institute, 2001).

Mann, P. *The Theory-Death of the Avant-Garde* (Bloomington and Indianapolis: Indiana University Press, 1991).

Mannin, E. *Confessions and Impressions* (London: Jarrolds, 1930).

Mannin, E. *Sounding Brass* (London: Jarrolds, 1926).

Martin, C. *English Life in the First World War* (London: Wayland Publishers, 1974).

Martin, C. 'Nevinson and Fiction: A Survey' in: Walsh, M.J.K. (ed.) *A Dilemma of English Modernism: Verbal and Visual Politics in the Life and Work of C.R.W. Nevinson* (University of Delaware Press, 2007).

Martin, M.W. *Futurist Art and Theory 1909-1915* (New York: Hacker Art Books, 1978).

Marwick, A. *The Deluge: British Society in the First World War* (New York: Norton, 1970).

Masterman, L. *C.F.G. Masterman: A Biography* (London: Nicholson & Watson, 1939).

May, H.A.R. *Memories of the Artist's Rifles* (London: Howlett and Son, 1929).

McConkey, K. *British Impressionism* (New York: Harry N. Abrams, 1989).

McGreevy, T. 'C.R.W. Nevinson, A.R.A.' *Studio* (May 1939).

Meyers, J. in *The Enemy: A Biography of Wyndham Lewis* (London: Routledge, 1980).

Montague, C.E. and J. Salis. *British Artists at the Front* Vol. 3 (London, 1918).

Moore, G. *Conversations in Ebury Street* (London: William Heinemann Ltd, 1924).

Mories, F.G. 'C.R.W. Nevinson, A.R.A.' *Studio* (September 1945).

Morris, L. (ed.) *Henry Tonks and the 'Art of Pure Drawing'* (Norwich: Norwich School of Art Gallery, 1985).

Mowat, C. *Britain Between the Wars 1918–1940* (University of Chicago Press, 1955).

Murray, A.H.H. accompanied by H.W. Nevinson and M. Carmichael, *Sketches On The Old Road Through France to Florence* (London and New York: EP Dutton and Co., 1904).

Nash and Nevinson in War and Peace: The Graphic Work 1914-1920, exh. cat. (London, The Leicester Galleries at the Alpine Club Gallery, 1977).

Nash, P. *Outline. An Autobiography and Other Writings* (London: Faber & Faber, 1949).

Neve, C. 'An Artist Over Arras. C.R.W. Nevinson's Air Pictures' ,*Country Life*, 28 September 1972.

Nevinson, C.R.W. *Paint and Prejudice* (London: Metheun, 1937; New York: Harcourt, Brace and Company, 1938).

Nevinson, C.R.W. 'When the Censor Censored 'Censored'.' Stories of a strange Chateau in France and Other War Memories of C.R.W. Nevinson, The Famous War Artist', *British Legion Journal*, October 1932.

Nevinson, C.R.W. "The Arts Within this Bellicose Civilization," *The Seven Pillars of Fire: A Symposium by Dr Maude Royden, Dr L.P. Jacks, Prof. A.E. Richardson, the Marquis of Tavistock, C.R.W. Nevinson, Capt. Bernard Acworth, and Sir E. Denison Ross* (London: Barrie and Jenkins, 1936).

Nevinson, H.W. "Marinetti: Futurist," Repr. from the *Atlantic Monthly*, November 1914, in his *Visions and Memories*. Collected Evelyn Sharp; intro. Gilbert Murray (London: Oxford University Press, 1944, repr. 1946).

Nevinson, H.W. *Changes and Chances* (London: Nisbet, 1923).

Nevinson, H.W. *Last Changes and Last Chances* (London: Nisbet, 1928).

Nevinson, H.W. *More Changes and More Chances* (London: Nisbet, 1925).

Nevinson, H.W. *Rough Islanders* (London: Routledge, 1930).

Nevinson, H.W. *The Natives of England* (New York, 1930).

Nevinson, H.W. *The Plea of Pan* (London, 1901).

Nevinson, H.W. *The Fire of Life* (London: Nisbet, 1935).

Nevinson, M. *Life's Fitful Fever* (London: A&C Black, 1926).

Nevinson, M. *Fragments of Life* (London, 1922).

Parkes, K. 'Nevinson', *Apollo*, November 1928.

Parsons, I. (ed.) *The Collected Works of Isaac Rosenberg: Poetry, Prose, Letters, Paintings and Drawings* (London: Chatto & Windus, 1979).

Perloff, M. *The Futurist Moment. Avant-Garde, Avant Guerre, and the Language of Rupture* (Chicago and London: University of Chicago Press, 1986).

Petrie, Sir C. *The Edwardians* (London: W. W. Norton, 1965).

Phillips, C. *Nash and Nevinson in War and Peace: The Graphic Work 1914 - 1920* (London: Alpine Club Gallery, 1977).

Pirandello, L. *The One-act Plays of Luigi Pirandello* (New York: Dutton, 1928).

Poggioli, R. *The Theory of the Avant-Garde* Trans. Gerald Fitzgerald (Cambridge: Harvard University Press, 1968).

Pound, E. *Small Magazines*, in H.N. Schneidau. *Ezra Pound. The Image and the Real* (Louisiana State University Press, 1969).

Rainey, L. "The Creation of the Avant-Garde: F.T. Marinetti and Ezra Pound," *Modernism/Modernity* 1.3,1994.

Roberts, W. *Some Early Abstract and Cubist Work 1913-1920* (London: Canale Publication of the Favil Press, 1957).

Rose, W.K. (ed.) *The Letters of Wyndham Lewis* (Norfolk, USA, 1963).

Ross, C. *Twenties London: A City in the Jazz Age* (London: Phillip Wilson, 2003).

Ross, M. *Robert Ross: Friend of Friends* (Jonathan Cape, 1952).

Rothenstein, J. *British Art Since 1900* (London: Phaidon, 1962).

Rothenstein, J. *British Artists and the War* (London: Peter Davies, 1931).

Rothenstein, J. *Modern English Painters, Volume 2: Lewis to Moore* (London: Eyre and Spottiswoode, 1956)

Rothenstein, J. *The Tate Gallery* (London: Thames and Hudson, 1962).

Rothenstein, W. *Men and Memories: Recollections of William Rothenstein, 1900-1922* (London: Faber & Faber, 1932).

Rutherston, A. (ed.) *C.R.W. Nevinson* Contemporary British Artist Series (London: Ernest Benn, 1925).

Rutter, F. *Revolution in Art* (London: Art News Press, 1910).

Rutter, F. 'The Influence of War on Art' in: H.W. Wilson and J.A. Hammerton, (eds.)

The Great War: The Standard History of the All Europe Conflict, Vol. 12 (London: The Amalgamated Press, 1919).

Rutter, F. *Art in My Time* (London: Rich & Cowan Ltd., 1933).

Rutter, F. *Some Contemporary Artists* (London: Leonard Parsons, 1922).

Salaman, M.C. *Modern Masters of Etching: C.R.W. Nevinson* (London: Studio, 1932).

Salaman, M.C. *Modern Woodcuts and Lithographs* (London: A. & C. Black, 1919).

Saler, M. 'Making it New: Visual modernism and the 'Myth of the North' in Inter-war England', *The Journal of British Studies* Vol. 37, No. 4, October 1998.

Sanders, M.L. and P.M. Taylor. *British Propaganda During the First World War, 1914-1918* (London: MacMillan, 1982).

Schneidau, H.N. *Ezra Pound. The Image and the Real* (London: Louisiana State University Press, 1969).

Schorer, M. *Sinclair Lewis: An American Life* (London: Heinemann, 1961).

Secrest, M. *Kenneth Clark: A Biography* (New York: Holt, Rinehart & Winston, 1984).

Severini, G. (trans. F. Franchina) *The Life of a Painter* (Princetown: Princeton University Press, 1995).

Sillars, S. *Art and Survival in First World War Britain* (Basingstoke and London: Palgrave MacMillan, 1987).

Sitwell, O. *C.R.W. Nevinson* (London: Ernest Benn, 1925).

Sitwell, O. *Great Morning,* in W.C. Wees *Vorticism and the English Avant-Garde.* (Manchester: Manchester University Press, 1972).

Sitwell, O. *Memorial Exhibition of Pictures by C.R.W. Nevinson* (London: Leicester Galleries, 1947).

Skipworth, P. 'A Synthesis of War: The Painting of C.R.W. Nevinson, 1914-1916', *Connoisseur*, October 1972.

Skipworth, P. Forward. *The Art of War 1914-1918. Wyndham Lewis, Paul Nash, C.R.W. Nevinson, William Roberts, exh. cat.* (London, The Morley Gallery, 1971).

Smith, D.C. (ed.) *Correspondence of H.G. Wells*, Vol. 3 1919-1934 (London: Pickering & Chatto, 1998).

Southam, B.C. *A Student's Guide to the Selected Poems of T.S. Eliot* (London: Faber, 1974).

Spalding, F. *British Art Since 1900* (London: Thames and Hudson, 1986).

Spalding, F. *Roger Fry: Art and Life* (London: Granada Publishing, 1980).

Speaight, R. *William Rothenstein* (London: Eyre & Spottiswoode, 1962).

Spencer, G. *Memoirs of a Painter* (London: Chatto & Windus, 1974).

Spencer, R. 'We Are Making a New World: Artists in the 1914-1918 War', *Studio*, December 1974.

Stanstell, C. *American Moderns: Bohemian New York and the Creation of a New Century* (New York: Metropolitan Books, 2000).

Stephenson, A. 'Strategies of Situation: British Modernism and the Slump c.1929-1934', *Oxford Art Journal* Vol. 14 No. 2, 1991.

Sutton, D. (ed.) *Letters of Roger Fry* (London: Chatto & Windus, 1972).

Tatham, Meaburn and James E. Miles (eds.) *The Friends Ambulance Unit, 1914-1919: A Record* (London: Swarthmore Press, 1920).

Taylor, J. *Futurism* (New York: M.O.M.A., 1961).

Terraine, J. *Impacts of War 1914-1918* (London: Hutchinson, 1970).

Tippett, M. *Art at the Service of War: Canada, Art and the Great War* (Toronto: University of Toronto Press, 1984).

Tisdall, C. and A. Bozzola. *Futurism* (New York: Oxford University Press, 1978).

Titterton, W.R. *A Candle To The Stars* (London: Grayson & Grayson, 1932).

Tonks, H. "Notes from 'Wander Years'," *Artwork* 5/20, 1929.

Tosh, J. *A Man's Place. Masculinity and the Middle-Class Home in Victorian England* (New Haven & London: Yale University Press, 1999).

Trotter, D. *Paranoid Modernism: Literary Experiment, Psychosis, and the Professionalization of English Society* (Oxford: Oxford University Press, 2001).

Troubetzkoy, Princess P. and C.R.W. Nevinson, *Exodus A.D.: A Warning to Civilians* (London: Hutchinson, n.d [1934]).

Troubetzkoy, Princess P. *Gallow's Seed* (London: Grayson and Grayson, 1934).

Turner, J. (ed.) *The Dictionary of Art* (London: MacMillan, 1996).

Viney, N. *Images of Wartime: British Art and Artists of World War I: Pictures from the Collection of the Imperial War Museum* (Great Britain: David and Charles, 1991).

Wadsworth, B. *Edward Wadsworth: A Painter's Life* (Salisbury: Michael Russell, 1989).

Walsh, M.J.K. *A Dilemma of English Modernism: Verbal and Visual Politics in the Life*

and Work of C.R.W. Nevinson (Delaware: University of Delaware Press, 2007).

Walsh, M.J.K. " 'The Eminent English Futurist': C. R. W. Nevinson and English Futurism in Peace and War," in Jonathan Black *et al.*, (eds.) *Blasting the Future: Vorticism in Britain 1910–1920*. (London: Philip Wilson, 2004).

Walsh, M.J.K. *C.R.W. Nevinson: This Cult of Violence* (New Haven: Yale University Press, 2002).

Ward, C. (ed.) *World War One British Poets* (New York, 1997).

Watney, S. *English Post-Impressionism* (London, 1980).

Watson, F. 'C.R.W. Nevinson' *Arts Review* (15 February 1980).

Wees, W.C. *Vorticism and the English Avant-Garde* (Toronto: University of Toronto Press, 1972).

Wells, H.G. *War and the Future: Italy, France and Britain at War* (London: Cassell, 1917).

Wells, H.G. *The Shape of Things to Come: The Ultimate Revolution* (London: Hutchinson, 1933).

Wells, H.G. *The War of the Worlds* (London: Heinemann, 1951; originally published: 1898).

Weintraub, S. (ed.) *Bernard Shaw on the London Art Scene 1885–1950* (Penn State University Press, 1989).

Williamson, A. *Henry Williamson: Tarka and the Last Romantic* (Stroud: Sutton, 1995).

Williamson, H. *A Test to Destruction* (London: Macdonald, 1960).

Williamson, H. *The Gold Falcon, or The Haggard of Love* (London: Faber, 1933).

Williamson, H. *The Linhay on the Downs and Other Adventures in the Old and the New World* (London: Faber, 1934).

Williamson, H. *The Phoenix Generation* (London: Macdonald, 1965).

Williamson, H. *The Power of the Dead* (London: Macdonald, 1963).

Williamson, H. *The Wet Flanders Plain* (London: Faber, 1929).

Winter, J.M. *The Great War and the British People* (Cambridge: Harvard University Press, 1986).

Woodall, M. *The Early Years of the N.E.A.C.* (London, 1952).

Woodeson, J. *Mark Gertler: Biography of a Painter, 1891–1939* (London: Sidgwick & Jackson, 1973).

Wyer, R. *War Paintings and Drawings by British Artists, Exhibited under the Auspices of the Ministry of Information London*, Introduction by Christian Briton, (USA, 1919).

Wykes-Jones, M. 'Nash and Nevinson in War and Peace' *Arts Review* (11 November 1977).

Index of Names

Art Index

Printed in the United Kingdom
by Lightning Source UK Ltd.
131325UK00001B/34-282/P

9 780718 830908